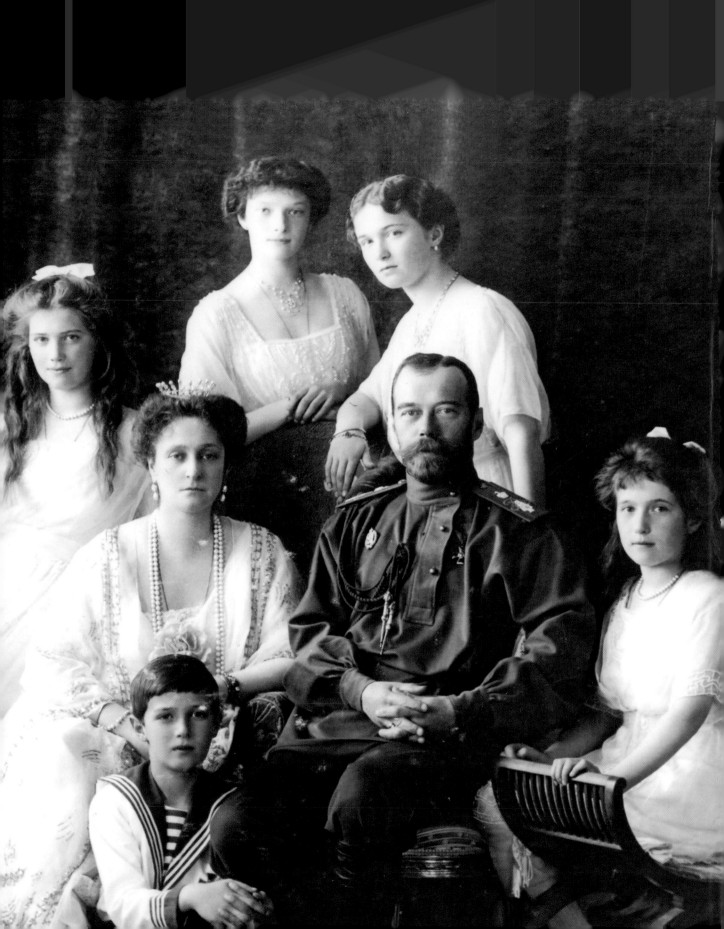

Nicholas
and
Alexandra

THE LAST TSAR AND TSARINA

National
Museums
of Scotland

Nicholas
and
Alexandra

First published in 2005 by
NMSE Publishing
a division of NMS Enterprises Limited
National Museums of Scotland
Chambers Street
Edinburgh EHI IJF

Reprinted 2005

British Library Cataloguing in Publication Data
A catalogue record for this book
is available from the British Library

ISBN: 1 901663 99 X

Book layout and design by Mark Blackadder
Printed and bound in the United Kingdom by Cambridge Printing

www.nms.ac.uk
www.hermitagemuseum.org

COVER IMAGE

The wedding of Tsar Nicholas II
and Tsarina Alexandra Feodorovna
(detail; completed 1895)
Laurits Regner Tuxen (1853-1927)

CATALOGUE NO. C01

PREVIOUS PAGE

The Russian Imperial family, 1894
Left to right, seated: Maria
Nikolaevna; Tsarina Alexandra
Feodorovna; Tsarevich Alexei
Nikolaevich; Tsar Nicholas II;
Anastasia Nikolaevna
Standing: Tatiana Nikolaevna;
Olga Nikolaevna
Photographer unknown
(The Royal Collection
© Her Majesty Queen Elizabeth II)

OPPOSITE

Tsarevich Nicholas of Russia
and Princess Alix of Hesse
at the time of their engagement,
Coburg, 1894
E Uhlenhuth
(The Royal Collection
© Her Majesty Queen Elizabeth II)

NMS | National Museums of Scotland

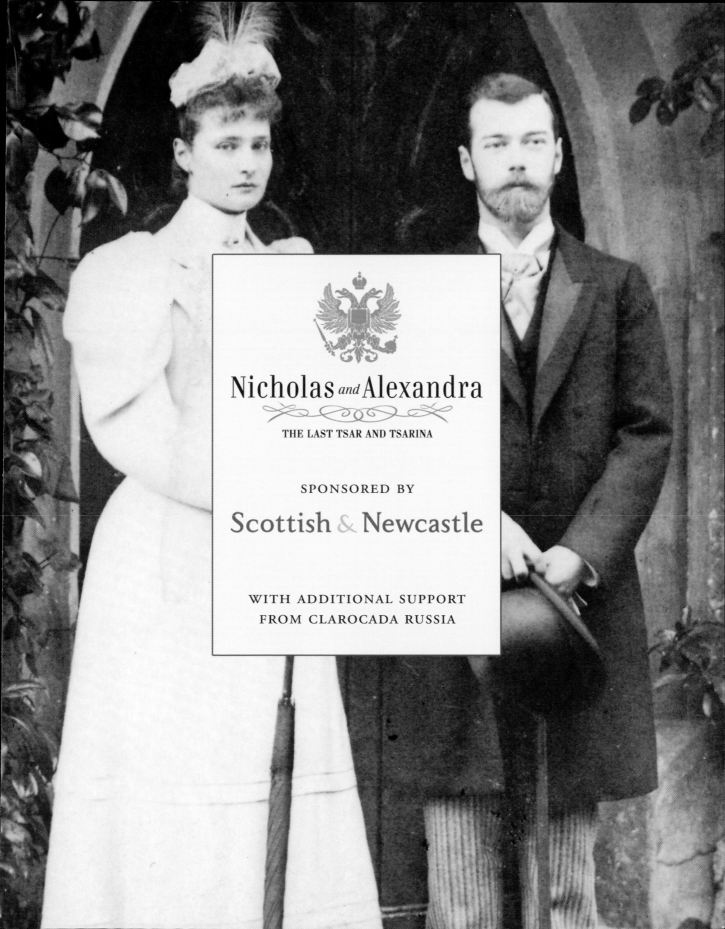

Nicholas *and* Alexandra

THE LAST TSAR AND TSARINA

SPONSORED BY

Scottish & Newcastle

WITH ADDITIONAL SUPPORT
FROM CLAROCADA RUSSIA

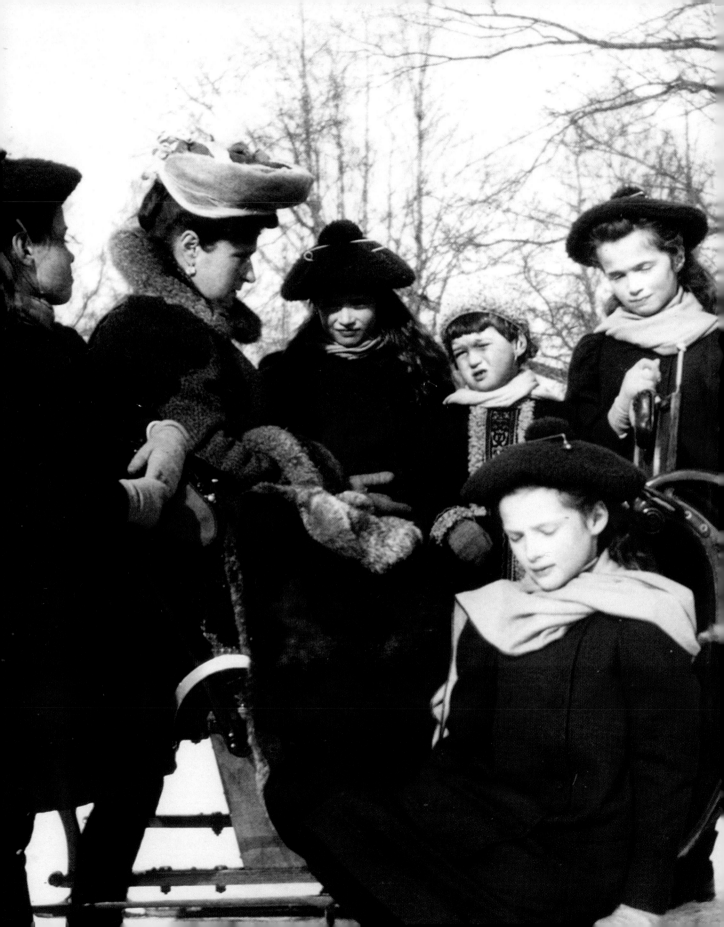

CONTENTS

Nicholas
and
Alexandra

OPPOSITE

Tsarevich Alexei with his
mother and sisters

(Beinecke Rare Book and Manuscript
Library, Yale University)

EXHIBITION CREDITS

Nicholas *and* Alexandra
THE LAST TSAR AND TSARINA

National Museums of Scotland, Edinburgh
14 July 2005 to 30 October 2005

Concept and co-organisation of the exhibition:
National Museums of Scotland
and State Hermitage Museum, St Petersburg

NATIONAL MUSEUMS OF SCOTLAND

Dr GORDON RINTOUL, Director
Ms MARY BRYDEN, Director of Public Programmes
Ms CATHERINE HOLDEN, Director of Marketing
and Development

Exhibition organising committee:
MAUREEN BARRIE
GODFREY EVANS
ALISON PATTERSON

Exhibition working team:

Steven Baird
Alison Cromarty
Tom Chisholm
Ros Clancey
Lisa Cumming
Russell Eggleton
Jane Ferguson
Sarah Foskett
Michelle Forster-Davies
Susan Gray

Irene Kirkwood
Karen Inglis
Lynn McClean
Annette MacTavish
Rachel Morrell
Nicola Pickavance
Elize Rowan
Joyce Smith
Charles Stable
Nicola Watt

Exhibition design:
StudioMB

STATE HERMITAGE MUSEUM, ST PETERSBURG

Exhibition organising committee:
Prof. Dr M. B. PIOTROVSKY
Director, State Hermitage Museum

Prof. Dr G. B. VILINBAKHOV
Deputy Director, State Hermitage Museum
(Science)

Dr V. Y. MATVEYEV
Deputy Director, State Hermitage Museum
(Exhibitions and Development)

V. A. FEDOROV
Head of the Russian Art Department,
State Hermitage Museum

Theme – exposition plan of the exhibition:
V. A. FEDOROV
S. A. LETIN
G. A. PRINTSEVA

*Restoration preparation of the exhibits was made
by the artist-restorers of the State Hermitage
Museum, under the supervision of:*
T. I. ZAGREBINA
Director – Chief Custodian
K. F. NIKITINA
Head of Restoration

*Ownership of exhibits
(unless otherwise credited):*

State Hermitage Museum, St Petersburg

Exhibition working team:

V. A. Fedorov (*Head*)
A. M. Bogolyubov
L. I. Dobrovolskaya
Y. Y. Gudymenko
E. S. Kmelnitskaya
S. A. Letin
O. V. Morozova
E. N. Nekrasova
G. A. Printseva
T. V. Rappe

CATALOGUE
from the exhibition

Nicholas *and* Alexandra
THE LAST TSAR AND TSARINA
National Museums of Scotland,
Edinburgh
14 July 2005 to 30 October 2005

STATE HERMITAGE MUSEUM,
ST PETERSBURG

Scientific editor of the catalogue:
Prof. Dr G. B. VILINBAKHOV

Authors of catalogue chapters:

N. I. TARASOVA (CH. 1)
G. N. KOMELOVA (2)
G. A. PRINTSEVA (3)
Y. B. PLOTNIKOVA (5)
A. G. POBEDINSKAYA (6)

Authors of annotations to the catalogue:

E. Anisimova (E.A.)
T. B. Arapova (T.A.)
A. A. Babin (A.A.B.)
I. R. Bagdasarova (I.B.)
A. M. Bogolyubov (A.M.B.)
O. P. Deshpande (O.D.)
L. I. Dobrovolskaya (L.D.)
M. A. Dobrovolskaya (M.D.)
T. M. Furasieva (T.F.)
I. A. Garmanov (I.G.)
Y. Y. Gudymenko (Y.G.)
N. Y. Guseva (N.G.)
E. S. Khmelnitskaya (E.K.)
T. T. Korshunova (T.T.K.)
M. N. Kosareva (M.K.)
O. G. Kostchuk (O.K.)
T. V. Kudryavtseva (T.V.K.)
I. N. Kuznetsova (I.K.)
S. A. Letin (S.L.)

M. Lopato (M.L)
L. V. Lyakhova (L.L.)
T. A. Malinina (T.M.)
A. A. Marishkina (A.M.)
G. A. Mirolyubova (G.M.)
E. Y. Moisyenko (E.M.)
K. A. Orlova (K.O.)
T. A. Petrova (T.P.)
S. L. Plotnikov (S.P.)
Y. V. Plotnikova (Y.P.)
A. G. Pobedinskaya (A.P.)
G. A. Printseva (G.P.)
T. V. Rappe (T.R.)
E. S. Shchukina (E.S.)
L. A. Tarasova (L.T.)
N. I. Tarasova (N.T.)
I. L. Tokareva (I.T.)
S. V. Tomsinsky (S.T.)
I. N. Ukhanova (I.N.)
L. A. Yakovleva (L.Y.)
G. V. Yastrebinskaya (G.V.Y.)
G. B. Yastrebinsky (G.B.Y.)
L. A. Zavadskaya (L.Z.)

Catalogue photography:

N. N. Antonova
S. A. Letin
S. V. Pokrovsky
I. E. Regentova
K. V. Sinyavsky
S. V. Suetova

Additional assistance:

A. Mikliaeva

NATIONAL MUSEUMS OF
SCOTLAND

Catalogue project management:

Cara Shanley
Lesley Taylor
NMS Enterprises Limited – Publishing

Catalogue layout and design:

Mark Blackadder

Editor of catalogue annotations:

Godfrey Evans (G.E.)

Additional chapters (CHS. 4, 7):

National Museums of Scotland

Original translations (CHS. 1, 2, 3, 6):
[*Nicholas & Alexandra: The Last Tsar and Tsarina*
(exhibition catalogue), 18 September 2004 to
13 February 2005, Hermitage Amsterdam]

*Hermitage Amsterdam catalogue
concept and editing:*

Viatcheslav Fedorov
(State Hermitage Museum)
Vincent Boele (Hermitage Amsterdam)

Translators:

Arnoud Bijl (Russian-Dutch)
Donald Gardner (Dutch-English)
Sam Herman (Dutch-English)

Additional translations and advice
(CH. 5):

Yevgeniya Matyunin (catalogue entries);
David Petherick, Clarocada Russia

Additional material and assistance:

NMS Design and Technical Support
NMS Library
NMS Photography

*Acknowledgements for use of additional
source material, loans and photographs
within the exhibition and catalogue:*

Her Majesty Queen Elizabeth II

The Royal Archives, Windsor Castle
(for photographs as credited and extracts
 from Queen Victoria's diaries, 1896-97):
Frances Dimond, Curator, Royal Photo-
 graph Collection
Lady Jane Roberts, Librarian and Curator,
 and Susan Owens, Assistant Curator,
 at the Print Room
Lucy Whitaker, Assistant Surveyor of the
 Queen's Paintings

The Royal Collection Trust

Beinecke Rare Books and Manuscript
 Library, Yale University (Romanov
 Photographic Albums)

National Library of Scotland

Royal Scots Dragoon Guards (Carabiniers
 and Greys)

Lieutenant-Colonel Roger Binks,
 Royal Scots Dragoon Guards Museum,
 Edinburgh Castle

Major-General Jonathan Hall,
 Lieutenant-Governor, Chelsea Hospital

Andrew Little,
 Royal Scottish Forestry Society

John Loch, Aldbourne, Wiltshire

Dr and Mrs Duncan Poore, Inverness-shire

FOREWORD
Gordon Rintoul
DIRECTOR, NATIONAL MUSEUMS OF SCOTLAND

THE NATIONAL MUSEUMS OF SCOTLAND IS DELIGHTED TO HAVE HAD
the opportunity to work with the State Hermitage Museum, St Petersburg.
The resulting exhibition and this publication have been a joint endeavour
of which we are very proud.

The links between Scotland and Russia go back many centuries. Scots
were instrumental in the formation of the Russian Navy, for example, and
important trade links existed for centuries between the two countries. Scots
also served as soldiers, physicians and governesses to the Russian Imperial
families and aristocracy. The architect Charles Cameron, another Scot, was
responsible for some of the finest buildings commissioned by Catherine the
Great. To this day there continues to be an enduring affinity between
Scotland and Russia.

Nicholas and Alexandra, the Last Tsar and Tsarina tells the story of the last
Imperial family of Russia. Through the very personal items connected to the
family – including court costumes, uniforms, paintings, furniture and toys –

it is possible to gain an understanding of the relationships and events which eventually cost them their lives. At times it is a very moving and human story, set against the backdrop of a society in the midst of significant change.

My thanks go, first of all, to Professor Mikhail Piotrovsky, Director of the State Hermitage Museum, for his generosity in agreeing to loan so many major items to the exhibition. Second, to Mr Vladimir Malygin, the Consul General for the Russian Federation in Edinburgh, and his staff for their support throughout the period of preparation for this exhibition. Third, to Ms Geraldine Norman, United Kingdom representative for the State Hermitage.

I would also like to acknowledge the special relationship that has developed between the staff of both museums. Dr Viatcheslav Fedorov, head of the Russian Art Department at the State Hermitage, and his staff have worked tirelessly with our own team to produce a unique exhibition for the National Museums of Scotland.

I know that my staff have benefited greatly from this opportunity to work with the State Hermitage Museum; and we hope that this initial partnership between the State Hermitage and the National Museums of Scotland will continue to develop and grow.

Finally, on behalf of the National Museums of Scotland I would like to thank Scottish & Newcastle plc for their generous sponsorship of the exhibition. The activities of the company in Russia today continue the long-established trade links between our two countries.

JULY 2005

Nicholas
and
Alexandra

XI

INTRODUCTION
Mikhail Piotrovsky

DIRECTOR, STATE HERMITAGE MUSEUM, ST PETERSBURG

The Splendour of a Doomed Empire

'MR EMPEROR NICHOLAS ALEXANDROVICH AND MADAM EMPRESS Alexandra Feodorovna' – that is the quaint form that was once used to address them; a best-selling biography of the pair, however, had as its title simply 'Nicholas and Alexandra'. A picture has been created of the couple as eternal lovers whose dearest wish was to enjoy a happy family life, but who were prevented in this by their responsibilities as Tsar and Tsarina. And this is a true picture. The history of this ill-starred couple who dreamed of domestic intimacy, and who thought they could also bestow it on their subjects, has almost become a historical *cliché*. Their tragic lives put in the shade the careers of many other monarchs who tried to combine royal responsibility and personal happiness.

Nicholas II and Alexandra Feodorovna aimed to have both a public existence as Tsar and Tsarina and a private life. They thought it possible to combine the two, but their tragic fate proved that this could not be done. Divisions in Russia confronted the couple with a whole range of conflicting demands for which there was no adequate solution. The Russian people gave them some respectful nicknames and many others that were scornful and insulting.

Russia lost wars abroad, and it also lost domestic battles with radical socialism, sectarian mysticism and with the proponents of parliamentary democracy. An abscess grew in society – that of the revolution that created a fissure in the Russian empire, bringing about its fall. The tragedy of the nation was also that of the Tsar and his family who, in many people's opinion, had had a duty to act and therefore bore responsibility for all the disasters.

The period just prior to the revolution was also a time of remarkable cultural achievements in Russia. It has become known as the Silver Age of

literature, with poets such as Alexander Blok, Nikolai Gumiliov and Anna Akhmatova. The Russian avant-garde in art and music has exerted a huge influence on Western culture throughout the twentieth century. This flowering of the arts also provided a foundation for the *Ballets Russes*, which has such an extraordinary impact on innovatory dance in Russia and internationally. The Russian court was celebrated for its extravagant and festive atmosphere. No one doubted the truth of the phrase, 'splendid St Petersburg'.

In this situation of historical upheaval, a family appeared on the scene that typically set so much store by domesticity. We can regard it as a fluke of history or perhaps precisely as a wise lesson in that discipline. Because opposed to that chaos stood the most important pillar of society – family life.

The history of the Tsar and his family during the tumultuous events in Russia has been overshadowed a little by a special emphasis on the memory of Tsarevich Alexei – a sickly but nonetheless charming youth, who was the symbol of both the hope and the agony of Russia. With his parents, he died a martyr's death; it was at once a political, religious and a family tragedy.

It is the history of Russia that never forgets the tragic pages of its past but is always compelled to learn from them over again. There is of course much one could say about this. But the original objects, which are full of beauty and radiance due to the memories they evoke, tell the final episodes of the history of the tsars in a far more eloquent and reliable manner. All that is needed is an effort of the imagination.

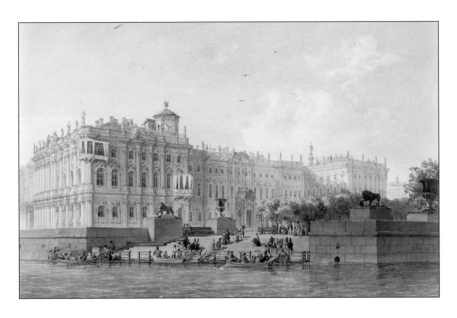

LEFT

The Neva Embankment
at the west end
of the Winter Palace
(dated 1847)

Ludwig Lugwigovich Bohnstedt
(1822-85)

CATALOGUE NO. AIIe

FAMILY TREE OF TSAR NICHOLAS II

Queen Victoria
of Great Britain
and Ireland
1819-1901 ⚭ Albert
of Saxe-
Coburg
1819-1861

Marie
Alexandrovna
(Marie of Hesse)
1824-1880 ⚭ Alexander II
Nikolaevich
1818-1881

♔

(1855-1881)

Alice
1843-1878 ⚭ Ludwig
of Hesse
1837-1892

Marie
Feodorovna
(Dagmar
of Denmark)
1847-1928 ⚭ Alexander III
Alexandrovich
1845-1894

♔

(1881-1894)

Alexandra
(Alix)
Feodorovna
(Alice of Hesse)
1872-1918 ⚭ Nicholas II
Alexandrovich
1868-1918

Georgy
Alexandrovich
1871-1899

(1896-1917)

Olga
Nikolaevna
1895-1918

Tatiana
Nikolaevna
1897-1918

Maria
Nikolaevna
1899-1918

Anastasia
Nikolaevna
1901-1918

Alexei
Nikolaevich
Tsarevich
1904-1918

FAMILY TREE OF TSAR NICHOLAS II

Vladimir
Alexandrovich
1847-1909
⚭
Maria
Pavlovna
1854-1920

Maria
Alexandrovna
1853-1920

Pavel
Alexandrovich
1860-1919
⚭
Alexandra
of Greece
1870-1891

Alexei
Alexandrovich
1850-1908

Sergei
Alexandrovich
1857-1905
⚭
Elizabeth
of Hesse
(Elizaveta Feodorovna)
1864-1918

Xenia
Alexandrovna
1875-1969
⚭
Alexander
Mikhailovich
1866-1933

Mikhail
Alexandrovich
1878-1918

Olga
Alexandrovna
1882-1960

Irina
Alexandrovna
1895-1970
⚭
Felix
Yusupov
1887-1967

BIOGRAPHICAL TIMELINE
OF TSAR NICHOLAS II†

1868	6	May	Birth of Nikolai Alexandrovich, son of Alexander Alexandrovich and Marie Feodorovna
1881	1	March	Tsar Alexander II is murdered by terrorists; Nikolai becomes Tsarevich, heir to the throne
1891	29	April	Attempted assassination of Tsarevich Nikolai (Nicholas) while on grand tour of Japan (in Otsu)
1894	8	April	Tsarevich becomes engaged to Alix of Hesse (Alexandra Feodorovna)
	20	Oct	Nicholas II becomes Tsar after death of Alexander III
	14	Nov	Nicholas II marries Alexandra Feodorovna
1895	3	Nov	Birth of daughter Olga
1896	14	May	Coronation in Assumption Cathedral, Moscow
1897	29	May	Birth of daughter Tatiana
1899	14	June	Birth of daughter Maria
1901	22	Jan	Queen Victoria of Great Britain dies
	5	June	Birth of daughter Anastasia
1903		Season	Famous fancy-dress ball in 'Russian style' is held in the Winter Palace
		Nov	During the congress of the Russian Social Democratic Workers' party in London, the party splits into two – the Mensheviks, led by Georgi Plekhanov; the Bolsheviks, led by Vladimir Iliych Lenin and Leon Trotsky
1904	27/8	Feb	Japan declares war on Russia (ends with Portsmouth Treaty on 23 August 1905)
	15	July	Minister of Internal Affairs, Vyacheslav Pleve, is murdered by a socialist revolutionary
	30	July	Birth of Tsarevich Alexei Nikolaevich
1905	9	Jan	Bloody Sunday in St Petersburg
	4	Feb	Grand Duke Sergei Alexandrovich, Governor of Moscow, is murdered by socialist revolutionary Ivan Kalyaev

1905			Escalating riots over spring and summer; crew of battleship *Potemkin Tavrichevsky* mutiny
	17	Oct	Nicholas II signs a manifesto, granting a constitution allowing basic civil rights and liberties, and an elected legislative body, the State Duma
1911		Sept	Piotr Stolypin assassinated by terrorist Dimitry Bodrov
1913		Feb–	Three hundredth anniversary (Tercentenary) of the founding of the Romanov dynasty (1613-1913)
1914	28	June	Archduke Franz Ferdinand, heir to the Austro-Hungarian throne, is assassinated in Sarajevo
	18	July	Russia mobilises troops in answer to Austro-Hungarian offensive against Serbia
	19	July	Germany mobilises and declares war on Russia
		Aug	St Petersburg is renamed Petrograd
	23	Aug	Nicholas takes over supreme command of the Russian Army from Grand Duke Nikolai Nikolaevich
1916	16/17	Dec	Rasputin is murdered
1917		Feb	Start of mass demonstrations in Petrograd
	2	March	Tsar Nicholas II abdicates on Pskov; Imperial family put under house arrest at Tsarskoe Selo
	1-6	Aug	Imperial family taken to Tobolsk in Siberia
		Sept	Alexander Kerensky proclaims the republic of Russia
		Nov	October revolution
		Dec	Truce between Germany and Russia – Treaty of Brest-Litovsk
1918	14	Feb	Russia introduces the Gregorian calendar
	26-30	April	Nicholas, Alexandra and Maria taken to Ekaterinburg
	23	May	Rest of the family arrives at Ekaterinburg
	16/17	July	Ex-Tsar and his family executed on the orders of Lenin
1998	17	July	Nicholas II and Alexandra and three of their children are interred in the Cathedral of St Peter and St Paul in St Petersburg

† PUBLISHER'S NOTE: Until 1918 Russia adhered to the old Julian calendar of 365.25 days and was thirteen days behind the rest of Europe, which followed the later Gregorian calendar. In February 1918, Russia adopted the Gregorian calendar and omitted or jumped thirteen days (1 February being reckoned as 14 February). In this book Old Style dates are generally given for events taking place within Russia up to February 1918, and Gregorian dates where the focus is on Western Europe or the response of the West to developments in Russia.

THE ROMANOV DYNASTY

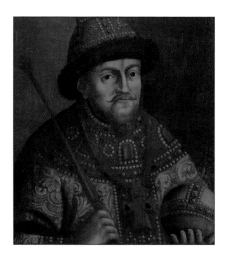

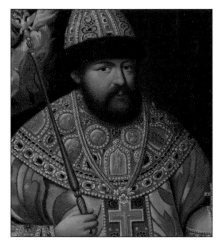

TSAR MIKHAIL FYODOROVICH
(1596-1645)

Unknown artist
(late 18th-early 19th century)
Mikhail Fyodorovich, the first of the
Romanov dynasty, was elected Tsar in 1613
and reigned up until his death in 1645.
Y.G.

CATALOGUE NO. AO1

TSAR ALEXEI MIKHAILOVICH
(1629-76)

Unknown artist
(late 18th-early 19th century)
Alexei Mikhailovich, the son of Mikhail
Fyodorovich, reigned from 1645 until 1676.
He was a well-educated and devout man,
who gained the nickname 'the meek Tsar'.
Tsar Alexei was Nicholas II's favourite Tsar.
Y.G.

CATALOGUE NO. AO2

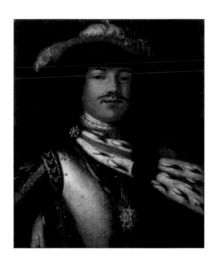

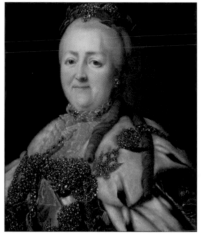

TSAR PETER I
(1672-1725)

Unknown artist
(18th century)
Peter I, the youngest son of Tsar Alexei
Mikhailovich and his second wife
Natalia Kirillovna Naryshkina, became
Tsar in 1682. Peter introduced Western
skills, technologies and fashions into
Russia and built St Petersburg as a
window on the West. Peter took the
title 'Emperor' in 1721 and has gone
down in history as 'Peter the Great'.
Y.G.

CATALOGUE NO. A03

EMPRESS CATHERINE II
(1729-96)

Unknown artist
(1780-90)
Princess Sophie of Anhalt-Zerbst was
the daughter of a minor German prince,
who married the future Emperor Peter
III in 1745 and overthrew him in 1762.
Empress Catherine II (as she became)
was an avid collector and patron on a
truly imperial scale. She expanded the
Russian empire and turned Russia into
a world power. The importance of her
reign of 34 years earned her the title
'Catherine the Great'. *Y.G.*

CATALOGUE NO. A04

TSAR ALEXANDER I
(1777-1825)

Unknown artist
(first quarter 19th century)
Alexander I, the grandson of Catherine
II and eldest son of the Emperor Paul I
was implicated in the murder of his
despotic father in 1801. Alexander was
forced to burn Moscow to stop the
French invasion of Russia in 1812, but
led his country to victory over Napoleon
in the Patriotic War. *A.P.*

CATALOGUE NO. A05

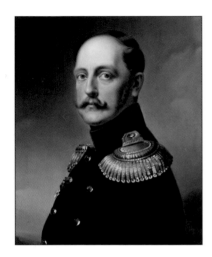

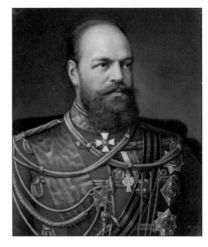

TSAR NICHOLAS I
(1796-1855)

Unknown artist
(second quarter 19th century)
Nicholas I was the brother of Alexander
I. In 1812 he married Princess Fredericka,
daughter of Russia's ally, King Frederick
William III of Prussia. Nicholas put
down a mutiny of 3000 soldiers in St
Petersburg at the start of his reign in
1825. He ordered loyal troops to open
fire, killing about sixty. *A.P.*

CATALOGUE NO. A06

TSAR ALEXANDER II
(1818-81)

Unknown artist
(dated 1888)
Alexander II, eldest son of Nicholas I,
married the daughter of the Grand Duke
of Hesse. He ascended the throne in 1855
and signed the law liberating peasants
from serfdom in 1861. Eight attempts
were made upon his life. Alexander II
was finally mortally wounded by a bomb
on 1 March 1881. *A.P.*

CATALOGUE NO. A07

TSAR ALEXANDER III
(1845-94)

Unknown artist
(late 19th century)
Alexander III, second son of Alexander
II, married the younger daughter of the
Danish King Christian IX of Denmark
in 1865. Like his eldest son, the future
Nicholas II, Alexander was a loving
father with a strong sense of humour.
Although he is represented here in the
uniform of the Life-Guards Hussar
Regiment, he was universally acknowl-
edged as a lover of peace. *A.P.*

CATALOGUE NO. A08

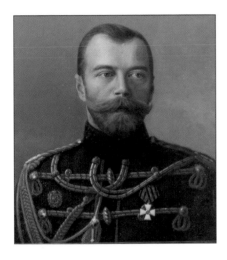

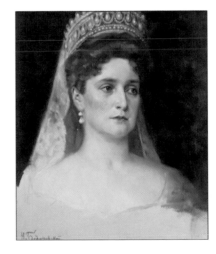

TSAR NICHOLAS II
(1868-1918)

Unknown artist
(1915-16)
Nicholas II, eldest son of Alexander III
and Marie Feodorovna, became Tsar in
1894. Contemporaries noted that Nicholas
'possessed an exceptional personal charm'.
Kaiser Wilhelm II's brother, Prince Henry,
wrote: 'The Tsar is benevolent, courteous
in his manners, but not so soft as he is
often considered.' This portrait was
painted during a short stay at Tsarskoe
Selo, when the Tsar was normally at Army
headquarters. *A.P.*

CATALOGUE NO. A09

EMPRESS ALEXANDRA
FEODOROVNA (1872-1918)

Nikolai Kornilevich Bodarevsky (1850-1921)
(dated 1907)
Nicholas II's wife, Princess Alice-Victoria-
Helena-Louisa-Beatrice, was the daughter
of the Grand Duke Ludwig IV of Hesse
and Princess Alice, daughter of Queen
Victoria. Alix, as she was called, visited
Russia for the first time when she was
twelve years old, for the marriage of her
elder sister Elizabeth ('Ella') (later Elizaveta)
to the Grand Duke Sergei Alexandrovich.
Nicholas fell in love with her and they
eventually became engaged in April 1894.
A.P.

CATALOGUE NO. A10

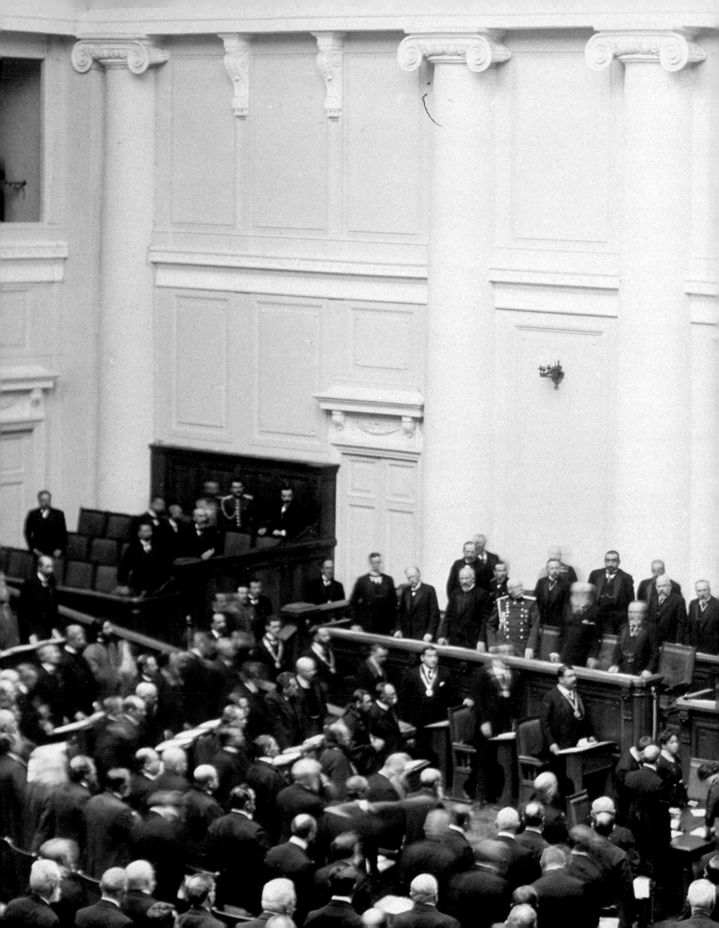

I

RUSSIA
IN THE REIGN
OF NICHOLAS II

Nina Tarasova

IN 1894 A NEW MONARCH OF THE ROMANOV DYNASTY ASCENDED *ascended the throne. As yet there was no sign that their rule would soon come to an end. Only a few far-sighted individuals had any idea that Nicholas II would be the last tsar of Russia.*

From his father, Tsar Alexander III, Nicholas II inherited a country with a thriving economy and a social and political situation that had stabilised – Russia was an empire that all the major powers had to take account of. Its material welfare was the product of the consistent and uncompromising policies pursued by Alexander III, who revoked the liberal reforms of the 1860s and 1870s and provisionally put a stop to outbursts of revolutionary terrorism.

On the day his father died, Nicholas spoke with a sob in his voice: 'I am not ready to be a tsar. I am not capable of governing an empire.' He had no definite programme, nor did he have the character to take decisions independently. Thus he ascended the throne with a single resolve: to follow in his father's footsteps. In January 1895, on receiving the representatives of the provincial nobility, Nicholas made a statement warning them against any 'foolish daydreams about participating in domestic affairs of state' and emphasised that he 'would maintain the principle of autocracy as vigorously and uncompromisingly' as his predecessor.

Nicholas attempted to stay true to the political principles of Alexander III and his most important advisor, Konstantin Pobedonostsev, yielding only reluctantly to the demands of the time. Pobedonostsev, an eminent jurist, professor of law, honorary member of a number of universities and of the Académie Française, and director general of the Holy Synod of the Russian Orthodox Church, was an ardent opponent of every move towards a constitution. He described the proposed reforms of Alexander II as a 'mistake'.

In addition to Pobedonostsev, Nicholas retained another of his father's advisors, the Minister of Finance Sergei Yulevich Witte, a passionate advocate of Russian integration with Europe. But Nicholas's efforts to combine the course of Pobedonostsev with that of Witte was to lead to serious inconsistencies in his policies, the repercussions of which would only later make themselves felt.

PREVIOUS PAGES

Meeting
of the State Duma, 1900s

Karl Karlovich Bulla
(1853-1929)

OPPOSITE

Sergei Witte, c.1915

Yosif Adolfovich Otsup
(late 19th/early 20th century)

Sergei Witte was a leading economist and statesman who occupied the post of Minister of Finance from 1892 to 1903. A member of a Dutch family promoted to the Russian aristocracy in 1856, Witte began his brilliant career under Alexander III as director of the South-Western Regional Railways. As a high-flying specialist and gifted administrator and politician, he viewed industrialisation as an essential prerequisite for Russia to take its place among the leading Western countries.

Alexander began by appointing Witte director of the department of Railway Affairs in the Ministry of Finance (1889); he then chose him as his Minister of Communications (1892) and Finance (1892). Under Witte the ministry took vigorous measures to expand Russian industry. To increase the nation's productivity and accelerate the offloading of goods, railways were built on a vast scale. Russia worked full speed ahead to overcome its backward economic situation. The railways programme, originally embarked upon under Alexander II, proceeded with remarkable rapidity. In 1891 work was started on the Trans-Siberian Railway, which was strategically important as well as having huge economic significance.

In a secret memorandum Witte, who was responsible for this hugely ambitious project, wrote:

> *From a political and strategic point of view the importance of this railway is that it gives Russia the shortest route for transporting its armed forces to Vladivostok and concentrating them in Manchuria, on the shores of the Yellow Sea and at a short distance from the capital of China*
> *This increases the prestige and influence of Russia, not only in China, but in the entire Far East.*

Ten years later the first trains travelled along the main line to Siberia. A journey from Moscow to Port Arthur took sixteen days. In around 1905 the total length of the railway network of the Russian empire was 62,000 kilometres, giving Russian industry an infrastructure that enabled the country to gain a leading position internationally.

Heavy industry expanded, above all in the south and north-western regions of Russia. Gigantic metal-producing firms were founded, equipped with modern technologies.

In the 1890s the speed of development of Russian industry easily surpassed that of other leading Western nations, and by the end of the century

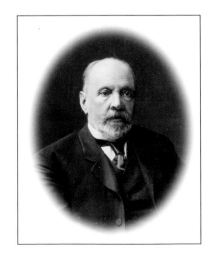

the country led the rest of the world in industrial growth. In its general economic level, Russia vied with Japan in those years. Although its share in world production was not yet great (amounting to some four per cent at the beginning of the twentieth century), it increased steadily (reaching seven per cent before the First World War).

One important indicator of Russia's industrial growth was the genuine improvement in its foreign trade balance, with the country beginning to acquire revenues from exports. At the end of the nineteenth century it had a balanced budget and gold reserves of over five hundred million roubles. Exports of Russian grain also increased continuously; and at the start of the twentieth century they were three times greater than in the mid-nineteenth century.

Native industrialists were offered privileges, benefits and credits. Some branches of production received special protection from the state – for example, that of sugar. Measures to increase treasury reserves and to stabilise the rouble also proved effective. One of these was the introduction of a wine monopoly in 1895.

In 1896 and 1897 Witte achieved a major financial reform, one that his predecessors had worked on but had not succeeded in pushing through: the introduction of the gold standard; and state letters of credit entered circulation along with gold. The exchange rate of the rouble, fixed at half an American dollar, stayed at that level until the outbreak of the First World War. The possibility of converting the rouble made the currency creditworthy in a real sense and facilitated an influx of foreign capital, especially French and Belgian. In 1899 the decision was taken to abolish all restrictions for investors in the industrial and financial sectors. At the turn of the century the total of Western investments in Russian industry amounted to some nine hundred million roubles.

Like other European countries, industrial growth in Russia was accompanied by increased exploitation of the proletariat, who in turn protested about their working conditions. To reduce social tensions, factory legislation was passed during Alexander III's reign that placed some restrictions on the arbitrary conduct of factory owners, in striking contrast to most developed countries which did not yet have any legal restrictions on adult male labour. Russian companies introduced savings books; payment in kind was forbidden, as was the employment of children under twelve; night work was banned for women and children under seventeen in the textile industry; the

working day for teenagers was limited to eight hours, and they were offered the possibility of three hours of schooling every day. A factory inspectorate supervised the enforcement of the new legislation. And although strikes were forbidden, workers had the right to dissolve their contract with the owner of the company 'in the case of ill treatment'. These laws were followed by a whole series of measures to protect the economic rights of the employee.

As a far-sighted politician Witte also urged that a solution be found for the nation's most fundamental problem – 'the question of the peasantry' – pointing out that the only way of guaranteeing social stability was to guarantee them land. Unfortunately the government did not consider the time was ripe for his proposals, nor did it give its support to the assembly for the agrarian industry, over which he presided from 1902 onwards. Another outstanding statesman, Piotr Arkadevich Stolypin (1862-1911), was put in charge of land reforms instead. Russia had, however, made impressive advances under Witte and, despite the economic crises that Europe suffered in the mid-1880s and in the period from 1901 to 1903, the country was well on its way to overcoming economic backwardness.

Thus, at the outset of Nicholas II's reign, Russia was already playing a weighty and consistent part in international affairs. The cautious, rational foreign policy of Alexander III that had earned him the title of 'peacemaker' ensured that the country did not get drawn into any of the conflicts in Western Europe at the time. Not only had Alexander avoided awkward situations, he had also exerted a positive influence on the whole of Western Europe.

Nonetheless, at the start of the 1880s Russia still did not have any reliable allies; but a treaty with the French Republic in 1891-92 put an end to the country's diplomatic isolation. This alliance between the two countries was a decisive factor in the international balance of power in the period that followed. The Russian empire proved a loyal ally to France, and from then on Europe's fate was decided not only in London, Paris, Berlin and Vienna, but also in St Petersburg.

The policy of peaceful co-existence was one that Nicholas II could also appreciate and it suited his inner convictions. Unfortunately, the time was not yet ripe for such idealism. In the summer of 1898 a memorandum was handed to the representatives of the foreign governments in St Petersburg, explaining the position of the tsarist government with regard to the arms race. Russia proposed concrete measures for arms control, including a

OVERLEAF

The arrival of Tsar Nicholas II
in Paris, October 1896,
at the start of his
state visit to France.

Georges Becker (1845-1909)
CATALOGUE NO. E12

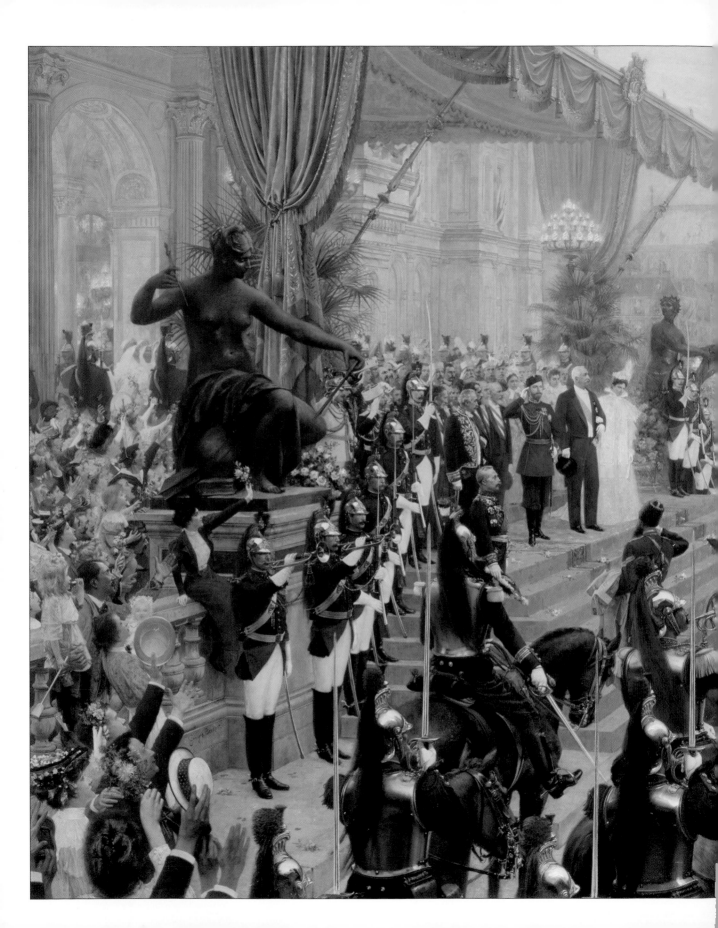

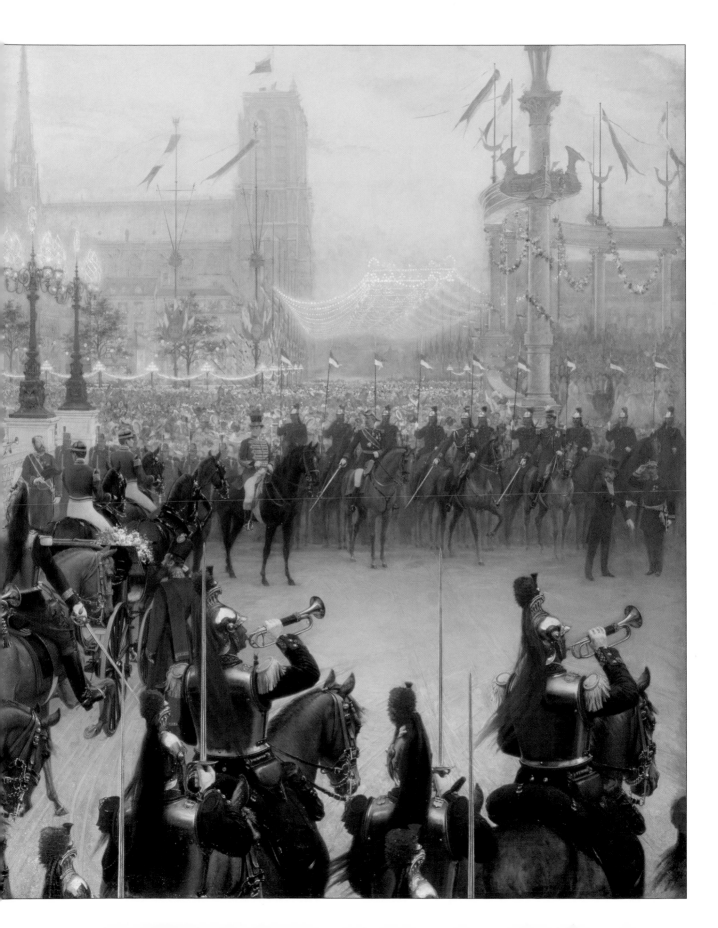

proposal for an international conference on war and peace. And even though the European states regarded Russia's initiative as somewhat inappropriate, the first international conference of delegates from twenty-seven countries was held in The Hague in the summer of 1899. Motions were adopted for the peaceful resolution of armed conflicts and for establishing a code for the conduct of war on land and at sea. However, the most important result of the conference was the founding of the International Court of Justice in The Hague, which sits there to this day under the flag of the United Nations.

At the beginning of the twentieth century the chief issue in foreign policy in Russia was the Pacific Ocean region. The increasing power of Japan, which had embarked on a period of active industrial expansion and was pursuing a policy of aggrandisement at the expense of Korea and China, posed a threat to Russia's security in the Far East and also impacted on the interests of France and Germany.

In government circles in Russia there was no consensus about how to deal with the question of the Far East. The 'war party', headed by Admiral Yevgeni Alexeyev, President of the Council of Ministers Ivan Durnovo, the Foreign Minister Vyacheslav Pleve, and Nicholas's brother-in-law the Grand Duke Alexander Mikhailovich, argued for a hard political line against Japan without concessions or compromise. A 'small war', moreover, was seen as a means of averting a growing social crisis. In favour of a peaceful resolution of international hostilities, on the other hand, was Minister of Finance Sergei Witte, and the ministers of Foreign Affairs Mikhail Muravyov and Vladimir Lamsdorf.

Discussions between Tokyo, St Petersburg, Berlin, Paris and London in 1902-3 proved fruitless. Engaged in modernising its Navy, Japan was preparing for an armed conflict. During the night of 27 January 1904 Japanese ships attacked a Russian squadron in the Korean port of Chemulpo, and on 28 January the country declared war on Russia.

This inglorious conflict, which lasted a year and a half, exposed the entire social and economic vulnerability of Russia and led to destabilisation at home. Its futility became clear at the end of 1904, especially after the fall of the Russian stronghold of Port Arthur. Nonetheless, the Second Pacific Fleet was dispatched to the Japanese coast. In May 1905 it was overwhelmed by the Japanese Navy in the Straits of Tsushima. The mood in Russia at the time can only be described as one of shock, dejection and anger.

After discussions around the negotiation table in the American city of Portsmouth, Russia made peace with Japan. Due to the efforts of Sergei

Witte, who headed the Russian delegation, the treaty was more an agreement between equal partners than a document testifying to a senseless war. The only important territory lost was the southern part of the island of Sakhalin, which was ceded to Japan.

A successful peace, however, was not enough to eliminate domestic social discontent; the Russian empire was in the throes of a revolution. The events of so-called 'Bloody Sunday', 9 January 1905, are usually cited as having sparked it off, when thousands of St Petersburg workers marched to the Winter Palace with a petition to the Tsar stating their political and financial demands. The protest was perceived as a threat to the very foundations of the state. In the absence of Nicholas II, who was staying outside the city in his residence at Tsarskoe Selo, the authorities ordered the garrison troops, who had arrived at the capital only days before, to fire on the unarmed masses.

It was a terrible day. Serious disturbances took place in St Petersburg. At a number of points in the city the garrison troops were forced to open fire, with many dead and wounded as a result. The Tsar wrote in his diary for 9 January, 'O Lord, how painful and distressing it is!'

The unrest among workers, peasants and students spread to many parts of the country in the winter and spring of 1905. On 4 February a member of the Revolutionary Socialist party, Ivan Kalyaev, assassinated the Governor of Moscow, Grand Duke Sergei Alexandrovich. In the Army too there was an extraordinary development in the summer of 1905: the mutiny of the crew of one of the finest ships of the Black Sea fleet, the battleship *Prince Potemkin Tavrichesky*. The defenders of the autocracy, the Army and the Fleet, were on the brink of collapse.

Without any suspicion of the disasters that would presently strike both Russia and himself, and under pressure from the liberal sector of society, Nicholas signed a manifesto on 17 October 1905, granting a constitution. It promised the people basic civil rights and liberties, ranging from the freedom of conscience, speech and assembly, to the setting up of an elected legislative body, the State Duma. The manifesto of 17 October was an extremely important first step towards a constitutional state in Russia.

And yet the 'Russian uprising, senseless and without quarter', continued. The first Russian revolution reached its climax in November/December 1905, when it spread to Poland, the Baltic States, the Caucasus and Siberia. A group was then formed in the government with the special task of putting

an end to public demonstrations. It was led by the Home Secretary Piotr Durnovo, an appointee of Witte who was by then Prime Minister.

Elections to the first State Duma were held in February and March 1906 under conditions that were hopelessly unstable. The opposition parties won with fifty-five per cent of the vote. On 27 April 1906, a day before the opening session, the deputies were received by Tsar Nicholas II in Saint George's Hall in the Winter Palace.

Lieutenant-General A. A. Mosolov, head of the office of the Ministry of the Imperial Court, wrote:

The procession started from the private apartments and headed towards the Throne Room. The Tsar was preceded by the highest officers of the state, bearing the Imperial regalia: the flag and the seal (on red cushions), the sceptre, the mace and the crown, studded with diamonds. They were accompanied by grenadiers with tall bearskin helmets, in full uniform. The deputies were allocated seats in the Throne Room to the right of the exit; in front of them stood the senators. On the left were the members of the Council of State, the highest ranks of the court and ministers.

His Majesty and the two Tsarinas [the Tsar's mother and wife] *came to a halt with the other members of the Imperial family in the middle of the hall. The regalia were brought to two platforms on either side of the throne, that was half covered with a wide Imperial robe, draped over red tabourets. A lectern was brought in and His Majesty was anointed by the Metropolitan Bishop. Prayers were then said, after which the Tsarinas and the leading dignitaries walked to a platform left of the throne. The Tsar waited alone in the middle of the hall, until the Tsarinas had arrived at their places, after which he walked with measured tread to the throne and sat down. He was then handed the address from the throne, which he read sitting upright with a loud clear voice.*

In his speech greeting 'the best people whom he had instructed his subjects to choose out of their midst', Nicholas expressed the hope that 'love for the Fatherland, the passionate desire to serve it', would 'inspire and unite' the deputies.

The Imperial court was, however, shocked by the calculated scorn of the deputies for the Tsar's speech. The Minister of Finance Vladimir Kokovtsev tells us:

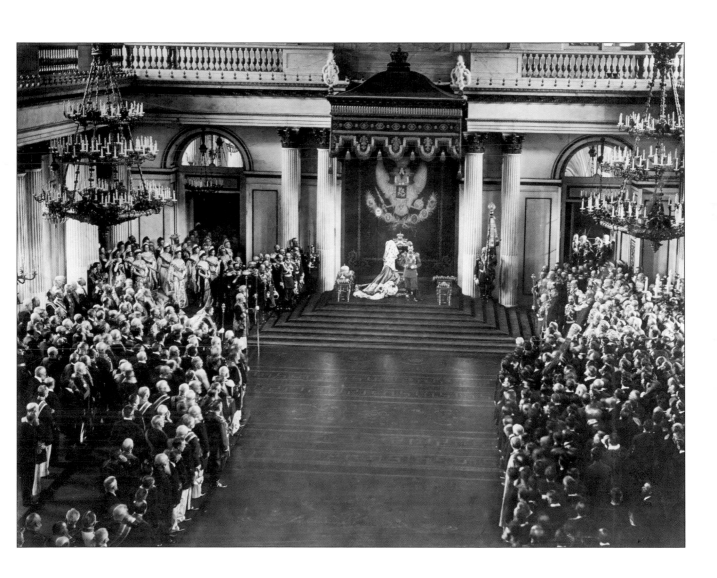

The overwhelming majority of those who were sitting demonstratively in front consisted of members of the Duma dressed in work shirts and shirt-sleeves. One tall figure in the front row was particularly striking as he stared at the throne and all around him with a mocking and impudent look on his face.

The Duma began proceedings in the Tauride Palace with an immediate display of hostility towards the tsarist state; in July 1906 Nicholas issued a *ukase* or decree dissolving the body and ordering new elections. With the Duma, part of the Russian cabinet was also dismissed. Piotr Stolypin was appointed the new President of the Council of State; he also kept the post of Minister of Home Affairs for himself.

Stolypin was an enlightened and purposeful politician, a man of resolute courage and an ardent patriot; he was the 'custodian of the new cabinet'. As a convinced monarchist, he considered that Russia and absolute rule were synonymous. However, to reinforce the constitution, it was essential to organise a basis of support within the people, a class of strong landowners and entrepreneurs. To achieve this he pressed for a speedy resolution of 'the land question' that would give the peasants genuine freedom and the power to dispose of their land. In Stolypin's view serious reforms such as this required lengthy and complicated preparations; they had to be implemented methodically and consistently so no loop-holes were left.

Therefore, simultaneously with the reforms, he proceeded to combat the revolution and terror that had overwhelmed the nation, terror that was to affect the Prime Minister personally. In August 1906 a massive explosion at his *dacha* or country house injured about sixty people, including his daughter and son. In his memoirs Kokovtsev wrote:

We were all impressed by Stolypin's calm and self-control. He at once acquired great moral authority and it became clear to everyone that an indubitably noble heart was beating in his breast; with a willingness to sacrifice himself if needs be for the general good and a resolute will to achieve what he deemed essential and useful for the state. In short, Stolypin emerged from this situation forthwith as a leader whom everyone acknowledged.

The success of the reforms depended to a large extent on the elections

for the second State Duma at the beginning of 1907. Once again, however, the results were unfavourable for the government, with the leftist parties emerging from the ballot even stronger. Stolypin's programme provoked ferocious criticism. It was then that the Prime Minister pronounced his prophetic words about the deputies on the left: 'What you want is great disturbances, but we want a great Russia.' The second Duma survived less than six months and was dissolved by *ukase* on 3 June 1907.

The third Duma survived the full term of five years; its extremely conservative composition gave Stolypin the opportunity to implement his essential agrarian legislation. He also pushed through important measures towards improving the education of the people and the reform of the Army and local and regional government. But the weaker the revolutionary movement became, and the more a mood of social reconciliation took hold of the country, so groups on the right – who had plenty of support at court – replaced those on the left in attacking Stolypin.

The Prime Minister also acquired an unusual but very powerful opponent, one who exploited the Empress Alexandra's superstitious character and whose influence prevailed in the highest court circles, the *staretz* or holy man Grigory Rasputin. As Rasputin's star ascended, so Stolypin's standing with the court declined. At the end of August 1911 Stolypin was assassinated in the Kiev Theatre by the terrorist Dmitry Bodrov.

The reforms carried out by Stolypin's cabinet, and later by his like-minded successors Vladimir Kokovtsev and Alexander Krivoshein, were aimed at the long-term view rather than immediate results. Thus the last years before the First World War saw genuine economic growth in various areas of society.

Back in 1900, however, Russian industry had been in the throes of an international monetary crisis, a situation that was exacerbated by political instability, and it only slowly managed to recover from the depression. By 1910, however, the economic tide had visibly begun to turn. In comparison with 1900 figures in, for example, coal and cast-iron production, the iron and steel industries, cotton-processing and sugar production had doubled. In the countryside the wheat harvest increased and grain exports had also grown significantly.

All of this was the direct result of government policies. Thus, on the eve of the First World War, Russia enjoyed a higher economic growth rate than Germany, Great Britain, France and the United States. National revenues had also grown by an annual figure of six per cent from 1909 to 1913, which

OPPOSITE

Piotr Stolypin, 1900s
Photographer unknown
(late 19th/early 20th century)

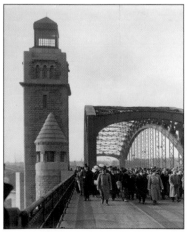

would have meant a two-fold increase over a twelve-year period. Russia had had a strong budgetary policy that was not upset even by the war with Japan or the revolution of 1905. In 1913 revenues exceeded expenditures by almost four hundred million roubles.

But perhaps even more impressive was the flowering of intellectual life in Russia during Nicholas II's short reign. In all areas of biology, mathematics and physics, Russian scholars made discoveries with international implications. Russian philosophy experienced a renaissance; and the brilliant flight of literature, music, theatre and the visual arts quite astounded the rest of Europe, revealing a new unknown Russia. The chemists Dmitry Mendeleev and Sergei Lebedev, the physicists Alexander Popov and Konstantin Tsiolkovsky, the biologists Ivan Sechenov and Ivan Pavlov, the historians Vasily Klyuchevsky and Sergei Platonov, the philosophers Nikolai Berdyaev and Sergei Bulgakov, the writers Leo Tolstoy and Anton Chekhov, Alexander Blok and Anna Akhmatova, the artists Ilya Repin and Valentin Serov, the composers Alexander Skryabin and Sergei Rachmaninov, theatre directors Konstantin Stanislavsky and Vsevolod Meyerhold, the great performers Feodor Shalyapin and Anna Pavlova, and patrons and collectors such as Sergei Diaghilev, Ivan Morozov and Sergei Shchukin – this list gives merely an impression of the contribution of Russian culture during its 'silver age' at the end of the nineteenth century and beginning of the twentieth.

St Petersburg and Moscow rivalled Paris and Munich as international centres of art. Life in St Petersburg, the political, social, military and cultural capital of the Russian empire, was indeed extraordinarily rich.

The presence of the Tsar and his family, though often invisible, left its mark on the city. Practically all the social institutions they ever visited have a plaque marking the occasion. No single relevant event in the life of St Petersburg escaped the notice of Nicholas II, whether it was the consecration of a church, the opening of a new bridge across the River Neva, the founding of an educational institute, the launching of a new ship, a première at one of the Imperial theatres, the unveiling of a monument, the opening of an exhibition or a new museum, or a ceremony presenting a regiment with its colours.

The sound of ceremonial marches never ceased here. Here and there you heard the ritual of commanding officers saluting the Tsar; and the lavishly decked-out coaches of the palace would ride past the defenders of the nation on the front line.

But meanwhile the heart of St Petersburg, the majestic Winter Palace, grew increasingly empty, becoming ever more purely symbolic of the Romanovs. After the birth of his successor, the Tsarevich Alexei Nikolaevich, Nicholas and his family lived outside the city in the Alexander Palace at Tsarskoe Selo.

The Imperial family, whose daily life increasingly resembled that of the European bourgeoisie, was waited on by a whole range of court personnel: there were countless different ranks, quite apart from the army of valets, footmen and other lackeys. All the financial and other everyday problems of the Tsar's family were smoothly dealt with by the Ministry of the Court under Baron Vladimir Fredericks.

The 'great' (Imperial) court and the 'small' courts (of the Grand Dukes) operated in different ways. In truth the family of Nicholas II had little contact with the aristocracy of St Petersburg, the brilliant world of high society. And although the small courts lived an increasingly open public life, the Romanovs lived largely isolated from the outside world. It was only during exceptional events with a relevance for the throne that the Imperial family and its entourage, the highest nobility, appeared in public together.

The beginning of the twentieth century was rich in major national feast days. It was as though, in expectation of its end, Russia was once more 'leafing through' the most important pages of its greatest historical period: the second centenary of the founding of St Petersburg (1903); the jubilee of the highest state institutions, the Senate (second centenary 1911) and the Council of State (first centenary 1910); the second centenary celebrations of the Battle of Poltava (1909) and the first centenary of the victory over Napoleon's France (1912); as well as other jubilee years for the founding of many units of the Russian Army and Navy.

The last great national occasion, the third centenary of the founding of the Romanov dynasty in 1913, was also the last year of peace for Russia as a monarchy. In 1613 the Assembly of the Land had unanimously appointed the youthful Mikhail Fyodorovich Romanov as Tsar. Three centuries later the jubilee of this great national event was celebrated far and wide with great solemnity, highlighting the historical continuity of the state, the power of the tsars, and the spirit of the nation.

The jubilee celebrations began in February in St Petersburg, after which, in May, the Imperial family toured the provincial governments of Central Russia, and the cities of Vladimir, Suzdal, Nizhny Novgorod, Yaroslav and

OPPOSITE TOP

Anna Pavlova,
the world-famous ballerina

Unknown photographer

OPPOSITE BELOW

The opening of the
Peter the Great Bridge
(Bolsheokhtinsky Bridge)
over the River Neva, 1911

Karl Karlovich Bulla
(1853-1929)

Rostov Veliky. On 19 May 1913 the distinguished visitors arrived in Kostroma; it was there, in the monastery of Ipatiev, that Mikhail Romanov had been crowned tsar.

The jubilee was also celebrated in Moscow, with splendid receptions, banquets and parades. In addition there were concerts and public spectacles with the sole aim of extolling the institution of the monarchy.

However, the jubilee celebrations were unable to stem the tide of events. Behind the façade of ambitious official measures, a deep-seated and increasingly visible social unrest was gathering strength. None of the social, economic or diplomatic achievements would be to any avail; on the contrary, the opponents of tsarist rule exaggerated as much as possible the mistakes and failures of the government. With the prospect of a bloody world war on the horizon, the monarchy was becoming psychologically isolated.

Europe was rushing headlong towards the most disastrous armed conflict in its history. The general political situation continued to be decided by the relationship between the four powers – France, Germany, Britain and Russia. Faced with increasing aggression from Germany, Paris and London found common ground on many issues; and in 1907 an unprecedented treaty was signed between Russia and Great Britain. This led in turn to a geopolitical coalition, the Triple Entente, in opposition to the military pact between Germany and the Austro-Hungarian empire. The treaty was further reinforced by official visits to Russia of King Edward VII of Britain in 1908 and the French president Raymond Poincaré in 1914.

This system of opposing coalitions, however, did not guarantee a balance of power in Europe; on the contrary, it destabilised an already delicate situation. The chief source of tensions on the Continent were the Balkan States; but due to Nicholas II's diplomatic efforts, Russia managed to avoid direct involvement in the Balkan wars of 1912 and 1913. Nicholas preferred to make concessions rather than jeopardise peace.

In 1914, however, a further crisis in the Balkans was to lead to world war. The Tsar was still deeply reluctant to become involved, being temperamentally opposed to armed conflict. Moreover, he knew that in materials and preparedness the Russian Army, despite efforts at modernisation, was no match for that of Germany. Above all, he was only too aware that military failure would lead to a revolutionary uprising at home that would be even worse than that of 1905/6. On the other hand, he did not feel free to let down his fellow Slavs in Serbia.

Nicholas made the decision to take the country to war, a war that would change the appearance of Russia and its people's way of life, including that of the members of the Imperial family.

For now, however, all thoughts were concentrated on achieving victory and the Romanovs trimmed their customary way of life accordingly. In the first months of the war the country was filled with a surge of patriotic pride, and the papers proclaimed the unity of the nation in the face of the German peril. But by 1915, after the Russian Army had suffered enormous casualties, with its most important regiments more or less disintegrating in bloody battles, the country lost heart. Patriotic sentiment gave way to despair.

At home, discontent grew with a government that appeared incapable of bringing the war to an end or preserving national stability. And many saw Rasputin, who had attached himself to the Tsar's family, as the main culprit for the disasters of the war. His murder in 1916, though widely applauded, did nothing to change the situation. The inevitable crisis was coming to a head.

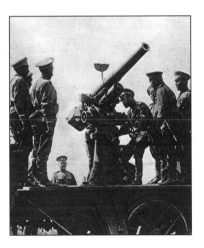

At the beginning of 1917 the previously silent masses – workers, soldiers and peasants – were now beginning to stir towards an outburst of anti-war sentiment. Their mood was skilfully exploited by the radical left parties for their own ends. On 27 February Nicholas, who was stationed at the general headquarters in Mogilev (now in Belarus), received reports of serious disturbances towards the capital. The situation had become critical and state power was paralysed. The next morning the Tsar left Mogilev for Petrograd, as St Petersburg had been renamed in 1914. The route of his train had to be altered because many stations were in the hands of revolutionary troops.

By now the monarchy had ceased to exist in the capital in any real sense. True power lay with the provisional government, and the troops had already started swearing oaths of loyalty to it. Under the walls of the Tauride Palace, the seat of the Municipal Duma, an endless meeting was in progress. Some of the deputies of the Duma proposed a meeting with the Tsar to persuade him to abdicate. On 2 March 1917, in the saloon car of the Imperial train, Nicholas II, the seventeenth monarch of the Romanov dynasty, signed a manifesto in his own name and that of his successor, the Tsarevich Alexei Nikolaevich, renouncing the throne in favour of his younger brother Mikhail, because he no longer felt able to bear the burden of Imperial power.

As Vasily Rozanov the Russian philosopher wrote in 1918: 'With a rattle, a crash and a screech, an iron curtain has fallen on the History of Russia.

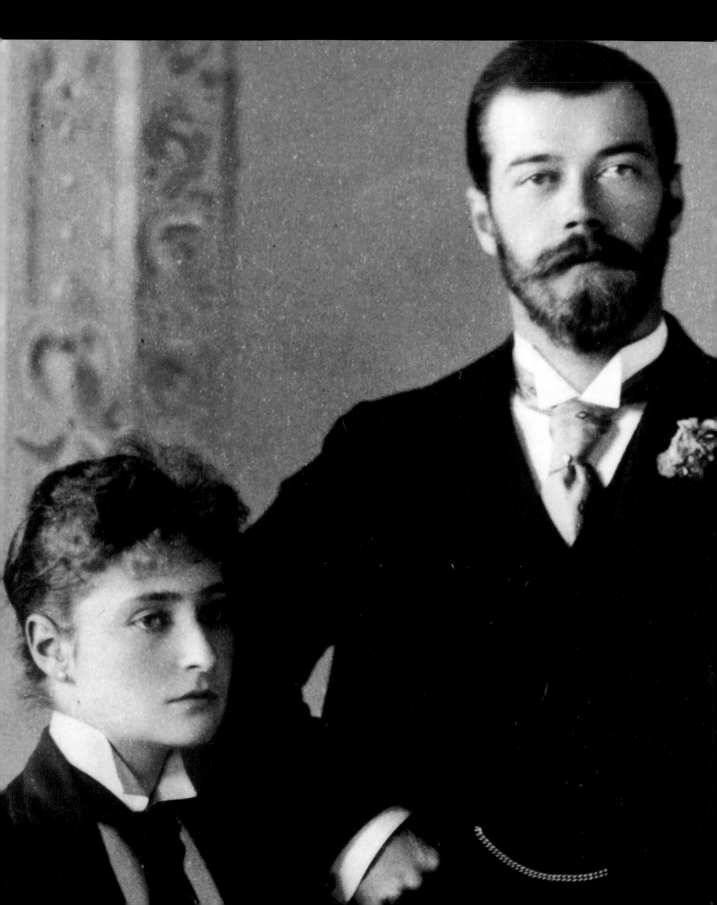

2

NICHOLAS AND ALEXANDRA:
THE LAST TSAR AND TSARINA

Galina Komelova

'THE REIGN OF NICHOLAS II HAS CERTAINLY BEEN ONE OF THE *bloodiest ever. Khodynka Field, two wars costing many lives, two revolutions, and various disturbances and pogroms in between, ending in merciless punitive expeditions under the slogans "take no prisoners" and "no quarter for bosses".'*

SERGEI P. MELGUNOV 1917

Nicholas II's reign began in 1894, after the unexpected death of Tsar Alexander III at the age of forty-nine. However, the accession and coronation of his son was to be overshadowed by the frightful events on the Khodynka Field that became known as 'Bloody Saturday'. From then on Nicholas was nicknamed 'the Bloody'. His reign was to end with the tragedy in July 1918 in the Ipatiev house in Ekaterinburg where, according to a majority of sources, the entire family of the last Tsar was brutally murdered.

The more than tragic figure of Nicholas II was fatal for Russia. The authors of the many memoirs of the time portray him as highly educated and friendly in his dealings with people. 'I believe him to be the most charming person in Europe,' one contemporary wrote, 'with an extremely modest private life, deeply religious, but utterly unsuited to the high office he inherited on the death of his father, Tsar Alexander III.' From the outset Nicholas himself was fully aware of this. Shortly after 1917 his sister, the Grand Duchess Olga Alexandrovna, wrote about how the young Tsar sobbed on his father's death that he 'didn't know what was going to happen to us all, that he was totally unsuited to being a tsar And my father bears some blame for this,' she continued, 'because he did not familiarise his successor with matters of state. And what a terrible price had to be paid for that error.'

The same observation is found in the reminiscences of Grand Duke Alexander Mikhailovich, a boyhood friend of the Tsar, who knew him well. He saw the death of Alexander III as a dreadful catastrophe, one that would lead to 'the fate of one-sixth of the world' falling into 'the trembling hands of a stripling who was easily upset'.

If Nicholas had been born of ordinary mortals he would have led a perfectly harmonious life, approved of by his superiors and respected by

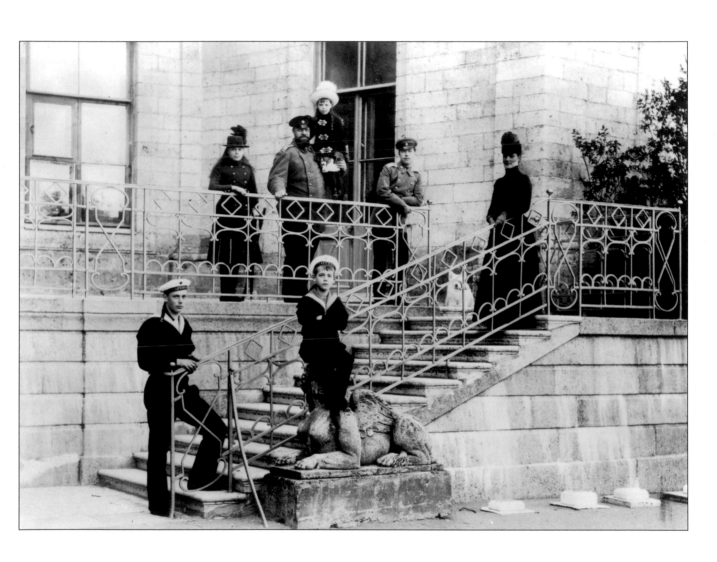

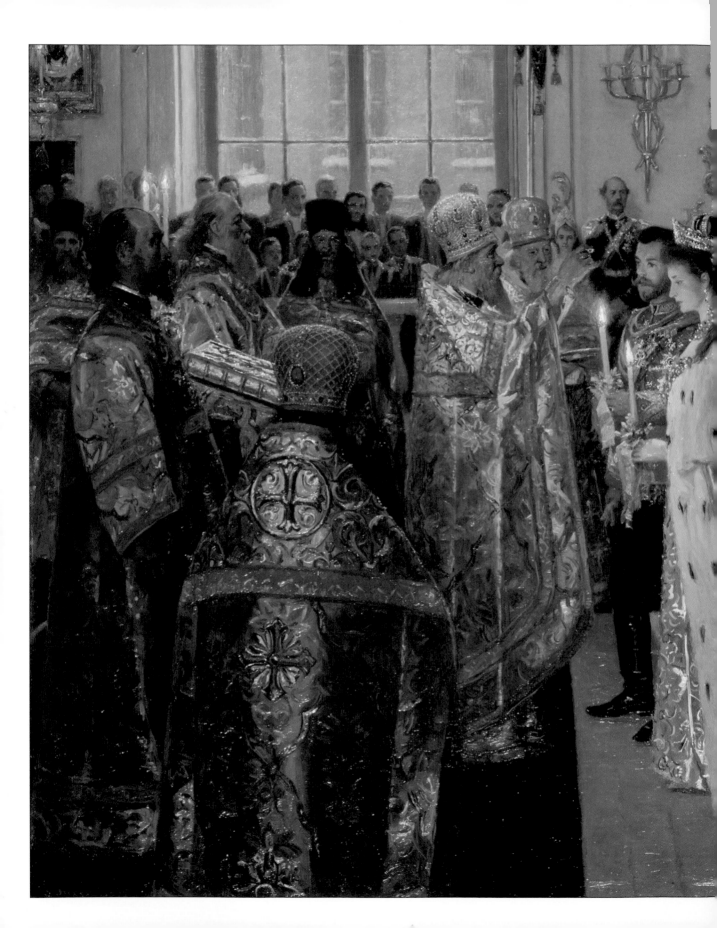

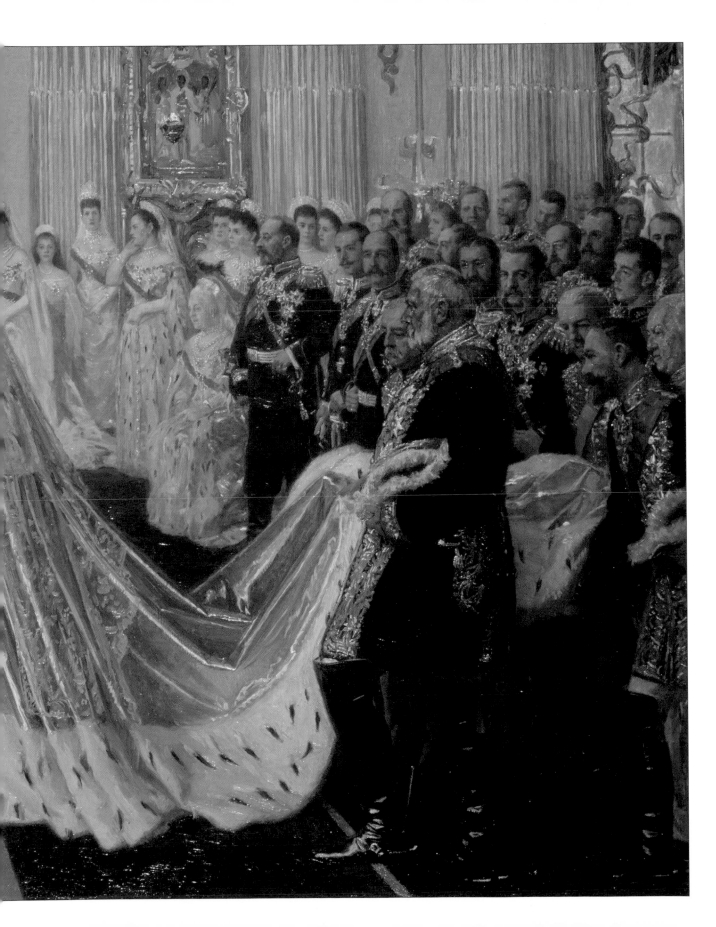

those around him. He was an ideal family man and believed in the weight of an oath he had sworn. It was not his fault that fate turned these good qualities into deadly weapons.

The French ambassador Maurice Paléologue, who had many conversations with Nicholas towards the end of his reign, wrote this astute and revealing comment about him: 'I don't know who it was who said about the Tsar that he "had all the vices and not a single failing"'. Indeed Nicholas II did not have any vices, but for an autocrat he had the very worst possible short-coming, namely a lack of personality. People were able to avoid, deceive or dominate him at will.

By nature Nicholas was a gentle man, with a weak character, who frequently changed his decisions or *ukases*; he was an 'irreproachable family man' who preferred the intimacy of family life and the company of his wife and children to affairs of state. He clearly regarded as burdensome his duties as a monarch. Moreover, many who knew him remarked that he was a fatalist and 'submissive to fate in mystical fashion'. One of the most influential women at the court, the Grand Duchess Maria Pavlovna, wife of his uncle Grand Duke Vladimir Alexandrovich, said about Nicholas, 'He is a fatalist. He is weak …. Instead of taking some form of action when things go wrong, he persuades himself that God has willed it so, and he then proceeds to surrender to God's will!'

A more graphic but rather harsh description was that of the malicious publisher, Alexei Suvorin: 'Alexander III tamed a Russian mare. Nicholas II has harnessed an old nag. He moves, that's for sure, but where? Where chance takes him!'

Nor should we gloss over the Tsar's purely human tragedy, the appalling sickness of his only son and heir, the Tsarevich Alexei Nikolaevich. The latter's haemophilia affected much of the Tsar's conduct and, strange as it may seem, was to play a decisive role in Russian history.

The artist Alexander Benois recalled that when he heard the gunshots proclaiming the birth of the long-awaited heir to the throne, like 'millions of [his] contemporaries' he thought,

God grant that our future tsar is closer to the ideal of a monarch than his father; who, for all his charm, has by now frittered away the love and loyalty of his subjects. But fate had a terrible and tragic reply to this hope.

Instead of dying a martyr's death, the child who was born that day was condemned to be the unasked-for cause of years of unremitting suffering for his parents; due to his fateful sickness the ghastly shadow of [Grigory] Rasputin loomed over the memory of his father and mother – he alone possessed the magic power to stop the bleeding that the unhappy boy suffered from. And yet it was such a bright and joyful day!

Alexei's tutor Pierre Gilliard, who was with him almost until his final moments in Ekaterinburg, wrote: 'The sickness of the … Heir to the Throne dominated the whole of the last years of the reign of Nicholas II.'

Alexandra herself would also play a distinctly negative role in the fate of both her family and that of Russia. She was a princess from the little duchy of Hesse who adopted the Orthodox faith on moving to Russia and was given the name Alexandra Feodorovna, although known as Alix by her family. Nicholas loved her from the moment they met, and subordinated himself to her almost stoically. Everyone who saw Alexandra praised her exceptional beauty. The daughter of Piotr Stolypin, Maria Bok, wrote: 'I gazed ecstatically at the young Tsarina, who was amazingly beautiful in her pale attire, glittering with diamonds. This is how I would imagine a fairy out of a fairytale. She was a beauty, a Russian tsarina in greatness and dignity.'

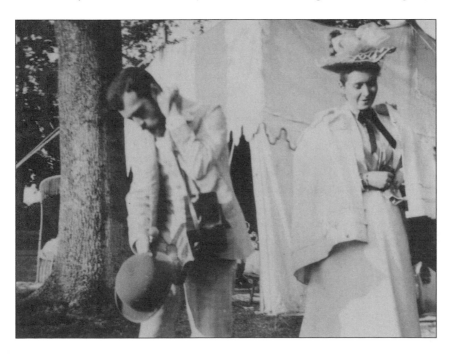

LEFT

Tsarevich Nicholas
and Princess Alix of Hesse
at Bagshot in 1894

Unknown photographer

(The Royal Collection
© Her Majesty Queen Elizabeth II)

However, according to A. A. Mosolov, head of the office of the Ministry of the Imperial Court, Alexandra, despite being a loving wife and marvellous, if unfortunate, mother, could 'never become a genuine tsarina due to her personal situation .… That is a great pity because with her firm character she could have been of great assistance to His Majesty. Unfortunately her ideas were even more bigoted than those of His Majesty so that her support of Nicholas did him more harm than good.'

Alexandra was different from her sister, the Grand Duchess Elizaveta Feodorovna ('Ella'), wife of Grand Duke Sergei Alexandrovich. In the words of Mosolov, '[Elizaveta] had become completely Russian in heart and soul after a couple of years in the country, while the Tsarina, although she loved Russia, never succeeded all her reign in understanding the Russian soul and could not instil in herself a love for Russia, as her sister did'.

The Empress was by nature very reserved and thus appeared severe and awkward in her dealings with people, only feeling at ease within her family. She cared little for the court or for St Petersburg society. She only attended the court balls and receptions of the city's aristocracy with any frequency during the first years after her marriage; from then on her public appearances became increasingly rare. She was incapable of making drawing room conversation; nor did she know how to smile at the proper moment, to say some kind or friendly word. Her stiff character set the court against her. Grand Duke Alexander Mikhailovich remarked that,

> … *by distancing herself from the complicated goings-on at the court the young Tsarina made mistakes that in themselves were trivial, but which constituted dreadful misdemeanours in the eyes of the St Petersburg beau monde. She was shocked by this attitude and this led in turn to that typical stiffness of hers towards her milieu. Nicholas II took this to heart, and presently relations between the court and the upper classes took on a very strained character.*

The Empress's character was excellently summed up by the young page Boris Gerua, who was to become a major-general with the General Staff. At the time of Nicholas's marriage he was working in the Winter Palace:

> *She* [the Tsarina] *finally arrived with her sister Grand Duchess Elizaveta Feodorovna, a quite exceptional beauty. Alexandra Feodorovna too was*

BELOW

Elizabeth of Hesse (Elizaveta), sister of Alix (Alexandra), with Grand Duke Sergei Alexandrovich, 1884

Carl Backofen

(The Royal Collection © Her Majesty Queen Elizabeth II)

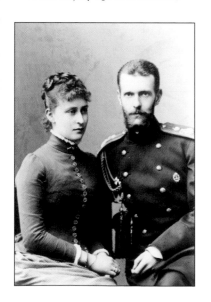

beautiful and stately; she looked very much like her sister, but could not compare with her. We went to meet them at the carriage door and helped them out. The Grand Duchess and bride gave us their hands to kiss, but [Alexandra] did so with an awkward and embarrassed gesture. A sense of unease was thus the first thing you noticed on meeting the young Tsarina, and this impression she never managed to dispel. She was so obviously nervous of conversation and at moments when she needed to show some social graces or a charming smile, her face would become suffused with little red spots and she would look intensely serious. Her superb eyes promised kindness, but instead of a bright spark, they contained only the cold embers of a dampened fire. There was a certain purity and loftiness in the look, but loftiness is always dangerous; it is akin to pride and can quickly lead to alienation.

Alexandra's reserve and her distaste for fashionable life became particularly apparent after her incurably sick son was born. The long-expected heir only arrived in 1904 after ten years of marriage and the birth of four girls. After then Alexandra Feodorovna appeared to be a very sick woman: her heart and nerves were frail, she had frequent bouts of hysteria, and her legs were weak, making it impossible for her to accompany her husband and children on their many walks.

In many ways it was understandable. She was a mother who was well aware that she was the cause of her son's disease. It was only inherited through the female line, in this case from Queen Victoria of Great Britain who passed it on to many of her descendants. Alexandra found herself powerless to alleviate her son's agony when he was screaming with pain, and her own endless suffering explains her unwavering trust in anyone who promised help after she lost faith in the doctors who attended her son.

Thus Alexandra had boundless faith in Grigory Rasputin, the *staretz* or holy man who undeniably possessed paranormal gifts. He was the only one who seemed able, even at a distance, to stop the poor child's blood from flowing and alleviate his suffering. This explains Rasputin's strange influence over the Tsarina, which was to give way to extreme requests or demands, and lead through Alexandra to Nicholas II. It also explains the 'dreadful shadow of Rasputin' which, in the words of contemporaries, was to be 'cast over Russia'.

Witnessing the distress of his son and wife, Nicholas permitted Rasputin

BELOW

Frame with a photograph of
Tsarina Alexandra Feodorovna
with her daughter Tatiana

*Workmaster M. E. Perchin
Fabergé* (1890s)

CATALOGUE NO. G13

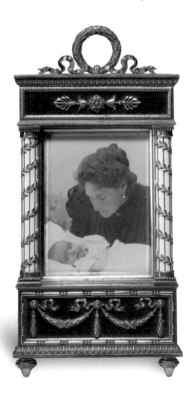

to come to the family residence at Tsarskoe Selo. Stolypin told his daughter that he 'warned the Tsar every time he did so':

But this was what he said to me recently: 'I agree with you, Piotr Arka-devich, but I'd rather have ten Rasputins than one of the Tsarina's fit of hysterics.' Of course that explains it all. The Tsarina is ill, seriously ill. She believes the only person in the whole world who can help the heir is Rasputin, and it is humanly impossible to persuade her otherwise. Because in general it is already very difficult to talk to her

One of the oddities in the Empress Alexandra's view of life, in the words of the Minister of Finance Vladimir Kokovtsev, 'was her belief in the stead-fastness, invincibility and permanence of the Russian autocracy as it had developed over three hundred years'. This she 'acquired together with her religiosity and ... gradually began to experience as pure political dogma'.

In her political beliefs the Tsarina was more absolutist than the Tsar. She was an unqualified advocate of the principle of a strong state, with the Tsar as it were as the basis and justification of his own ideas.

To realise how unlimited an influence Alexandra exercised on the Tsar, one only needs to read their correspondence during the First World War, at the most critical point in Russian history, when Nicholas was stationed at Army headquarters in Mogilev. A theme running through these letters is her unshakeable faith in the notion of an unbridled autocracy: 'Don't forget that you are the absolute monarch and that this is what you must be! We are not ready for a constitutional government,' she wrote on 17 June 1915 when the question of introducing a constitutional monarchy was becoming urgent.

None of her letters showed any understanding of developments on the ground in Russia. They betrayed instead that she was entirely under the control of Rasputin and his circle. She alluded, for instance, to the opinions of 'our friend' and passed on his requests and demands to award posts in ministries to new people and to get rid of the old staff. Nicholas did not refuse and the result was a rapid turnover of ministers, with almost all existing members of the government losing their jobs. Unlike predecessors such as Catherine the Great or Alexander II, Nicholas could not or would not surround himself with sensible, practically-minded individuals who might

have given him good advice, and who might even have changed the course of history. People like Sergei Witte, Piotr Stolypin, Vladimir Kokovtsev and Sergei Sazonov did not retain their posts for long, and left for one reason or another. In their place, and at the prompting of Rasputin, untalented and reactionary individuals were appointed to take their places: people like Ivan Goremykin, Alexander Trepov, Boris Stürmer and Nikolai Golitsyn.

'Our friend is asking you to repeal the Duma,' Alexandra wrote to Nicholas on 14 February 1916, as the autocracy teetered on the edge of the abyss: '[Be] Peter the Great, Ivan the Terrible or Tsar Paul, crush them all, don't laugh …. I'd just love to see you acting like that against those people who are trying to control you.'

Even a majority of members of the large and heterogeneous Romanov family, of which the Tsar was the head, and which comprised sixty-one members in 1913, saw the need for change. The Tsar was approached in their name by his uncle, Grand Duke Nikolai Mikhailovich, to offer him this advice. But Alexandra continued to pressurise her husband: 'Show them all that you are the ruler. Gone are the days of leniency and being nice, now is the time for your autocracy of will and power! They [the Romanov family] will have to learn to feel guilty …. Why do they hate me?'

The English ambassador Sir George Buchanan commented:

Right from the start [Alexandra] *misjudged the situation. By encouraging the Tsar to stick to a course that was full of dangers for the ship of state, while the political waves had already reached dangerous heights, she proved the perfect means for its downfall. If his wife had had a broader vision and greater shrewdness and had understood that a regime like this was an anachronism at the beginning of the twentieth century, the history of his tsardom would have been different.*

The problem lay partly in Nicholas's character: his ardent faith in his predestination as absolute ruler of Russia, as 'God's anointed', that made him unwilling to compromise. It was aggravated by an almost stoical submission to his wife, who in turn was under the spell of Rasputin, supporting his reactionary group at the court, the 'Camarillas' as contemporaries called them. Nicholas additionally lacked flexibility as a politician and, in the words of Grand Duke Alexander Mikhailovich, was heading 'straight for the abyss, thinking that it was the will of God'. And yet all the tragic circumstances in

the life of the Tsar and his family, and 'the tragic events in Russia that followed one on top of each other ever more rapidly under his rule, could not break through the dense confusion of tsarist customs or bring any change in the strictly defined protocol'. Official life at the Russian court continued to flow along its official channels, conspicuous as before for its luxury and splendour.

Grand Duke Alexander Mikhailovich observed Nicholas thus:

> *While he was extremely modest and simple in his private life, the Tsar had to comply with the requirements of etiquette. The ruler of a sixth of the globe had no choice but to receive his guests in an atmosphere of lavish luxury.*

And perhaps it was this aspect that most amazed the foreign diplomats and everyone else who was received at court. Alexander Mikhailovich illustrates this point in his description of one of the balls at the Winter Palace:

> *Enormous halls, decorated with mirrors with gilt frames, were crowded with dignitaries, courtiers, foreign diplomats, guard officers and oriental potentates. Their splendid uniforms, adorned with silver and gold, served as the magnificent background for the court costumes and precious objects worn by the ladies. Cavalrymen of the Guard wearing helmets with the two-headed eagle of the tsars and Cossacks of His Majesty's own escort in Circassian uniforms lined the staircase and crowded the entrance of the Nicholas Hall. The rooms were adorned with countless palms and tropical plants from the court orangeries. The dazzling light of the great chandeliers, reflected in many mirrors, gave the whole scene an immensely enchanting character. Gazing at the sumptuously furnished Nicholas Hall you forgot the functional twentieth century and were swept away to the brilliant age of Catherine …. And suddenly the whole crowd fell silent. The master of ceremonies appeared and tapped three times on the floor, to announce the Entry of his Highness. The massive door of the hall swung open, and on the threshold the Tsar and Tsarina appeared, accompanied by their family and retinue.*

The French ambassador Maurice Paléologue also provides an interesting description of the Tsar's court. Writing about a reception for the French president, Raymond Poincaré, on his visit to St Petersburg in June 1914, he notes:

OPPOSITE

Portrait of
Tsar Nicholas II
(dated 1915-16)

Unknown artist
(second half 19th-
early 20th century)

CATALOGUE NO. A09

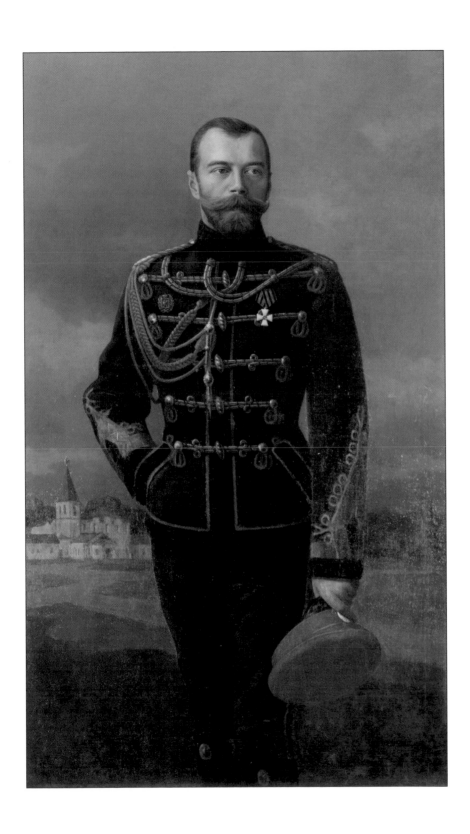

At half-past seven a banquet was held in the Tsarina Elisabeth Hall
[at Tsarskoe Selo]. *In the opulence of the uniforms, the extravagance of
the dress of the ladies, the richness of the liveries, the sumptuousness of the
costumes, the entire display of splendour and power, this spectacle is so
magnificent, no court in the world can vie with it. I will long remember
the dazzling brilliance of the jewels strewn over the ladies' shoulders. It was
a fantastic river of diamonds, pearls, rubies, sapphires, emeralds, topazes,
beryls: a river of light and fire.*

This was, of course, purely an impression of the exterior of something
called the 'Russian court', of a traditional ceremonial that had its origins in
the eighteenth century and which had remained virtually unchanged over
nearly two hundred years. It was remarkable, moreover, to see it combined
with all the novelties of the twentieth century – telephones, telegrams, films,
cars and electricity.

Full dress was obligatory at court, especially the 'Russian' or 'uniform
dresses' that ladies wore to balls and official receptions. Strict regulations had
already been prescribed for such matters by Tsar Nicholas I in 1834, and they
remained unchanged, apart from a few insignificant adjustments, until 1917.
The obligatory costumes for court officials who were invited to formal
ceremonies, and for palace servants – valets, court blackamoors, pages and
others – were an indispensable ritual element of court life. Strictly regulated
too was the group of people who attended the great and small processions of
the Tsar and his family from their private apartments in the Winter Palace to
the public rooms or to the church, with everyone knowing who should walk
with whom. Official processions from the palace, obligatory attendance at
garrison feast days (especially when the commander was a member of the
Tsar's family), visits to openings of exhibitions, the consecration of new
churches, and other major social events, were also bound by strict ceremonial.

Particularly solemn were the processions to the churches of the Winter
Palace on days of major religious festivals such as Easter and Christmas. As
both Nicholas and Alexandra were deeply devout, in the private apartments
of all their palaces there were innumerable icons, placed on special screens or
hanging on the walls, adorned with Easter eggs suspended by ribbons.
As Yuri Danilov noted, in the private railway car of the Tsar there was
'a whole chapel of large and small icons and a variety of devotional objects
.... [The Tsar] never missed any services, any more than Alexandra did,

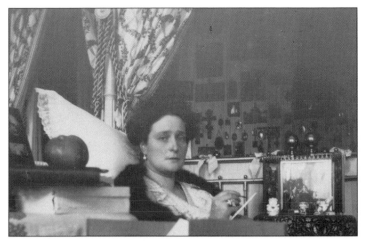

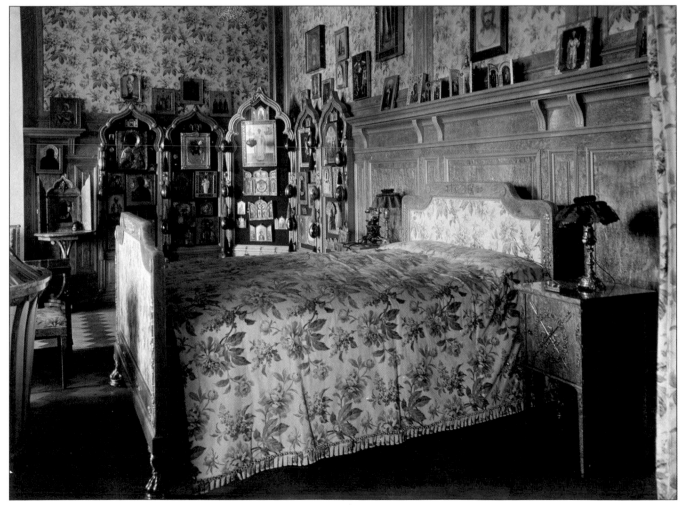

who spent hours on her knees, praying for the health of her son and family.'

Every palace of the Tsar had its court church. In the Winter Palace, the most important residence, there were two, the Great and the Small Churches of the Saviour, built after a design by Bartolomeo Francesco Rastrelli and rebuilt almost unchanged by the architect Vasily Stasov after a fire in 1837. The Great Church, or cathedral, was marvellously elegant and brilliant with the gold leaf of its magnificent interior and superbly carved iconostasis.

It should also be remembered that the Russian monarch was also the head of the Orthodox Church and that this was a further reason why the most solemn masses were held specifically in the Great Church in his residence. In the richness of its interiors, the luxury of the gold and silver objects and its vestments adorned with many precious stones, the Russian Church vied in splendour with the court.

The services were usually accompanied by the choir of the court chapel, or else occasionally the metropolitan choir. During services, according to Maurice Paléologue, one could hear 'marvellously beautiful hymns, sometimes broad and mighty or else tender and ethereal, expressing better than any words the infinite aspirations of orthodox mysticism and the Slav sensibility'.

But as early as the second decade of the century – mainly as a result of the outbreak of war – the luxury and brilliance of the Russian court and the church services gradually began to decline.

The Tsar and his family lived in Tsarskoe Selo after 1905 and only visited the Winter Palace on days of special celebrations and church festivals. 'In those years there were no longer any receptions at the court,' wrote Maria Bok, 'so that I only know of the brilliant balls in the Winter Palace and the Anichkov Palace from the stories of the older generation.'

Quoting Paléologue once more by way of an epilogue, he tells how, a few days after the abdication of Nicholas II on 2 March 1917, he met in the summer gardens one of the 'Ethiopians' who had so often shown him into the Tsar's office:

[He] *wore civilian dress and his face was sad. He had tears in his eyes ….*
In this dismantling of a whole political and social system he represents
for me the former luxury of the tsars and the picturesque and splendid
ceremonial, as established by Elisabeth and Catherine the Great. From
now on the Russian court, and all the enchantment this phrase evoked,
no longer mean anything.

OPPOSITE

Interior of the cathedral
at the Winter Palace, 1829

Alexei Vasilyevich Tyranov
(1808-59)

CATALOGUE NO. BOI

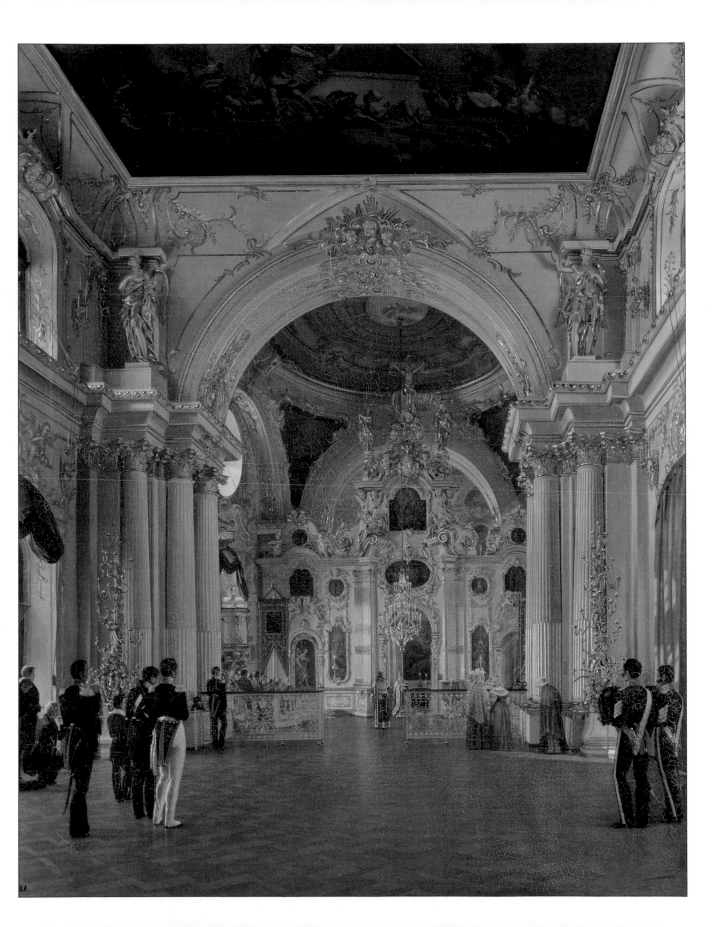

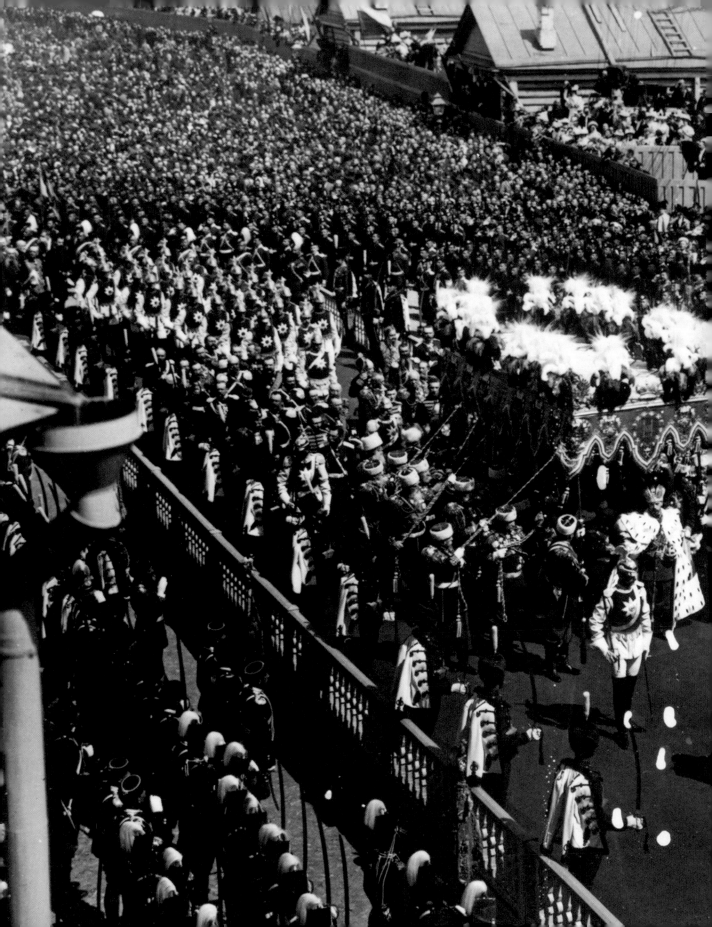

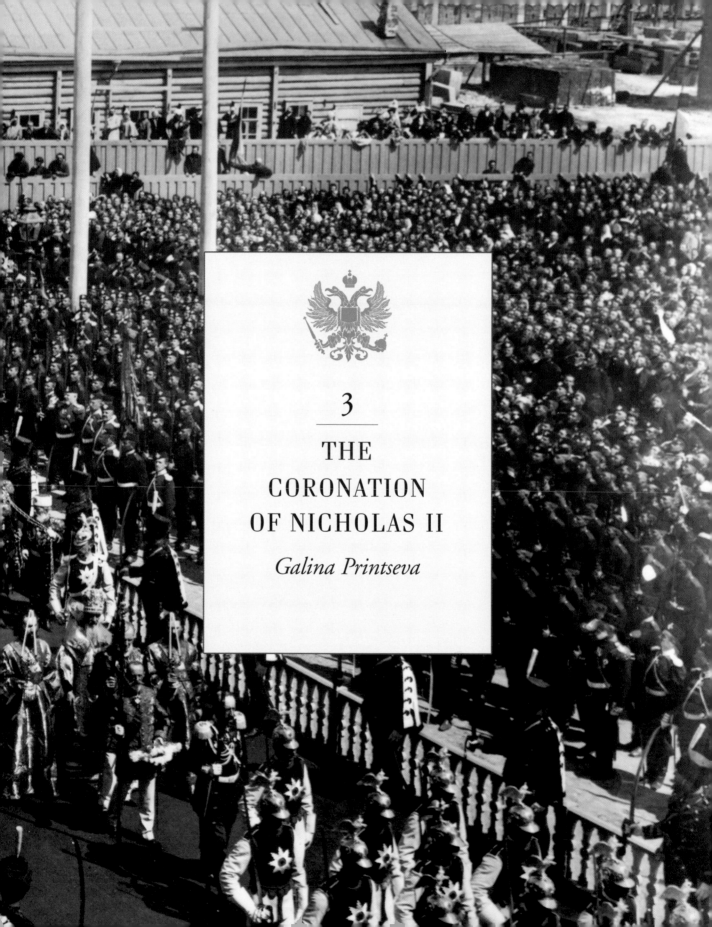

3

THE
CORONATION
OF NICHOLAS II

Galina Printseva

'PERFECT DAYS OF SPRING, A HISTORIC CITY ENTIRELY *decorated with flags, the sound of bells from sixteen hundred bell towers, the huge crowds shouting "hurrah", the young Tsarina wearing her crown, radiant with beauty leading dignitaries from all the European nations in golden carriages. No strict ceremonial could have stirred the masses to greater enthusiasm than the sight of this spectacle.'*

ALEXANDER MIKHAILOVICH

The coronation of a new emperor was the most important national event in pre-revolutionary Russia. Until this ritual had taken place the monarch was not considered definitively to have assumed power; only the Church in the person of its highest dignitaries was able to invest the tsar with his supreme authority. Through this ceremony the profound faith of tsar and people were initiated in the divine nature of power. It was with good reason then that the coronation was referred to as 'holy'.

The crowning of the last representative of the Romanov dynasty is particularly interesting. The ceremony was held in the former capital Moscow (still the religious capital), in the Assumption Cathedral in the Kremlin. Beginning with the reign of Ivan IV ('the Terrible') in the sixteenth century, this was the traditional setting for the coronation of Russian tsars.

The ceremony did not coincide with the accession to the throne. First of all the period of mourning for the former tsar had to be completed; second, it was not permitted to disturb other state events. Account also had to be taken of the time of year. Spring and summer were considered more suitable for the street festivities and processions that accompanied the coronation.

Nicholas II set his coronation for May 1896. The twelve-month period of mourning for Alexander III was over and the new Tsar, who cherished his father's memory, wished to be crowned in the same month as the coronation of thirteen years before. The solemnities would last for three weeks from the arrival of the Imperial family in Moscow, from 6 to 26 May and the coronation itself would take place on 14 May. The programme for each day was planned according to

protocol and the days prior to the arrival of the Emperor and Empress in Moscow were taken up with preparations.

The manifesto for the coronation was issued in January 1896. A committee was set up at the same time to prepare the event, with the Governor-General of Moscow, Grand Duke Sergei Alexandrovich, uncle of the young Tsar, presiding over it. His wife, Grand Duchess Elizaveta Feodorovna, *née* Princess of Hesse, and sister of the Tsarina, gave him more than mere moral support, practically taking on the work of secretary. In this capacity she wrote to Grand Duke Konstantin Konstantinovich, who was their friend, a nephew of Nicholas's father and commandant of the Preobrazhensky Guard Regiment: 'We must remember everything. But meanwhile difficulties are piling up.'

For not only did the programme and ceremonial for each day require to be planned, but the city had to be decorated and grandstands built in the Kremlin and along the route of the coronation procession. Seating arrangements and an order of precedence had to be drawn up for the many envoys of European and Asiatic courts, members of the Tsar's family, guests from other Russian cities, sections of the Guard regiments, and all the journalists and artists. Finally, order had to be guaranteed in the streets of Moscow. The work of adorning the city, especially the decorations and illuminations for the Kremlin, required thousands of building workers and engineers. In short, the task was enormous.

On 3 April, a month before the solemnities, the Tsar's regalia were transported by special train from the Winter Palace in St Petersburg to the Armoury in the Kremlin: the large and small crown, the sceptre and the mace, the coronation robes, and the parade insignia. On the eve of the coronation they were brought to the Throne Room of the Kremlin, and from there to the Assumption Cathedral. At the end of April the first units of the Guard regiments who were to play a role in the ceremony arrived from St Petersburg. Every day, new garrison troops arrived in Moscow, transforming it from the seat of government into a garrison town; from a Russian city into an international one.

The coronation of Nicholas II was the first such occasion to be attended not just by the delegates of all the Orthodox patriarchs, but also by those of the Vatican and the Anglican Church. Eastern States, including China, were significantly better represented this time around than at the coronation of Alexander III in 1883. From press reports we learn that the occasion was

PREVIOUS PAGES

The coronation procession of
Tsar Nicholas II, May 1896

J Daziaro

(The Royal Collection
© Her Majesty Queen Elizabeth II)

OPPOSITE

Miniature copy
of the Imperial regalia,
by Fabergé

*Master Yuli Alexandrovich
Rappoport, Fabergé, 1899-1900*

CATALOGUE NO. D14

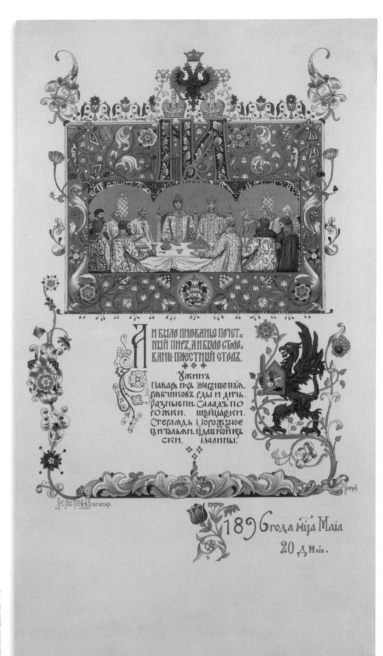

attended by one queen, three grand dukes, two reigning monarchs, twelve crown princes, sixteen princes and princesses, not to mention the many members of the Romanov family. The lavishness of the preparations surpassed all previous coronations, almost as though there was a premonition that this would be the last to be held in Russia.

More than two hundred correspondents and artists converged on Moscow and a special building was vacated to accommodate them. The Imperial Art Academy appointed Viktor Vasnetsov, Vladimir Makovsky, Valentin Serov, Ilya Repin, Andrei Ryabushkin and Mikhail Nesterov to sit in the stands and make sketches for the coronation album. The occasion was also portrayed in miniatures by Isaac Levitan, Nikolai Karazin, Mikhail Zichi, Nikolai Samokish, Alexander Pervukhin, Elena Samokish-Sudkov-skaya, Ernst Liphart and others. They produced decorative work for documents, programmes, invitations and menus.

A photographic album with scenes of the coronation was created by the court photographer, Karl von Hahn, and others. Furthermore, the coronation of 1896 was set to be the first major government occasion to be recorded on film. In April 1897 'living photographs' were shown for the first time in St Petersburg, with nineteen moving pictures of the coronation created using the cinematographic techniques of the Lumière brothers who had pioneered the first moving picture shows in 1895.

Despite the large number of artists and correspondents, only twenty seats were set aside for them at the coronation itself. Among those who attended was Pavel Yakovlevich Piasetsky, who created one of the most impressive records of the event – an enormous fifty-eight metre long panorama, depicting the most important moments from the arrival of the Imperial couple on 6 May to their departure from Moscow on May the 26th.

Piasetsky, an eminent geographer, ethnographer, doctor and artist, was a close acquaintance of Nicholas II. His panoramas, a record of his geographical and military expeditions to China, Bulgaria and Central Asia, had already been exhibited under Alexander II and Alexander III. Although a traveller and geographer by vocation, his talent as an artist allowed him to make rapid sketches *en route*. On the basis of these drawings he produced panoramic watercolours of up to one hundred metres or more in length. He then pinned them onto a canvas to make them easier to view. By winding the canvas around a cylinder and then unwinding it frame by frame, he created the illusion of a curious manually-operated film. Similar moving

OPPOSITE LEFT

Menu of the dinner held on
14 May 1896 in Moscow
to celebrate the coronation
of Tsar Nicholas II

Viktor Mikhailovich Vasnetsov
(1848-1926)

CATALOGUE NO. D02

OPPOSITE RIGHT

Menu of the banquet given by
Grand Duke Sergei Alexandrovich,
Governor-General of Moscow
on 20 May 1896
to celebrate the coronation
of Tsar Nicholas II

Viktor Mikhailovich Vasnetsov
(1848-1926)

CATALOGUE NO. D04

panoramas were also produced during this period by artists from other countries, but in Russia the format is linked exclusively with Piasetsky.

Back in December 1895 Piasetsky asked the Minister of the Imperial Court for permission to create a coronation panorama and this was duly granted. Signing himself 'P. Piasetsky, doctor in medicine', he wrote:

> *The ever-friendly opinions about my works, and in particular the kind interest taken in some of them by the Emperors Alexander II and Alexander III embolden me to ponder on how happy I would be if I could present some of them to his Imperial Highness, and certainly if you put in a good word for me to get leave to compose a new work, a Panorama of the Holy Coronation of their Royal Highnesses.*
>
> *If I do indeed get leave to do this, then I feel obliged to request that you show me the best vantage-points for the depiction of the materials. Part of this can be done some time in advance, as for instance the costumes, the architecture of the building and the streets from special angles, etc. I will also need to know the programme of the ceremonial by which the events will occur. A painting like this, if I succeed in making it, would be a most welcome work for all the inhabitants of the cities and villages of our fatherland.*

Today the painted panorama provides a unique record of the occasion, taking viewers step by step through the ceremony, illustrating the correct sequence of events.

On 6 May 1896 the train carrying the Tsar and his wife arrived in Moscow. A lavish pavilion, adorned with flowers and tropical plants, with French-style furniture on a velvet carpet, was built on a platform to welcome them. Nicholas wrote in his diary:

> *We arrived in Moscow at five o'clock. The weather was dreadful – rainy, windy and cold. On the platform we were welcomed by the guard of honour of the Ulansky Regiment. From there we rode with an escort of all the cavalry officers to the Peter Palace.*

On the same day Moscow celebrated the Tsar's birthday. A solemn mass was held in the Church of Christ the Saviour. According to a tradition that began with Paul I (1796-1801), the Peter Palace just outside the city was used

as the residence for foreign statesmen before their entry into Moscow for the coronation. Nicholas and Alexandra stayed there for three days to receive the princes and oriental rulers and their entourages who had arrived specially for the occasion.

On 9 May the solemn entry of the Tsar into Moscow took place. 'The first heavy day for us – that of the entry,' wrote Nicholas.

> *The weather was now marvellous. At twelve the whole group of princes, with whom we were to have breakfast, assembled. At about half-past three the procession started off. I rode on Norma* [his white Arab horse]. *Mama sat in the first golden coach, Alix in the second, also alone. As for the reception, there is nothing to say about it; it was as solemn and warm-hearted as only Moscow is capable of!*

A huge crowd of people had gathered on and between the stands along the whole route of the procession from the Peter Palace to the Kremlin – through the Triumphal Arch, along Strastny Boulevard and the whole length of Tverskaya Street, lavishly decorated for this occasion. The garrison troops stood, drawn up in two ranks. All the windows, balconies and rooftops were packed with people.

> *It was just after two when a shot finally rang out from the Kremlin, proclaiming that his Highness the Tsar had left the Peter Palace. Everyone bared their heads and crossed themselves devoutly. Immediately after the shot all the church bells of Moscow began to ring in unison. First a convoy of men in uniforms of various colours appeared, followed by the other participants in the procession, according to the ceremonial.*

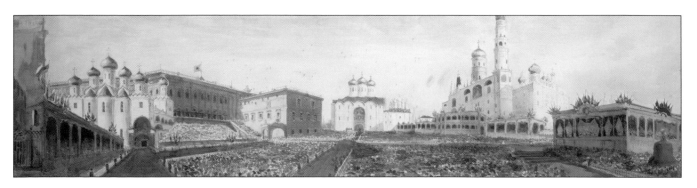

This is how the artist Mikhail Nesterov described the event in his memoirs:

The garrison troops stood at attention, music began to play, and the young Tsar appeared on a white Arab horse. He rode slowly, greeted the people affectionately; he was excited, with a pale, emaciated face. The Tsar then rode on through the Spassky gate and into the Kremlin.

Behind him the Tsarina Alexandra and the Dowager Empress Marie, the Tsar's mother, rode in their respective carriages, with the other members of the Imperial family.

Princess Olga Alexandrovna, youngest sister of the Tsar, recalled one particular, if trivial, detail. She rode in one of the gilded coaches that looked so beautiful, but confessed that they 'were a torture chamber' inside. The springs were poor and no one had thought of providing ventilation. The girl sat between her aunt, the Queen of Greece Olga Konstantinovna, and her cousin, Crown Princess Maria of Romania. The three of them nearly fainted for lack of oxygen and were terrified that their arms and legs would break with all the jolts.

The cortège came to a final halt inside the Kremlin, where the Tsar and Tsarina were supposed to visit the three most important churches in the city: the cathedrals of the Assumption, the Archangel and the Annunciation. The final cathedral was missed out, however, due to an error of the clergy who were leading the procession. The Tsar's entourage, who were keeping a close eye on every detail of the ceremony, thought that this might cast a shadow over the occasion. But the real tragedy was yet to come.

Piasetsky's panorama recorded all the main moments of the coronation, from the arrival of the Tsar by train to his entry into the Kremlin. The

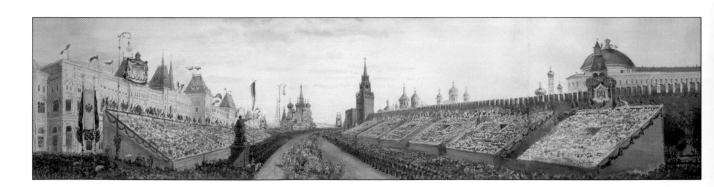

decorations along Nicholas's route into Moscow were particularly colourful – with flags, banners, garlands, decorative obelisks, the spectators' stands, and the special pavilions – making the centre of the city as festive as it had ever been. In order for the panorama to depict Moscow in as much detail as possible, the artist chose views from both banks of the River Moskva: first the far side opposite the Kremlin; then a view of the Kremlin itself from the far side, with the Church of Christ the Saviour, the Great Palace, the cathedrals, the Ivan the Great Tower, and the buildings inside the Kremlin.

Two days after the entry into the Kremlin, after countless official banquets and receptions, another event took place, again captured in the panorama. Men in medieval heralds' attire announced the day of the sacred coronation, proclaiming with loud voices the text of Nicholas II's speech to the people and distributing copies as a souvenir on their way through the city.

The coronation itself took place on 14 May 1896 in the Assumption Cathedral. A special dais was built underneath a canopy opposite the altar, and covered with a carpet, as was the whole route that the monarch took from the steps of the Palace of Facets. Three thrones were placed on the dais: one in the middle for the Tsar, and one on either side for Tsarina Alexandra and Empress Marie. The clergy were positioned next to the dais and the altar, while places were reserved for the highest dignitaries elsewhere in the cathedral. Outside, stands were built for the public throughout the square.

The procession from the palace apartments in the Kremlin to the Assumption Cathedral began at half-past nine in the morning. It was even more magnificent than Nicholas II's entry into the Kremlin. There were horse guards and a mass of courtiers, senators and ministers, members of the Council of State, and delegates from the cities and the *zemstvos* (provincial governments) – it was like a river of uniforms gleaming in the sunlight.

OVERLEAF

The coronation of the Emperor
Nicholas II and Empress
Alexandra Feodorovna, 1896
(dated 1898)

Laurits Regner Tuxen (1853-1927)

CATALOGUE NO. DOI

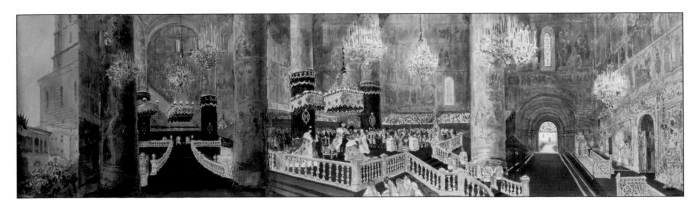

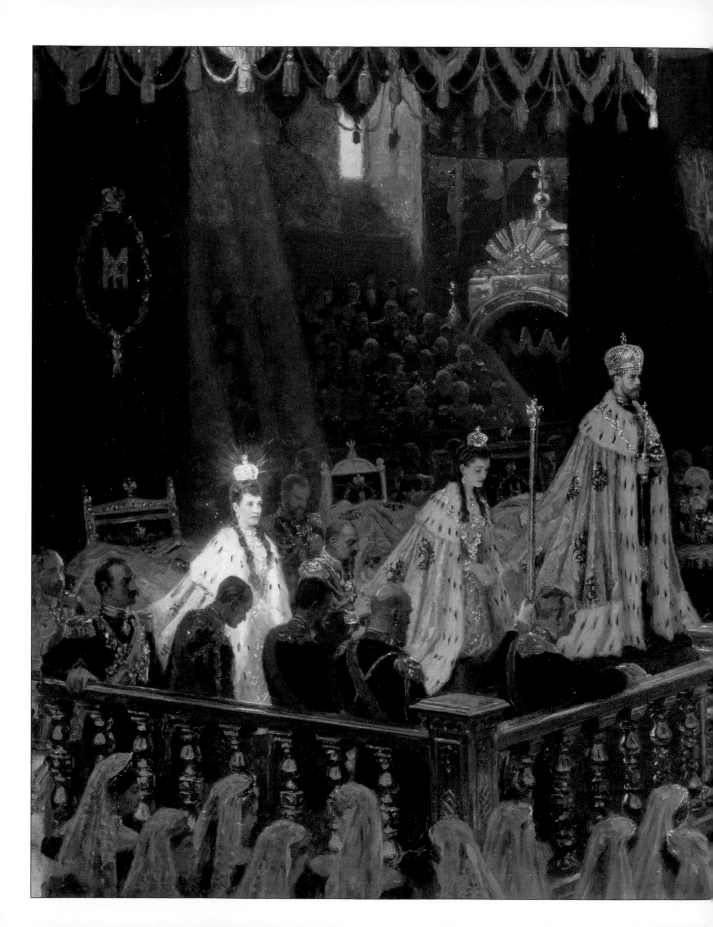

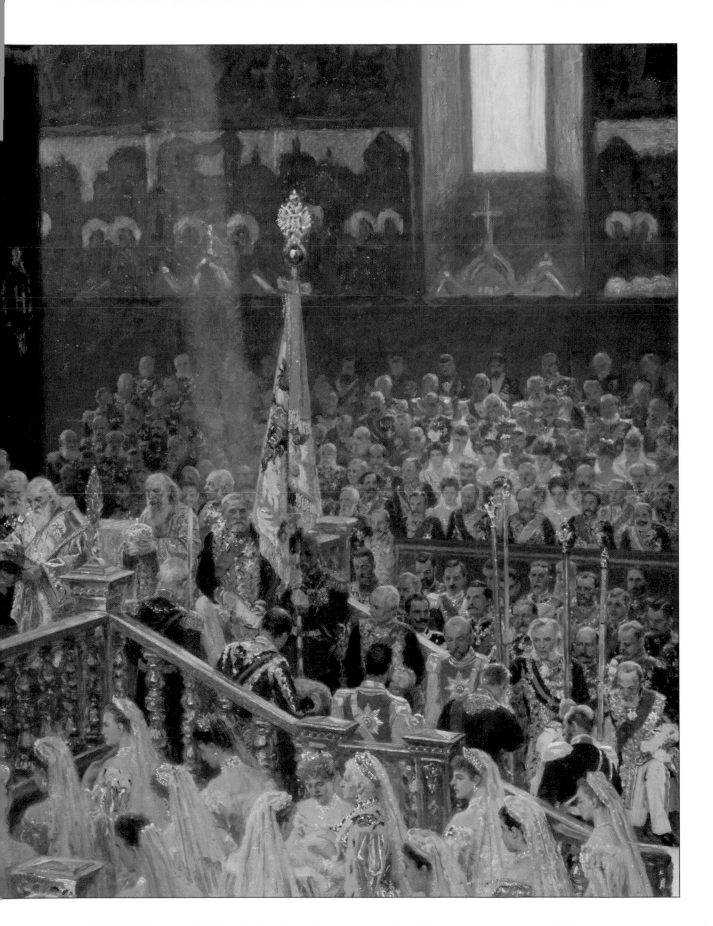

The first to enter the cathedral was the Tsar's mother who stood before her throne. Then, in the words of Grand Duke Gavril Konstantinovich:

Their Majesties entered the cathedral after her. His Majesty the Tsar wore the uniform of the Transfiguration. Her Majesty the Tsarina wore a Russian silver brocade robe. They also went and stood before the throne. The coronation service began in an exceptionally festive atmosphere. The Assumption Cathedral, that had witnessed some centuries of Russian history and where all the Romanov tsars had been crowned, the great group of clergy in splendid vestments with the metropolitan bishops at their head, the beautiful singing – the whole scene gave the ceremony a profoundly mystical character.

The service was conducted by the three Metropolitan Bishops of Moscow, St Petersburg and Kiev. After saying the prayers that had been chosen for the coronation ritual, 'he [Nicholas] ordered [the Metropolitan Bishop of St Petersburg] to present him with his crown'. After accepting it from the hands of the Metropolitan Bishop, and 'standing in his Tsar's robes before his crown, he placed it on his head'. Thereupon he was given the symbols of his rule – the mace and sceptre.

After reading the special prayers for the coronation, and hearing the responses of the Metropolitan Bishop spoken in the name of the Russian people, the Tsar moved to the throne on the altar to be anointed and to receive the sacrament. But as he was climbing the steps to the altar, the massive chain of the order of Saint Andrew slid off his shoulder, a detail some noted as another bad omen. After a moment's hesitation those close to the Tsar behaved as though nothing untoward had happened; and later no one referred to the incident for fear of spreading superstitious gossip.

On leaving the altar as consecrated Tsar, Nicholas took off his crown, touched the head of the kneeling Tsarina with it, put it back on his head and set the smaller crown on her head. The Tsar's sister later wrote: 'The ceremony was conducted in a very warm and human atmosphere. Aliki kneeled before Niki. I will never forget how attentively he placed the crown on her head and how tenderly he kissed her and helped her to her feet.'

The concluding moment of the ceremony in the stately interior of the Assumption Cathedral is captured in Piasetsky's panorama (page 45) and in the painting by the Danish artist Laurits Regner Tuxen (pages 46-7).

OPPOSITE

The coronation procession of
Tsar Nicholas II, May 1896

J Daziaro

(The Royal Collection
© Her Majesty Queen Elizabeth II)

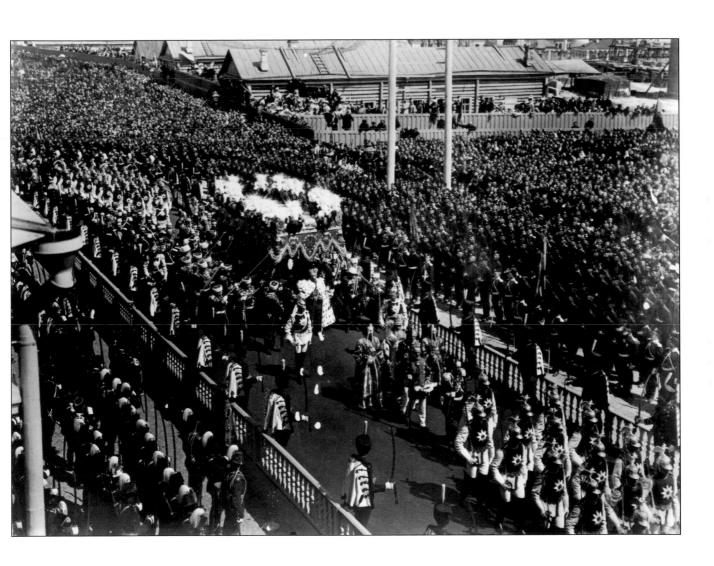

The magnificent procession then made its way to the Archangel and Annunciation cathedrals; and after greeting the people from the steps of the Palace of Facets the Tsar and Tsarina continued to the Kremlin Palace.

From the diary of Nicholas II:

14 May. Tuesday. A great and solemn, but, in a spiritual sense, heavy day for Alix, mamma and me. From eight in the morning we were up and about; and our procession only started moving at half-past nine. Fortunately the weather was perfect: the steps of the palace offered a glorious view. It all happened in the Cathedral of the Assumption. Although it felt like a dream, I shall never forget it all my life!!! We returned once more at half-past one. At three o'clock our procession set off again in the same order for the Palace of Facets, where we sat down at the great table. Everything went according to plan and by four o'clock it was over. With my soul filled with gratitude to God, I was able to take a complete rest.

The impressions of this day are also recorded in the memoirs of Grand Duke Alexander Mikhailovich:

Perfect days of spring, a historic city entirely decorated with flags, the sound of bells from sixteen hundred bell towers, the huge crowds shouting 'hurrah', the young Tsarina wearing her crown, radiant with beauty leading dignitaries from all the European nations in golden carriages. No strict ceremonial could have stirred the masses to greater enthusiasm than the sight of this spectacle.

May 14, the day of the official confirmation of Nicholas II as Tsar of

Russia, was a day full of congratulations, receptions, balls and popular festivities. Many of these events were held in the state rooms of the Kremlin Palace. Piasetsky must have sketched these rooms in advance, because although he was not invited he could hardly have omitted them from his panorama. In addition the rooms of the Terem Palace, which linked up with those of the Kremlin (the Vladimir, Catherine, Alexander and Saint George's Halls), were all sketched beforehand. One reception in the Throne Room, captured by Piasetsky, was also the subject of a note in Nicholas's diary:

15 May. Wednesday. At half-past eleven I received the congratulations of the clergy, the representatives of the highest public bodies, the nobility, the zemstvos *and the cities. Unexpectedly, however, the congratulations ended at breakfast time, two hours earlier than planned.*

One special feature of the coronation events was the colourful illuminations in Moscow, powered for the first time by electricity. They were switched on during the evening of Nicholas II's solemn entry into Moscow on 9 May, when the Tsar and his spouse stayed in the Kremlin. Nicholas commented in his diary: 'At nine o'clock we went out onto the highest balcony and there Alix lit the electrical illuminations of the bell tower of Ivan the Great, after which the towers and walls of the Kremlin, the opposite bank and the neighbourhood on the far side of the River Moskva were lit up in turn.'

In the official description of the coronation we read:

Her Imperial Highness the Tsarina Alexandra Feodorovna was presented with a bouquet and when her Highness was so good as to accept it, it lit up all by itself with a large number of little electric lamps; and at the

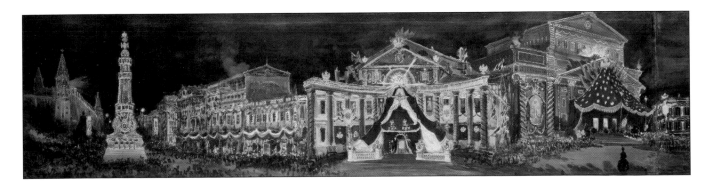

same moment, due to an unusual system of electric wires, as if someone had waved a magic wand, the different coloured lamps began to shine from the towers and the bell tower of Ivan, after which the other lamps also lit up on the towers and walls. The sight from the terrace across to the extravagantly illuminated opposite bank of the Moskva was quite splendid.

Multi-coloured illuminations and electric cascades beside the walls of the Kremlin lit up the Moscow sky, as well as projectors of light, in a display of great technical innovation. An enormous amount of money had been spent designing these illuminations, with the best of Russian engineers, architects and artists involved in creating the spectacle. The effects were commented upon not only by the popular press, but also in technical journals throughout the country.

Most members of the Emperor's family and their foreign visitors were now free to take a walk through Moscow which, according to the memoirs of Grand Duchess Olga Alexandrovna, was transformed into a fairytale city. Vladimir Nemirovich-Danchenko, coronation correspondent for the journal *Niva*, observed the lights with his colleagues from the roof of the Rumyantsev Museum:

We held our breath, literally afraid we might disturb this astonishing Fata Morgana [mirage] *by gasping; all we could do was stand and stare, enchanted by the beauty for which no description was adequate, alternating our whispers with suppressed shouts.*

Piasetsky also surpassed himself by capturing the beauty of the illuminations in marvellous fashion. The scene with the night-time festivities in Moscow is the most imposing part of his panorama (see pages 50 and 51), with its battery of colour effects taking into account how spectators must have seen it from a distance. The grand finale was now over.

However, a feast day planned for 18 May, four days after the coronation, was to bring with it a disaster that would drive out all other impressions of the royal event and cast a shadow over the whole of Nicholas II's reign.

A popular festival had originally been planned to take place on the Khodynka Field where presents were to be distributed to the crowd – sweetmeats and enamel mugs with the arms of the city and the monogram of

the Tsar. The field was situated on what was then the edge of Moscow, opposite the Peter Palace. The area was normally used as an exercise terrain for artillery and sappers, and trenches and pot-holes that had been dug there by engineers had not been properly filled in. To compound matters the police force posted there to keep the peace on the feast day was woefully ill-prepared to restrain a large crowd. People began streaming into the field before nightfall, and by morning they numbered about half a million. The authorities took practically no notice of the developing situation, even though there would have been time to take precautionary measures before daylight.

At around six o' clock in the morning, as dawn revealed pyramids of mugs piled high on special wooden platforms, tragedy struck. Word spread among the crowd that there were not enough presents to go round, and everyone naturally wanted a souvenir of the occasion. One witness described what happened:

> [The crowd] *rushed forward as one man, as desperately as though they were fleeing a fire The rows of people behind pressed down on those in front and anyone who fell over was trampled on; people didn't even realise that they were walking over living bodies; they felt more like rocks or wooden beams.*

The journalist P Shostakovsky wrote:

> *The weather was excellent The morning was calm, without any wind. There wasn't a breath of fresh air, and in the crush it was harder and harder to breathe. Sweat poured down over the ashen faces of the crowd, as though they were shedding tears. And the half-million strong packed mass of bodies was driven with all its unimaginable weight towards the buffers. They fell in their thousands in the trenches, on top of the heads of those already standing there. Behind them even more people fell, until the ditch was filled to the brim with bodies. And people walked over them. They couldn't help themselves, it was impossible to stop.*
>
> *The crowd went down, trampled and crushed. Official figures stated that there were 2690 victims in the Khodynka Field, including 1389 dead.*

Appalled, Nicholas wrote in his diary of 18 May:

*Up till then, thank God, everything had run smoothly, but today a great
tragedy took place. The crowd that had waited overnight in the Khodynka
Field to be given food and mugs, fell against an earthwork and people there
were terribly crushed, so that – it is dreadful to confess – about 1300 people
were trampled on!!! I heard the news at half-past ten.*

Immediately people started to move the dead and wounded from the
field to erase all traces of the catastrophe, and to prevent any delay to the
arrival of the Emperor, which had been planned for two o'clock. Many
witnessed the harrowing spectacle of the carts taking away the dead, hastily
covered with mats and canvas. Along with the Muscovites who observed this
appalling scene were members of Nicholas's own family. Grand Duchess
Olga Alexandrovna wrote: 'The Moscow authorities dealt with the matter
incompetently and the same goes for the court officials. Our coaches were
ordered too early. It was a marvellous morning. I remember how happy
we felt as we rode through the gates of the city and how short-lived that
happiness was.' A line of carts rolled towards them. They were covered with
pieces of canvas, and arms of the bodies beneath were sticking out. 'At first I
thought they were people waving at us. Suddenly my heart stopped. I began
to feel sick, but I continued to stare at the carts. They were transporting
corpses. The drama had broken the spirit of the Muscovites.'

It was a terrible catastrophe that shook Moscow to its very foundations.
The reputation of the Tsar was badly damaged and after that day he was
nicknamed 'Nicholas the Bloody'; while the Governor-General of Moscow,
Grand Duke Sergei Alexandrovich, was labelled 'the Duke of Khodynka'.
The tragedy was considered by many a harbinger of doom for the Tsar's
new reign, a prelude to future disaster. The name 'Khodynka' has since
entered the Russian language as a byword for occasions where accidents
occur.

Watching the carts moving forwards, piled up with dead bodies, Sergei
Witte, Minister of Finance, found himself tormented by questions:

*Will they manage to get all those still alive to the hospitals on time and
transport the corpses to some spot where they won't be seen by the rest
of the people, who are still celebrating, or by His Majesty, all his foreign
guests, and the whole entourage of more than a thousand? Shouldn't
the Tsar issue a decree now to cancel the whole festivities and have a*

*day of mourning for the tragedy, ordering a solemn mass to be celebrated
instead of the songs and concerts?*

Among the Tsar's family discussion raged on about whether or not the
festivities should be cancelled. Alexander Izvolsky, later to become Foreign
Minister, testified that the Imperial couple were deeply distressed by the
tragedy and wanted to call off the celebrations. Nicholas's mother thought
the same. Grand Duke Alexander Mikhailovich and his brothers demanded
the immediate sacking of the Governor-General of Moscow, Sergei Alex-
androvich, and the cancellation of any further festivities, while Grand Duke
Nikolai Mikhailovich attempted to persuade Nicholas that 'the blood of the
[thousands of] men, women and children will be a permanent blot on your
reign. You cannot resurrect the dead, but you can show your concern for
their families. Do not give your enemies any reason to say the young Tsar
was dancing while his deceased subjects are being taken to the mortuary.'

However, the older generation of grand dukes, the brothers of Sergei
Alexandrovich, supported the Governor-General. The latter felt he bore no
blame for the disaster and that there could be no question of him being
sacked, or indeed of any mourning period. Sergei did not visit the scene of
the disaster or display any sympathy for the families of the victims, and
denied that there was any need to investigate the cause of the tragedy. In his
view the event was an 'accident' and the victims were 'unexpected', therefore
the festivities should not be interrupted.

Nicholas was thus persuaded not to alter the timetable for the coro-
nation celebrations. And so, at two o'clock on 18 May, the Tsar and Tsarina
were present in the Khodynka Field as planned. Nicholas's diary records:

> *At half-past twelve we had breakfast and Alix and I left for Khodynka
> to attend that mournful 'festival'. There was nothing to be seen: we gazed
> down from a pavilion on a colossal crowd round a platform where all the
> time musicians were playing hymns and the National Anthem.*

The *Niva* correspondent who attended the festivities, Vladimir
Nemirovich-Danchenko, wrote about the theatre pavilion which was set up
on the field, the choirs, the acts of the clown Durov, and all the fashionable
public on the stands; but he also observed that corpses not yet removed still
lay in tents at the edge of the field:

It is true there were few people, you could walk freely around the field. The atmosphere was hardly cheerful. Next to the fairground booths and the gypsy choirs lay a pile of dead bodies. The contrast was remarkable and felt like a nightmare.

On the evening of the same day Nicholas and Alexandra remained in a sad frame of mind, but they decided to attend the ball of the French ambassador, De Montebello. The tears were still fresh on Alexandra's face. The political purpose of the ball – to strengthen the Franco-Russian alliance – meant nothing to the vast majority of the people.

During the two days that followed the catastrophe, the Tsar and Tsarina visited the injured in the hospitals; and on the orders of Nicholas a funeral meal was offered to his loyal subjects in the court chapel. All families who had lost a loved one received a thousand roubles and money was provided from the Treasury for funerals. But no gift could erase the terrible impression of that day. It felt like a bad omen for the new reign and remained engraved on everyone's memory.

The catastrophe in the Khodynka Field was not depicted in Piasetsky's panorama of the coronation celebrations, although a people's party held in the daytime was sketched, showing the pavilion of the Tsar and a festive crowd with balloons floating skywards. Chronologically, the picturesque furnishing of the halls of the Assembly of the Moscow Nobility was depicted next, where a great ball was held on 21 May. The panorama was then finished off with the final event of the coronation, the military parade on 26 May which took place on the same Khodynka Field.

Although mindful of the tragedy, Nicholas II had some reason to be pleased as, to all appearances, the coronation celebrations came to an end in the same festive atmosphere as they had begun. Nonetheless, in his response to all the official events of the ceremony, one is struck by Nicholas's deep conviction that the tasks of a monarch were a heavy burden sent to him by God and that he would be doomed to bear them all his life.

After the festivities the Tsar travelled with his family to Sergei Alexandrovich's estate at Ilyinskoe near Moscow. Nicholas wrote: 'An indescribable happiness to have arrived at this lovely peaceful spot! And the greatest consolation is that all the festivities and ceremonies are over and that I can now live quietly and peacefully for myself.' He was not to know that these days of peace were just the beginning of an arduous road full of tribulation.

The liberally inclined Prince Sergei Mikhailovich Volkonsky, grandson of the Decabrist revolutionary Sergei Grigoryevich Volkonsky, wrote in his memoirs:

During the coronation of Nicholas II, I remember talking to someone who shared my feeling that this would be the last. In the midst of this carefree climax, I thought, we have to be vigilant, because what if the people have had enough of shouting 'hurrah' and what will they do when they no longer get any pleasure out of a 'piece of theatre'?

The darkest times were yet to come. The coronation was merely the beginning of the most tragic period in the history of Russia.

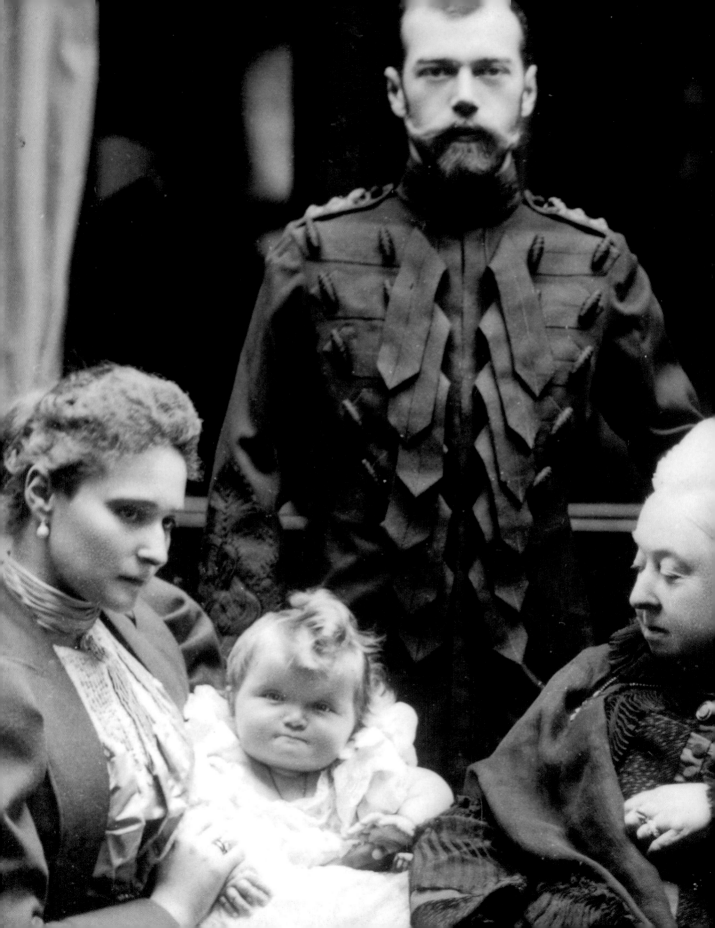

4

ALLIED BY
MARRIAGE:
BRITAIN AND RUSSIA
DURING THE LIVES
OF NICHOLAS AND
ALEXANDRA

'WORDS FAIL ME TO EXPRESS MY SURPRISE AND THE *pleasure I felt upon receiving the news that you had the kindness of appointing me Colonel-in-Chief of the beautiful Royal Scots Greys, just the regiment I saw and admired so last summer at Aldershot. I shall be happy and proud to appear one day before you in their uniform.'*

NICHOLAS II TO QUEEN VICTORIA

The British and Russian royal families were to become inextricably linked during the nineteenth century by a series of marriages. The first took place in March 1863 between Queen Victoria's eldest son Edward, Prince of Wales, and Princess Alexandra, eldest daughter of Prince Christian of Schleswig-Holstein-Sonderburg-Glucksburg who became Christian IX of Denmark in November 1863. The following year Princess Alexandra's sister, Dagmar, became engaged to the eldest son of Tsar Alexander II of Russia, the Grand Duke Nicholas, and the Prince and Princess of Wales began to look forward to the wedding in St Petersburg.

Sadly Nicholas died suddenly in 1865, but Dagmar consented to marry his brother, the new Tsarevich Alexander Alexandrovich (later Alexander III). By the time of her sister's marriage a year later, Princess Alexandra was pregnant with her third child and unable to travel. However, the Prince of Wales was absolutely delighted to receive pressing invitations from both the Danish and Russian royal families. He overcame his mother's objections to taking part in the celebrations and journeyed out to the Russian capital. Tsar Alexander II and all the male members of his family came

to welcome the Prince at the railway station, and the Tsar personally conducted him to his apartments in the Hermitage Palace. Thereafter Edward was lavishly entertained to a non-stop round of wonderful balls, banquets and parades, both in St Petersburg and during his short stay in Moscow. He also took part in a hunt at Gatchina, at which seven wolves were killed. This first exposure to the grand scale of Russia, and to Russian architecture and the splendour of the Imperial court, alerted the Prince

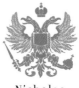
to the tremendous wealth and power of the country and the need to develop better relations with such a European and Asian colossus.

The visit was regarded as a great success, and Major Teesdale, who was travelling with the Prince, informed Queen Victoria that Prince Edward left Russia 'carrying with him the goodwill and affection of every one with whom he had been thrown in contact'.

In the wake of this success, in 1869 Tsar Alexander sanctioned the Prince's desire to sail from Constantinople to see the battlefields of the Crimean War, and invited both the Prince and Princess of Wales to stay a night at the nearby Imperial palace at Livadia.

Subsequent meetings and greater involvement between the British and Russian royal families led to the engagement in April 1873 of Queen Victoria's second son Alfred, Duke of Edinburgh, to the Grand Duchess Maria, the only daughter of Tsar Alexander II. Two months later the Prince and Princess of Wales invited the Tsarevich Alexander and Marie (as Dagmar was now known), and their two young sons Nicholas and George, to spend a few weeks with them at Marlborough House in London. During the visit Edward exercised his considerable talents as an organiser and host and made a very favourable impression upon the Russian Imperial family – and especially on the future Nicholas II, who would always cherish memories of his first introduction to Britain and his 'Uncle Bertie'.

The wedding of the Duke of Edinburgh and the Grand Duchess Maria took place in the Winter Palace in St Petersburg in January 1874, and was attended by the Prince and Princess of Wales and the Prince's brother Arthur, Duke of Connaught (Queen Victoria's third son). The wedding itself went well, but when Tsar Alexander sought to promote better relations and honour the Prince of Wales (and Britain) by making Edward a colonel of a Russian regiment, his gesture was rebuffed by Queen Victoria's resolute refusal to allow this. Although the Tsar tried to persuade the Queen to change her mind after the Prince of Wales arrived in St Petersburg, he failed completely. Her Majesty wired her regret at 'being compelled to decline your friendly offer of giving the Prince a regiment which he could not accept, as it is contrary to the custom of this country'.

The visit was also marred by the Tsar's request for Mitchell, one of the Prince's suite, to leave Russia for expressing doubts on the eve of the wedding about the possibility of permanent harmony between the two countries.

PREVIOUS PAGES

Tsarina Alexandra Feodorovna, holding Olga on her lap; Tsar Nicholas II; Queen Victoria; Albert Edward, Prince of Wales: at Balmoral, September 1896

J Dazairo

(The Royal Collection
© Her Majesty Queen Elizabeth II)

OPPOSITE

A cigar box by Fabergé, commissioned by Tsar Nicholas II for King George V in 1915

*Karl Gustav Hjalmar Armfeldt
for Fabergé*

CATALOGUE NO. 110

Before Edward's return to Britain, Lord Granville, the British Foreign Secretary, prompted the Queen to invite the Tsar to visit England in May, an invitation that was graciously accepted. Once again, the Prince of Wales found himself acting as host and he took personal charge of the hospitality.

Edward met the Tsar and his suite of fifty-one people at Dover on 14 May and took them directly to Windsor Castle before, two days later, going on to Buckingham Palace. An elaborate dinner on the first night at Marlborough House was followed by a brilliant fête in the Tsar's honour at the Crystal Palace, a military review at Aldershot, and a ball at Buckingham Palace. The Tsar departed – exhausted – on 21 May. Indeed, the atmosphere of the visit was so convivial that it inspired the Queen to send the Tsar an unusually optimistic farewell telegram assuring him that 'our countries will remain on friendly, nay cordial, terms'.

The assassination of Tsar Alexander II in March 1881 led to further developments in Anglo-Russian relations. The Prince and Princess of Wales attended a service at the Russian Orthodox Church in London the day after the murder, and a week later travelled out to St Petersburg to comfort the new tsar and tsarina and to show their solidarity with the Russian Imperial family. After the funeral, Alexander and 'Minnie' (as Marie was also known) moved from the Winter Palace to stay with 'Alix' and 'Bertie' in the Anichkov Palace. From there the Tsar wrote to Queen Victoria to assure her that 'the presence [of the Prince and Princess] has been a great consolation for me and the Empress in our affliction'.

Edward had secured Victoria's agreement to present his brother-in-law with the Order of the Garter after the funeral. The investiture duly took place, in the heavily guarded palace, and was much appreciated. It also provided some light relief amid the gloom. Lord Frederick Hamilton recounts in his reminiscences that the procession of the Insignia of the Garter, on cushions, inspired one woman to cry out in English, '"Oh! my dear! Do look at them! They look exactly like a row of wet-nurses carrying babies!".... The two sisters, Empress and Princess of Wales, looked at one another for a moment and then exploded into laughter.'

Alexander III was a much more peace-loving man than his father, and although clashes of interest arose between Britain and Russia – notably over Afghanistan – they were far less serious and dangerous than in the past. There was also more of a 'family relationship' between the two royal

OPPOSITE

Princess Alix of Hesse,
June 1881

C Backofen

(The Royal Collection
© Her Majesty Queen Elizabeth II)

families, with frequent meetings at Christian IX's birthday celebrations in Copenhagen and elsewhere.

In July 1893 the Tsarevich Nicholas came to London to attend the marriage of his cousin George, Duke of York (the son of the Prince of Wales) to Princess May of Teck. Nicholas looked very like George, and this greatly pleased the Queen, who noted in her diary 'no end of funny mistakes, the one being taken for the other'. Nicholas himself confided in his diary: 'The Queen – a round ball on unsteady legs – was remarkably kind to me. We lunched with her and the Battenbergs [at Windsor Castle …]. Then she presented me with the Order of the Garter, which I certainly had not expected!'

The royal alliances culminated in 1894 with the engagement and marriage of Queen Victoria's beloved grand-daughter Princess Alix of Hesse to Tsar Nicholas II – the nephew of the Prince of Wales, later King Edward VII, and cousin of the future King George V.

Alix was Victoria's special favourite – partly because she had been left motherless at the age of only six, when Victoria's daughter, Princess Alice, died of diphtheria in 1878. The Queen kept a close watch on her grand-daughter's upbringing and frequently invited Alix to stay with her. In August 1888 Alix came to Glasgow (with her father and brother) to take part in the Queen's official visit to the city. She accompanied the Queen to the opening of the new City Chambers and attended the International Exhibition, before going on to stay with the sovereign at Balmoral.

Nicholas had wanted to marry Alix for many years, but she had been unwilling to give up her Lutheran faith and convert to Russian Orthodoxy. She eventually agreed to marry the Tsarevich in April 1894, when they were at Coburg for the wedding of her brother 'Ernie'. Alix's father had died two years earlier and Ernst, the new Grand Duke of Hesse, was about to marry Victoria, the daughter of the Duke of Edinburgh (who had become the Duke of Saxe-Coburg-Gotha the year before). The wedding celebrations were attended by Victoria and many of her extended family.

It was arranged that Alix, who was very close to her brother but did not get on well with her new sister-in-law, would come to England and stay with Queen Victoria after the wedding. The Queen was delighted about Nicholas and Alix's engagement and strongly supported the young couple. 'Grandmama' or 'Granny' (as she was now to be called) warned Nicholas that his future bride was exhausted after her brother's wedding and

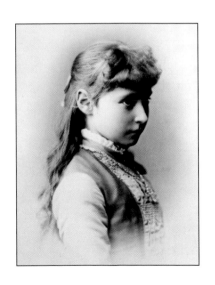

encouraged Alix's recuperative stay at the spa in Harrogate in May. Nicholas was invited to visit Windsor when Alix returned in June and he stayed at Windsor Castle and at Osborne House, on the Isle of Wight, for a month (11 June to 11 July 1894). During this time Nicholas introduced 'Grandmama' to his old tutor, Mr Heath, and the Imperial chaplain who was preparing Alix for her reception into the Orthodox Church. The old lady noted in her diary, with great satisfaction, that the young man was 'most affectionate & attentive to me'.

Alix was still in Britain, staying with the Queen at Balmoral, when Nicholas's father became seriously ill. Nicholas sent letters and telegrams asking Alix to join him and she managed to get to Livadia in the Crimea ten days before Tsar Alexander III died, on 20 October 1894.

Queen Victoria wrote to 'Dearest Nicky' from Balmoral eight days later:

I can hardly find words to express all my feelings in writing to you my dearest (future) grandson. The best I can find are comprised in 'God bless you'. May He indeed bless, protect, and guide you in your very responsible and very high position in which it has pleased Him to place you when still so young! May our two Countries ever be friends, and may you be as great a lover of Peace as your dear Father was!

Ever your devoted (future) Grandmama, VRI

The Prince and Princess of Wales also journeyed out to Livadia to support the Empress Marie and her family. They arrived after the Tsar's death, but were able to help the Imperial family bring his body back to St Petersburg, via Sebastopol and Moscow. 'Uncle Bertie' assisted his nephews as they carried their father's coffin on a number of occasions during the long journey, and walked and stood beside the new Tsar during the ceremonies in the Kremlin, in the procession from the railway station to the Cathedral of St Peter and St Paul (the burial place of the Russian Imperial family since Peter the Great), and at the funeral itself. The British royal family's importance and involvement were demonstrated by the placing of Queen Victoria's wreath in the position of honour – along with the Empress's – at the foot of the coffin, for the lying-in-state and the funeral. At the end of the funeral service itself, Edward came forward with Nicholas and his brothers and moved Tsar Alexander III to his final resting place.

OPPOSITE

George, Duke of York (standing)
and Tsarevich Nicholas, 1893

W & D Downey

(The Royal Collection
© Her Majesty Queen Elizabeth II)

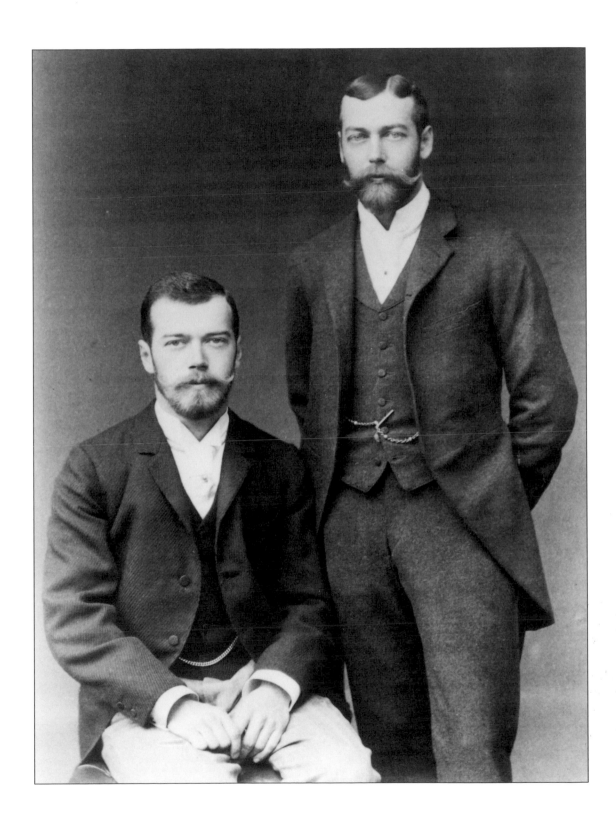

A week later Nicholas and Alexandra (as Alix was now officially called) were married in the Winter Palace, with the Prince and Princess of Wales – 'Uncle Bertie' and 'Aunt Alix' – among the principal guests. (Interestingly, Laurits Regner Tuxen's small painting of the marriage in the Hermitage, see page 22, shows the Prince a few metres from the bride and groom; but in the much larger canvas Tuxen completed for the British royal family – still in the British Royal Collection – 'Uncle Bertie' is 'repositioned' directly behind the Tsar.) The Prince and Princess of Wales had been joined at the funeral and wedding by their son George, who informed Queen Victoria of his thoughts:

> *Nicky is a very lucky man to have got such a lovely and charming wife*
> *& I must say I never saw two people more in love with each other or*
> *happy than they are. When they drove from the Winter Palace after the*
> *wedding they got a tremendous reception and ovation from the large*
> *crowds in the streets, the cheering was most hearty & reminded me of*
> *England Nicky has always been kindness itself to me, he is the same*
> *dear boy he has always been to me & talks to me quite openly on every*
> *subject He does everything so quietly & naturally; everyone is struck*
> *by it & [he] is very popular already.*

As a wedding present – at Edward's recommendation – Victoria made Nicholas Colonel-in-Chief of the Royal Scots Greys. Nicholas was thrilled by the Queen's gift. He wrote to 'My dearest Grandmama' on 16 November:

> *Words fail me to express my surprise and the pleasure I felt upon*
> *receiving the news that you had the kindness of appointing me Colonel-*
> *in-Chief of the beautiful Royal Scots Greys, just the regiment I saw*
> *and admired so last summer at Aldershot. I shall be happy and proud*
> *to appear one day before you in their uniform.*

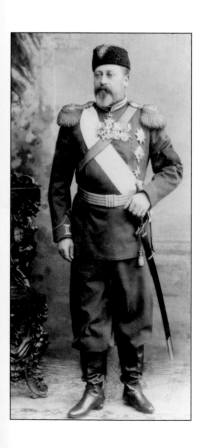

The Scots Greys were also delighted. Lieutenant-Colonel Welby wrote to the Tsar on 1 December to express his pleasure and to submit his first monthly account of the state of the regiment. Two months later, on 2 February 1895, Welby visited the Tsar, with Major Hippisley, Captain Scobell and Regimental Sergeant-Major Duncan, to present a painting of

the new Colonel-in-Chief leading the regiment, dressed in the uniform of the Greys. The three officers were received by Nicholas and Alexandra in the Anichkov Palace, with the Tsar wearing the full dress uniform of the Greys. According to Major Hippisley, the Prince of Wales had wanted the Tsar's uniform to be 'absolutely correct' and had arranged for a London tailor to make it. Unfortunately the tailor had become confused by the metric measurements and had supplied a uniform and boots that were too small. Thankfully it proved possible to carry out the necessary alterations in Russia, and the Tsar was able to assure Welby that 'his uniform fitted quite well and that he liked it very much'.

Four months after their coronation, which took place in May 1896, Nicholas and Alexandra visited Queen Victoria at Balmoral to congratulate her on reigning longer than any previous British monarch, and also to show her their infant daughter, the Grand Duchess Olga. Although it was stressed that this was a private visit, the beginning and end were semi-state occasions. Victoria had intended a simple reception, but the Prince of Wales quickly drafted an elaborately detailed programme which provided the pomp he thought essential to honour the Emperor and Empress, and the Queen acquiesced to his proposals.

On 22 September 1896 the Russian Imperial family sailed into the Firth of Forth on board the new Imperial yacht, the *Standart*, and were welcomed with a royal twenty-one-gun salute from the British Channel Squadron – and by heavy rain. They were met in the Forth by Edward and

OPPOSITE

The Prince of Wales in
Russian Military Uniform,
St Petersburg, 1894

A. Pasetti

(The Royal Collection
© Her Majesty Queen Elizabeth II)

LEFT

The Royal Scots Greys present
a painting to Tsar Nicholas II
in St Petersburg, 1895

The Graphic
16 February 1895

(© The Trustees of the National
Library of Scotland)

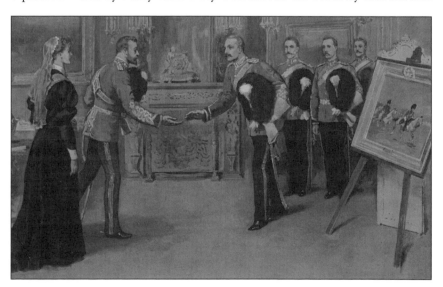

his brother, the Duke of Connaught. The Tsar was dressed in his Scots Greys uniform. In 1894 Nicholas had made his uncle Colonel-in-Chief of the Kiev Dragoons, and Edward was likewise attired in his Dragoons' uniform to show how much he appreciated the honour.

The Prince and the Duke brought the Tsar and Tsarina ashore and a short reception was held at the port of Leith, involving the Provost of Edinburgh, the Duke and Duchess of Buccleuch, and many other distinguished figures. Afterwards the royals rode in a carriage, with an escort of Scots Greys, to the local railway station. The streets were lined with Argyll and Sutherland Highlanders, King's Own Scottish Borderers, and the Mid Lothian Artillery and Leith and Queen's Edinburgh Volunteers. A regimental band played the Russian national anthem, and a 'dense throng of spectators' who 'greeted the Czar and Czarina with the heartiest expressions of goodwill' and 'lusty cheering'.

At the station the Imperial family and the Queen's two sons boarded a train bound for Ballater, on Royal Deeside. 'As the train passed out of the Waverley station a salute boomed forth from [Edinburgh] Castle to speed their Majesties on their way.' At Dundee the Corporation seized the opportunity of a short stop to present an address. On their arrival at Ballater station at seven o'clock, a hundred men of the Black Watch presented arms, and the Duke and Duchess of York stepped forward to greet their guests. Then, with bonfires blazing and church bells ringing, the party drove in carriages to Balmoral, escorted by another detachment of the Greys and by Crathie and Ballater Volunteers and Balmoral Highlanders carrying flaming torches.

Victoria had been waiting, in eager anticipation, in the visitors' rooms at Balmoral and was standing at the door when the procession arrived, punctually, at eight o'clock. She embraced 'Nicky' and 'darling Alicky' and took them through to the drawing room. Here she was introduced to the Imperial suite. Finally, as the Queen later noted in her diary, 'the dear Baby was then brought in, a most beautiful child & so big'.

The twelve-day visit included carriage drives to the Dantzig Shiel and other places for tea, deer and grouse shooting for the men, and enjoyable family meals. Victoria felt it was 'quite like a dream having dear Alicky & Nicky here' and was enchanted with the 'dear fat beautiful Baby'.

OPPOSITE TOP

The Arrival of Tsar Nicholas II and the Tsarina at Balmoral, 22 September 1896

Orlando Norie (1832-1901)

(The Royal Collection © Her Majesty Queen Elizabeth II)

CATALOGUE NO. E32

OPPOSITE BELOW

Left to right: George Gordon; Arthur, Duke of Connaught; Princess Victoria Patricia of Connaught; Tsar Nicholas II; Queen Victoria; Princess Helena Victoria of Schleswig-Holstein; Alexandra Feodorovna; Louise Margaret, Duchess of Connaught; Princess Margaret of Connaught: at Balmoral, September 1896

W & D Downey

(The Royal Collection © Her Majesty Queen Elizabeth II)

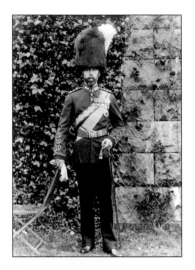

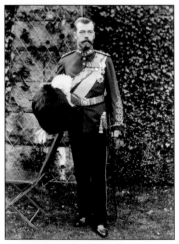

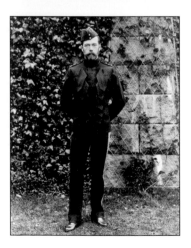

The Imperial visit was recorded in considerable detail by Orlando Norie, Amédée Forestier and other artists, as well as by photographers. Forestier's work is particularly interesting because he had been employed by the *Illustrated London News* since 1882 and had apparently gone out to Moscow, in the Duke of Connaught's suite, a few months earlier to make a record of the Tsar's coronation for the British royal family. Forestier produced sketches of the procession from Ballater to Balmoral and the meeting of the Queen and the Tsar for the *Illustrated London News*, and a watercolour of *The Reception of the Emperor and Empress of Russia at Balmoral, 22 September 1896* for the Queen, for which he was paid fifty guineas.

Victoria also employed two photographers. Local photographer Robert Milne visited Balmoral on 29 September to take the 'official' photographs which could be distributed to relatives and also published in magazines. On 30 September *The Times* reported:

> *By command of the Queen Mr. R. Milne, Aboyne and Ballater, attended and took a large number of photographs of the royal guests. The Emperor was taken in various poses and costumes. He was at first dressed in the handsome uniform of the Scots Greys, of which his Majesty is colonel, and he wore the ribbon of the Garter. He was photographed in the old-fashioned flower garden to which a flight of stone steps led from the terrace at the west end of the Castle. Then he put on the undress uniform of the same regiment, subsequently changing this for another military uniform. He was also taken in company with the Duke of Connaught, who wore the undress uniform of the Scots Guards. The most interesting group of the day included her Majesty the Queen, the Emperor and Empress of Russia, the Prince of Wales, and the Grand Duchess Olga The members composing the households of her Majesty and the Emperor of Russia were also photographed, and by command of her Majesty the portrait of the Cossack who came with the Imperial visitors was taken. He wore the splendid uniform which attracted so much attention when the party arrived in this country.*

Milne's work was supplemented by the court photographers W & D Downey. They took more informal photographs and, on 3 October, movie footage of the party 'walking up & down & the children jumping about'

(to quote Queen Victoria). The edited film was shown to the Queen at Windsor Castle on 23 November.

Much to the Queen's regret the visit ended on 3 October. Nicholas and Alexandra each planted a tree in the grounds in the afternoon, to commemorate their visit, and departed at ten o'clock that night, accompanied by the Duke and Duchess of Connaught. As before, they were escorted by Scots Greys and Highlanders carrying torches. From Ballater the Imperial family travelled down the West Coast line to Portsmouth, where they boarded the old Imperial yacht, the *Polar Star*. The *Polar Star* and *Standart* then set sail and were greeted by a twenty-one-gun salute from the Channel Squadron. A formation of six battleships, eight cruisers and twelve torpedo-boat destroyers escorted the Imperial yachts across the Channel.

About halfway to Cherbourg they rendezvoused with the French fleet. The British bade farewell to the Tsar and Tsarina with another twenty-one-gun salute, while the French honoured their main ally with an exceptional 'salute of 100 guns from every ship in the fleet'. It was just a foretaste of the impressive arrangements that had been made for the Tsar's state visit to Paris, designed to ensure that he would continue the Franco-Russian alliance and make additional crucial commitments to France.

Less than a year later, the birth of Tatiana prevented the Imperial couple from attending the celebrations to mark the sixtieth anniversary of Queen Victoria's accession to the throne, in June 1897. Nicholas sent his uncle, Grand Duke Sergei, and his wife, Grand Duchess Elizaveta (the Tsarina's sister), to represent them, and told the Prince of Wales that he envied their good fortune in being able 'to witness all the jubilee festivities'. To take the sting out of their disappointment, arrangements were made for the specialist panorama painter Pavel Yakovlevich Piasetsky to produce a huge panorama of the scenes in London for the Imperial family. When completed, it measured 127 metres long.

The death of Queen Victoria in January 1901 greatly saddened the Russian Imperial family, and Nicholas wrote to 'Dearest Uncle Bertie' to convey his condolences:

It is difficult to realise that beloved Grandmama has been taken away from this world. She was so remarkably kind and touching towards me since the first time I ever saw her, when I came to England for George's and May's wedding.

OPPOSITE TOP AND MIDDLE

Tsar Nicholas II in the uniform of the Scots Greys at Balmoral, September 1896

Robert Milne

(The Royal Collection © Her Majesty Queen Elizabeth II)

OPPOSITE BELOW

Tsar Nicholas II in the undress uniform of the Scots Greys at Balmoral, September 1896

Robert Milne

(The Royal Collection © Her Majesty Queen Elizabeth II)

I felt quite at home when I visited Windsor and later in Scotland near her and I need not say that I shall forever cherish her memory. I am quite sure that with your help, dear Bertie, the friendly relations between our two countries shall become closer than in the past, notwithstanding the occasional slight frictions in the Far East. May the new century bring England and Russia together for their mutual interests and the general peace of the world.

On 22 May 1901 Nicholas wrote again to 'My dearest Uncle Bertie', urging him to end the Boer War, but his courteous and tactful letter had little effect – either on the war or on his relationship with Edward. The new king was naturally keen to improve Britain's relations with Russia and his desire increased in 1903, as Britain began to resolve its international and colonial problems with France. It was clear that the 'Entente Cordiale' (which was eventually signed with France on 8 April 1904) would only become truly effective if Britain had a very good understanding with France's main ally, Russia.

Edward had tentative conversations about improving Anglo-Russian relations with Count Benckendorff, the new Russian ambassador to London, in November 1903 and discussions with Alexander Isvolsky, the Russian Minister at Copenhagen, during his visit to the Danish court in April 1904. The King very much hoped that the arrival of his great friend, Sir Charles Hardinge, as ambassador to St Petersburg the following month, would lead to a breakthrough.

The war between Russia and Japan (1904-5) made it impossible for Sir Charles to make much headway. The Russians were unhappy about the treaty the British had signed with the Japanese in January 1902 and tension was increased when they sent cruisers from the Black Sea and searched neutral vessels for contraband of war in the Red Sea. However, all this paled into insignificance in October 1904 when the Russian Baltic Squadron sailed from St Petersburg to the Far East and fired on British trawlers fishing on the Dogger Bank, in the belief that they were hostile Japanese torpedo boats. This action was a result of panic in Russia following the Japanese successes in the Far East and 'intelligence' received about Japanese naval activities in the Baltic and North Seas that had been supplied by the Russian spy Hekkelman and others. The attack occurred when Britain was celebrating the ninety-ninth anniversary of the Battle of

Trafalgar and there was an outcry about the sinking of one of the trawlers and the killing and wounding of several fishermen.

War was averted, but negotiations had to be postponed. As far as the British were concerned, the problem was largely solved by the International Commission of Inquiry's decision on 25 May 1905 that Russia should pay compensation of £65,000, and by the defeat of the Baltic Squadron only two days later. At the Battle of Tsushima – the 'Trafalgar of the East' – the Japanese Admiral Togo sunk six of the eight Russian battleships and captured the other two.

On 6 June Sir Arthur Nicolson, the new British ambassador, and Isvolsky, now the Russian Foreign Minister, began talks which would reduce friction over Afghanistan, Tibet and Persia. Fifteen months later, on 31 August 1907, they signed the Anglo-Russian Convention. One reason the negotiations took so long was Isvolsky's concern not to antagonise Germany.

The Convention was ratified by King Edward and the Tsar and the idea of a meeting between the two sovereigns – postponed because of the Russo-Japanese war and internal problems in Russia – was revived. It was agreed that because of the conditions in Russia and German alarm over the improvement of Anglo-Russian relations, the King would pay a state visit to Reval (now Tallinn, in Estonia), rather than St Petersburg. King Edward and Queen Alexandra would sail across on the British royal yacht to be met by the Tsar and Tsarina on their yacht. The meeting was scheduled to last only two days, 9 and 10 June 1908, and would take place on the ships, under heavy naval protection.

King Edward and Queen Alexandra duly arrived on the *Victoria and Albert*, accompanied by Admiral Fisher, General French, Hardinge and Nicolson, and escorted by the cruisers HMS *Minotaur* and HMS *Achilles*. The King was dressed, very uncomfortably, in his Russian Dragoons' uniform, but nevertheless excelled at Reval. Immediately prior to meeting the Tsar, he interrogated Nicolson on a huge range of Russian subjects – major and minor – and then proceeded to use this wealth of additional information to brilliant effect in his conversations with his nephew, Prime Minister Piotr Stolypin, Isvolsky and others. Stolypin expressed his surprise at Edward's knowledge of Russian affairs and subsequently told Hardinge that the King 'fascinated' him: 'It was not only what he said but his manner bore the impression of an artist in international politics whom Europe regarded as the first statesman in Europe.'

On his own initiative, on the second day, Edward made the Tsar an admiral of the British Navy. This was necessary, he explained, because the Tsar needed to add a naval uniform to his Scots Greys uniform, since 'he was more likely to meet British warships in future than he was to encounter British troops'. At the dinner that night, Nicholas responded by asking his uncle to do him the honour of becoming an admiral 'of our young and growing fleet'.

The meeting at Reval celebrated the limited success of the Anglo-Russian Convention, but it was recognised that a lot more work would be needed if the two countries were to come to a more fundamental understanding and an alliance. Edward therefore continued to meet with Isvolsky. He invited him to Britain and passed on Isvolsky's wish to achieve progress on the opening of the Dardanelles to Russian warships. The British cabinet agreed that there was no longer a strategic need to oppose the passage of Russian warships through the Straits. This pleased and encouraged Isvolsky, and discussions took place between him and Sir Edward Grey about reciprocal rights of passage in the event of war.

Edward built on these moves when the Tsar made a return state visit to Britain in early August 1909. It was agreed that Nicholas and his family would come across to Cowes, on the Isle of Wight, after the Tsar had had a meeting with the French President at Cherbourg. Three days earlier there had been a spectacular naval review in the Solent, consisting of twenty-four battleships, sixteen cruisers, forty-eight destroyers and over fifty other vessels. The Imperial family was escorted across the English Channel by three of the largest warships and were met by the King on the royal yacht. Edward welcomed his guests and then invited them to board the *Victoria and Albert* and inspect the fleet. The Tsar was obliged to salute each British ship, while the crews cheered and the band played the Russian national anthem. It was a classic 'show of force' designed to demonstrate the naval, industrial and economic might of the British empire – three salient reasons for the Tsar and the Russian government to bind themselves closer to Britain.

Despite Edward's heavy-handed 'statesmanship', the Imperial family enjoyed both encounters with their British relatives. Queen Alexandra's photographs of the meeting at Reval show both the Tsar and Tsarina smiling broadly, and Olga observed that 'I hadn't laughed so much in ages'. Similarly the photographs taken at Barton Manor in 1909 record two

OPPOSITE LEFT

Tsar Nicholas II and Alexandra Feodorovna at Reval, June 1908

Queen Alexandra

(The Royal Collection
© Her Majesty Queen Elizabeth II)

OPPOSITE RIGHT

Prince Edward, Tsar Nicholas II, Tsarevich Alexei and George, Prince of Wales, at Barton Manor, 4 August 1909

Photographer unknown

(The Royal Collection
© Her Majesty Queen Elizabeth II)

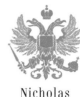

families at ease with one another. Alexei was apparently reluctant to play with his godfather, King Edward, but the children had a lovely time on the beach and enjoyed buying postcards.

King Edward died in 1910 and his involvement with Russia was mirrored at his funeral. The Dowager Empress Marie accompanied Queen Alexandra. Even more tellingly, three officers of the Hussar Regiment of Kieff represented the late King's regiment, while a deputation from the Russian Navy bore witness to his Russian admiralcy.

King George V continued his father's policy of encouraging better relations with Russia, and invited the Russian Foreign Minister Sergei Dmitrievich Sazonov and Sir Edward Grey to Balmoral in 1912 to resolve tension over the presence of Russian troops in Persia. Nicholas and 'Georgie' had always been close and the First World War, 1914-18, was to bring them even closer, as allies against Germany and Austria-Hungary.

The war on the 'Eastern Front' was, of course, horrendous. Russia's initial two-pronged attack on Eastern Prussia left her Second Army virtually

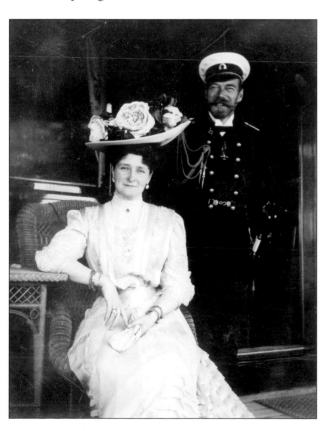

destroyed, while in the south the campaign against Austria-Hungary resulted in the loss of some 250,000 men. Nevertheless, Nicholas kept abreast of 'his' British regiment, the Scots Greys, and in January 1915 he sent Prince Felix Yusupov to France to award Russian decorations to twenty officers and men who had been mentioned in recent despatches. They ranged from Brigadier General (formerly Lieutenant-Colonel) Bulkeley-Johnson, who was presented with the Order of St George third class, to three non-commissioned officers who received the Medal of St George second class.

In 1915 the Germans and Austro-Hungarians overran all of Russian Poland and killed or captured over two million Russians. In September that year, shortly after the fall of the fortress of Kovno and the loss of 1,360 guns, Nicholas took over from his uncle, Grand Duke Nikolai Nikolaevich, as Supreme Commander of the Russian Army. It was largely a figurehead role. However, in his own eyes, and in those of most Russians, the Tsar became personally responsible for the course of the war. King George appreciated the enormous weight Nicholas had placed on his own shoulders, and wrote to the Tsar:

> *Emperor of Russia: On the occasion of our New Year, when our two Armies are fighting against a Common Enemy, I am anxious to appoint you a Field Marshal in my Army as a mark of my affection for you.*
>
> *If you accept, it will be a great pleasure to me, and an honour to the British Army.*

Nicholas replied, two days later, saying that he was 'deeply grateful for the great honour you do me', and accepted 'this high distinction with much pleasure'.

The Tsar was presented with his British Field Marshal's baton, on behalf of King George, by General Sir Arthur Paget at the Russian general headquarters on 29 February 1916. In his speech Sir Arthur said:

> *My August Sovereign trusts that your Majesty will receive [the baton] as a token of his sincere friendship and affection, and as a tribute to the heroic exploits of the Russian Army. Though the distance which separates them has rendered it as yet impossible for the Russian and British armies to fight shoulder to shoulder against the common enemy, they*

OPPOSITE

King George V (*right*) and Tsar
Nicholas II in Berlin, May 1913

Ernst Sandau

(The Royal Collection
© Her Majesty Queen Elizabeth II)

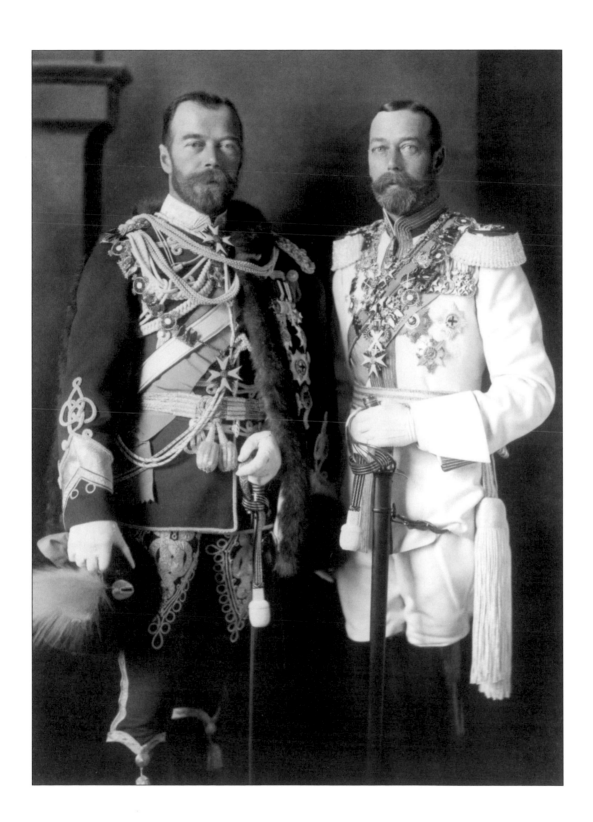

are united in the firm determination to conquer the enemy and never to make peace till victory has been secured The British Army, who share his Majesty's admiration for their Russian comrades, welcome your Imperial Majesty as a British Field-Marshal.

Despite the enormous losses incurred in 1916 – estimated at three million men killed or captured – the Tsar sent Russian troops to Marseilles, to fight alongside the French and British armies on the Western Front. The first Russian troops arrived on 20 April, and the scenes of great rejoicing were witnessed by the British military attaché to France and by 'many British officers and men of units from all over the Empire'.

However, time was running out. By January 1917 Russia's war on the Eastern Front had petered out in stalemate. Two months later, on 15 March, Tsar Nicholas II abdicated and by July 1918 the Imperial family had been executed.

The only 'crumb of comfort' for King George V was that he was able to save his aunt. The Dowager Empress Marie had refused to board HMS *Tribune* in November 1918 and had turned down another offer of escape from a Canadian millionaire called Joe Boyle. But in 1919 the Bolsheviks came within striking distance of the Crimea, and HMS *Marlborough* was ordered to evacuate the Empress. Queen Alexandra sent her sister a letter begging her to leave, and 'Minnie' consented, provided her relatives and friends were also taken on board.

The Dowager Empress of All the Russias eventually returned to Portsmouth on HMS *Lord Nelson* in May 1920, to the embrace of Queen Alexandra and a sad exile in Denmark.

OPPOSITE

His Imperial Majesty
Tsar Nicholas II.
This portrait was a personal
gift from the Tsar
to the Royal Scots Greys

Anton Aleksandrovich Serov
(1865-1911)

(Courtesy of the Royal Scots Dragoon
Guards [Carabiniers and Greys])

CATALOGUE NO. E33

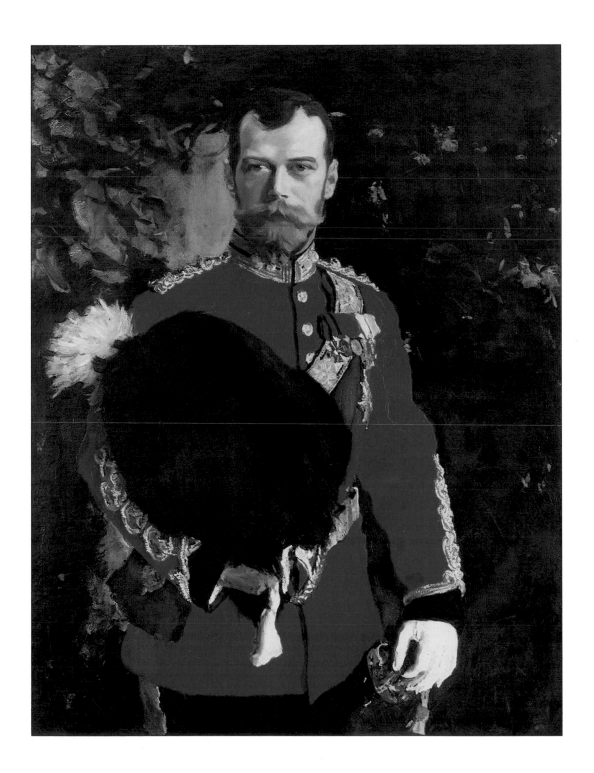

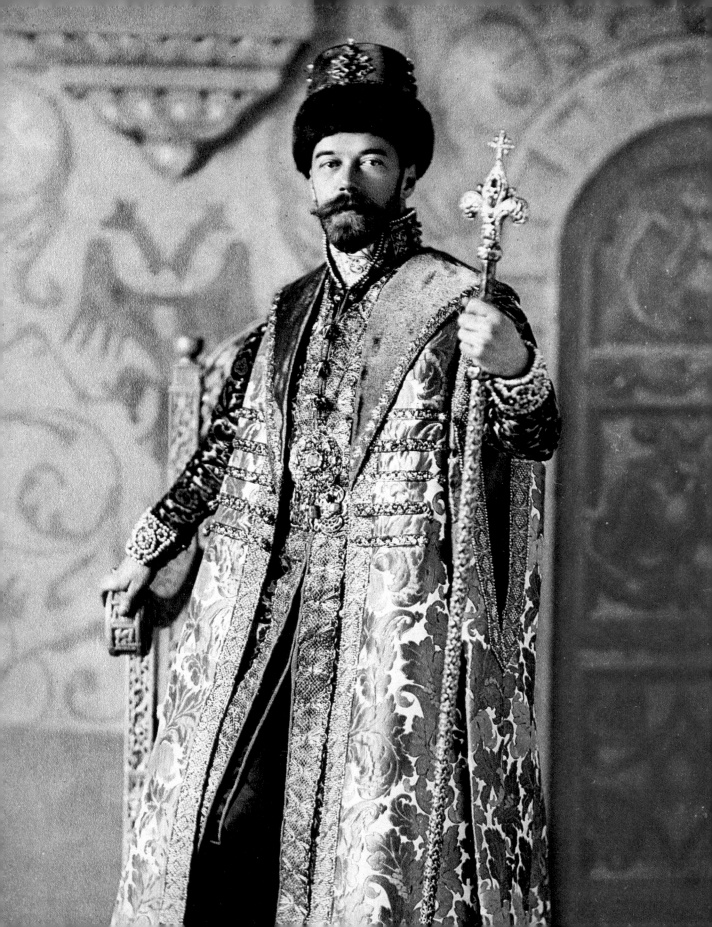

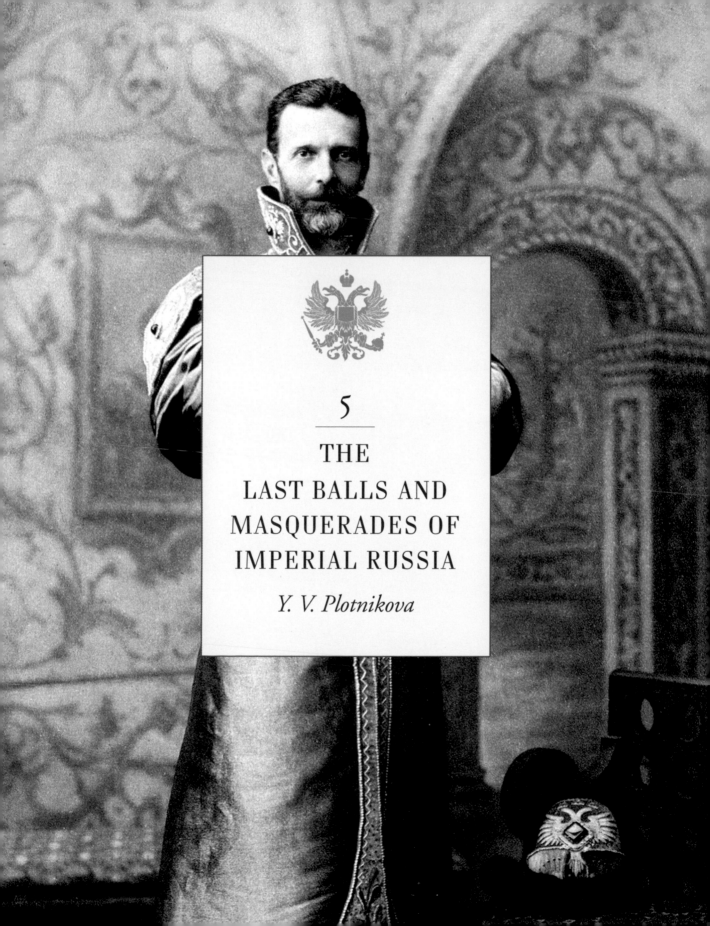

5

THE
LAST BALLS AND
MASQUERADES OF
IMPERIAL RUSSIA

Y. V. Plotnikova

Nicholas
and
Alexandra

82

PREVIOUS PAGES

Emperor Nicholas II (*left*)
in the costume of Tsar Alexei
Mikhailovich; and Grand Duke Sergei
Alexandrovich in the costume of a
17th-century prince

Photo-engravings from the 'Album
of the Costume Ball held in the
Winter Palace in February 1903'

CATALOGUE NOS. FII a AND FII e

BELOW AND OPPOSITE

Crown from the masquerade costume
of Alexandra Feodorovna, as
17th-century Russian Tsarina
Maria Ilinichna, wife of
Tsar Alexei Mikhailovich

CATALOGUE NOS. FOI AND FII b

'IN THE OPULENCE OF THE UNIFORMS, THE EXTRAVAGANCE
*of the dress of the ladies, the richness of the liveries, the sumptuousness of
the costumes, the entire display of splendour and power, this spectacle
is so magnificent, no court in the world can vie with it*'

MAURICE PALÉOLOGUE

Lieutenant-General A. A. Mosolov, former head of the office of the
Ministry of the Imperial Court, said in his memoirs: 'Whenever I watch
Hollywood pictures supposedly showing the magnificence of the
Russian court, I want to laugh …'.[1] Indeed no movie – foreign or Russian
– could ever capture the splendour of the gala receptions, balls and
masquerades in Russia in the late nineteenth and early twentieth centuries.
From as far back as the time of Catherine the Great, foreign visitors to St
Petersburg had been astonished by the luxury of the Eastern-style receptions
and balls of high society. There was no trace of so-called 'Asian barbarity', and
any European royal court could only envy the taste of the Russian aristo-
crats in decoration and dress.

The French ambassador, Maurice Paléologue, wrote:

*In the opulence of the uniforms, the extravagance of the dress of the ladies,
the richness of the liveries, the sumptuousness of the costumes, the entire
display of splendour and power, this spectacle is so magnificent, no court
in the world can vie with it. I will long remember the dazzling brilliance
of the jewels strewn over the ladies' shoulders. It was a fantastic river of
diamonds, pearls, rubies, sapphires, emeralds, topazes, beryls: a river of
light and fire.[2]*

This splendour was designed to demonstrate the affluence and power of the
Russian empire, because 'the ruler of a sixth of the globe had no choice but
to receive his guests in an atmosphere of lavish luxury'.[3]

In Russia the winter 'Season', when balls and masquerades were
normally held, started after the Christmas festivities. They then
continued from the middle of January until the beginning of March,
the start of the Lenten fast.

The first royal ball was given in St Petersburg in the main Imperial

residency, the Winter Palace. Three thousand guests were invited. The ball was held in the largest hall in the palace – the Nikolaevsky or Nicholas Hall – and, strictly speaking, was the only one held there in the year. Other royal balls were held in the Concert and Hermitage (or Pavilion) halls. Fewer guests attended these occasions, which were named after their respective venues.

Tickets for the Nikolaevsky ball were sent out two weeks in advance. The right to attend the ball was granted to the highest military and secular dignitaries of the Russian empire (individuals who held the rank of general or above), their wives and daughters. In addition the field-officers of the Guards regiments, with their wives and daughters, were invited. Any shortage of dancing partners was solved by inviting young Guards officers, and an order would be dispatched to a relevant regiment to delegate a certain number of officers to the ball. The chief colonel considered this a tour of duty, and part of his regiment's responsibilities.

The chief director of the ball separated the hall into four areas and explained to his four assistants, also officers of the Guards, the course of every dance before the beginning of the ball. The officers were required to dance with the ladies and engage them in conversation; and it was strictly forbidden for the officers to congregate in a group in one place.

Guests arrived at the ball at exactly half-past eight. Sleighs approached the four front entrances of the Winter Palace according to the rank of the guests: grand dukes, dukes, courtiers, and then secular and military dignitaries.

It was a faerie sight. January. Severe frost. All three wings of the palace overflowed with light. There were bonfires next to the monolithic pillar with an angel on the top. Carriages arrived one after another. Ladies' silhouettes slid nervously from carriages to an entrance Furs – ermine, black and brown fox Heads were not covered, because married women came in diadems, and young ladies with flowers in [their] hair.[4]

Inside, the guests left their coats and jackets, complete with attached visiting cards, to the footmen and made their way up the stairs, which were covered with soft carpets. Court footmen stood at the sides, wearing red tailcoats embroidered with gold. In the corners there were hot scat-iron scoops on which perfume was poured at intervals, filling the air with fragrance.

The guests then proceeded towards the Nicholas Hall through the corridors and halls between lines of Cossacks and court 'Moors' (or 'Araps'

BELOW

Empress Alexandra
Feodorovna in the costume
of Tsarina Maria Ilinichna

CATALOGUE NO. FIIb

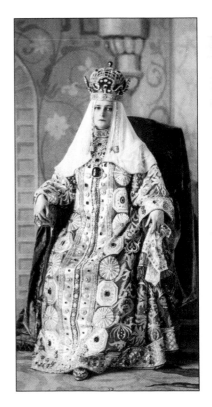

as they were commonly known). The presence of the latter was a tradition of the Russian Imperial court.

In the gallery parallel to the Nicholas Hall a large buffet was laid out with champagne, cranberry juice, almond drinks and fruit. (The Guard 'dancers' were not permitted to drink alcohol, so their breath would not smell of wine.) In large vases there were cookies and candies made in the royal confectionery in Tsarskoe Selo. As such treats were not sold in shops, guests often took them home as souvenirs.

Despite its great size the hall was usually overcrowded, so 'real aristocrats did not put on the latest models when they came to the Nikolaevsky ball: it was crowded, no place to turn properly – they would just crumple a dress from Wort or Redfern'.[5] 'Therefore, a very expensive new dress was normally a sign of a wealthy provincial who, in addition, was skulking in piers which separated the hall from the gallery.'[6]

Ladies who had been invited to the ball were instructed to wear 'Russian-style' court dresses, introduced by Tsar Nicholas I as early as 1834. The costumes consisted of a white satin *sarafan* (a type of long a-line jumper-style dress) embroidered with gold or silver on the front, and a bodice on top of the sarafan complete with long, loose sleeves and a long train. The Tsarina's dress was made of silver brocade or velvet of pale yellow colour, and was embroidered with gold and silver. The dresses of the maids of honour and ladies-in-waiting were made of scarlet, blue or green velvet and embroidered according to rank.

Ladies who had been invited to the court usually wore dresses of the same style, but in any colour. Maids of honour wore a diamond monogram of the Tsarina on the left side of a bodice, while ladies-in-waiting wore her portrait in a diamond mount. A *kokoshnik* (traditional head-dress) with a veil was also worn.

The description below illustrates the luxury of the Russian court dresses:

Princess A. V. Trubetskaya, the widow of the jagermeister, wore a magnificent train made of blue velvet and edged with sables; a white sarafan embroidered with pearls and gold; instead of buttons – precious stones. Her kokoshnik was covered with diamonds and sapphires. The young Princess Trubetskaya had a white satin sarafan embroidered with pearls, [and a] train of silver fabric decorated with bouquets of pink and tea roses. She wore the same kokoshnik with pearls. M. Plautina wore a train

of silver brocade edged with Venetian guipure [embroidered lace]. The sarafan buttons were made of silver of ancient minting. The kokoshnik was illuminated by a river of large diamonds. Princess Mescherskaya had a train made of damask of crème with gold colour. Her kokoshnik was golden with diamonds.[7]

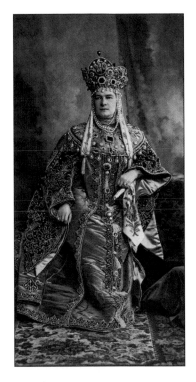

The spouse of the head of one of St Petersburg's districts, Madame Zinovieva, 'wore as buttons nine or ten emeralds, each of the size of a pigeon's egg'.[8]

Gentlemen invited ladies to dance in advance:

St Petersburg's high society was drowning under the flow of casual guests, ladies and young girls, admitted to the palace because of the position of their husbands or fathers or arrived from province for the season of the rich gentry: they were looking for eligible bachelors for their daughters. And you could hardly find a better market for marriageable girls than the court ball.[9]

The ball commenced when the master of ceremonies struck three times with his rod and the 'Moors' opened the doors from the Malachite to the Nicholas Hall. The proceedings usually started with a polonaise, a tradition established during the time of Catherine the Great. The Tsar and Tsarina always led this solemn promenade: the Tsar with the wife of the Dean (the head of the diplomatic corps) entered as the first pair; then the Tsarina together with the Dean. After them, the pairs that followed were made up in a similar manner – grand dukes with the wives of diplomats and grand duchesses with diplomats.

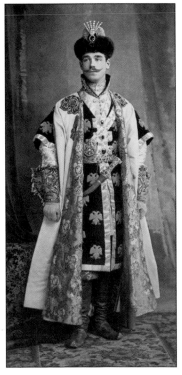

Contredanses, waltzes and mazurkas followed on from the polonaise. The waltz was opened by the best dancer of the Guards, with a partner agreed in advance. Grand duchesses were not to be invited to dance; instead they were allowed to choose their own partners. If the grand duchesses' chosen partners were already spoken for, the man was required to apologise and to dance with her Highness instead.

During the evening footmen offered the guests drinks and ice-cream. Immediately after the dancing, supper was served in the magnificently decorated rooms adjoining the Nicholas Hall. Huge palms, specially delivered from the St Petersburg Botanic and Tavricheskiy gardens, were arranged on the pavilions; and under the trees, tables had been set for

twelve pre-arranged guests. The dinner service on these tables was white and bore the Russian coat of arms; the silver and crystal was also decorated with pictures of the double-headed eagle. All the other guests had to content themselves with a buffet.

Tables for their Highnesses were served separately, on a specially raised platform. The dinner service and table decorations were even more splendid. Here the Tsarina, grand dukes and grand duchesses, members of the diplomatic corps, and the highest military and secular dignitaries, would sit. In keeping with tradition the Tsar did not remain with them, but socialised with the guests, occasionally taking a seat at their tables. For this reason every table was provided with an empty chair. While the Tsar spoke with the guests, his escort would discreetly step aside until the end of the conversation.

After supper the Tsar accompanied the Tsarina to the Nicholas Hall, where a cotillion was about to begin. After that their Highnesses left unnoticed for their apartments, which were next to the Malachite Hall. The ball, however, continued for some time after their departure.

Other events of the Season, the Concert and Hermitage balls, were held for seven hundred and two hundred guests respectively, and organised with less solemnity. Many palace halls would remain empty:

> *You could take a hand of your lady partner and walk with her through an endless succession of palace rooms. Suddenly you could find yourself far from dances, high society gossips and the sweltering heat of the ball. Scarcely illuminated, these halls appeared to be more intimate and snug You could walk like this for half an hour. It was a strange and scary fairytale come true.*[10]

The last royal court ball was held in 1904. After the Russo-Japanese war of 1904-5, and the first Russian revolution of 1905, there were to be no more festivities of this kind in the Winter Palace.

The celebration of the three-hundredth anniversary of the house of Romanov in 1913 was to be the only exception, although it did not take place in an Imperial residence. On 23 February of that year a ball was held in the Noble Assembly in St Petersburg. It was 'beautiful and very lively, but less splendid than the nobility ball given in Moscow the same spring'.[11]

This ball began with the usual polonaise, opened by the Tsar dancing with the wife of the head of the St Petersburg nobility; while the Tsarina

danced with the head himself. The Grand Duchess Olga Nikolaevna danced in the first pair of the waltz.

There was a mood about that evening that was impossible to ignore – and even members of the ruling dynasty noticed:

> *The anniversary of the Romanov's house was celebrated without enthusiasm ... there was a sense of the revolution in the air. Of course, in the theatre the invited public shouted 'hurray', the orchestra played 'God Save our Tsar',[12] but there was no atmosphere. Everything was so official; there was no feeling that the whole of Russia with one accord was celebrating the anniversary of its dynasty.[13]*

The brightness of the ball given by Moscow's nobility in the Grand Assembly in the spring of 1913 overshadowed the St Petersburg festivities of February that year. The main hall at the Moscow ball was drowned in tropical plants and flowers. The structure and ceremony of this ball remained the same as St Petersburg's, however, for after the polonaise 'the Grand Duke Dmitry Pavlovich danced the Boston waltz ... with his sister Maria Pavlovna. He was very handsome and elegant in a red uniform of the Horse Guards decorated with a blue St Andrew's ribbon; Maria Pavlovna in a white dress with diamonds and a diamond diadem in the form of rays of light.'[14]

The court of Nicholas II also hosted masquerades and fancy dress balls. One such fancy dress ball in the Winter Palace in 1903 was to be hailed as the most magnificent and memorable of all. This ball was held at the request of the Alexandra Feodorovna and approved by the Tsar. As his cousin Grand Duke Alexander Mikhailovich noted, 'Nikki wanted to return into the lovely past of his people at least for a night'.[15]

Balls in the 'Russian style' came into vogue during the rule of Alexander III. The most famous event of that time was the fancy dress ball hosted by Grand Duke Vladimir Alexandrovich in his palace in 1883, and it is interesting to note that some participants at the 1903 occasion wore the same costumes, still in pristine condition after twenty years. There are numerous memoirs from contemporaries, as well as an album which contains photographs of all the 1903 participants. Their solemn march through the halls was also filmed, but sadly the film was not preserved.

Invitations to the 1903 ball were sent out at the beginning of January to four hundred and sixteen people from the grand-ducal families and the

OPPOSITE

Grand Duke Sergei
Alexandrovich in the
costume of a 17th-century prince

CATALOGUE NO. FIIe

OVERLEAF

The grand ball in the
Assembly Hall of the Nobility,
St Petersburg, 23 February 1913,
held to celebrate the
three hundredth anniversary
of the house of Romanov.

Dimitry Nikolaevich Kardovsky
(1866-1943)

CATALOGUE NO. HOI

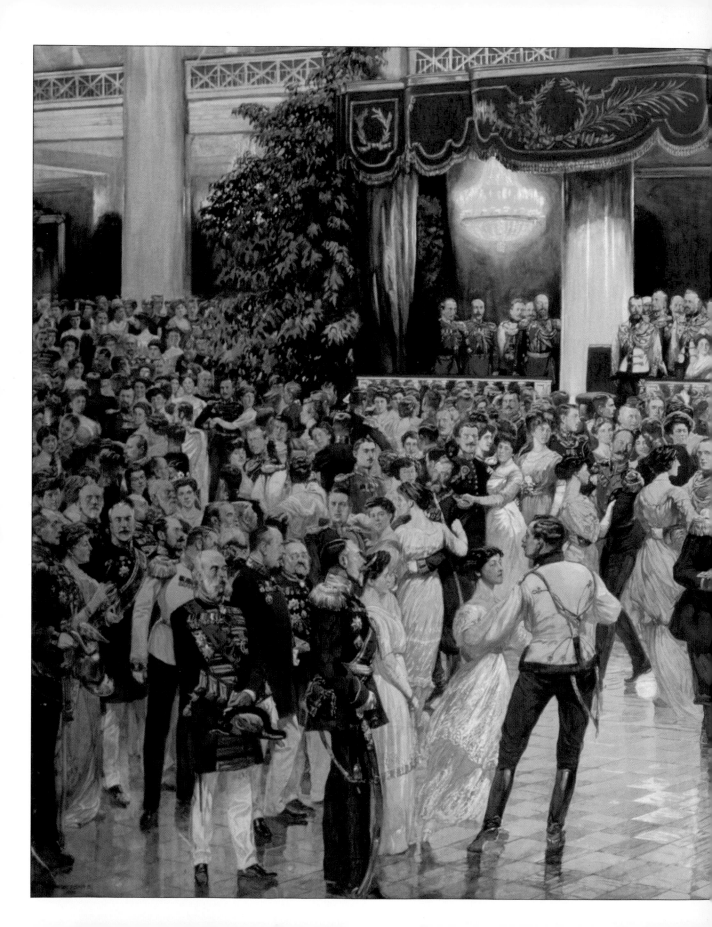

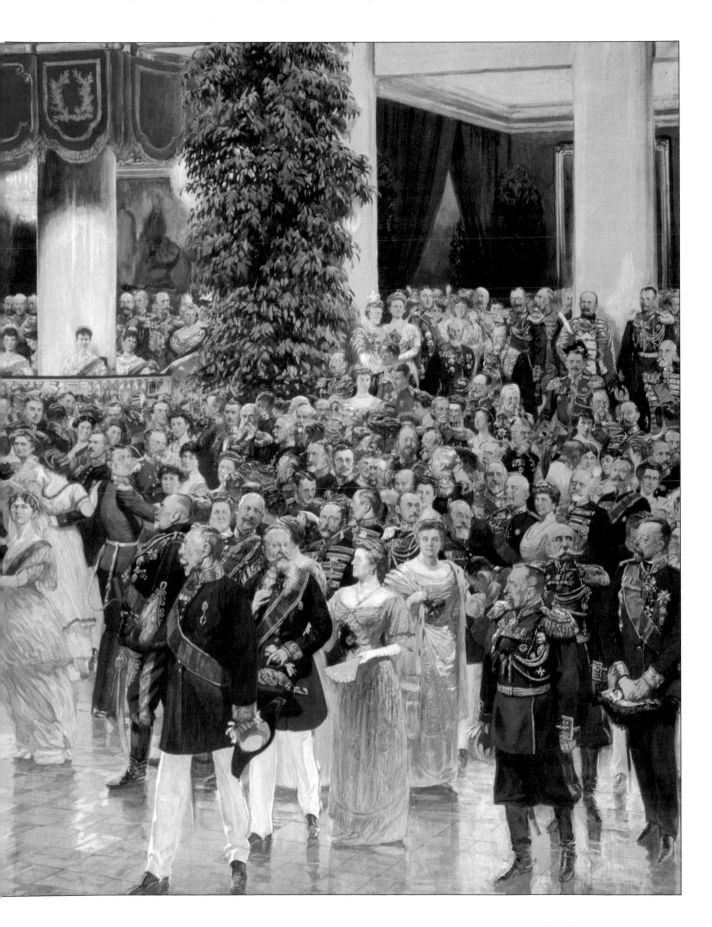

highest aristocracy. All participants were instructed to dress in costumes dating from the period of Tsar Alexei Mikhailovich (father of Tsar Peter I). Preparations for the festivities then took on a certain urgency, as 'those who were invited looked for family portraits, started visiting art galleries and examined old engravings. Historical works were studied diligently' as guests searched for inspiration.[16]

From the very beginning it was clear that such a ball would be expensive for participants and many declined the invitation. But some of those who accepted sought assistance from the director of the Tsar's Hermitage, I A Vsevolozhskiy, who had been director of the Royal Theatres for eighteen years and had designed more than a thousand theatre costumes.

The design of the Tsarina's dress was taken from an icon of the Moscow Kremlin church, on which the first spouse of the Tsar Alexei Mikhailovich, Maria Illyinichna, was portrayed. Precious stones on the dress and the crown were placed according to the design of artists from the Fabergé company. The head of the company personally selected precious stones from the Diamond Room of the Winter Palace, where the best gems and jewellery were kept.

Looking at the Tsar's brocade costume, which is preserved to this day, one can imagine that at the 1903 ball the upper part of his chest would have been covered with a *barmy* (a kind of a wide turndown collar) embroidered with emeralds and diamonds and edged with a fringe of pearls and emeralds. The crown was decorated with diamonds, emeralds and pearls, while the strings coming from the crown were braided with pearls and diamonds.

The most amazing decoration of all, however, was a huge emerald, the size of the palm of a hand, which was fastened to the front of the Tsarina's dress. Today this and some of the other magnificent costumes can be seen in photographs from an album published in memory of the ball. (The Tsarina's dress has recently been conserved and will feature in this exhibition.)

Nicholas's costume was based on a stylised ceremonial dress worn by Tsar Alexei Mikhailovich (kept in the Armoury Chamber of the Moscow Kremlin). It consisted of two kaftans made of figured velvet and satin, edged with golden lace and pearls. A brocade belt and a hat were decorated with precious stones, including large emeralds. During the ball Nicholas carried the original sceptre of Alexei Mikhailovich (also from the Armoury Chamber).

Some of the costumes for the grand dukes and duchesses were ordered from the most famous theatre artists or the best tailors in St Petersburg

OPPOSITE

Masquerade costume of
Grand Duchess Maria Georgievna
as a 17th-century peasant woman
from the town of Torzhok

CATALOGUE NO. F04

and Moscow; the majority of the fancy dress costumes, however, were made in the workshops of St Petersburg's Imperial theatres.

The festivities took place on 11 February. Guests started to arrive at the Winter Palace at half-past eight and gathered in the Pavilion Hall of the Small Hermitage. When Nicholas and Alexandra entered from the apartments adjoining the gallery, it was noted that 'Alix looked fantastic, but the Emperor was not tall enough for his magnificent dress'.[17] The participants then proceeded, in pairs, to the Hermitage Theatre. The performance that night consisted of several scenes from Mussorgsky's opera 'Boris Godunov' (1868-74), based on Alexander Pushkin's original historical drama (1825). The legendary performer Feodor Shalyapin sang the aria of Tsar Boris. The second part of the performance consisted of several scenes from various ballets, one of which was performed by the famous ballerina Anna Pavlova.

After the performance the guests moved to the halls of the Imperial Hermitage where supper was served. After the meal the guests walked back to the Pavilion Hall, one wall of which led to a hanging winter garden which had on display numerous cages containing songbirds. Here, against the backdrop of the white marble and shining crystal chandeliers, around an hour after midnight, the ball itself was opened. It began with the Russian dance 'russkaya' performed by soloists Countess Tserkanau and the Lieutenant of the Life-Guards Ulan Regiment Kotsebu. Then there was a waltz, followed by a cotillion, which included a traditional Russian *khorovod* (round dance), with Princess Zinaida Nikolaevna Yusupova performing solo. Those present commented that she danced 'ideally'[18] – 'The Princess danced that dance better than any true ballerina.'[19]

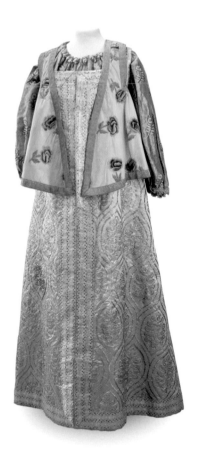

The Tsar's mother, the Dowager Empress Marie, and Nicholas's brother, Grand Duke Mikhail Alexandrovich, were not present at the ball because of ill-health and it was decided to repeat the event especially for them two days later – this time in the Concert Hall of the Winter Palace. In addition, members of the diplomatic corps were invited. The Dowager Empress had not ordered a special costume; she simply wore a loose violet gown embroidered with sables. However, it was generally agreed that Grand Duke Mikhail Alexandrovich's outfit was the most magnificent because his mother had provided her best diamonds for its decoration. Mikhail's cloak, edged with sables, was adorned with several rows of large pearls, and the hat bore a large brooch made of precious stones, with diamond rays.

Members of the Imperial family, dressed in their own costumes, opened

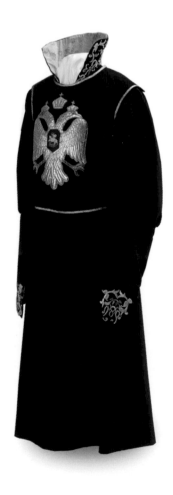

the procession at the second ball. In the hall, which was decorated with camellias in bloom, the dance started with the russkaya, followed by a waltz, quadrille and mazurka. Princess Yusupova again danced the russkaya in a khorovod style. The dances were composed by the chief director of the Imperial Ballet, and instead of a theatrical performance a choir sang Russian folk songs in the Nicholas Hall. This was followed by supper. After the meal the dances continued, and 'everyone danced quite a lot and was in high spirits'.[20] The ball finally came to an end at three o'clock in the morning.

Grand Duchess Xenia Alexandrovna wrote in her diary that one guest, Count A. D. Sheremetyev, had been 'so pleased with his costume that he danced … staying in the hall all the time!' Indeed he was so impressed that he decided to repeat the masquerade in his own palace the very next day, 14 February. All the participants of the first and second ball, including the members of the Imperial family, were invited to the Count's evening. This time half the guests, including the Imperial couple, wore ordinary ball costumes. Nicholas arrived in the ceremonial uniform of His Majesty's Escort. Alexandra wore a pink ballerina-style dress, decorated with lace and roses. Her head was crowned with a diadem complete with diamonds encircling large pale-pink rubies. A string of pearls, favoured by the Tsarina, together with a chain of rubies and diamonds, adorned her neck.

During the evening, choral music was performed by Sheremetyev's own orchestra. The dances began with a mazurka and, for the third time in four days, the russkaya was performed by the same soloists. The cotillion followed, during which ladies were presented with a mass of flowers – roses, lilies, lilacs, pinks and narcissi. The tables of the guests were covered with pinks; while the table of the Imperial couple was decorated with red double roses. After supper the dancing continued until after three o'clock in the morning.

Alongside the Imperial balls and masquerades, the St Petersburg and Moscow aristocracy held balls and masquerades during the winter high-society seasons. During the 1908 Season, for example, a magnificent ball was given in the palace of the Grand Duke Vladimir Alexandrovich and his spouse Grand Duchess Maria Pavlovna, one of the brightest and most fashionable high society ladies. In spite of her advancing years the Grand Duchess was dressed in a tight-fitting gown of white satin with a long train edged with silk muslin and lace, complete with a diadem and necklace of large diamonds.

Another ball that Season, organised by St Petersburg beauty Countess Pototskaya, attracted the attention of high society. The hostess of the ball was dressed in a beautiful pale-yellow satin dress edged with Venetian lace, and wore a necklace of emeralds and diamonds of such size that it covered nearly the whole *décolleté*; a diamond and emerald tiara crowned her head. The costume of the Countess Sophia Ferzen was also remarkable; it was made of scarlet satin with waves of scarlet veil and chiffon draped over the top, embroidered all over with shining spangles: 'The Countess's figure shone with thousands of flashes of light with every slightest move.'[21]

The so-called 'pink' and 'white' balls came into vogue among the aristocracy in 1910s. The former was mostly for young ladies; the latter for unmarried girls. A pink ball was held in 1913 by the commander of the Life-Guards Horse Regiment, General Skoropadskiy, at which more than two hundred people joined in the dancing. As usual, during the cotillion bouquets of many different flowers, from simple field flowers to roses, were distributed. The ball started quite late and supper was served at half-past two in the morning, but the dancing continued. The regiment's orchestra provided music during the ball, and the choir of the regiment's trumpeters entertained guests during supper.

The 1913 Season ended as usual with the so-called *folle journée* (literally meaning 'mad day'), given on the last day before Lent. This time a ball was held by the Countess Natalia Karlova, the morganatic spouse of Duke George Meklenburg-Strelitski, in her palace in Oranienbaum. The hostess spared no expense for the event. Two trains were specially ordered: one brought guests to Oranienbaum where cars and coaches were waiting to take them to the palace; another, a night train, took guests back to St Petersburg. In the palace the atmosphere of a southern summer was created: the stairs and front rooms were filled with tropical plants and flowers. During the mazurka more bouquets were distributed; and the tables set for supper were also swathed in flowers. Members of St Petersburg's high society were in attendance as usual, and officers of the Guards regiments were invited as dancers.

It could be said that the last true Season of Imperial Russia's high society was held over the winter of 1914. Perhaps people could feel the end was drawing near; the newspapers commented that no member of high society could remember such a bright, but short, Season. It came to an end on 16 February – but while it lasted there were several balls held every night.

OPPOSITE

Masquerade costume of
Adjutant-General
Prince D. B. Goltsyn
as a 17th-century Lord Falconer

CATALOGUE NO. FO3

In St Petersburg the most remarkable event of the 1914 Season was a ball given by Countess Maria Kleinmichel. It was announced well in advance so that guests could prepare their masquerade costumes properly. The hostess originally planned to bring a group of *malorosses* (as the people of present-day Ukraine were known) from Poltava with *banduras* (traditional stringed musical instruments) to sing songs at the beginning. However, during the preparations this idea was changed and the guests were requested to wear Eastern costume. The best dressed on the night was the Grand Duke Boris Vladimirovich who came as the Persian shah, wearing a brocade kaftan edged with sables and a brocade skirt embroidered with precious stones, with a genuine Eastern sword at his side. The costume of one of the most fashionable Russian aristocrats, Countess Olga Orlova, was designed by the famous Russian artist-decorator Leo Bakst. The same artist's drawings were used for the magnificent costume of Helen Oleev, consisting of a blue wig with feathers, green gloves, and a dress made of velvet and silk in black and green, embroidered with silver, sapphires and diamonds.

In Moscow the traditional ball was given in the Noble Assembly where, as at the celebration of the three hundredth anniversary of the house of Romanov, the attire of the wife of the head of the Moscow nobility, Madame Basilevskaya, was deemed especially remarkable. Her stunning emerald necklace attracted the attention of all those present, and guests of both balls commented on it in their memoirs.

During the 1914 Season it was fashionable to hold a 'ball of the coloured wigs'. The most famous of these was given by Countess Elizaveta Shuvalova. All women guests were required to wear coloured wigs. The hostess herself was dressed in a gown of white and gold, with a green wig twisted with pearls. Countess Golenischeva-Kutuzova wore a white dress and an orange wig. Countess Orlova came in a white dress and a golden wig with coloured feathers. Madame Delphen sported a red dress and a red wig with black feathers. Countess Kochubei had a golden hairstyle, while her daughters favoured silver. Countess Tolstaya wore a white dress with a green wig decorated with emeralds. Baroness Meyendorf arrived in a blue dress with a blue wig; while Countess Kudasheva wore a cyclamen one. During the cotillion many flowers – roses, pinks and pink orchids – were distributed. Supper was served in a hall that was decorated with an enormous amount of flowers of different colours to emphasise the brightness of the ladies' dresses.

In that last Season such novelties as a 'dance of wild men' and the tango

OPPOSITE

Masquerade costume of
Princess E. V. Goltsyna
as a 17th-century boyar

CATALOGUE NO. F05

were in vogue. At the ball-cabaret hosted by Madame Kozlovskaya it was said that 'rarely have people of St Petersburg ever danced as wholeheartedly and infectiously as on this evening'.[22]

After the beginning of the First World War the high-society seasons of 1915 and 1917 were quite modest – it was considered bad form among the aristocracy to enjoy yourself and to dance (such entertainments became the fate of the *demi-monde*). Only weddings were really celebrated; with brides often seeing their officer husbands leave for war only days after the marriage. The 1917 Season, interrupted by the February revolution, followed by Tsar Nicholas II's abdication from the throne, was high society's last in Imperial Russia. Having just celebrated its three-hundredth anniversary the Romanov dynasty was cast from the throne, and with it a glorious chapter in Russian history was gone.

1 A. A. Mosolov: *In the Court of the Last Emperor* (St Petersburg: Nauka, 1992), p. 198.
2 M. Paléologue: *Tsar's Russia on the Eve of the Revolution* (Moscow: 1991), p. 146.
3 Grand Duke Alexander Mikhailovich: *Book of Memoirs* (Moscow: Sovremennik, 1991), p. 135.
4 See Mosolov, p. 197.
5 Ibid., p. 196.
6 Count Aleksey Ignatiev: *Fifty Years in the Ranks. Memoirs* (Zakharov: Moscow, 2002), p. 115.
7 *Damskiy Mir* (1913), 4, p. 27.
8 See Mosolov. p. 194.
9 See Ignatiev, p. 115.
10 See Mosolov, p. 201.
11 Grand Duke Gavril Konstantinovich: *In the Marble Palace. Chronicles of our family* (St Petersburg: Logos-Düsseldorf Goluboy Vsadnik, 1993), p. 122.
12 Russian hymns in pre-revolution Russia began with the words, 'God, Save our Tsar'.
13 See Gavril Konstantinovich, p. 122.
14 Ibid., p. 124.
15 See Alexander Mikhailovich, p. 174.
16 Cit.: *Costume Ball in the Winter Palace. In two volumes. Research, documents, materials* (Moscow: Publishing House Russkiy Antikvariat, 2003), V. II, p. 24.
17 See Alexander Mikhailovich, p. 174.
18 Cit.: *Costume Ball in the Winter Palace*, p. 59.
19 See Alexander Mikhailovich, p. 174.
20 Cit.: *Costume Ball in the Winter Palace*, p. 59.
21 *Damskiy Mir* (1908), 1, p. 5.
22 *Damskiy Mir* (1914), 2, p. 39.

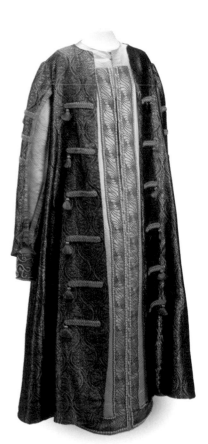

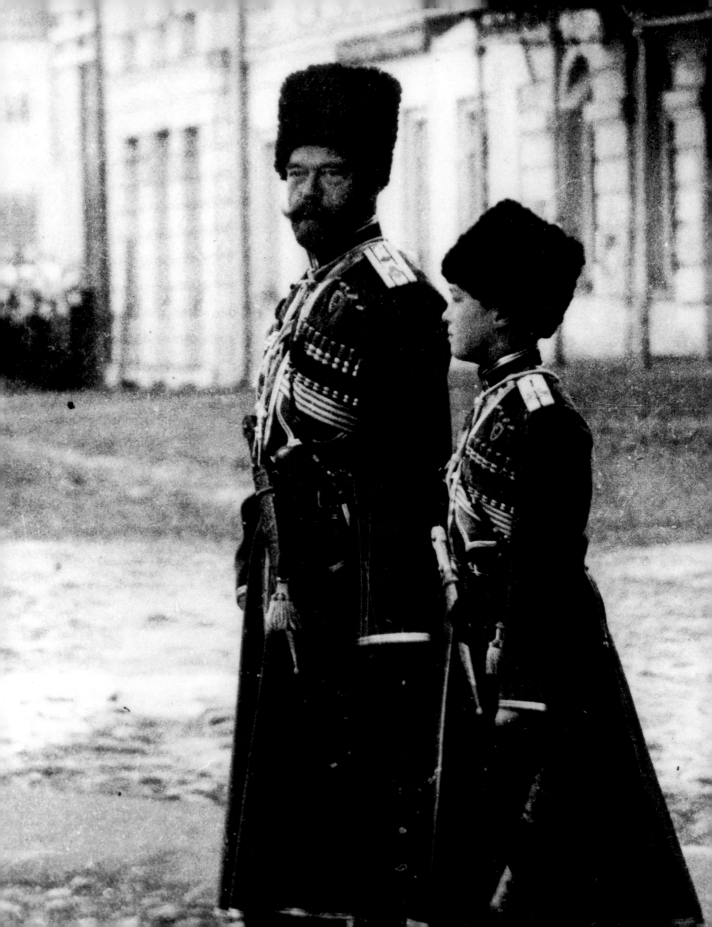

6

TSAREVICH ALEXEI: THE HEIR TO THE THRONE

Augusta Pobedinskaya

'WHEN HE GOT THE CHANCE HE ENJOYED LIFE LIKE ANY *other happy active boy. When he was in good health, it was as if the palace was reborn; he was like a ray of sunshine lighting up everything and everyone.'*

PIERRE GILLIARD

In July 1904 a great event occurred in the family of the Tsar: the birth of their long-awaited son, the successor to the Russian throne. The public was informed of the joyful news by a 301-gun salute from the cannons of the Peter and Paul Fortress. The birth day of the new heir was a great festival not just for the Tsar and his family, but for the whole population. People went out onto the streets, prayers of thanksgiving were offered in the churches, bells rang out, and at night the city was illuminated by bonfires.

Traditionally the succession in Russia was based on the male line, but this was broken by Peter the Great who published a *ukase* or edict that an heir was to be appointed only by the Tsar. After Peter's death this led to a series of palace coups, resulting in the accession of Catherine I (1725-27), Anna Ioannovna (1730-40), Elizaveta Petrovna (1741-61) and Catherine the Great (1762-96). Finally, in 1797, Tsar Paul I issued a new declaration on the question, stating that the succession was to be based on seniority and again only via the male line. After that the law was never breached.

Nicholas II was the father of four daughters in a row: Olga, Tatiana, Maria and Anastasia. As long as no male child was born, Nicholas's younger brother Mikhail Alexandrovich was deemed the official heir. For this reason the birth of a son, his fifth child, was an event of exceptional importance for Nicholas and his wife. In his diary entry for 30 July he wrote:

An unforgettable and great day, on which we received so evident a sign of God's love. At a quarter past one in the afternoon Alix had a son, who was named Alexei during prayers. Everything proceeded at a remarkable pace. As always I was with Mamma in the morning ... then I joined Alix to eat Half an hour

later the happy event took place. No words are adequate to thank God for the consolation he has bestowed on us in this year of difficult tribulations

The name of the heir to the throne was not chosen by chance. It was that of one of the first members of the Romanov dynasty, Tsar Alexei Mikhailovich (1645-76), later known as 'the unifier of Russia'. Nicholas told an acquaintance, 'The Tsarina and I have decided to call the heir Alexei; it's time we broke with the series of Alexanders and Nicholases'.

The happiness of Nicholas and Alexandra knew no bounds. The boy was healthy and a delight and soon became the family's darling. 'He is an amazingly calm baby, he almost never cries,' the happy father recorded in his diary. Although a wet nurse was hired, his mother never left her son's side, and the Tsarina's close friend Anna Vyrubova described little Alexei Nikolaevich thus: 'I saw the Tsarevich in the Tsarina's arms. How beautiful and contented he was. With his golden locks, blue eyes and a wise expression on his face that was unusual for a child of his age.'

Alexei's christening was celebrated in Peterhof, one of the official Imperial residences where the family stayed regularly and where Alexei was born. According to the tradition of the Orthodox Church his parents were not present. The most important godfather was the Tsar's uncle, Alexei Alexandrovich, while Dowager Empress Marie Feodorovna was the main godmother. After the ritual the Tsar presented his tiny son with the highest Russian order, the gold chain of Saint Andrew. The population of St Petersburg heard the news of the christening via a twenty-one-gun salute from the fortress of Peter and Paul; those in Moscow from the Spasskaya Tower of the Kremlin. After the christening the diplomats who came to congratulate the family were invited to breakfast. A manifesto was also issued on the occasion, offering favours to the Tsar's subjects: amnesties or shorter sentences for prisoners, the abolition of corporal punishments, aid to orphans, and the like.

But the family's happiness was to be short-lived. Less than a month later the delightful boy baby, whom everyone had welcomed with such joy, was to become the source of anguish and bitter disappointment. Little Alexei's navel suddenly started to bleed and it was beyond the power of the eminent doctors who had been called in to stop it. Indeed not until the second day did they manage to staunch the flow. From that moment on the health of

PREVIOUS PAGES

Tsar Nicholas II and Tsarevich Alexei in Cossack uniform, 1916

Unknown photographer

(The Royal Collection © Her Majesty Queen Elizabeth II)

OPPOSITE

White plush bear, played with by Nicholas II's children

(early 1900s)

CATALOGUE NO. G21

the heir to the throne was the foremost concern for Nicholas and Alexandra, both as parents and heads of state. The family's anxiety was made greater still by the fact that haemophilia, as it was diagnosed, was hereditary in the dynasty of Hesse-Darmstadt, Alexandra's family. The disease was incurable and other members of the family had suffered from it. Queen Victoria had passed it to her daughters Beatrice and Alice (Alexandra's mother). Frederick, who was Alice's son and Alexandra's brother, had died of it at the age of three.

The strictest measures were taken to deal with Alexei's illness, to ensure his health. The nature of his illness was kept secret, and even withheld from the inner circle of the court. A short while after Alexei's birth the Tsar and his family moved from Peterhof to the Alexander Palace in Tsarskoe Selo. There they were able to lead a fairly peaceful and secluded life, especially as Alexandra did not particularly care for the official receptions in the Winter Palace.

Nicholas was proud of his son and showed him to everyone who visited Tsarskoe Selo. In his diary for 4 August 1904 he wrote, 'It was a very busy morning. The commandants of the Guards units arrived first thing, twelve of them, to thank me for having little Alexei enlisted in their ranks.' The tradition of members of the Tsar's family being, as it were, 'adopted' by heads of Guard divisions, had a long history in tsarist Russia. For an heir to the throne to be made commander of a regiment was considered an exceptional honour. Only a few days after the birth of the Tsarevich, the *hetman* or commander of the Astrakhan Regiment of the Cossacks received a telegram from the Tsar:

> *It is with great joy that I instruct you to inform the Cossacks of the Astrakhan unit that the Heir to the Throne Tsarevich Alexei Nikolaevich is appointed hetman of all the Cossack regiments. Nicholas.*

When the heir to the throne was a little older, he began to be introduced to the regiments that he was to command. In this context it is worth quoting the reminiscences of General Krasnov, who was present when the Tsarevich was presented in person by the Tsar to the Astrakhan Regiment: 'His Highness took his successor by the hand and went slowly with him past the front line of the Cossacks ... And when his Highness walked on ... the Cossacks wept and waved their swords in their rough calloused hands.'

When the Tsarevich was just over a year and a half old, he was introduced to the Finnish Regiment. Nicholas's diary entry for 12 December 1905 reads:

At half-past ten a church parade was held in the Exerzierhaus: for the first company of the Page Corps, the Finnish Regiment and the platoon of the Volyn Regiment. Alexei was present and he conducted himself well. After the clergy had sprinkled the troops with holy water I took him in my arms and carried him along the front rank. The first time that the Finns and their commander saw each other.

The occasion was depicted by the artist Boris Kustodiev in a painting of 1906 entitled *The Solemn Parade of the Guard of the Finnish Regiment*. The Tsarevich was, of course, too young to understand anything of the significance of the introduction.

Pierre Gilliard, who later became Alexei's tutor (but was then French teacher to the Tsar's daughters), describes his first meeting with the boy:

In February 1906 I met the heir to the throne for the first time; he was one and a half years old …. I had just finished giving Olga Nikolaevna her lesson, when the Tsarina came in with him in her arms. She came to meet us with the visible intention of showing us her son, whom I hadn't seen before. His mother's joy that her deepest wish had finally been granted was boundless. You felt that she was quite radiant with happiness and pride about her beautiful child. And the heir really was the most charming child you could imagine, with lovely blond curls, large pale blue eyes and long arched eyebrows! His complexion was that of a healthy boy, fresh and ruddy, and you could see how his rounded cheeks were covered with dimples when he smiled. When I approached him, he gave me [a] solemn frightened look and only stretched out his chubby little arm toward me with some reluctance.

The Tsar soon started taking his son to inspections and manoeuvres of Army units to show him the role and power of an army in the survival of a state. Many regiments and private individuals gave the little boy presents. A delegation of Siberian Cossacks, for example, brought him a miniature Cossack battle outfit, with rifle, sword, lance and cartridge box. Workers from the Perm metal forging factories made a model of a cannon. Other sorts of present were also made for him. From one of the factories in the Ural region he was given a collection of miniature farm tools; while the pupils of the trade school in Odessa presented him with a set of fitters' tools. One of

OPPOSITE

Alexei with Andrei Derevenko
on board the Imperial yacht *Standart*
at Reval, June 1908

Queen Alexandra

(The Royal Collection
© Her Majesty Queen Elizabeth II)

BELOW, LEFT AND RIGHT

Alexei with his father

(Beinecke Rare Book and Manuscript
Library, Yale University)

the most original presents he received – a working model of a printing press – was given to him by the inmates of a Russian jail; and one of his most remarkable possessions was an electric train set from the President of France.

When he was a little older, the retired boatswain of the Imperial yacht *Standart*, Andrei Derevenko, accompanied the boy everywhere. Except for his sisters, Alexei had no children of his own age to play with. Derevenko's two sons and the son of the doctor, Botkin, were allowed to play with him. In general only a limited circle of people had access to the Tsar's family, and the only place in Tsarskoe Selo where the family could feel free to go for a walk was in the royal park.

Alexei grew up to be a lively, energetic and even naughty young boy, and the adults of the family had to keep an eye on him all the time. They did everything they could to protect him against any possible physical traumas. Despite this, Alexei loved working with his father in the park. They sawed down old trees and planted new ones, swept the snow away in the winter and built snowmen. In the summer time the family went to the Crimea in the deep south of the country. There they went for long walks along the coast or in the mountains, or sailed a boat or yacht.

Despite every precaution, however, it simply was not possible to protect the Tsarevich from minor accidents. In his reminiscences Vladimir Voyeikov wrote:

When he was three, Tsarevich Alexei suffered a cut when he was playing in the park and he started bleeding. The family's principal surgeon was summoned at once, and he applied every known method to staunch the blood, but to no avail. The Tsarina fainted …. His Majesty aged ten years in a single night.

The suffering of the little boy and his parents knew no bounds. Olga Alexandrovna, Nicholas II's sister, also wrote about the incident:

The poor little boy lay there in excruciating pain, with black rings under his eyes, contorted with suffering and with a dreadfully swollen leg. There was simply nothing the doctors could do to help. They looked even more frightened than we did …. Hours passed, and they gave up hope. Then Aliki sent someone to St Petersburg to get [Grigory] Rasputin to come. He arrived in the palace around midnight or later still …. In the morning Aliki called me to come to Alexei's bedroom. I just couldn't believe my eyes. Not only was the boy alive; he was in good health.

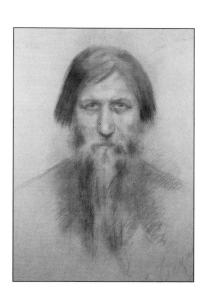

This was not the only time, when the doctors' efforts and conventional medicine had failed, that Alexandra Feodorovna sought help from people with paranormal gifts, quack doctors, 'wise old men' and the like. Grigory Rasputin was one such individual.

The first time Rasputin's name was mentioned as having been at the court of the Tsar was back in 1905. 'We had the good fortune,' Nicholas had noted in his diary, 'to meet the man of God Grigory from the province of Tobolsk.' However it was in 1907 that Rasputin was recommended to the Tsarina for the first time. He arrived late in the evening, witnessed how the boy and his mother were suffering, and remained seated by Alexei's bed saying prayers. In the morning the child had recovered. From then on the family began to believe in the miraculous power of the staretz and appealed to him for help on many occasions.

Having been a popular figure with some members of society, Rasputin's reputation was by then fading. But despite Russian society's growing dislike

of the 'holy man', the Tsarina 'accepted him unconditionally' – for her it was enough that he knew how to relieve her son's suffering.

The French ambassador, Maurice Paléologue, provides this rather astute insight into the character of the man: 'His gaze was both fierce and endearing, naive and cunning, distant and severe. During a serious discussion it was as though his pupils radiated magnetic waves.'

The most serious episode of Alexei's illness took place in the Belovezhski Forest (now on the border of White Russia and Poland) in 1912. This great expanse of forest was one of the Tsar's favourite hunting grounds and he often went there with his entourage. The woods were famous for their wealth of game such as roe deer, bison and aurochs. The boatswain Derevenko describes in his diaries the visit of the Tsarevich, whom Nicholas had brought with him. According to him, they 'sailed in rowing boats, they went into the forest in motor boats and saw twenty aurochs and a wild boar, they looked for mushrooms, built a campfire in the garden, cooked the mushrooms'.

On 6 and 7 September the tone takes on a different character: 'In the morning we stayed home, his leg was hurting and a compress was put on it, we played cards.' And the next day: 'The heir to the throne is still not well. We didn't go out for a walk, we played draughts and did some drawing.'

This new bout of the Tsarevich's illness began when, without thinking, Alexei jumped from a boat and bumped his leg. The internal bleeding was impossible to stop and his condition grew steadily worse. Once again the most eminent doctors were summoned – the paediatricians Ostrogorsky and Raukhfus and the surgeon Sergei Feodorov. But they were powerless to do anything. The bleeding in Alexei's groin caused him unbearable pain, his temperature rose to forty degrees centigrade, and from time to time he lost consciousness. His condition was so bad that everyone prepared for the worst. Alexandra did not leave her son's side for a minute. Finally, in a state of total desperation, she ordered Anna Vyrubova to send a telegram to Rasputin, who at that time was in his homeland in Siberia. Next day they received his answer: 'God has seen your tears and heard your prayers. Don't be sad, the little boy is not going to die. Don't let the doctors bother him.'

The following day the bleeding stopped and the Tsarevich was able to sleep again. Vyrubova wrote, 'The boy lay there exhausted, completely worn out by the sickness, but he was alive'.

Only after Alexei had recovered slightly did Nicholas write to his mother to tell her about the incident.

OPPOSITE

Grigory Efimovich Rasputin
(dated 1914)

Elena Nikandrovna Klokacheva
(1871-after 1915)

CATALOGUE NO. 108

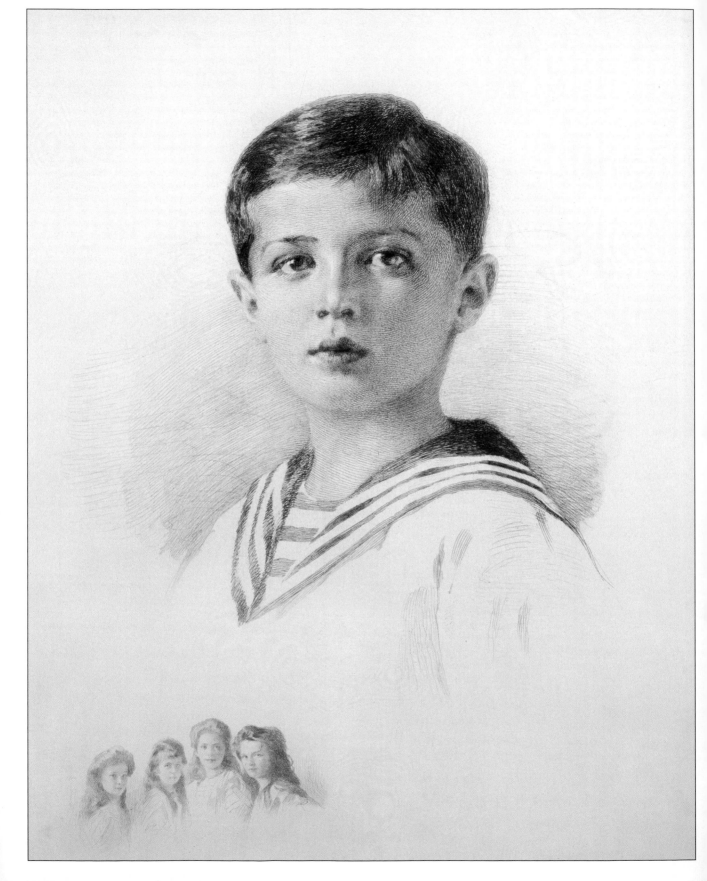

*The days from 6 to 10 October were the worst. The unhappy little fellow
suffered agonies. The pains produced spasms that recurred every quarter
of an hour. He was delirious …. He could hardly sleep, or even cry; all
he could do was groan and say, 'Lord have mercy on me'.*

Pierre Gilliard, who kept his own diary, wrote of the boy's frequent bouts
of sickness. It goes without saying that the fact he was often ill prevented
Alexei from studying seriously. It was not until 1913 that his education was at
all systematic. His oldest teacher was Piotr Petrov, who taught him Russian,
while Sidney Gibbs was his English tutor, and Pierre Gilliard taught him
French. Alexandra herself took on the task of instilling in him the principles
of statecraft and the Ten Commandments, and she often attended other
lessons. In the Alexander Palace at Tsarskoe Selo, where the family lived a
great deal of the year, Alexei had two rooms – a bedroom, and a classroom
where he had his lessons. As Gilliard commented: 'With his great mental
agility he would have been able to develop normally if his sickness hadn't
prevented him. It meant that interruptions had to be allowed for, which
made his education an extremely hard task, despite his natural abilities.'

Everyone who met the Tsar's family over the years spoke of the charm
and wisdom of the Tsarevich. One of Nicholas's equerries, who had observed
Alexei at different periods and in different situations, wrote afterwards:

OPPOSITE

Portrait of
Tsarevich Alexei Nikolaevich
with sketches of his sisters,
Grand Duchesses Olga, Tatiana,
Maria and Anastasia
(dated 1911)

Mikhail Viktorovich Rundaltsov
(1871-1935)

CATALOGUE NO. G18

ABOVE

Tsarevich Alexei
with Pierre Gilliard

London Illustrated News
1917

(NMS Library)

It was infinitely sad to see a boy who was attractive in every respect and who was remarkable for his great talents, enormous memory, physical beauty and a mental agility that was astonishing for his age, suffer from a chronic sickness that was usually provoked by some small piece of carelessness during play.

In 1913 a major event was celebrated in Russia: the three hundredth anniversary of the Romanov dynasty. Like the coronation, the closing festivities were held in Moscow. The ritual was planned down to the minutest detail. The Tsar was supposed to enter the Kremlin by foot, while the Tsarina and Tsarevich rode in their coach. At the time Alexei had not yet completely recovered from a spell of his sickness and was unable to walk. He had to be held in someone's arms during the inspection of the regiments:

The fragile little figure of the Tsarevich stood out against the hands of a burly Cossack. The thin little arm of the Tsarevich clung to his strong broad neck, the emaciated little face of the Tsarevich was so pale as to be almost transparent, and his amazingly beautiful eyes were full of grief.

BELOW

Toy soldiers,
part of a game about the
Napoleonic Wars

CATALOGUE NO. G25

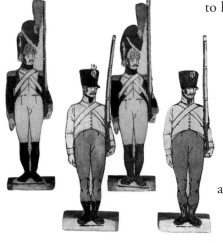

The boy's health improved as he grew older, but it still remained essential to keep an eye on him. Alexei had many toy soldiers that he loved to play with, especially when he was unable to move about. With Derevenko and his sons he laid out ranks of soldiers for a parade, a campaign or a charge; one way of learning about history and the art of war. Among the toys was a relief map of the Battle of Borodino that the chamberlain Sergei Khitrovo gave to him. Not only did it provide a general depiction of the Russian war with Napoleon Bonaparte in 1812, it also illustrated many separate episodes of the battle and views of the surroundings, the road and buildings in the village of Borodino.

At home the loyal friend of the mischievous and highly active Alexei was his sister the Grand Duchess Anastasia, who was considered a 'hopeless good-for-nothing'. The equerry Simeon Fabritski also describes how Alexei raced around with the cabin boys when he was on board the sailing boat *Polyarnaya zvezda* [*Pole star*]. Another contemporary describes an incident of 1913 in the Livadia Palace in the Crimea, when 'Alexei Nikolaevich was feeling relaxed and happy and played … with Kolya [Nikolai] Derevenko and made an incredible amount of noise, not

sitting still in his chair for a moment before springing up again and diving under the table'. Pierre Gilliard wrote: 'When he got the chance he enjoyed life, like any other happy active boy. When he was in good health, it was as if the palace was reborn; he was like a ray of sunshine lighting up everything and everyone.'

Gilliard's diary entries give us a very complete picture of the daily life of the heir to the throne. For 7 January 1914 he notes: 'The compulsory lessons started at 10.20 – Russian, the Ten Commandments, algebra, French and English. Between the lessons A.N. [Alexei] walks in the park, goes sledging, plays and runs round.' The entry for 16 January reads: 'Between 11 and 12 in the morning he went walking. In the daytime he received a delegation of peasants from Ekaterinoslav [now Dnepropetrovsk], who presented him with an icon. Walking and lessons. He doesn't feel well (pain in his right thigh-bone under the groin).' Another entry for 10 February reads: 'He got up at 8 after a good night's sleep …. Lessons …. He was in a mischievous mood and poured water over the chamberlain, on the floor, the bedding and the walls.'

As successor to the Russian throne, Alexei Nikolaevich was expected to attend many official festivities, receptions and parades. Most of them involved the religious festivals of regiments that he was commander of, or where he was a member of the staff. His father had taught him from an early age to understand the art of war. Alexei was presented with an Army uniform which a number of regiments had got together to make for him and he often wore it. He also appeared in a sailor suit and cap with the name of the Imperial yacht *Standart* on it, and wore Army uniforms from time to time.

A 'play regiment' was specially set up for Alexei, consisting of the sons of the highest officers. Second-class Naval Lieutenant Derevenko was appointed commander. Military exercises, marches, inspections and gymnastic exercises to music were organised, and strict discipline observed. On Alexei's birthday in 1912, an inspection of the 'play regiment' was organised on the parade ground, in the presence of the Tsarevich and the cream of St Petersburg society.

Alexei's interest in military matters undoubtedly increased when the First World War broke out and Nicholas departed for the real Army. It was the first time that the Tsar and his family had been separated from each other for so long. Alexei in particular missed his father, to whom he was devoted. Alexandra realised that in the difficult circumstances of war the Tsar had to

BELOW
Alexei in uniform, 1911

Photographer unknown

(The Royal Collection
© Her Majesty Queen Elizabeth II)

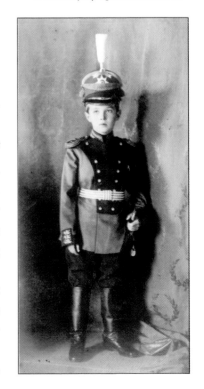

act alone without any moral support. Gilliard summed up this situation succinctly: 'The Tsar's loneliness became burdensome. He was robbed of his greatest consolation, his family.' Thus, in 1915 the Tsarina wrote to general headquarters in Mogilev: 'Our "Baby" has again gradually started asking if you couldn't find a place for him at the headquarters, but he would also be very upset if he had to leave me.' It was a wretched situation for both of his parents, but in the autumn of 1915 the Tsar and his heir went to the front together. Nicholas thought the journey to Army headquarters would broaden his son's horizons. The Tsarevich replaced his sailor's cap with a soldier's uniform.

What Alexei did at headquarters and how he conducted himself is known in some detail due to the copious correspondence between Nicholas and Alexandra and the reminiscences of their contemporaries. The Tsar's diaries, for example, provide a daily account of Alexei's activities. Nicholas gave his son lessons about life on campaign. He made space for him in his room, modestly furnished with two beds and a table, and took Alexei with him when he went to the front, visited hospitals or distributed payments. On these occasions the Tsarevich always wore a uniform appropriate to the regiments that were symbolically under his command. In their free time father and son walked along the River Dnieper, went on boat trips, or went to the cinema. As the son of Doctor Botkin wrote: 'Alexei Nikolaevich worshipped his father and it was moving to see how he always went with him wherever he went.'

Later Alexei's teachers joined Nicholas at headquarters. But although he began his lessons again, they were not as frequent or regular as they should have been. Shabelski, Arch-priest of the Russian Army and Fleet, was at the headquarters when the Tsarevich arrived. In his memoirs he recalls:

Alexei Nikolaevich always breakfasted at the common table, sitting on the left-hand side of the Tsar. In the afternoon he ate with his teachers Alexei Nikolaevich's illness had a strong influence on his upbringing and education. As an invalid he was allowed a great deal of latitude and he was forgiven for things that would not have been acceptable in a healthy individual. In fact the limits of the permissible were often transgressed. To ensure that he did not become overtired, care was taken not to cram him, with all the obvious drawbacks for his progress. For instance, in autumn 1916 Alexei Nikolaevich became thirteen – high school age, that is, or that

of a third-class cadet – but he was unable to do fractions in arithmetic. The fact that he had fallen behind in his education could also have been due to the choice of mentors.

Shabelski was not only concerned about Alexei when he was in the palace or at Army headquarters; he was thinking about the heir's future: 'I met him twice a day in the palace, I saw how he related to people, how he played and indulged in pranks, and I asked myself, "When he grows up, what kind of a Tsar will he be?"'

Ultimately Shabelski did not come to any conclusion about Alexei. He ended his remarks by saying: 'The Lord has endowed the unhappy boy with marvellous natural qualities – a quick and powerful mind, resourcefulness, a warm compassionate heart, and, for a tsar, a brilliant simplicity; his mental and spiritual beauty matched his physical beauty.'

At the Army headquarters Alexei made friends with the cadets. They organised lessons and war games in the city gardens, and Alexei began to enjoy the soldiers' food and the brown bread. Sometimes he even refused his food at headquarters, saying 'that's not what soldiers eat'.

The story is often told of how the Tsarevich used to stand on guard by his father's tent:

In the summer there was one task the heir to the throne fulfilled that revealed both his love for Army exercises and his affection for his father. In the morning ... before his father entered the tent, Alexei was already standing with his rifle at attention before the entrance, to salute his Imperial Highness when he arrived; and when the latter left the tent once more Alexei saluted him again – only then did he go off duty.

The equerry Anatoli Mordvinov adds this detail: 'While he was waiting for his father's arrival holding his tiny rifle ... he gave a salute; the most experienced junior officer in a model regiment of the time of Nicholas I could not have performed this exercise with greater competence and elegance.'

Everyone who saw the Tsarevich after his stay at the Army headquarters remarked that he was taller and more manly than before. Gone were his childish fragility and his chubby cheeks; gone too was his timidity.

Alexei's services were highly prized: in autumn 1915 he was awarded the medal of Saint George, and in May 1916 he was promoted to the rank of corporal.

At the beginning of 1917, after spending the whole of 1916 at head-quarters, Alexei rejoined his sisters in Tsarskoe Selo. Events then developed at breakneck speed, and in March 1917 the Tsar signed the document in Pskov declaring his abdication on behalf of himself and Alexei, his heir. Before his definitive abdication, Nicholas II summoned his personal physician, Professor Sergei Feodorov. In the presence of Shabelski they had the following conversation:

— *Tell me honestly Sergei* [Feodorov]: *can Alexei Nikolaevich ever be completely cured?*
— *If Your Majesty believes in miracles, he can, because miracles have no limits. But if you want to know what science has to say about it, I have to tell you that there are no known cases in science of a complete cure for this disease.*
— *So, you regard his disease as incurable?*
— *Yes, Your Majesty.*

The Tsarevich learned of the abdication from his French tutor, Pierre Gilliard.

OPPOSITE

Portrait of Nicholas II
with sketch of Tsarevich
Alexei Nikolaevich
(dated 1913)

Mikhail Viktorovich Rundaltsov
(1871-1935)

CATALOGUE NO. G08

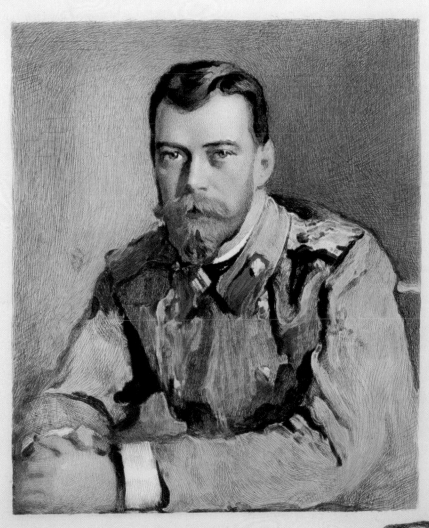

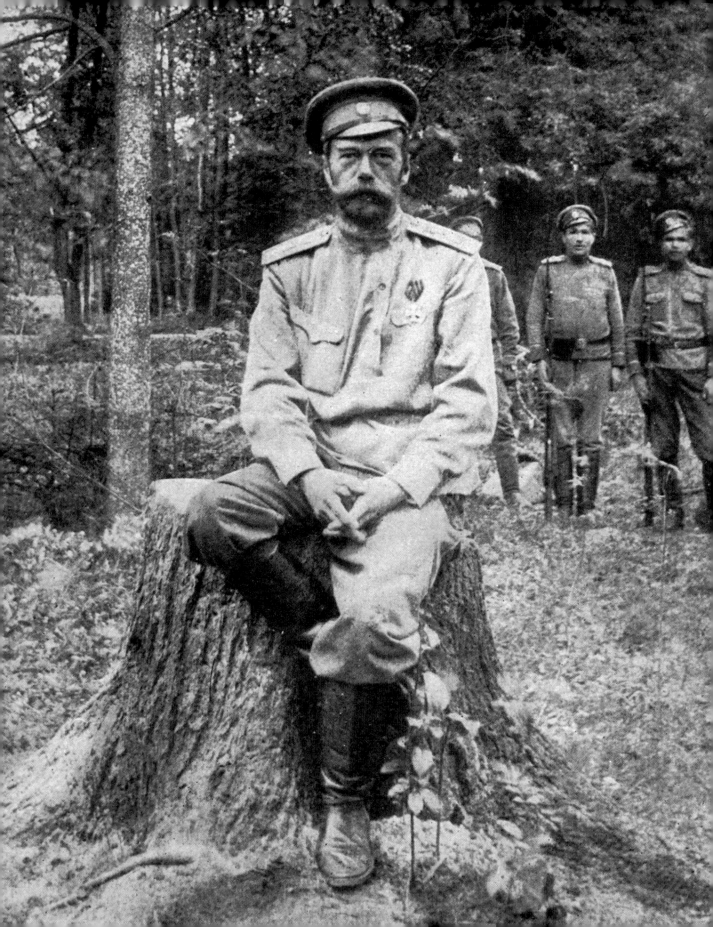

7

THE DEATH
AND AFTERLIFE
OF NICHOLAS II

ALTHOUGH THE MURDER OF THE LAST TSAR AND HIS FAMILY *tends to be viewed as an isolated personal tragedy, it can only be fully understood in the much wider context of Russian history.*

Given the undoubted spirit of co-operation between the Tsar and his cousin during the First World War, it was deeply distressing to King George and the British royal family that they were unable to save Nicholas and his family after the war on the Eastern Front was effectively over. George sent a message of sympathy to Nicholas on 17 March 1917, but it failed to reach him. Two days later Sir George Buchanan, the British ambassador in Petrograd, as St Petersburg was now called, was officially instructed to inform M. Miliukov, Foreign Minister in the provisional government, that 'any violence done to the Emperor or his family would have a most deplorable effect and would deeply shock public opinion in [Britain]'.

Miliukov enquired whether the British government would grant the Imperial family asylum in Britain, and on 22 March the British agreed to offer sanctuary for the duration of the war. Unfortunately George intervened on 30 March to question the offer, on the grounds of the danger of the voyage and 'expediency'. This reflected the fear that the arrival of the Tsar and his German wife would cause further unrest in Britain and could bring down the King and the coalition government. After further discussion the government agreed, and Buchanan was advised in April not to pursue the matter. Once the second revolution took place in Russia, in October 1917, it became impossible – for strategic, political and practical reasons – to rescue the Romanovs from their captivity in central Russia.

In the weeks following his abdication Nicholas and his loved ones had been allowed to live at Tsarskoe Selo, but in early August 1917 the provisional government sent them to Tobolsk in Siberia. This was primarily for their personal safety, but it also moved them well away from the principal centre of political power. After the second revolution the Bolshevik government maintained this arrangement. However, in April 1918 the militant Soviet at Ekaterinburg, to the west of Tobolsk, used force and the threat of further force to pressure the Chairman of the Central Committee to agree to their transfer to Ekaterinburg.

The outcome of this regional struggle was to seal the fate of the family because they became inextricably involved in the civil war between the Reds (the Bolsheviks) and the Whites (anti-Bolsheviks), and victim to a sudden and unexpected turn of events in the Ekaterinburg area.

Following the peace between Russia and Germany, the Czechoslovak Legion was moving east along the Trans-Siberian Railway with the intention of leaving Russia through the port of Vladivostok, in order to fight the Austrians on the Western Front and create an independent Czechoslovak state. Unfortunately, an incident on 14 May between the Czechs and Austrian and Hungarian prisoners of war at Chelyabinsk station, to the south of Ekaterinburg, resulted in the Czechs disarming Bolshevik troops and the capitulation of a Bolshevik commissar. The Czechs rejected an order from the Czechoslovak National Council to stop carrying weapons, and on 25 May Leon Trotsky, principal lieutenant of the Red Armies, ordered that all Czechs should be disarmed and any armed Czech 'shot on the spot'. The Czechs reacted by seizing the railway and moved against Ekaterinburg, which they took on 25/26 July.

The Bolsheviks were ill prepared and could not risk losing control of the Imperial family. They faced the very real danger of the former Tsar, Tsarina, Tsarevich and Grand Duchesses being captured by the Czechs and handed

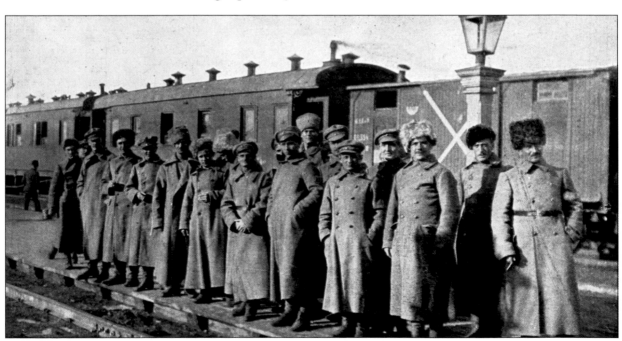

over to the White Russians, who would have used them to rally a large army that could have defeated the young Red Army.

This had to be prevented, and expediency necessitated the 'liquidation' of the entire family.

By this time the family was confined in the Ipatiev house, which was called the House of Special Purpose. The Commandant, Yakov Yurovsky, apparently received instructions on 15 or 16 July to kill his prisoners. According to Yurovsky, on the night of 16/17 July the family was woken up and ordered down to a small room on the ground floor where Yurovsky summarily informed them they were to be shot. Yurovsky subsequently stated, clearly and categorically, that he was in charge of the firing squad of twelve men that executed the Tsar and his family, together with their doctor and loyal servants. In 1934 Yurovsky told a meeting of old Bolsheviks that he killed Nicholas with his first shot, but that the other Romanovs did not die immediately in the furious hail of bullets. Yurovsky claimed credit for dispatching the petrified Alexei. After an unsuccessful attempt to bayonet them to death, Alexei's sisters – who were partly protected by jewels and other valuables sewn into their clothing – were finished off with rounds to the head.

There are some inconsistencies with the various accounts and reports of the tragedy. Yet despite the claims and counter-claims that some or all of the Romanovs had escaped, it seems likely that the entire family perished, either on the night of 16/17 July or around this time.

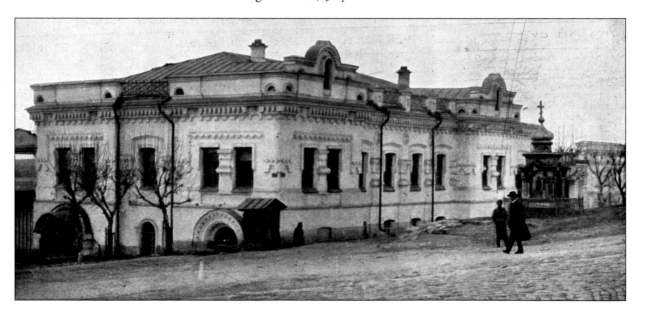

On 1 February 1934 Yurovsky told the meeting of old Bolsheviks in Ekaterinburg that the dead were taken not far from the village of Koptiaki, where they were stripped, the valuables collected, and their clothing burned. All the naked bodies were thrown down a mine and then retrieved after they landed in shallow water and could not be covered by the team. They were moved to another location. Alexei and a woman (apparently the maid Anna Demidova) were burned and their bones buried in a pit, while the others were disfigured with sulphuric acid before being interred in a separate grave. A big fire was lit over the first burial, so that people could not see that the soil had been disturbed, and the second was hidden with railway sleepers.

Shortly after taking over the area, the White Russians began an extensive investigation, which led them to the mine. Here they found charred clothing and jewellery which were recognised as belonging to the Imperial family, a fingertip, some skin, part of a set of dentures, and the body of a dog. But the final burial site eluded them.

Sixty years elapsed. Then, in 1979, the main grave was apparently found by the geologist Alexander Avdonin and the writer and film-maker Geli Ryabov. They were helped by an account of the execution and disposal of the bodies which seems to have been written by Yakov Yurovsky around 1920 and was actually given to them by Yurovsky's son, Alexander. Accompanied by their wives and a couple of friends, Avdonin and Ryabov claim they unearthed skulls and skeletal remains of the Imperial family on the morning of 30 May 1979.

Avdonin and Ryabov publicised their discovery in 1989-90, during *perestroika*, and in 1991 the authorities of the Sverdlovsk region excavated the site and work began to identify the remains. Two years later the Russian government set up a commission to consider the issues of identification and reburial. DNA was extracted and compared with samples taken from descendants of the Romanov family. On 30 January 1998, the commission concluded that the body parts were, indeed, those of Tsar Nicholas II and members of his family. The government confirmed these findings and, on 27 February, decided that the bones should be laid to rest in the Cathedral of St Peter and St Paul, in St Petersburg, on 17 July 1998 – the eightieth anniversary of the executions.

And so, on 15 July, the remains of Nicholas, Alexandra and three of their daughters were placed in small coffins in Ekaterinburg. The following day,

OPPOSITE

The Ipatiev house at Ekaterinburg

London Illustrated News
20 September 1919

(NMS Library)

they were flown to Pulkovo Airport, outside St Petersburg, where they were received by the governor of the city Vladimir Yakovlev, members of the Romanov family, many officials, and a military band and guard of honour. Four representatives of the Royal Scots Dragoon Guards (the successor regiment to the Royal Scots Greys) were also present to honour their former Colonel-in-Chief.

The coffins were placed in hearses and taken into St Petersburg – along streets that were lined with thousands of soldiers and military students – to the cathedral. At the fortress the Royal Scots Dragoon Guards marched behind the guard of honour and directly in front of the coffins, with Pipe Major Brotherton playing a selection of slow airs, culminating in 'Going Home'.

The funeral itself took place on 17 July 1998 and was attended by President Boris Yeltsin.

On 14 August 2000 the Synod of Bishops of the Russian Orthodox Church within Russia agreed after much discussion that the former Tsar and all six of his immediate family should be canonised.

The consecration of the new Cathedral of Christ the Saviour in Moscow and the canonisation of the 'Royal Martyrs and Palm-Bearers', and 860 other saints, took place on the important feast of the Transfiguration of Christ on Sunday, 20 August. The process of canonisation had begun the previous day. An icon of Tsar Nicholas and his family was revealed in the centre of the cathedral and the vigil services included the *tropar,* or hymn:

> *Most noble and sublime was your life and death, O Sovereigns;*
> *wise Nicholas and blest Alexandra, we praise you,*
> *acclaiming your piety, meekness, faith, and humility,*
> *whereby ye attained to crowns of glory in Christ our God,*
> *with your five renowned and godly children of blest fame.*
> *Martyrs decked in purple, intercede for us.*

On the Feast of the Transfiguration, Nicholas, Alexandra, Alexei, Olga, Maria, Tatiana and Anastasia were formally declared saints, and the cathedral was consecrated to Christ the Saviour.

Today the Russian people can beseech the 'Holy Royal Martyrs' to 'Pray unto God for us'. The family that was murdered and reviled has been transformed into some of the most potent saints of Russia.

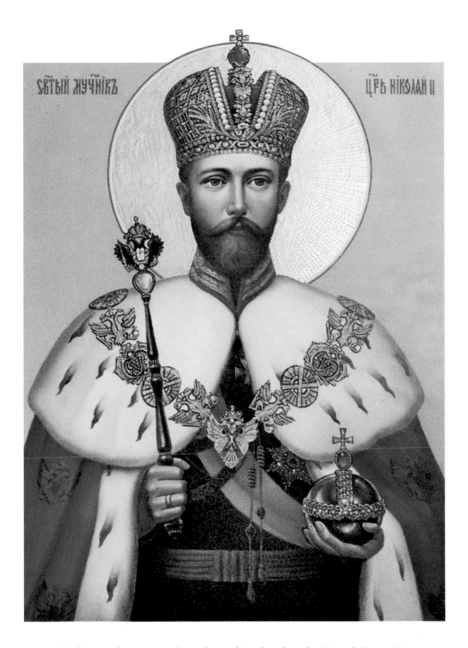

СВ҃ТЫЙ МУЧ҃НІКЪ Ц҃РЬ НІКОЛАЙ ІІ

Nicholas is also remembered to this day by the Royal Scots Dragoon Guards, his 'beautiful Royal Scots Greys'. An icon of the former Colonel-in-Chief was commissioned and presented to the regiment by the Caledonian Society of Moscow in 2001. It now travels with the Royal Scots Dragoon Guards as they go about their dangerous duties and manoeuvres. One hopes that – in the words of the prayer – the Holy Tsar-Martyr Nicholas will help and watch over them all the days of their lives.

ABOVE

Icon of Tsar Nicholas II presented by the Caledonian Society of Moscow to the Royal Scots Dragoon Guards, 2001

(Courtesy of the Royal Scots Dragoon Guards [Carabiniers and Greys])

CATALOGUE NO. 101

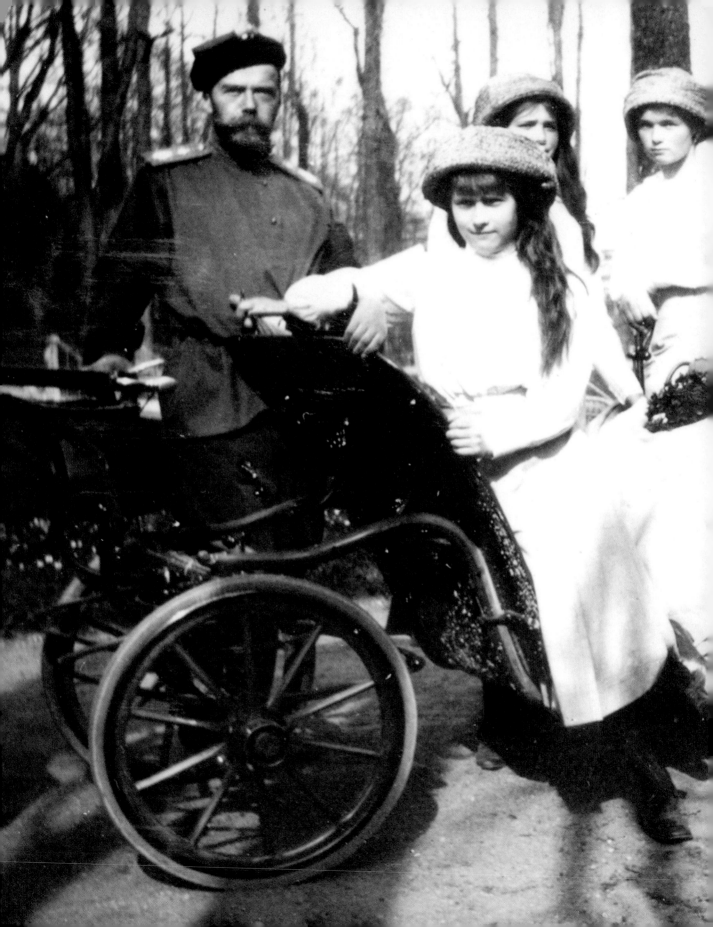

EXHIBITION
CATALOGUE

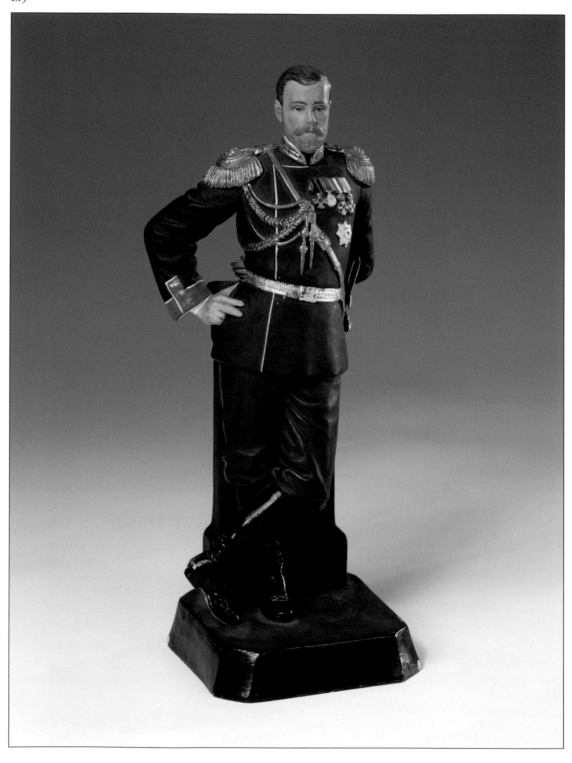

A. The Romanov Dynasty

A01
TSAR MIKHAIL FYODOROVICH (1596-1645)

Unknown artist, late 18th-early 19th century
Oil on canvas, 83 x 71 cm
Origin: acquired in 1941 from the State Museum of
Ethnography of the Peoples of the USSR; previously in 'The
Gallery of Emperor Peter I at The Academy of Science'
State Hermitage Museum, inv. no. ERZh-520 *Y.G.*

A02
TSAR ALEXEI MIKHAILOVICH (1629-76)

Unknown artist, late 18th-early 19th century
Oil on canvas, 81 x 68 cm
Origin: acquired in 1941 from the State Museum of
Ethnography of the Peoples of the USSR; previously in 'The
Gallery of Emperor Peter I at The Academy of Science'
State Hermitage Museum, inv. no. ERZh-522 *Y.G.*

A03
TSAR PETER I (1672-1725)

Unknown artist, 18th century
Oil on canvas, 94 x 70 cm (oval)
Origin: acquired in 1941 from the State Museum of
Ethnography of the Peoples of the USSR; previously in the
collection of Count Chernyshev
State Hermitage Museum, inv. no. ERZh-536 *Y.G.*

A04
EMPRESS CATHERINE II (1729-96)

Unknown artist, 1780-90
Oil on canvas, 79 x 65 cm
Origin: acquired in 1993 under G. D. Dushin's Will (Leningrad)
State Hermitage Museum, inv. no. ERZh-3262 *Y.G.*

A05
TSAR ALEXANDER I (1777-1825)

Unknown artist, first quarter 19th century
Oil on canvas, 84.5 x 66.5 cm
Origin: acquired in 1941 from the State Museum of
Ethnography of the Peoples of the USSR
State Hermitage Museum, inv. no. ERZh-605 *A.P.*

A06
TSAR NICHOLAS I (1796-1855)

Unknown artist, second quarter 19th century
Oil on canvas, 85 x 56.7 cm
Origin: acquired in 1941 from the State Museum of
Ethnography of the Peoples of the USSR
State Hermitage Museum, inv. no. ERZh-619 *A.P.*

A07
TSAR ALEXANDER II (1818-81)

Unknown artist (monogram 'VG'), dated 1888
Oil on canvas, 73 x 57.5 cm
Origin: acquired in 1941 from the State Museum of
Ethnography of the Peoples of the USSR
State Hermitage Museum, inv. no. ERZh-633 *A.P.*

A08
TSAR ALEXANDER III (1845-94)

Unknown artist, late 19th century
Oil on canvas, 55 x 47 cm
Origin: acquired in 1994 through the Expert-Purchasing
Commission of the State Hermitage
State Hermitage Museum, inv. no. ERZh-3247 *A.P.*

A09
TSAR NICHOLAS II (1868-1918)

Unknown artist, 1915-16
Oil on canvas, 187.5 x 106.5 cm
Origin: acquired in 1998 through the Expert-Purchasing
Commission of the State Hermitage
State Hermitage Museum, inv. no. ERZh-3270 *A.P.*

A10
EMPRESS ALEXANDRA FEODOROVNA (1872-1918)

Nikolai Kornilevich Bodarevsky (1850-1921), dated 1907
Oil on canvas, 67 x 49.5 cm
Signed at bottom: 'N Bodarevsky. 1907. Tsarskoe Selo
15 May'
Origin: acquired in 1941 from the State Museum of
Ethnography of the Peoples of the USSR
State Hermitage Museum, inv. no. ERZh-647 *A.P.*

A11

VIEWS OF ST PETERSBURG AND ITS SUBURBS AND THE MOSCOW KREMLIN

The following views are selected from thirty-two water-colours painted by first-rate Russian artists. They were intended as a present for Tsar Nicholas I to give to Queen Victoria, when he visited her on the tenth anniversary of her succession to the throne in 1847. Her Majesty Queen Elizabeth II presented all thirty-two watercolours to the Chairman of the Presidium of the Supreme Soviet of the USSR, K. E. Voroshilov, during his visit to the United Kingdom in 1956. They subsequently became part of the collections of the State Hermitage Museum. *G.P.*

a

THE TSAR BELL IN THE MOSCOW KREMLIN

E. Gilbertson (active in Moscow during first third 19th century), dated 1838
Watercolours on paper, 26.4 x 36.2 cm
Signed bottom right: 'E. Gilbertson 1838'
State Hermitage Museum, inv. no. ERR-5540 *G.P.*

b

IVANOVSKAYA SQUARE IN THE KREMLIN WITH THE BELL TOWER OF IVAN THE GREAT AND THE CATHEDRAL OF THE ARCHANGEL MICHAEL

E. Gilbertson (active in Moscow during first third 19th century), dated 1838
Watercolours on paper, 26 x 35.8 cm
Signed bottom right: 'E. Gilbertson 1838'
State Hermitage Museum, inv. no. ERR-5539 *G.P.*

c

THE BOYAR GROUND AND THE CATHEDRAL OF THE 'SAVIOUR BEHIND THE GOLDEN FENCE' IN THE MOSCOW KREMLIN

E. Gilbertson (active in Moscow during first third 19th century)
Watercolours on paper, 26 x 34.7 cm
State Hermitage Museum, inv. no. ERR-5538 *G.P.*

d

VIEW OF THE SPIT OF VASILYEVSKY ISLAND

Ludwig Ludwigovich Bohnstedt (1822-85), dated 1847
Watercolours and gouache on paper, 27.3 x 38.2 cm
Signed bottom right: 'L. Bohnstedt 1847'
State Hermitage Museum, inv. no. ERR-5524 *G.P.*

e

THE NEVA EMBANKMENT AT THE WEST END OF THE WINTER PALACE

Ludwig Ludwigovich Bohnstedt (1822-85), dated 1847
Watercolours and gouache on paper, 27.2 x 37.5 cm
Signed bottom right: 'L. Bohnstedt 1847'
State Hermitage Museum, inv. no. ERR-5526

The pier with the steps was used for mooring pleasure-boats and cargo ships. In 1832 the Palace pier was decorated with figures of lions and vases. It was dismantled during the construction of the Palace Bridge. *G.P.*

f

VIEW OF NEVSKY PROSPECT BY ANICHKOV BRIDGE

Ludwig Ludwigovich Bohnstedt (1822-85), dated 1847
Watercolours and gouache on paper, 27 x 37.9 cm
Signed bottom right: 'L. Bohnstedt 1847'
State Hermitage Museum, inv. no. ERR-5525 *G.P.*

g

THE ALEXANDER PALACE AT TSARSKOE SELO

Alexei Mikhailovich Gornostaev (1808-62), dated 1847
Watercolours and gouache on paper, 25.8 x 38.2 cm
Signed bottom right: 'A. Gornostaeff, 1847'
State Hermitage Museum, inv. no. ERR-5530

The Alexander Palace was the last important building designed by the Italian architect Giacomo Quarenghi for the Empress Catherine the Great. It was constructed not far from the Catherine Palace between 1792 and 1800. The Alexander Palace was the property of the Imperial family, and became the main residence of Tsar Nicholas II and his family. Nicholas and Alexandra employed the architect Roman Melzer to redesign the interiors of the private rooms in a modern Arts and Crafts/Art Nouveau style, and they lived in them until they were sent to Siberia on 1 August 1917. *G.P.*

h

THE CAMERON GALLERY AND GROTTO AT TSARSKOE SELO

Adolph Andreevich Beseman (1806-67), 1847
Watercolours and gouache on paper, 25.5 x 37.7 cm
Signed bottom left: 'A. Beseman'
State Hermitage Museum, inv. no. ERR-5533 *G.P.*

i

THE PALACE AT PAVLOVSK

Unknown artist, 1847
Watercolours and gouache on paper, 25 x 33.5 cm
State Hermitage Museum, inv. no. ERR-5536 *G.P.*

j

THE COTTAGE IN ALEXANDRIA PARK
AT PETERHOF

Unknown artist, 1847
Watercolours and gouache on paper, 25 x 33 cm
State Hermitage Museum, inv. no. ERR-5535 *G.P.*

k

VIEW OF THE PALACE AT STRELNA
FROM THE PARK

Alexei Mikhailovich Gornostaev (1808-62), about 1847
Watercolours, gouache and graphite pencil on paper,
25.7 x 38 cm
Signed bottom left: 'Gornostaeff'
State Hermitage Museum, inv. no. ERR-5529 *G.P.*

l

THE GREAT PALACE AT ORANIENBAUM

Adolph Andreevich Beseman (1806-67), 1847
Watercolours and gouache on paper, 25.5 x 37.8 cm
Signed bottom left: 'A. Beseman'
State Hermitage Museum, inv. no. ERR-5531 *G.P.*

B. Holy Russia

B01

INTERIOR OF THE CATHEDRAL
OF THE WINTER PALACE

Alexei Vasilyevich Tyranov (1808-59), dated 1829
Oil on canvas, 146 x 108 cm
Signed on back of canvas: 'P[ainted by]. A. Tyranov. 1829'
Origin: acquired in 1956 from the Central Depot of the City's
Museum Palaces; before that stored in the Catherine Palace
at Tsarskoe Selo
State Hermitage Museum, inv. no. ERZh-2431

The cathedral in the Winter Palace was created by the
Italian architect Bartolomeo Francesco Rastrelli between
1754 and 1762. The 'Resurrection of Christ' on the
ceiling was painted by the Italian artist Francesco
Fontebasso. Russian craftsmen made the carved and
gilded wooden iconostasis, and Fontebasso and the
brothers Belsky undertook the icons. *A.P.*

B02

METROPOLITAN ANTONY (1846-1912)

Andrei Andreevich Karelin (1866-after 1911), 1911
Oil on canvas, 140 x 108.5 cm
Origin: acquired in 1941 from the State Museum of
Ethnography of the Peoples of the USSR; before that in the
collection of the Alexander Nevsky Monastery
State Hermitage Museum, inv. no. ERZh-701

Alexander Vasilievich Vadkovsky, known as Antony,
became Metropolitan of St Petersburg and Ladoga in
1898. He was appointed principal attendant in the
Most Holy Synod in 1900 and elected a member of the
State Council in 1906. *A.P.*

B02

B03

B06

B08

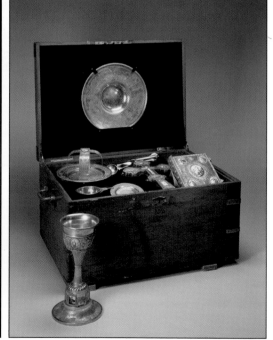

B03

PRIEST'S VESTMENTS (*PHELON* OR CHASUBLE AND *EPITRAKHELION* OR STOLE) OF GOLD BROCADE DECORATED WITH A REPRESENTATION OF A DOUBLE-HEADED EAGLE

Russian, early 20th century
Brocade, metal wire and embroidery: (chasuble, length along back) 146 cm; (stole) 145 x 34.5 cm
Origin: chasuble from the Winter Palace Church; stole acquired in 1941 from the State Museum of Ethnography of the Peoples of the USSR
State Hermitage Museum, inv. nos. ERT-II-1254, ERT-15850

A sewn-in label records that the outer robe – the *phelon* or chasuble – belonged to Peter Afanasievich Blagoveshchensky. From 1911 Blagoveshchensky was the head of the court clergy, as Protopresbyter (Arch-priest) of the cathedral of the Winter Palace. *I.K.*

B04

PRIEST'S VESTMENTS (*PHELON* OR CHASUBLE AND *EPITRAKHELION* OR STOLE) OF BLUE VELVET WITH GOLD EMBROIDERY

Russian, second half 19th century
Velvet, metal wire, spangles, appliqué work and embroidery: (chasuble, length along back) 144 cm; (stole) 148 x 29 cm
Origin: acquired in 1941 from the State Museum of Ethnography of the Peoples of the USSR
State Hermitage Museum, inv. nos. ERT-15865, 15866
I.K.

B05

CHASUBLE OF RED VELVET WITH GOLD EMBROIDERY

Russian, second half 19th century
Velvet, metal wire, spangles and embroidery, (length along back) 140 cm
Origin: acquired in 1941 from the State Museum of Ethnography of the Peoples of the USSR
State Hermitage Museum, inv. no. ERT-15964

On the back of the chasuble is a representation of the resurrection of Jesus: a large figure of Christ trampling upon an empty coffin, with an Angel and three guards. *I.K.*

B06

HANGING ICON-LAMP

Workshops of A. A. Alexandrov and N. V. Alexeev, Moscow, early 1900s
Silver, enamel and gold, 95 x 11 x 11 cm
Marks: maker's marks 'NA' and 'AA', and Moscow assay mark for 1903-7 with the silver standard '88'
Origin: acquired in 1941 from the State Museum of Ethnography of the Peoples of the USSR
State Hermitage Museum, inv. no. ERO-5663 *L.Z., K.O.*

B07

ICON OF THE LOYAL PRINCE ALEXANDER NEVSKY, THE MIRACLE WORKER ST TITUS AND THE MARTYR ST POLYCARPUS

Icon by Vasily Vasilievich Vasiliev (1829-94); frame by the Ovchinnikov Company, Moscow, 1879
Wood, oil paint, silver, diamonds, pearls, enamels and gold, 128 x 85 cm
Marks: maker's mark of P. Ovchinnikov, unknown assay master's mark 'IK/1879', Moscow town mark, and silver standard mark '84'
A plaque on the frame inscribed, 'MADE BY THE DILIGENCE OF AND PRESENTED TO THE EMPEROR ALEXANDER II BY I. F. Kozmin, O. G. Samsonova, V. A Gostev, P. A. Ovchinnikov, M. I. Fukova, D. A. Petrov, M. A. and A. A. Alexandrovs, E. I. Sivokhin, Academic V. V. Vasiliev and Collegiate Counsellor Z. I. Dekhtyarev'
Origin: acquired in 1922 from the Church of the Icon of the Saviour Not Made By Hands in the Winter Palace
State Hermitage Museum, inv. no. ERO-7257

This icon was made after the assassination attempt on the Emperor Alexander II on 2 April 1879, the Saints' Day of Saints Titus and Polycarpus, by the terrorist A. K. Soloviev. It was presented to the Emperor in 1879 and was in the Church of the Icon of the Saviour Not Made By Hands in the Winter Palace from then until 1922.

Saint Alexander Nevsky (1220-63), prince of Novgorod and Vladimir, was a distinguished Russian military commander and a diplomat. The 9th-century Saint Titus was a monk and a hermit in the Studiysk dwelling in Tsargrad and a venerable miracle worker from his youth. Saint Polycarpus was martyred in Alexandria in the 4th century. *L.Z., K.O.*

B08

THE COMMUNION SET FROM THE FIELD
CHURCH OF THE EMPEROR ALEXANDER I

Workshop of Axel Hedlund, St Petersburg, 1812
Wood, silver, gold, enamel and paper
Marks: maker's marks 'HEDLUND' and 'AH', Alexander
Yashinov's 'AY' assay master's mark, St Petersburg town
mark, and silver standard mark '84'
Set is in a wooden chest, 38.3 x 70.4 x 52.1 cm
Chest contents: (chalice) 32.5 x 13 x 17 cm; (altar cross)
36.3 x 22.5 cm; (Book of Gospels) 5.3 x 20.4 x 17 cm;
(asterisk) 14.7 x 10.4 cm; (paten) 9 x 22.2 x 22.2 cm; (basin
for washing hands, diameter) 31.7 cm; (two plates, diameter)
13.9 cm; (small jug) 3.7 x 14.4 x 9.3 cm; (tabernacle) 12.3 x
16.5 x 10.3 cm; (flagon) 3.4 x 2.1 cm; (liturgical spoon) 25.4
x 4.6 cm; (two lances) 19.9 x 2.7 and 13.8 x 1.7 cm
Origin: acquired in 1956 from the Central Depository of the
Leningrad Suburban Palaces; before that in the Alexander
Palace at Tsarskoe Selo
State Hermitage Museum, inv. nos. ERO-8765 a,
8765-8774 a, b, 8776-8778

This communion set was made to the design of the
architect A. N. Voronikhin. According to tradition,
Alexander I took it on all his campaigns, including his
entry into Paris in 1814. The Emperor had the set with
him on his last journey to Taganrog in 1825. Later it
was used by his son Nicholas I, Alexander II, Alexander
III and Nicholas II in the Winter Palace. During
Nicholas's reign the items were also used in the
Alexander Palace at Tsarskoe Selo. *L.Z., K.O.*

B09
BOOK OF GOSPELS

P. I. Olovianishnikov and Sons, Moscow, 1911
Paper, print, velvet, silver, amethysts and gold, 6.2 x 19 x
15 cm
Marks: maker's mark 'O.S. ᴱ⸍' and Moscow assay mark for
1908-17 with the silver standard '84'
Origin: acquired in 1956 from the Central Depository of the
Leningrad Suburban Palaces; before that in the Alexander
Palace at Tsarskoe Selo
State Hermitage Museum, inv. no. ERO-8827

In late August 1911 Nicholas II visited Kiev. On 30
August he visited the Kievo-Pecherskaya Monastery,
where the monks presented him with these Gospels.
 L.Z., K.O.

B10
BLESSING CROSS

P. I. Olovianishnikov and Sons, Moscow, 1912
Wood, tempera, mica, aquamarine, amethysts, almandine,
rock crystal, rhodonite, silver and enamel, 38 x 18.3 x 2 cm
Marks: the maker's mark and Moscow assay mark for
1908-17 with the silver standard '84'
Inscribed: 'GIFT OF THE BESSARABIAN CLERGY TO
KISHINEV CATHEDRAL IN 1912, TO COMMEMORATE
THE ONE HUNDREDTH ANNIVERSARY OF BESSARABIA
JOINING RUSSIA'
Origin: acquired in 1951 from the State Depository of
Treasures
State Hermitage Museum, inv. no. ERO-7729

This magnificent cross, made to a design by S. Vashkov,
was presented by the Bessarabian clergy to Kishinev
Cathedral in 1912. After the Russo-Turkish war of
1806-12, under the terms of the Treaty of Bucharest,
Bessarabia joined the Russian Empire. On 16 May
1912, the one hundredth anniversary of this event
was celebrated in Kishinev. *L.Z., K.O.*

B11
PORCELAIN EASTER EGGS WITH
MONOGRAMS AND INSCRIPTIONS

a

EASTER EGG WITH A PICTURE OF HENS
AND THE INSCRIPTION 'XB'

Factory of M. S. Kuznetsov, St Petersburg, beginning of the
20th century
Porcelain, with overglaze polychrome painting and gilding,
10 x 7.8 cm
Origin: acquired in 1941 from the State Museum of
Ethnography of the Peoples of the USSR
State Hermitage Museum, inv. no. ERF-5483

Eggs with the inscription 'XB' ('Christ is risen') and
a picture of hens were very popular in Russia. The
'Explanation of the Easter Service and Easter customs',
published in 1898, notes that 'Jesus, our life, is born
from an egg set by a hen; Jesus compares himself with
a hen and He with His blessing inspires it with the
spiritual life'. *E.K.*

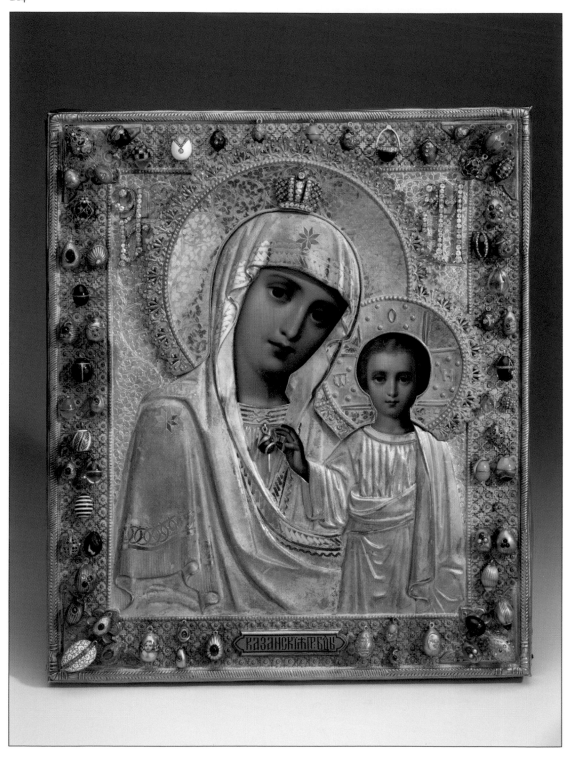

b

EASTER EGG WITH THE INSCRIPTION 'XB'

Imperial Porcelain Factory, St Petersburg, 1894-1917
Porcelain, with underglaze cobalt coating, etching and tinted gilding, 9.2 x 7.2 cm
Origin: acquired in 1941 from the State Museum of Ethnography of the Peoples of the USSR
State Hermitage Museum, inv. no. ERF-5502 *T.V.K.*

c

EASTER EGG WITH THE MONOGRAM OF THE EMPRESS ALEXANDRA FEODOROVNA

Imperial Porcelain Factory, St Petersburg, 1915
Porcelain, with overglaze painting in gold, 8.7 x 7 cm
Origin: acquired in 1941 from the State Museum of Ethnography of the Peoples of the USSR
State Hermitage Museum, inv. no. ERF-9311 *T.V.K.*

d

EASTER EGG WITH THE MONOGRAM OF THE EMPRESS ALEXANDRA FEODOROVNA

Imperial Porcelain Factory, St Petersburg, 1915
Porcelain, with underglaze cobalt coating, etching and tinted gilding, 8.9 x 7.1 cm
Origin: acquired in 1941 from the State Museum of Ethnography of the Peoples of the USSR
State Hermitage Museum, inv. no. ERF-5494 *T.V.K.*

e

EASTER EGG WITH THE MONOGRAM OF THE EMPEROR NICHOLAS II

Imperial Porcelain Factory, St Petersburg, 1894-1917
Porcelain, with high-temperature-fired 'ox blood' (*sang de boeuf*) glaze, etching, and tinted gilding, 9.2 x 7.4 cm
Origin: acquired in 1941 from the State Museum of Ethnography of the Peoples of the USSR
State Hermitage Museum, inv. no. ERF-5493 *T.V.K.*

B12

ICON OF SAINT MITROFAN OF VORONEZH

Russian, about 1914
Wood and enamel: 26.5 x 23 cm; (wooden case) 32.5 x 28 x 6 cm
Inscription on right-hand shutter of case records that this icon was given to Nicholas and Alexandra by the Union of the Russian People during their visit to Voronezh in 1914
Origin: acquired in 1941 from the State Museum of Ethnography of the Peoples of the USSR; before that in the Winter Palace
State Hermitage Museum, inv. nos. ERZh-2305 a, b (case)
 A.P.

B13

TRIPTYCH WITH THE BOGOLIUBSKAYA MOTHER OF GOD ON THE CENTRAL PANEL AND SAINT ALEXANDER NEVSKY AND SAINT MARY MAGDALENE ON THE SIDES

Workshop of Ivan Petrovich Khlebnikov, Moscow, 1882
Wood, tempera, silver and enamels, 54 x 49.2 cm
Origin: acquired in 1956 from the Central Depository of the Leningrad Suburban Palaces; before that in the Gatchina Palace
State Hermitage Museum, inv. no. ERF-8837

This icon was made by order of the nobility of the town of Vladimir and was presented to the Emperor Alexander III and the Empress Marie Feodorovna on the day of their coronation, 14 May 1883. *L.Z., K.O.*

B14

ICON OF THE 'HOLY MOTHER OF KAZAN', IN A SILVER SETTING

Icon painted in Moscow, late 19th century; setting made by the Ovchinnikov Company, Moscow, 1887; small 'Easter eggs' by Karl Fabergé, St Petersburg, 1890s
Wood, tempera, silver, gold, diamonds, sapphires, emeralds, rubies, pearls and enamels, 31.5 x 27 cm
Marks: maker's mark of P. Ovchinnikov, assay mark 'IK/1887' of Viktor Savinkov, Moscow town mark and silver standard mark '84'; some of the eggs are struck with the gold standard mark '56'
Origin: acquired in 1941 from the State Museum of Ethnography of the Peoples of the USSR; before that in the Museum Fund
State Hermitage Museum, inv. no. ERO-6501 *L.Z., K.O.*

B15

ICON OF SAINT NICHOLAS

Russian, early 20th century
Wood, oil paint and velvet: 36 x 26.5 cm; 39 x 24.5 cm
(wooden case)
Signed at the bottom: 'Peasant Grigory Zhuravlev painted
with his teeth. Samara region. Buzuluk. Of the district of the
selo Utkvki'
Origin: acquired in 1928 from the State Museum Fund;
before that in the Winter Palace
State Hermitage Museum, inv. nos. ERZh-23075 a, b (case)

On the back of the icon are letters and paper stickers
which show that this remarkable item belonged to the
Tsarevich Alexei Nikolaevich. It was probably given to
Alexei by a delegation from Samara. Saint Nicholas is
one of the most honoured saints in Russia, the patron
of warriors and sailors. *A.P.*

C. 'The Funeral Bride'

C01

WEDDING OF THE EMPEROR NICHOLAS II
AND EMPRESS ALEXANDRA FEODOROVNA

Laurits Regner Tuxen (1853-1927), dated 1895
Oil on canvas, 65.5 x 87.5 cm
Signed bottom left: 'L. Tuxen, 1895'
Origin: acquired in 1918 from the Anichkov Palace in
St Petersburg
State Hermitage Museum, inv. no. GE-6229

The wedding took place in the cathedral of the Winter
Palace on 14 November 1894. Nicholas is depicted in
his uniform of the Life-Guard Hussar Regiment;
Alexandra is wearing a magnificent robe trimmed with
ermine. To the right of the window are Nicholas's
grandfather, Christian IX of Denmark, his mother,
Dowager Empress Marie Feodorovna, and his sisters,
the Grand Duchesses Olga and Xenia. Nicholas's uncle,
Edward, Prince of Wales, is further along to the right.
The Hermitage painting was undertaken as preparation
for Tuxen's large painting in Buckingham Palace.

A.A.B.

C02

PART OF A DINNER AND DESSERT SERVICE
GIVEN BY KAISER WILHELM II OF GERMANY
AS A WEDDING PRESENT TO NICHOLAS II
AND ALEXANDRA FEODOROVNA IN 1894

Royal Porcelain Manufactory, Berlin, about 1894
Porcelain, with overglaze painting and gilding:
(candelabrum, height) 63 cm; (tureen and cover, height)
24 cm; (tureen stand, length) 57.5 cm; (sauce boat on
stand, length) 25.2 cm; (plate, diam.) 23.2 cm
Origin: acquired in 1922 from the service room of the
Winter Palace
State Hermitage Museum, inv. nos. ZF-24832 (candela-
brum); 19927 a, b (tureen and cover), 19931 (tureen stand);
19914 (sauce boat); 19954 (salt cellar); 19908 (plate)

The service, with table decorations, was sent to St
Petersburg in two shipments. One arrived in the capital
in time for the wedding, the other was delivered at the
beginning of 1895. *L.L.*

C03
ICON OF THE 'GUARDIAN ANGEL'

Grachev Brothers, St Petersburg, 1894
Painting on zinc, silver, wood, and velvet, 14.9 x 10.1cm
Marks: maker's mark and St Petersburg assay mark
Inscribed on back: '14 NOVEMBER 1894'
Origin: acquired in 1956 from the Central Depository of the
Leningrad Surburban Palaces; before that in the Alexander
Palace at Tsarskoe Selo
State Hermitage Museum, inv. no. ERO-8708

The icon was presented on the wedding of the
Emperor Nicholas II and the Empress Alexandra
Feodorovna. *L.Z., K.O.*

C04
TWO EXAMPLES OF THE MEDAL COMMEMORATING THE WEDDING OF THE EMPEROR NICHOLAS II AND PRINCESS ALICE OF HESSE ON 14 NOVEMBER 1894, SHOWING FRONT AND BACK

St Petersburg Mint (designed by Anton Feodorovich
Vasyutinsky), 1896
Silver, (diam.) 7 cm
Front: overlapping head and shoulder portraits of Nicholas
and Alexandra, in profile, facing left
Inscribed: 'TO COMMEMORATE THE WEDDING OF
EMPEROR NICHOLAS II AND PRINCESS ALICE OF HESSE',
and the date '14 NOVEMBER 1894'
Reverse: scene of the marriage, with the monogram 'AV' (for
Anton Vasyutinsky) bottom right
Origin: both acquired in 1896 from the St Petersburg Mint
State Hermitage Museum, inv. nos. RM-4605, PRM-6377
 E.S.

D01
CORONATION OF THE EMPEROR NICHOLAS II AND EMPRESS ALEXANDRA FEODOROVNA

Laurits Regner Tuxen (1853-1927), dated 1898
Oil on canvas, 66 x 87.5 cm
Signed bottom left: 'L. Tuxen, 1898'
Origin: acquired in 1941 from the State Museum of
Ethnography of the Peoples of the USSR
State Hermitage Museum, inv. no. ERZh-1638

The coronation of Nicholas and Alexandra took place
on 14 May 1896 in the Cathedral of the Assumption in
the Kremlin, Moscow. Nicholas and the two Empresses
sat, on a raised platform, on the magnificent thrones of
Ivan III, Mikhail Fyodorovich and Alexei Mikhailovich,
inset with hundreds of diamonds, rubies, pearls and
turquoises. Among the guests were the Queen of the
Hellenes, Kaiser Wilhelm II's brother, Prince Henry,
Queen Victoria's son, the Duke of Connaught, Crown
Prince Victor Emmanuel of Italy, Prince Constantine of
Greece, Prince Ferdinand of Bulgaria and Crown
Prince Ferdinand of Romania. *A.P.*

D02
MENU OF THE CORONATION DINNER IN MOSCOW ON 14 MAY 1896

Designed by Viktor Mikhailovich Vasnetsov (1848-1926)
Colour-printed paper, 92.5 x 33.3 cm
Under the picture is the date 'year 1896 month 14 of May'
and signature 'Viktor Vasnetsov 1896'
Origin: acquired in 1941 from the State Museum of
Ethnography of the Peoples of the USSR
State Hermitage Museum, inv. no. ERT-10629/9

The colourful design is in the Old Russian style; all
texts are written in ligatured script. At the top is the
inscription: 'The Sacred Coronation of the Sovereign
Emperor Nicholas II and the Sovereign Lady Empress
Alexandra Feodorovna.' Underneath is a scene of the
coronation of the first representative of the Romanov
House, Tsar Mikhail Fyodorovich, in the Cathedral of
the Assumption in the Moscow Kremlin, which took
place in 1613. *G.M.*

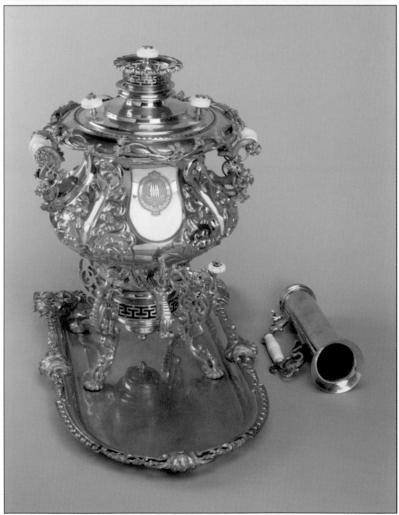

D03

MENU OF THE BANQUET FOR REPRESENTATIVES OF THE ESTATES IN THE ALEXANDER HALL OF THE KREMLIN ON 19 MAY 1896

Designed by Albert Nikolaevich Benois (1852-1936)
A. A. Levinson's Printing Press, Moscow, 1896
Colour lithograph, 37.5 x 27 cm
Origin: acquired after 1917; probably from the M. G.
Meklenburg-Strelitski collection
State Hermitage Museum, inv. no. Lm-1004 lit *.T.*

D04

MENU OF THE BANQUET GIVEN BY THE GRAND DUKE SERGEI ALEXANDROVICH, GOVERNOR-GENERAL OF MOSCOW, ON 20 MAY 1896

Designed by Viktor Mikhailovich Vasnetsov (1848-1926)
A. A. Levinson's Printing Press, Moscow, 1896
Colour lithograph, 41 x 24.5 cm
Origin: acquired after 1917; probably from the M. G.
Meklenburg-Strelitski collection
State Hermitage Museum, inv. no. Lm-1002 lit

Fifteen hundred people sat down to the banquet and at each place was a menu, decorated with an illustration of an old Russian Grand Duke's meal. The inscription in the centre of the menu reads: 'And there was feasting, an honorary feast, and there was dining, a sanctified board.' *I.T.*

D05

MENU OF THE DINNER IN THE MOSCOW KREMLIN ON 25 MAY 1896, CELEBRATING THE CORONATION OF NICHOLAS II

Ernst Karlovich Liphart (1847-1932), 1896
Colour lithograph, 34.5 x 24.5 cm
Signed bottom right: 'Liphart'
Origin: from the original collection of the Hermitage
State Hermitage Museum, inv. no. ERT-10628/8

On 25 May 1896 'at seven o' clock a gala dinner was held in the George Hall of the Great Kremlin Palace and on Boyars Square The Emperor's table was laid for 96 guests and decorated with a priceless dinner service and a whole carpet of live flowers There were 700 guests altogether During the meal artists from the Imperial Russian Opera gave a splendid concert from the gallery.' *G.M.*

D06

CELEBRATORY ADDRESS, PRESENTED TO NICHOLAS II AND THE EMPRESS ALEXANDRA FEODOROVNA BY THE FRENCH INHABITANTS OF ST PETERSBURG DURING THE CORONATION CELEBRATIONS IN 1896

E. Bastanier, France, 1896
Leather, paper, copper, enamel, gold, diamonds and other materials, 45 x 32.5 cm
Origin: from the collection in the Winter Palace
State Hermitage Museum, inv. no. E-9703 *O.K.*

D07

PRESENTATION SALT CELLAR

Fabergé, Moscow, 1896
Silver and gold, 7 x 7 x 7 cm
Marks: the Fabergé mark, and Moscow assay mark for 1896-1903 with the silver standard '84'
Inscribed: 'TO THEIR IMPERIAL MAJESTIES FROM LOYAL KIRGIZS OF THE BUKEEV HORDE'
Origin: from the Silver Room of the Winter Palace
State Hermitage Museum, inv. no. ERO-3896

The salt cellar was a present for the coronation of Nicholas II. *L.Z., K.O.*

D08

VASE-SHAPED SAMOVAR WITH CHIMNEY AND TRAY, WITH THE IMPERIAL MONOGRAM 'N II A' AND DATE 1896

Samovar Factory of the Successors of Vasily Stepanovich Batashev, Tula, about 1896
Copper, bone and gold: 54 x 40 x 43 cm; (chimney) 28 x 14 x 10 cm
The lid is marked 'Successors of Vasily Stepanovich Batashev in Tula' and decorated with two prize medals received by the factory at the All-Russia Arts and Industry Exhibitions in 1870 and 1882
Origin: acquired in 1951 from the State Museum of Ethnography of the Peoples of the USSR
State Hermitage Museum, inv. no. ERM-2275 a-g

Towards the end of the 19th century there were about seventy samovar factories in Tula. The one with the best reputation had been founded in 1840 by Vasily Stepanovich Batashev and operated up to the beginning of the 20th century as 'Successors of V. S. Batashev'. Their samovars were so popular that 'false' factories existed which stamped their products 'Inheritors and Successors of Batashev'. *M.K.*

D09

PASS-TICKET TO THE USPENSKY CATHEDRAL OF THE KREMLIN FOR THE CORONATION CEREMONY OF NICHOLAS II IN 1896

Silver and gold, 3.7 x 3.1 cm (without ribbon)
Origin: from the collection of I. I. Tolstoy (1858-1916), distinguished statesman, public figure, numismatist and collector
State Hermitage Museum, inv. no. RM-4731

Only those who were admitted to the coronation ceremony in the Cathedral of the Assumption of the Moscow Kremlin had the right to wear this badge.

L.D.

D10

BADGE FOR AN ARTIST INVOLVED IN THE CORONATION OF NICHOLAS II IN 1896

Silver, enamel and gold, 4.3 x 2.9 cm
Origin: from the Pushkin House of the Academy of Science of the USSR
State Hermitage Museum, inv. no. IO-7235 *M.D.*

D11

SOUVENIR BEAKER MADE FOR THE CORONATION OF NICHOLAS II IN 1896

Factory of M. S. Kuznetsov, Tver, about 1896
Faience, with coloured glaze, 12 x 9.5 x 9.5 cm
The beaker is decorated with the Moscow coat of arms, with Saint George on horseback killing the dragon, and the inscription 'In memory of the sacred coronation' and the monograms 'N II' and 'AF' crowned with the Imperial crown
Mark: 'M. S. Kuznetsov, 1878/15' impressed in paste
Origin: acquired in 1941 from the State Museum of Ethnography of the Peoples of the USSR
State Hermitage Museum, inv. no. ERO-6482 *E.K.*

D12

KERCHIEF COMMEMORATING THE CORONATION OF NICHOLAS II AND ALEXANDRA FEODOROVNA IN 1896

Prokhorovskaya Manufactory, Moscow, 1895
Glazed cotton, with printed decoration, 78 x 77 cm
Printed inscription: 'Trekhgornaya manufacture of Prokhorovykh Partnership'
Origin: acquired in 1941 from the State Museum of Ethnography of the Peoples of the USSR
State Hermitage Museum, inv. no. ERT-20890 *E.M.*

D13

TWO EXAMPLES OF THE GREAT CORONATION MEDAL OF THE EMPEROR NICHOLAS II

St Petersburg Mint (designed by Anton Feodorovich Vasyutinsky), 1896
Silver, (diam.) 6.4 cm
Front: overlapping heads of the Emperor and the Empress, in profile, facing left; on the edge of Nicholas's neck is the signature of Anton Vasyutinsky
Inscribed: 'THE EMPEROR NICHOLAS II EMPRESS ALEXANDRA FEODOROVNA. CROWNED IN MOSCOW 1896'
Reverse: 'GOD WITH US' above the state coat of arms, a double-headed eagle under an Imperial crown holding the sceptre in the left leg and the orb in the right one; on the eagle's breast is a shield with the picture of St George; around the shield is a chain of the Order of St Andrew; on the eagle's wings are eight coats of arms of the Russian kingdoms
Origin: the first acquired in 1896 from the St Petersburg Mint; second in 1932 from the Institute of History and Languages
State Hermitage Museum, inv. nos. RM-4651, PRM-6407

E.S.

D14

MINIATURE COPY OF THE IMPERIAL REGALIA BY FABERGÉ

Yuli Alexandrovich Rappoport, St Petersburg, 1899-1900
Gold, silver, platinum, diamonds, spinel, pearls, sapphires, rose quartzite, wood and velvet: (large crown) 7.3 x 5.4 cm; (small crown) 3.8 x 2.9 cm; (sceptre, height) 15.8 cm; (orb) 6.7 x 4.2 cm
Marks: maker's mark 'I.P.', Fabergé company mark, assay mark for St Petersburg for 1899-1908 and silver standard '88'; on the pedestal for the large crown 'C. Fabergé. SPB. 1900.'
Origin: made for the International Exhibition in Paris in 1900, and later purchased by Nicholas II and kept in the Gallery of Treasures in the Winter Palace
State Hermitage Museum, inv. no. E-4745/1-8 *O.K.*

D15

PANORAMA OF MOSCOW DURING THE CORONATION OF THE EMPEROR NICHOLAS II

Pavel Yakovlevich Piasetsky (1843-1919), 1896-1900
Watercolours on paper glued onto fabric,
41.8 cm x 58.5 metres
Origin: acquired from the Central Geographical Museum
in St Petersburg
State Hermitage Museum, inv. no. ERR-9210

The panorama depicts the main events of the coronation celebrations, beginning with the arrival of the royal train into Moscow on 6 May 1896, and ending with the farewell parade on Khodynka Field on 26 May. *G.P.*

E. Pomp and Circumstance

Travels in the Far East

E01

PAIR OF CANDELABRA IN THE FORM OF A BIRD ON A STAND

Bangkok, Thailand, late 19th century
Silver, gold and black enamel, (height) 45 cm
Origin: from the private rooms of Nicholas II in the Winter Palace; presented to the Tsarevich by King Rama the Fifth, Chulalongkorn, of Siam on 22 March 1891, during his visit to Siam
State Hermitage Museum, inv. nos. IS-313, 314

These candelabra were specially made for Nicholas and, like the table decoration, incorporate the sacred bird *Khamsa*. *O.D.*

E02

TABLE DECORATION

Bangkok, Thailand, late 19th century
Silver, lead, gold and black enamel, (height) 45 cm
Origin: from the private rooms of Nicholas II in the Winter Palace
State Hermitage Museum, inv. no. IS-315

This item, decorated with the coats of arms of Russia and Siam, was presented to Nicholas by King Rama the Fifth, Chulalongkorn, of Siam on 22 March 1891, at the same time as the candelabra. The two bowls supported by the three sacred birds are similar in form and decoration to the containers for betel leaves used by the heirs to the Siamese throne. *O.D.*

E03

MODEL OF A SHIP IN A FRAME

Japanese, 1891
Turtleshell, glass and other materials, (model) 17.5 x 13 cm
State Hermitage Museum, inv. no. ЯP-590

The model represents the *Pamiat Azov* which transported Nicholas to the Far East. *A.M.B.*

E04
THE SHIRT NICHOLAS II WAS WEARING DURING THE ASSASSINATION ATTEMPT ON HIM IN JAPAN IN 1891

'Maulle', St Petersburg, 1890
Linen, with mother-of-pearl buttons, (back) 100 cm
Marks: 'MAULLE / Perspective de Nevsky 24 /
St. Petersbourg'; below, under an imperial crown, the
monogram 'NA' and number '90'
Origin: acquired in 1941 from the State Museum of
Ethnography of the Peoples of the USSR; before that in the
Alexander Palace at Tsarskoe Selo (in the wardrobe of the
Emperor Nicholas II [?])
State Hermitage Museum, inv. no. ERT-12766

During a visit to the town of Otsu on 29 April 1891, a
Japanese policeman hit Nicholas on the head with a
sabre. The man was overpowered and Nicholas was not
seriously injured. The Japanese Emperor came to see
him and remained in Kyoto until he had recovered.
Alexander III ordered his son to return home. The
Japanese Emperor accompanied the Tsarevich to the
docks at Kobe, where he boarded the *Pamiat Azov* and
set sail for Vladivostok. *S.L.*

E05
SCROLL IN A FRAME WITH A PHOTOGRAPHIC IMAGE OF THE TSAREVICH NIKOLAI ALEXANDROVICH

Japanese, 1891
Paper, red and black ink; (photograph) ferrotype, and paint;
wood and glass, 16 x 51 cm
Inscribed in Japanese: 'Portrait of His Majesty the Crown
Prince of Russia'
Origin: from the private rooms of Nicholas II in the Winter
Palace; brought back by the Tsarevich from his visit to the
Far East in 1891
State Hermitage Museum, inv. no. ЯT-2220 *A.M.B.*

E06
SEATED OLD MAN

Satsuma workshops, Japan, 1880s
Faience, with polychrome overglaze painting and gilding,
25 x 25.5 x 19 cm
Origin: from the private rooms of Nicholas II in the Winter
Palace; brought back by the Tsarevich from his visit to the
Far East in 1891
State Hermitage Museum, inv. no. ЯK-985

The costume and the attributes suggest that the old
man is a scientist. *T.A.*

E07
HOTEI

Satsuma workshops, Japan, 1880s
Faience, with polychrome overglaze painting and gilding,
19.4 x 18.5 x 14.5 cm
Origin: from the private rooms of Nicholas II in the Winter
Palace; brought back by the Tsarevich from his visit to the
Far East in 1891
State Hermitage Museum, inv. no. ЯK-984

One of the 'seven gods of fortune', Hotei is represented
according to the classic representation of him as a fat
man holding a bag with a boy in it. *T.A.*

E08
FOLDING ALBUM OF MINIATURES IN A BLACK LACQUER BOX

Japanese, 17th century and later
Paper, silk and paint; wood and black lacquer:
(album, closed) 26.2 x 20.5 cm, (open) 370 cm; (box) 29.6 x
24.2 cm
Origin: from the private rooms of Nicholas II in the Winter
Palace; brought back by the Tsarevich from his visit to the
Far East in 1891
State Hermitage Museum, inv. no. ЯK-2218 a, b

The album consists of sixteen miniatures signed by the
artist Kano Tanyu (1602-74), a representative of the
Kano painting school of the Edo Period, and the artist
Serodo Serin. All sixteen miniatures depict Japanese
gods.
A.M.B.

E04

E05

142

E09

FOLDING ALBUM WITH JAPANESE PAINTINGS ON SILK

Paper, silk and paint; wood and black lacquer (box):
(album, closed) 18 x 28 cm, (open) 500 cm
Inscribed in Japanese: 'Kiotosskaya court school of arts for girls'
Origin: from the private rooms of Nicholas II in the Winter Palace; brought back by the Tsarevich from his visit to the Far East in 1891
State Hermitage Museum, inv. no. T-2219 a, b

The album consists of thirty-six miniatures of women in kimonos and landscapes. *A.M.B.*

E10

ICON OF THE 'RESURRECTION OF CHRIST'

Yamashita Rin (1857-1938), about 1891
Papier-mâché, oil paint and lacquer, 32 x 26.5 cm
Origin: acquired in 1941 from the State Museum of Ethnography of the Peoples of the USSR; before that in the Winter Palace
State Hermitage Museum, inv. no. ERZh-2283 a, b

Given to Nicholas during his visit to Japan in 1891, the icon has a painting of the Orthodox Church of the Resurrection of Christ in Tokyo and a dedicatory inscription on the reverse. Japanese artist Yamashita Rin converted to Russian Orthodoxy and learned icon-painting in St Petersburg in the Voskresensky Novodevichy monastery for women. *A.P.*

E11

MODEL OF THE BURYAT YURT IN ITS ORIGINAL BOX

Master Schultz, Irkutsk, 1890s
Silver and wood: 24.5 x 30.5 x 30.5 cm; 29 x 38 x 38 cm
Inscribed on the door: 'Schultz in Irkutsk'
The medallions are inscribed: 'His Imperial Highness Grand Prince Heir Tsarevich God with us from Buryat of the Balagansk district, foreign departments of Kunginsk, Ukyrsk, Nelkhaysk, Malkinsk, Bo-Khansk, Uliysk, foreign departments of Alarsk, Nigdinsk, Ashekhabotsk, Zugaro-Bugotsk, Bilgursk, Kutiysk'
Origin: from the stores in the Winter Palace
State Hermitage Museum, inv. no. ERO-7328

The model of the Buryat yurt was presented to Nicholas during his return from the Far East in 1891. It is an interesting ethnographic record and shows the layout of the Buryat – a nomad dwelling – at the end of the 19th century. In 1894 it was exhibited in the Hermitage, in the exhibition of presents given to the Tsarevich during his grand tour. *L.Z., K.O.*

Russia and France

E12

ARRIVAL OF TSAR NICHOLAS II IN PARIS

Georges Becker (1845-1909), about 1896-97
Oil on canvas, 180 x 200 cm
Signed on the base of the column: 'Georges. Becker.'
Origin: acquired in 1955; before that in the Museum of the Revolution (Leningrad)
State Hermitage Museum, inv. no. ERZh-II-545

The signing of the Triple Alliance between Germany, Austria and Italy in 1882 led to a loose agreement between France and Russia in 1891 and to a detailed and binding military-political alliance in January 1894. On 5 October 1896 the French fleet welcomed Tsar Nicholas II at the start of his state visit to France. President Félix Faure met the Tsar, his wife and infant daughter Olga at Cherbourg and took them to Paris, where they were warmly greeted by a crowd of about a million people as they drove from the station to the embassy. This painting is believed to be based on this enthusiastic reception. *Y.G.*

E13

ALLEGORY OF PEACE

Lucien Falize, Paris, 1896
Silver and gold, (height) 60 cm
Signed on the pedestal edge: 'Falise orf. 1896'
Inscribed on the laurel branch: 'PAX PORTIBUS A.S.M./
NICOLAS II / EMPEREUR / DE TOUTES LES RUSSIES / LA
VILLE DE PARIS'
Origin: acquired in 1956 from the Central Museum Fund
Repository; before 1941 in the Alexander Palace at Tsarskoe
Selo
State Hermitage Museum, inv. no. E-17253

The statuette was presented to Nicholas II by the city
of Paris, probably either in connection with his
coronation or his state visit to France in 1896. *M.L.*

E14

DEVOTION (THE FRENCH FIREMAN)

Edouard Drouot, Paris, 1891
Bronze, with golden brown patina, (height) 45 cm
Inscribed on helmet: 'Sapeurs pompiers de cellier';
bottom right on back of base: 'E. DROUOT'; on the shield:
'LE DEVOUEMENT PAR DROUOT MEDAILLE AU SALON';
on the plate of gilded bronze attached to marble base:
'Hommage de l'Union Departementale des Sapeurs
Pompiers de l'Oise à sa Majesté Nicolas II Empereur de
Russie. 1901'
Origin: acquired in 1902 from the Winter Palace
State Hermitage Museum, inv. no. M.sk-507

The statuette was presented to Nicholas II by French
fire-fighters during his visit to France in 1901. *E.K.*

E15

FEMALE MASK

Cesar Isidore Henri Cros, Sèvres, France, about 1896
Fused stained glass powder, 23 x 22 cm
Signature on the reverse: 'H. Cross'
Origin: acquired in 1931 from the Winter Palace; presented
to Nicholas II and Alexandra Feodorovna by the French
government in 1896 and shown on a special display stand in
the couple's bedroom
State Hermitage Museum, inv. no. ZF-23401 *E.A.*

E16

VASE WITH WATER-LILIES AND DRAGON-FLIES ON THE WING

Emile Gallé, Nancy, France, 1892, with silver mount by Yuli
Alexandrovich Rappoport for Fabergé
Mould-blown, four-layered glass with silver mount, (height,
with mount) 20.5 cm, (diam.) 10.5 cm
On the base is the signature and date: 'Emile Gallé 1892
Nancy fecit'
Marks on the silver mount: maker's mark 'Y.R.', Fabergé
company mark, and St Petersburg assay mark with the silver
standard '88'
Engraved inscription at the rim of the vase: 'Végétations de
Symboles'; on the upper ring: 'Palmes lentes de mes
desires. Nénuphars mornes des plaisirs. Mousses
Maeterlinck'
['Languid palms of my desires; sad water-lilies of pleasures;
cold mosses, soft lianas Maurice Maeterlinck']
Origin: acquired in 1931 from the Winter Palace; recorded on
the Empress's desk in 1909
State Hermitage Museum, inv. no. ZF-23410 *E.A.*

E17

VASE WITH DAHLIA FLOWERS AND LEAVES

Workshops of Emile Gallé, Nancy, France, about 1898, with
silver mount by Yuli Alexandrovich Rappoport for Fabergé,
St Petersburg
Mould-blown, three-layered glass with silver mount, (height,
with frame) 25.8 cm, (diam.) 5.6 cm
Engraved inscription with the cross of Lorraine on the
background: 'Emile Gallé'
Marks on silver mount: maker's mark 'Y.R.', Fabergé
company mark, and St Petersburg assay mark and silver
standard '88'
Origin: acquired in 1931 from the Winter Palace; recorded in
the Dining Room of the palace in 1909
State Hermitage Museum, inv. no. ZF-23411

Gallé planned a bronze mount for this model. *E.A.*

E16

E17

E18
SOUVENIR BEAKER COMMEMORATING THE RUSSIAN-FRENCH ALLIANCE

Kornilov Factory, St Petersburg, 1902
Porcelain, with overglaze printed decoration, 9.2 x 7.8 cm
Inscribed: 'In Saint Petersburg / Brothers Kornilov' and impressed 'II'
One side has crossed Russian and French flags with inscription and dates 'Paris / 1896 / – Compiégne / 1901 / S. Petersburg / 1897 – 1902'; on the other is monogram 'RF' and double-headed eagle surrounded by wreath of laurel and oak leaves
Origin: acquired in 1941 from the State Museum of Ethnography of the Peoples of the USSR
State Hermitage Museum, inv. no. ERF-7249

The factory of the Kornilov Brothers, founded in St Petersburg in 1835, was among the leading private producers of porcelain in 19th-century Russia. The decoration of this conical beaker commemorating the Russian-French political agreement of 1902 includes symbols of this historic event. *I.B.*

E19
STATUETTE OF THE EMPEROR NICHOLAS II IN THE UNIFORM OF THE LIFE-GUARDS PREOBRAZHENSKY REGIMENT

French (?), late 1890s
Biscuit, with polychrome painting, 25 x 10.5 x 9.5 cm
Origin: acquired in 1941 from the State Museum of Ethnography of the Peoples of the USSR
State Hermitage Museum, inv. no. ERO-7992 *E.K.*

E20
BUST OF NICHOLAS II

French (?), late 1890s
Biscuit, with polychrome painting, 14 x 9 x 5 cm
Inscribed on the pedestal in gold: 'Nicolas II'
Origin: acquired in 1941 from the State Museum of Ethnography of the Peoples of the USSR
State Hermitage Museum, inv. no. ERO-7241 *E.K.*

E21
BUST OF THE EMPRESS ALEXANDRA FEODOROVNA

French (?), late 1890s
Plaster, with polychrome painting, 15.5 x 10 x 6 cm
Inscribed on the pedestal in gold: 'Czarine'
Origin: acquired in 1941 from the State Museum of Ethnography of the Peoples of the USSR
State Hermitage Museum, inv. no. ERO-7242

The small figure and busts (nos. E19-21) of the royal couple were probably made in France for the visit of Nicholas II and Empress Alexandra to Paris in October 1896. *E.K.*

'A Very Scottish Affair'

E22
PHOTOGRAPH OF THE GRAND DUCHESS MARIA ALEXANDROVNA, DUCHESS OF EDINBURGH, DATED 1914

L. Gorodetsky (active late 19th-early 20th century)
Platinum print, in a desk frame of mahogany, 14 x 10 cm; (frame) 27.5 x 22.5 cm
Mount bears stamp of the studio and is signed in ink: 'Maria 1914'
Origin: acquired in 1964 from the Scientific Library of the State Hermitage
State Hermitage Museum, inv. no. ERFт-29400

In 1874 the Grand Duchess Maria Alexandrovna (1853-1920), only daughter of the Emperor Alexander II, married Queen Victoria's second son Alfred, Duke of Edinburgh and later Duke of Saxe-Coburg-Gotha (1844-1900). After the wedding, Maria used to visit St Petersburg almost annually. She had rooms reserved for her in her brother, the Grand Duke Vladimir Alexandrovich's house at 26 Dvortsovaya (Palace) Embankment. Maria Alexandrovna also often used to spend summer in the Tsarskoselsky Vladimirsky Palace and this photograph could have been taken there.
 G.M.

E24

E25

E26

E27

E23

CATALOGUE OF THE INTERNATIONAL EXHIBITION HELD IN GLASGOW IN 1888

T. and A. Constable, Glasgow, 1888
Leather, paper, ink and gold, 18.5 x 13 cm
First clean page after title page inscribed in ink: 'Alix Glasgow. 1888'
Top fly-leaf has book-plate of Empress Alexandra Feodorovna
Origin: acquired after 1917 from the Imperial Libraries
State Hermitage Museum, inv. no. 127700

Princess Alix visited the Glasgow Exhibition with Queen Victoria in 1888. This is her copy of the catalogue and contains eighteen handwritten comments, such as 'fine' and 'beautiful' against the entries. *T.F.*

E24

THE SCOTTISH CLANS AND THEIR TARTANS

W. and A. K. Johnston, Edinburgh and London, early 20th century
Leather, paper, ink and gold, 13 x 10 cm
Top fly-leaf has book-plate of Empress Alexandra Feodorovna
Origin: acquired after 1917 from the Imperial Libraries
State Hermitage Museum, inv. no. 44494 *T.F.*

E25

HISTORY OF THE 2ND DRAGOONS, BY LIEUTENANT-COLONEL PERCY GROVES

Edinburgh and London, 1893
Cardboard, cloth, paper and ink, 32 x 26 cm
Top fly-leaf has dedicatory inscription, 'For Dearest Nicky from his affectionate uncle Berti: December 1894' and book-plate of Nicholas II
Origin: acquired after 1917 from the Imperial Libraries
State Hermitage Museum, inv. no. 113608

The dedication reveals that the book was given to Nicholas II by Edward, Prince of Wales (later King Edward VII) in December 1894, shortly after the Tsar's succession to the throne and his marriage. *T.F.*

E26

LETTER 'TO HIS IMPERIAL MAJESTY THE EMPEROR OF RUSSIA COLONEL IN CHIEF ROYAL SCOTS GREYS' FROM LIEUTENANT-COLONEL ALFRED C. E. WELBY, COMMANDING OFFICER, ROYAL SCOTS GREYS, DATED 1 DECEMBER 1894

Paper and ink, 32 x 26 cm
State Hermitage Museum, inv. no. 113 *T.F.*

E27

'MONTHLY STATE' OF THE ROYAL SCOTS GREYS, DATED 1 DECEMBER 1894

Paper and ink, 32 x 26 cm
State Hermitage Museum, inv. no. 113

Both the letter and monthly report on the Royal Scots Greys follow Queen Victoria's appointment of Nicholas as Colonel-in-Chief of the Royal Scots Greys, as a wedding present. They have been carefully preserved inside Groves's *History of the 2nd Dragoons*, who are better known as the Royal Scots Greys. *T.F.*

E28

BRITISH PASSPORT ISSUED TO MAJOR W. H. HIPPISLEY OF THE ROYAL SCOTS GREYS ON 1 JANUARY 1895 FOR HIS VISIT TO ST PETERSBURG TO SEE TSAR NICHOLAS II

Paper and ink, 39 x 28 cm
Lent by the Royal Scots Dragoon Guards (Carabiniers and Greys) *G.E.*

E29

TWO NOTEBOOKS CONTAINING THE HANDWRITTEN *ACCOUNT OF MY VOYAGE TO RUSSIA AS ONE OF THE DEPUTATION OF THE SCOTS GREYS TO OUR NEW COLONEL IN CHIEF THE EMPEROR OF RUSSIA*, 27 JANUARY TO 21 FEBRUARY 1895, BY MAJOR W. H. HIPPISLEY, ROYAL SCOTS GREYS

Paper, ink, linen and leather: 16 x 10.2 x 1.2 cm; 17.6 x 11.7 x 1.4 cm
Lent by the Royal Scots Dragoon Guards (Carabiniers and Greys) *G.E.*

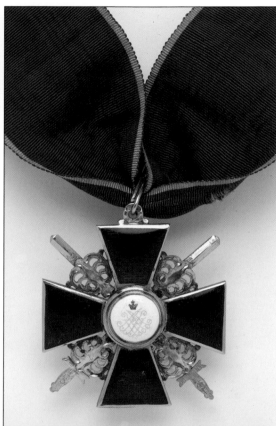

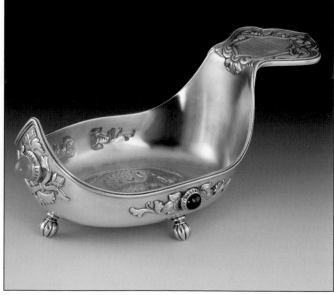

E35 (DETAIL)

E35

E30, E35 (*photography: National Museums of Scotland*)

E30

BADGE OF THE ORDER OF ST ANNE, THIRD CLASS, AWARDED TO CAPTAIN (LATER MAJOR-GENERAL SIR) HENRY J. SCOBELL BY TSAR NICHOLAS II IN FEBRUARY 1895

Silver, enamel, gold and silk, 4.9 x 4.4 x 0.3 cm (medal only)
National Museums of Scotland, inv. no. M.1955.322

Captain Scobell was one of the four representatives of the Royal Scots Greys who visited their new Colonel-in-Chief, Tsar Nicholas II, in St Petersburg on 2 February 1895. Scobell and the others were presented with Russian decorations by Count Bobrinsky, on behalf of the Tsar, on 14 February and wore them to a reception at the British Embassy that evening. *G.E.*

E31

RUSSIAN PASSPORT ISSUED TO MAJOR W. H. HIPPISLEY OF THE ROYAL SCOTS GREYS, IN ST PETERSBURG ON 4 FEBRUARY 1895, FOR HIS RETURN JOURNEY AFTER SEEING TSAR NICHOLAS II

Paper and ink, 44.6 x 29.7 cm
Lent by the Royal Scots Dragoon Guards (Carabiniers and Greys) *G.E.*

E32

THE ARRIVAL OF TSAR NICHOLAS II AND THE TSARINA AT BALMORAL ON 22 SEPTEMBER 1896

Orlando Norie (1832-1901), 1896
Watercolours on paper, 45.2 x 98.2 cm
Lent by The Royal Collection,
inv. no. RL 23604 / RCIN 45158 *G.E.*

E33

TSAR NICHOLAS II (1868-1918)

Valentin Aleksandrovich Serov (1865-1911)
Oil on canvas, 165 x 119 cm
Lent by the Royal Scots Dragoon Guards (Carabiniers and Greys)

This portrait, by the greatest of contemporary Russian portrait painters, was a personal gift from Tsar Nicholas II to his regiment. *G.E.*

E34

RUSSIAN MEDAL FOR ZEAL AWARDED TO 'BOY FUNNELL' OF THE ROYAL SCOTS GREYS

Silver and silk, 3.5 x 3 x 0.3 cm (medal only)
Lent by the Royal Scots Dragoon Guards (Carabiniers and Greys)
National Museums of Scotland, inv. no. IL.2005.32

The medal is said to have been presented to Bandsman Funnell by the Tsar on the occasion of a concert given by the band on the Royal yacht at Leith in August 1909. However, the Tsar visited Cowes, not Leith, in August 1909 and the history of the medal has still to be established. *G.E.*

E35

KOVSH, IN ITS ORIGINAL CASE

Alexander Wäkeva for Fabergé, St Petersburg, about 1914
Silver, gold, agate and almandine garnets; oak and other materials: 12.5 x 32 x 17.5 cm (kovsh); 14.3 x 34.5 x 20.7 cm (case)
Marks: maker's mark 'A W', Fabergé mark, St Petersburg assay mark for 1908-17 with the silver standard '88', and a kokoshnik mark in a circle
Inscribed: 'To The Royal Scottish Arboricultural Society 1854-1914. from The Russian Imperial Ministry of Agriculture'
On loan from the Royal Scottish Forestry Society to the National Museums of Scotland, inv. no. IL.2002.18.1 & 2

This is an official gift from the Russian Imperial Ministry of Agriculture to the Royal Scottish Arboricultural Society to celebrate and commemorate the fiftieth anniversary of the foundation of the Society. The Society was at the forefront of promoting better forest management, both to sustain future yields and preserve natural forests. *G.E.*

E36

CROSS OF ST GEORGE, FOURTH CLASS, AWARDED TO PRIVATE WILLIAM HUNTER OF THE ROYAL SCOTS GREYS IN 1915

Silver and silk, 4.2 x 3.4 x 0.2 cm (medal only)
National Museums of Scotland, inv. no. M.1953.461

One of twenty Russian decorations presented to officers and men of the Royal Scots Greys by Prince Yusupov, on behalf of Tsar Nicholas II, in France, 1915. *G.E.*

E37

PANORAMA OF BRITAIN WITH VIEWS OF
LONDON DURING THE CELEBRATIONS
OF THE SIXTIETH ANNIVERSARY OF
QUEEN VICTORIA'S REIGN

Pavel Yakovlevich Piasetsky (1843-1919), about 1897
Watercolours, gouache and India ink on paper glued to
canvas, 48.5 cm x 127 metres
Origin: acquired from the Central Geographical Museum
in Leningrad
State Hermitage Museum, inv. no. EPP-9211

This panorama was painted for the Imperial family, who
could not attend Queen Victoria's Diamond Jubilee in
June 1897 because of the birth of Tatiana. They were
represented by Grand Duke Sergei Alexandrovich,
uncle of Nicholas II, and his wife Grand Duchess
Elizaveta Feodorovna, granddaughter of Queen Victoria
and sister of Empress Alexandra Feodorovna. Piasetsky
came to Britain on the Russian cruiser *Russia* to make
sketches for the panoramas; but he also used magazines
such as *World Illustration* to complete this ambitious
project. *G.P.*

Military and Court Life

E38

FIGURES FROM THE
'PEOPLES OF RUSSIA' SERIES

Imperial Porcelain Factory, St Petersburg, 1907-19
Porcelain, with overglaze polychrome painting and gilding
Models by Pavel Pavlovich Kamensky (1858-1922)

The 'Peoples of Russia' series was started by Nicholas II
and was planned to consist of male and female figures
for each of the one hundred and fifty nations. The
largest and biggest series was made between 1907 and
1917, after models by Pavel Pavlovich Kamensky.
Between 1901 and 1914, Kamensky created over one
hundred figures for the series. *E.K.*

a

AN ALEUT

Date 1909, (height) 40 cm
Mark: green stencilled 'N II 1909' under a crown
Signatures: impressed facsimile 'P. Kamensky' and
handwritten 'P. Sh.' (for the sculptor P. V. Shmakov)
Inscription: 'Aleut' impressed in paste
Origin: acquired in 1941 from the State Museum of
Ethnography of the Peoples of the USSR
State Hermitage Museum, inv. no. ERF-3693 *E.K.*

b

A MONGOLIAN WOMAN

Date 1910, 46 x 15.5 x 15.5 cm
Mark: overglaze green stencilled monogram 'N II 1910'
beneath a crown
Signature: traces of facsimile 'P. K …' impressed in paste
Inscription: 'Mongolian woman' impressed in paste
Origin: acquired in 1941 from the State Museum of
Ethnography of the Peoples of the USSR
State Hermitage Museum, inv. no. ERF-3678 *E.K.*

c

A GOL'D

Date 1911, 38.3 x 16.8 x 15.8 cm
Mark: green stencilled 'N II 1911' under a crown
Signature: facsimile 'P. Kamensky' impressed in paste
Inscription: 'Gol'd' impressed in paste
Origin: from the main collection of the State Hermitage
State Hermitage Museum, inv. no. ERF-3692 *E.K.*

d

A SART (UZBEK)

Date 1911, (height) 38.8 cm
Mark: green stencilled 'N II 1911' under a crown
Signatures: facsimile 'P. Kamensky' impressed in paste and
handwritten 'A. L.' (for the sculptor A. Lukin)
Inscription: 'Sart' impressed in paste
Origin: from the main collection of the State Hermitage
State Hermitage Museum, inv. no. ERF-3702 *E.K.*

e

A GEORGIAN WOMAN

Model introduced in 1912, (height) 39.6 cm
Mark: underglaze green stencilled 'N II' under a crown
Signatures: impressed facsimile 'P. Kamensky' and hand-
written 'K.Z' (for the sculptor K. Zakharov)
Inscription: 'Georgian woman' impressed in paste
Origin: from the main collection of the State Hermitage
State Hermitage Museum, inv. no. ERF-3716 *E.K.*

E38 a

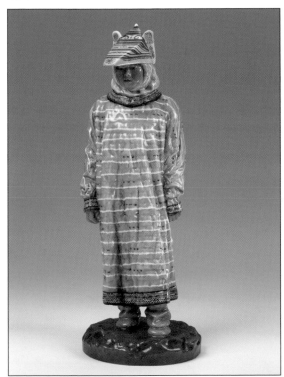

E38 c

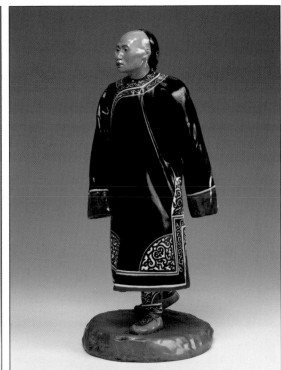

E38 d

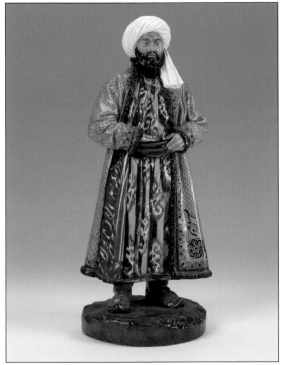

E38 f and e

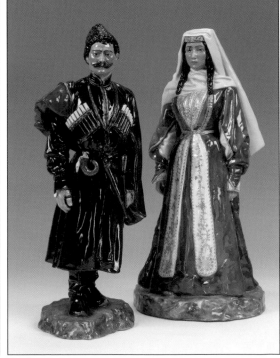

f

A LEZGIN

Date 1915, (height) 39.8 cm
Mark: green stencilled 'N II 1915' under a crown
Signature: 'A. Lukin' (for the sculptor A. Lukin) impressed in paste
Inscription: 'Lezgin' impressed in paste
Origin: from the main collection of the State Hermitage
State Hermitage Museum, inv. no. ERF-3714 *E.K.*

g

A SART WOMAN

Date 1915, (height) 39.4 cm
Mark: green stencilled 'N II 1915' under a crown
Signature: 'A. Lukin' (for the sculptor A. Lukin) impressed in paste
Inscription: 'Sart woman' impressed in paste
Origin: acquired in 1941 from the State Museum of Ethnography of the Peoples of the USSR
State Hermitage Museum, inv. no. ERF-3701 *E.K.*

h

A MORDVA GIRL FROM THE MOKSHA TRIBE

Date 1917-19
Marks: blue sickle and hammer with a fragment of a gear wheel and date '1919', over green stencilled date '1917'
Signatures: facsimile 'P. Kamensky' impressed in paste and handwritten 'N. S.' (for the sculptor N. Suslov)
Inscription: 'A Mordva girl from the Moksha tribe' impressed in paste
Origin: acquired in 1941 from the State Museum of Ethnography of the Peoples of the USSR
State Hermitage Museum, inv. no. ERF-3679 *E.K.*

E39

TWELVE MEDALS, BADGES AND TOKENS FROM THE PRIVATE COLLECTION OF TSAR NICHOLAS II

a

TOKEN COMMEMORATING THE FIFTIETH ANNIVERSARY OF THE MOSCOW IMPERIAL SOCIETY OF AMATEUR HORSE RIDING IN 1884, PRESENTED TO THE TSAREVICH NIKOLAI ALEXANDROVICH

4.6 x 3 cm
Origin: in the personal collection of Nicholas II in the Winter Palace
State Hermitage Museum, inv. no. ONGE Vz-308 *L.D.*

b

TOKEN IN THE FORM OF A FLAG, 1886

Silver and enamel, 6.2 x 2.6 cm (with chain)
Origin: in the personal collection of Nicholas II in the Winter Palace
State Hermitage Museum, inv. no. ONGE IO-4957 *M.D.*

c

HUNTING HORN AND TWO RIFLES WITH THE NUMBER 21, 1896(?)

Bronze and gold, 3.3 x 4.5 cm
Origin: in the personal collection of Nicholas II in the Winter Palace
State Hermitage Museum, inv. no. ONGE IO-4960

Probably a hunting token. *M.D.*

d

TOKEN COMMEMORATING THE SUCCESSFUL END OF THE GRADE MEASUREMENT IN I. SPITSBERGEN

Silver, gold and enamel, 4.9 x 3 cm
Mark: kokoshnik mark in a circle
Origin: in the personal collection of Nicholas II in the Winter Palace
State Hermitage Museum, inv. no. ONGE IO-4958

The token was approved on 20 July 1902 at the request of the President of the Imperial Academy of Science, Grand Duke Konstantin Konstantinovich. *M.D.*

e

TOKEN COMMEMORATING THE FORTIETH ANNIVERSARY OF THE FOUNDATION OF THE KOLOMENSKY MACHINE BUILDING FACTORY IN 1903

Gold and enamel, 4.4 x 2.6 cm
Marks: '56 ЯL ı VORBS'
Origin: in the personal collection of Nicholas II in the Winter Palace
State Hermitage Museum, inv. no. ONGE Az-708

In 1903 the huge factory, near Kolomna, celebrated its fortieth anniversary and the production of its three thousandth steam engine. The inscription 'TO THE EMPEROR' indicates that this token was made as a present to Tsar Nicholas II. *L.D.*

f

BADGE OF THE UNION OF THE RUSSIAN PEOPLE

Silver, enamel and gold, 4.9 x 3.3 cm
Marks: illegible maker's mark, mark for St Petersburg with
the initials 'AR' of the assay inspector A. V. Romanov, silver
standard mark '84', and kokoshnik mark
Origin: in the personal collection of Nicholas II in the
Winter Palace
State Hermitage Museum, inv. no. ONGE IO-4956

The Union of the Russian People was founded in
St Petersburg in November 1905 to fight against the
revolutionary movement. *M.D.*

g

MEDAL COMMEMORATING
THE PEACE CONFERENCE AT THE HAGUE

The Utrecht Mint, The Netherlands, 1907
Gold, 2.8 x 4.2 cm
Front: façade of Oude Gravenzaal (the building of the States
General) in The Hague under beams of light shining through
clouds and surrounded by a frame of olive branches; below
in two lines 'HAGAE COMITIS MCMVII'; below the medallist's
monogram (Johann Cornelius Wienecke)
Reverse: in a wreath of orange branches is an inscription in
fourteen lines, 'WILHELMINA NEERLANDIAE REGINA
ALTISSIMO. EXIMIO MAGNANIMO POTENTISSIMO AUCTORI
CONVENTUUM PACIS NICOLAO II RUSSIAE IMPERATORI
SALUTEM DAT GRATIASQUE AGIT'
Origin: acquired in 1922 from the Winter Palace; before that
in the personal collection of Nicholas II
State Hermitage Museum, inv. no. Az-1600

The second Hague Peace Conference was convened on
the initiative of the Tsar Nicholas II and was attended
by delegates from forty-four countries. This medal was
kept on display in the billiard room of the personal
apartments of the royal family in the Winter Palace.
The blue ribbon for wearing the medal has not been
preserved. *E.S.*

h

TOKEN OF THE SOCIETY OF FORMER
COMRADE-IN-ARMS OF THE 2ND DRAGOON
GUARDS REGIMENT OF PRUSSIA OF THE
EMPRESS ALEXANDRA FEODOROVNA,
ABOUT 1907(?)

White metal and fabric, 3.6 x 3.6 cm
Origin: in the personal collection of Nicholas II in the
Winter Palace
State Hermitage Museum, inv. no. ONGE IO-4973
 M.D.

i

BADGE OF THE SOCIETY FOR HELP TO THE
SOLDIERS INJURED IN THE WAR AND THEIR
FAMILIES

Alfred Thielemann, St Petersburg, mid 1910s
Coloured gold, silver and enamel, 4.5 x 5.4 cm
Marks: maker's mark 'AT' and St Petersburg assay mark
for 1908-17 with the gold standard '56'
Origin: in the personal collection of Nicholas II in the
Winter Palace
State Hermitage Museum, inv. no. ONGE Vz-309

The Society for Help to the Soldiers Injured in the War
and their Families was founded in 1906 and approved
two classes of badges on 5 May 1913. This badge was
specially made for Tsar Nicholas and the society's board
of directors met the cost of eighty-five roubles. *L.D.*

j

TOKEN COMMEMORATING COMPLETION OF
THE KOLCHUGINSKAYA RAILWAY

Made specially for the Emperor in 1915
Gold, silver and enamel, 3.9 x 1.9 cm
In the form of a piece of coal, made of silver with black
finishing, and with gold monogram of Nicholas II under the
Imperial crown; on reverse, below another Imperial crown, is
the coat of arms of the town of Tomsk; beneath this is the
inscription 'THE KOLCHUGINSKAYA RAILWAY', the symbol
of railway workers, the crossed axe and anchor, and dates
'1913-15'
Origin: in the personal collection of Nicholas II in the
Winter Palace
State Hermitage Museum, inv. no. ONGE Vz-312 *L.D.*

k

BADGE OF THE PETROGRAD ASYLUM FOR
INVALIDS FROM ENGINEERING

Gold, enamel and semi-precious stones, 3.2 x 2.8 cm
First Class badge, for patrons and guardians, in the form of
an equal triangle covered with blue enamel; on the front is a
representation of the Monomakh's Hat, decorated with Ural
stones, and dates '1613-1913' in Slavonic letters; on the
reverse is the inscription: 'PGD/ASYLUM/INVALIDS
ENGINEERING'
Marks: maker's mark 'K.P' and St Petersburg assay mark
for 1908-17 with the gold standard '56'
Origin: in the personal collection of Nicholas II in the
Winter Palace
State Hermitage Museum, inv. no. ONGE Vz-311

The Asylum was founded in 1915 by the Society of
Military, Navy and Agricultural Engineering. It approved
three classes of badges on 1 September 1915. *L.D.*

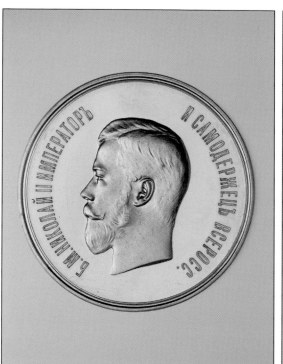

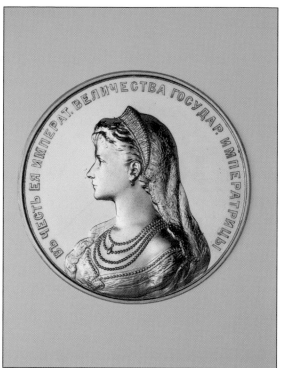

E40 (top and below) E41 (top and below)

I

TOKEN COMMEMORATING COMPLETION OF THE BUKHARA RAILWAY IN 1916

Gold, silver and enamel, 4.2 x 3.3 cm
Origin: in the personal collection of Nicholas II in the Winter Palace
State Hermitage Museum, inv. no. ONGE Vz-313 *L.D.*

E40

PRIZE MEDAL, NAMED AFTER THE EMPEROR NICHOLAS II, FROM THE IMPERIAL MOSCOW SOCIETY FOR THE ENCOURAGEMENT OF BREEDING TROTTING HORSES, 1903

St Petersburg Mint (designed by A. Vasyutinsky)
Gold, (diam.) 6.4 cm
Front: the Emperor's head is turned to the left, and there is a circular inscription, 'BY GOD'S MERCY NICHOLAS II THE EMPEROR AND THE MONARCH OF ALL RUSSIA'
Reverse: central inscription in four lines, 'PRIZE OF HIS IMPERIAL MAJESTY', and circular inscription, 'IMPERIAL MOSCOW SOCIETY FOR ENCOURAGEMENT OF BREEDING THE TROTTING HORSES'
Origin: acquired in 1905 from the St Petersburg Mint
State Hermitage Museum, inv. no. Az-806 *E.S.*

E41

PRIZE MEDAL, NAMED AFTER THE EMPRESS ALEXANDRA FEODOROVNA, FROM THE IMPERIAL MOSCOW SOCIETY FOR THE ENCOURAGEMENT OF BREEDING TROTTING HORSES, 1903

St Petersburg Mint
Gold, (diam.) 6.4 cm
Front: bust portrait of the Empress, turned to the left; the Empress is portrayed in a pearl kokoshnik, with a lace veil on her head, wearing a dress decorated with pearls, and four pearl necklaces on her breast; below, on the right edge, is the inscription 'GRILICH SON' (signature of the medallist A. A. Grilikhes)
Reverse: in the centre is a wreath of two laurel branches tied with a bow; between the laurel branches is a rectangular plaque for engraving a name; circular inscription, 'THE IMPERIAL MOSCOW SOCIETY FOR ENCOURAGEMENT OF BREEDING THE TROTTING HORSES'
Origin: acquired in 1905 from the St Petersburg Mint
State Hermitage Museum, inv. no. Az-805 *E.S.*

E42

MEDAL COMMEMORATING THE FIFTIETH ANNIVERSARY OF THE ST PETERSBURG IMPERIAL SOCIETY FOR THE ENCOURAGE-MENT OF BREEDING TROTTING HORSES IN 1911

Gold, 3.7 x 2.7 cm
Marks: maker's mark 'K.P.', St Petersburg assay mark with the initials of the assay inspector Yakov Lyapunov (active 1899-1903), and kokoshnik mark
Origin: acquired in 1980 through the Expert-Purchasing Commission of the State Hermitage
State Hermitage Museum, inv. no. ONGE Az-2662 *L.D.*

E43

MEDAL, SECOND CLASS, FOR ESCORTING THE IMPERIAL TRAIN, AWARDED TO THE RAILWAY ENGINEER N. S. DOBRANOV

Elisabeth or Evgeniy Tilemanov, St Petersburg, about 1915/16
Gold, enamel and diamond, 4.4 x 2.5 cm
Marks: maker's mark 'E.T.', St Petersburg assay mark for 1908-17, and gold standard '56'
Origin: acquired in 1986 through the Expert-Purchasing Commission of the State Hermitage
State Hermitage Museum, inv. no. Bz-1456

This type of token was approved on 4 May 1904 and had three ranks. It was designed by Agathon Fabergé and all three classes were made in the workshops of the Fabergé company. *L.D.*

E44

GIFT BROOCH, IN ITS ORIGINAL BOX, PRESENTED TO I. G. SAMSANOVA (1877-1972), A TEACHER OF PAINTING AT THE MOSCOW INSTITUTE FOR NOBLE GIRLS, FOR ORGANISING AN EXHIBITION OF PAINTINGS FOR THE VISIT OF TSAR NICHOLAS II

Alfred Thielemann, St Petersburg, about 1908-10(?)
Coloured gold, silver, diamonds and sapphires:
4.3 x 2.6 cm; 7.8 x 5.8 cm (box)
Marks: maker's mark 'A.T.' and the assay mark of St Petersburg for 1908-17 with the gold standard '56'
Origin: acquired in 1980 through the Expert-Purchasing Commission of the State Hermitage
State Hermitage Museum, inv. no. ONGE Vz-1391 *M.D.*

E45

PRESENTATION BROOCH
WITH A DOUBLE-HEADED EAGLE

Gold, silver, sapphires and diamonds, 3.3 x 2.9 cm
Origin: acquired in 1988 through the Expert-Purchasing
Commission of the State Hermitage
State Hermitage Museum, inv. no. ONGE Vz-1466

The quality of this brooch indicates that it was made by craftsmen associated with the Fabergé company. According to the former owner, it was presented to her mother at a reception in the Winter Palace for pupils who graduated with gold medals. *M.D.*

E46

PRESENTATION DISH

Unknown master, Sakhalin Island, 1891
Wood and silver, 45 x 45 cm
Unmarked
Inscribed: 'Sakhalin Island, 1891'; on the back a fragmentary
inscription: 'Work of the ex. convict. Vlad... Alex... nova
1891'
Origin: acquired in 1941 from the State Museum of
Ethnography of the Peoples of the USSR; before that in the
Diamond Store in the Winter Palace
State Hermitage Museum, inv. no. ERO-5426

This dish was presented to Nicholas during his return from the Far East in 1891. Three years later, it was exhibited in the Hermitage, in the exhibition of presents received by the Tsarevich during his trip. The first Russian settlers arrived to Sakhalin in 1857. Soon the island became one of the harshest places of detention in Russia. At the end of the 19th century nearly half the inhabitants were exiled convicts. *L.Z., K.O.*

E47

PRESENTATION BOX

Ekaterinburg Lapidary Factory, Ekaterinburg, 1891
Ural jasper, rock crystal, chrysolite, gold and silver, 15.7 x 40
x 21 cm
Marks: assay master's mark 'IA/1891' of I. Obregov, and
the town mark of Perm with the silver standard mark '84'
Inscribed on inside of lid: 'FROM THE CITIZENS OF EKATER-
INBURG'
Origin: from the Winter Palace
State Hermitage Museum, inv. no. ERO-6454

The whole surface of the box is decorated with triangular pieces of jasper mined in the Urals. On the cover is the monogram 'NA' in porphyry under the Imperial crown. The state coat of arms is under the key plate and the coat of arms of the town of Ekaterinburg inside the lid. The box was presented to Nicholas by the citizens of Ekaterinburg during his return from the Far East in 1891. It was exhibited in the Hermitage in 1894, in the exhibition of presents received by the Tsarevich during his trip. *L.Z., K.O.*

E48

PRESENTATION DISH

Porcelain plate Chinese, 19th century; frame made in the
workshop of I. A. Fuld, Moscow, 1896
Porcelain, silver and gold, 49 x 49 cm
Marks: the assay master's mark 'AS/1896', Moscow town
mark and the silver standard mark '84'
Inscribed: 'Work of I. Fuld. First harvest of the Russian tea.
Nizhny Novgorod exhibition. First Konstantina Popova
Russian Tea. 1895-1896'
Origin: from the Winter Palace
State Hermitage Museum, inv. no. ERO-5409

This dish was presented to Nicholas II on 20 June 1896 when he visited the tea pavilion at the Nizhny Novgorod fair. It is decorated with the coats of arms of St Petersburg, Moscow, Niznhy Novgorod and the Tiflis region.

L.Z., K.O.

PRESENTATION DISH AND SALT CELLAR

Workshop of Iosif Abramovich Marshak, Kiev, 1896
Labradorite, silver and gold: (dish) 54.5 x 54.5 x 5 cm;
(salt cellar) 16.5 x 14 x 14 cm
Marks: maker's mark of I. A. Marshak, assay master's mark
'CO/1896', Kiev town mark and silver standard mark '84'
Front of the dish inscribed: 'From the loyal nobility of Kiev',
monogram 'N II A', 'August 1896'; the back: 'Iosef Marshak's
work in Kiev' and 'Labradorite is made by V. V. Korchakov-
Sivitskiy'
Front of salt cellar inscribed: 'Work of Iosif Marshak in Kiev'
Origin: acquired from the State Museum of Ethnography of
the Peoples of the USSR; before that in the Diamond Store
of the Winter Palace
State Hermitage Museum, inv. nos. ERO-5428, 3922 a, b

The stone for the dish and salt-cellar was cut and
polished by V. V. Korchakov-Sivitskiy, the master-
lapidary from Kiev. Both items were presented by a
delegation of the Kiev aristocracy in August 1896,
when Nicholas II came to Kiev for the dedication of
St Vladimir's Cathedral. On top of the salt cellar is a
figure of the Archangel Michael, the crest of Kiev.
L.Z., K.O.

PRESENTATION DISH AND SALT CELLAR

F. Kulagin, St Petersburg, 1902
Wood and silver, 49 x 48.5 cm; 10.8 x 16 cm
Marks: maker's mark 'FK', and St Petersburg town mark for
1896-1903 with the initials of the assay inspector Yakov
Lyapunov and the silver standard '84'
Inscribed in centre: 'From the Kursk Nobility. 1902'
Origin: from the Diamond Room of the Winter Palace
State Hermitage Museum, inv. nos. ERO-5422, 3920

These pieces were presented on 1 September 1902
during the 'tsar' days in Kursk by the Head of the
Regional Nobility, Master of the Horse Durnovo.
L.Z., K.O.

PRESENTATION DISH

Workshops of Edward Ivanovich Kortman, St Petersburg,
1903
Wood, silver and gold, 51 x 49 cm
Marks: maker's mark 'EK' and St Petersburg assay mark for
1896-1903 with the silver standard '84'
Inscribed: 'Workers of the Nevsky shipbuilding and
mechanical factory 14 August 1903'
Origin: acquired in 1941 from the State Museum of
Ethnography of the Peoples of the USSR; before that in the
Silver Room of the Winter Palace
State Hermitage Museum, inv. no. ERO-5423

This dish was presented to Nicholas II on 17 August
1903 to commemorate the launch of the armoured
cruiser *Zhemchug*. During the Russo-Japanese war of
1904-5 the cruiser took part in the Battle of Tsushima.
In the First World War it was part of an Allied squadron
and escorted merchant ships in the Indian Ocean. The
Zhemchug was sunk on 15 October 1914. *L.Z., K.O.*

PRESENTATION DISH

K. Linke for K. E. Bolin, St Petersburg, 1903-4
Wood, silver and gold, 70 x 70 cm
Marks: maker's marks 'KL' and 'BOLIN', and Moscow assay
mark for 1896-1903 with the silver standard '84'
Inscribed: 'To His Imperial Majesty the Emperor Nicholas II
from the Don Nobility, 16 August 1904'
Origin: acquired in 1941 from the State Museum of
Ethnography of the Peoples of the USSR; before that in
the Diamond Store of the Winter Palace
State Hermitage Museum, inv. no. ERO-5429

On 16 August 1904 this dish was presented to Nicholas
II by a delegation of the Don nobility in a Cossack
camp near the town of Novocherkassk. The presen-
tation took place during the inspection of troops,
before they were sent off to war. *L.Z., K.O.*

E48

E51

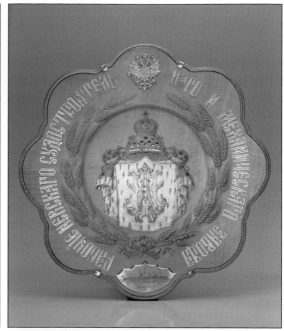

E55

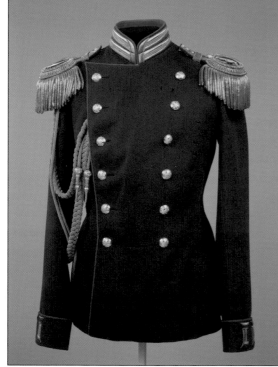

E56

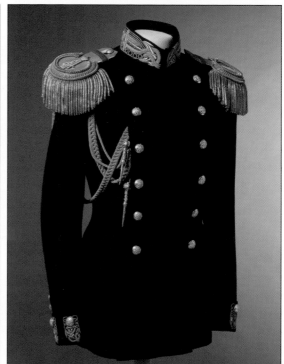

E53

CEREMONIAL COVER

Lypetsk Orphanage, Lypetsk, 1883
Cloth, lint lace, silk, cross embroidery and netting,
244 x 47 cm
Inscribed on one side under the monogram 'MF' and an
Imperial crown, 'Honour by accepting' and 'children's work';
on the other side '15 May 1883', 'Tsarina is our Mother' and
'Lipetsk orphanage'
Origin: acquired in 1941 from the State Museum of
Ethnography of the Peoples of the USSR; before that in the
collection of N. L. Shabelskaya
State Hermitage Museum, inv. no. ERT-9334 *E.M.*

E54

CEREMONIAL COVER

Russian, early 20th century
Cloth, with silk embroidery, 224 x 40.5 cm
Inscribed: 'God save the Tsar'
Origin: acquired in 1941 from the State Museum of
Ethnography of the Peoples of the USSR; before that in the
collection of N. L. Shabelskaya
State Hermitage Museum, inv. no. ERT-19417 *E.M.*

E55

UNIFORM OF AN OFFICER OF THE 16TH INFANTRY REGIMENT OF TSAR ALEXANDER III, BELONGING TO TSAR NICHOLAS II

Russian, early 1900s
Woollen cloth, silk, gold braid and tassels, and other
materials: (uniform, back) 69 cm; (waist) 106 cm; (epaulettes)
16.5 x 15 cm; (gorget) 13 x 8 cm; (aiguillette, length) 110.5
cm; (sash) 99.5 cm x 5 cm
Origin: the uniform was acquired in 1973 from the palaces-
museums of Pushkin; before that it was in the Alexander
Palace at Tsarskoe Selo (in the wardrobe of the Emperor
Nicholas II); aiguillette and sash acquired in 1941 from the
State Museum of Ethnography of the Peoples of the USSR
State Hermitage Museum, inv. nos. ERT-18195 a, b, c, d
(uniform); 14813 (aiguillette); 10769 (sash) *S.L.*

E56

CEREMONIAL UNIFORM OF A NAVAL OFFICER, WHICH BELONGED TO TSAR NICHOLAS II

Russian, early 1900s
Woollen cloth, silk, metal wire, gold, copper and other
materials: (uniform, back) 78 cm, (waist) 101 cm; (epaulettes)
16.5 x 12 cm; (aiguillette, length) 94 cm
The double-breasted uniform is made of black cloth and has
Naval embroidery on the collar and cuffs and gilded buttons;
epaulettes are of a first rank captain and have monogram of
Emperor Alexander III beneath the Imperial crown; aiguillette
of gold is of special court style
Origin: the uniform was acquired in 1973 from the palaces-
museums of Pushkin; previously in the Alexander Palace at
Tsarskoe Selo (in the wardrobe of Emperor Nicholas II); the
aiguillette was acquired in 1941 from the State Museum of
Ethnography of the Peoples of the USSR
State Hermitage Museum, inv. nos. ERT-18194 a, b, c
(uniform with epaulettes), 10805 (aiguillette)

Unlike some other members of the Imperial family,
Nicholas II was not in the Navy, although he gained
some experience of naval life on the cruiser *Pamiat Azov*
during his world tour in 1890-91. As Emperor he wore
the Navy uniform of a first rank Captain (which was
the equivalent of his Army rank of Colonel) during
Navy ceremonies and aboard the Imperial yachts. *S.L.*

E57

CEREMONIAL UNIFORM OF AN OFFICER OF THE CAVALRY GUARDS REGIMENT, INCLUDING A JACKET OWNED BY TSAR NICHOLAS II

St Petersburg, early 1900s
Cloth, steel, brass, leather, gold, silk, silver, other materials:
(jacket, back) 75.5 cm, (waist) 92 cm; (epaulettes, each)
18 x 12.5 cm; (helmet) 37.2 x 26.7 x 19 cm; (cuirass, breast
plate) 48 x 35.5 x 17.5 cm; (cuirass, back plate) 44 x 35.5
x 15 cm; (cartridge pouch) 16.5 x 8.5 x 4.7 cm; (sword belt)
137 x 5 cm; (sash) 92.5 x 5 cm
Jacket or tunic of white cloth with red collar, cuffs and piping;
collar, lapels and cuffs faced with silver braid and red stripes;
silver stitching on buttonholes and buttons; silver epaulettes
of the Captain of the Horse are for the Guards Regiments
and do not belong to the ordinary set; officer's helmet made
of gilded brass with silver crowned double-headed eagle on
the top and St Andrew's star on the front; chin belt covered
with silver-plated metal scales; round metal cockade on the
right side; cuirass (breast plate and back) made of gilded
steel, decorated with red cord along borders, with shoulder
straps of red leather with gilt metal scales; cartridge box of
the Guards Regiment with St Andrew's star on silver top and
sword belt of red leather decorated with silver braid
Origin: acquired in 1941 from the State Museum of
Ethnography of the Peoples of the USSR; before that the
jacket was in the Alexander Palace at Tsarskoe Selo (in the
wardrobe of the Emperor Nicholas II); helmet and cuirass
acquired in 1975 from the Armoury of the State Hermitage
State Hermitage Museum, inv. nos. ERT-12757 (jacket),
10633 b, c (epaulettes), 18786 (helmet), 18797 a, b (cuirass),
10820 (cartridge box), 10822 (sword belt), 10768 (sash)

The Cavalry Guards were one of the outstanding
Guards cavalry regiments. They trace their origin back
to a company of bodyguards formed by Peter the Great
at the time of the coronation of Ekaterina Alexeevna in
1724. During the 18th century, the Cavalry Guards
protected the Emperor but were not officially part of
the Guards. In 1799 Paul I established the Cavalry
Guards as an official part of the Guards. A year later
they became a regiment. From 1881-1917 Tsar Nicholas's
mother, the Dowager Empress Marie Feodorovna, was
the Chief of the Cavalry Guards. Nicholas himself and
his son Alexei were enrolled in the regiment from birth.

S.L.

E58

SET OF TEN ORDERS AND MEDALS BELONGING TO TSAR NICHOLAS II

Gold, silver, bronze, enamel and silk, 17 x 9.7 cm
The four orders and six medals consist of:
Badge of the Order of St Vladimir, Fourth Class (instituted 22
September 1782), 3.4 x 4.5 cm;
France – Croix de Guerre with swords (instituted 8 April
1915), 3.6 x 4.6 cm;
Medal commemorating the Coronation of the Emperor
Alexander III (instituted 4 May 1884), (diam.) 2.9 cm;
Medal commemorating the reign of Alexander III (instituted
17 March 1896), (diam.) 2.7 cm;
Medal commemorating the two hundredth anniversary of the
victory at Poltava (instituted 27 June 1909), (diam.) 2.7 cm;
Medal commemorating the hundredth anniversary of the
Patriotic War of 1812 (instituted 26 August 1912),
(diam.) 2.7 cm;
Medal commemorating the Tercentenary of the Reign of the
House of Romanov (instituted 12 March 1913), (diam.) 2.8 cm;
Medal commemorating the two hundredth anniversary of the
Battle of Gangut (instituted 12 June 1914), (diam.) 2.7 cm;
Denmark – Badge of the Order of Daneborg (the Danish flag)
(instituted 1219, re-established 1671), 2.7 x 5.7 cm;
Greece – Badge of the Order of the Saviour (instituted
1833), 3.3 x 5.5 cm
Origin: acquired in 1938 from the former Gallery of Treasures
of the Winter Palace
State Hermitage Museum, inv. no. ONGE Vz-319 *M.D.*

E59

STAR OF THE ORDER OF ST ANDREW THE FIRST-CALLED

Wilhelm Keibel, St Petersburg, mid-19th century
Gold and enamel, 8.2 x 8.3 cm
Marks: maker's mark 'Keibel', coat of arms of St Petersburg
in a circle, and silver standard mark '84'
Origin: from the State Museum Fund
State Hermitage Museum, inv. no. ONGE Vz-1320

The Order of St Andrew the First-Called – the first and
highest Russian Order – was inaugurated by Peter the
Great at the end of the 1690s. *M.D.*

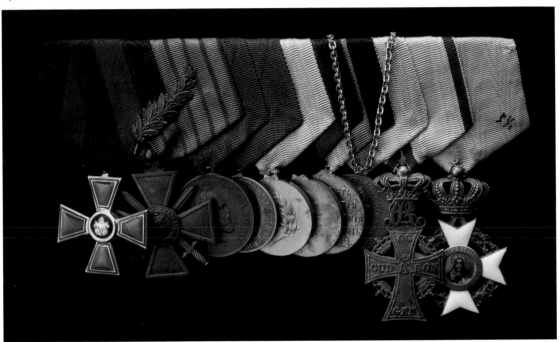

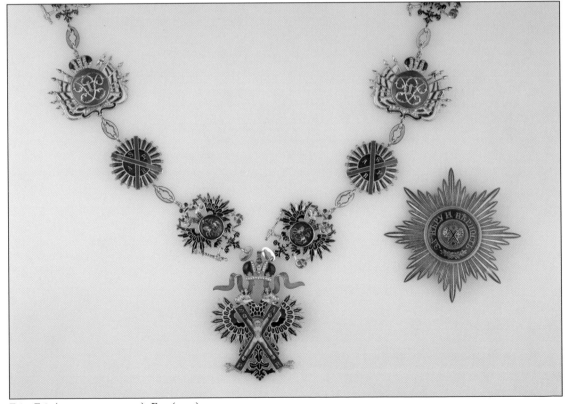

E60, E61 (CHAIN AND BADGE); E59 (STAR)

E60

CHAIN OF THE ORDER OF ST ANDREW
THE FIRST-CALLED

Wilhelm Keibel, St Petersburg, 1856
Gold and enamel, 5.5 x 106 cm
Marks: maker's marks 'Keibel' and 'WK', double-headed
eagle mark denoting a supplier to the court, coat of arms of
St Petersburg and year 1856, and gold standard mark '72'
Origin: from the State Museum Fund
State Hermitage Museum, inv. no. ONGE Vz-1384 *M.D.*

E61

BADGE OF THE ORDER OF ST ANDREW
THE FIRST-CALLED

Wilhelm Keibel, St Petersburg, 1861
Gold and enamel, 6.3 x 8.1 cm
Marks: maker's mark 'WK', the double-headed eagle mark
denoting a supplier to the court, coat of arms of St
Petersburg in a circle, and the gold standard mark '56'
Origin: acquired in 1863 from the Chapter House of Orders
State Hermitage Museum, inv. no. ONGE Vz-93 *M.D.*

E62

RIDING CROP IN ITS ORIGINAL CASE

'Edward', St Petersburg, 1910s
Wood, silver, gold, enamel and leather, 2 x 82.5 x 2 cm
There are no marks on the crop
The case is inscribed: 'EDWARD. MANUFACTURE OF
SYMBOLS AND TOKENS. DIAM. GOL. AND SILV. ART.
NEVSKIY 10 TEL 663'
Origin: acquired in 1956 from the Central Depository of the
Leningrad Surburban Palaces; before that in the Alexander
Palace at Tsarskoe Selo
State Hermitage Palace, inv. no. ERO-8682 a, b

**The riding crop belonged to the Grand Duchess Olga
Nikolaevna.** *L.Z., K.O.*

E63

LADY'S DOLMAN OF THE 5TH
ALEXANDRIYSKY HUSSARS, BELONGING TO
THE EMPRESS ALEXANDRA FEODOROVNA,
COMMANDER-IN-CHIEF OF THE REGIMENT

Workshop of P. Kitaev, St Petersburg, 1907-17
Woollen cloth, silk, silver braid and cords, and other
materials, (back) 67 cm, (waist) 82 cm
Origin: acquired in 1941 from the State Museum of
Ethnography of the Peoples of the USSR; before that in the
Alexander Palace at Tsarskoe Selo (in the wardrobe of the
Empress Alexandra Feodorovna [?])
State Hermitage Museum, inv. no. ERT-12759

As a unique honour following the birth of the
Tsarevich Alexei, the Empress Alexandra was appointed
Commander-in-Chief of the 5th Alexandriysky
Dragoon Regiment. Exactly three years later, Alexei was
enrolled in the regiment. In December 1907 the
Alexandriysky Dragoon Regiment reverted to being
called Hussars and went back to wearing their tradi-
tional black and silver Hussar uniforms (as here). *S.L.*

E64

COURT UNIFORM OF A SOLDIER OF THE
CAVALRY REGIMENT OF THE LIFE-GUARDS

Russian, 1855-1914
Kersey (woollen cloth), leather, linen, brass, silver, gold and
other materials: (collet, back) 77.5 cm, (waist) 90 cm; (helmet)
36.5 x 28.5 x 18 cm; (soubreveste [scarlet jacket], back)
52 cm
Origin: acquired in 1941 from the State Museum of
Ethnography of the Peoples of the USSR; before that in the
Imperial Academy of Arts
State Hermitage Museum, inv. nos. ERT-10634 (collet);
10872 (helmet); 10603 (soubreveste) *S.L.*

E65

UNIFORM OF A COSSACK OF THE BEDCHAMBER

St Petersburg, late 19th-early 20th century
Woollen cloth, silk and metallic threads, gold braid
and tassels, metal, leather, fur and other materials:
(outer caftan, length) 126 cm; (inner caftan) 93 cm; (trousers)
109 cm; (*papakha* [Caucasian hat]) 16 x 22 cm
Origin: acquired in 1941 from the State Museum of
Ethnography of the Peoples of the USSR; the inner caftan
jacket belonged to Timofey Ksenofontovich Yaschik (1878-
1946), an orderly of the Emperor Nicholas II and, from 1915
to 1928, the Chamber Cossack of the Empress Marie
Feodorovna
State Hermitage Museum, inv. nos. ERT-11923, 11926,
11915, 12638 *T.T.K., N.T.*

E66

CEREMONIAL COURT COSTUME OF THE EMPRESS ALEXANDRA FEODOROVNA

Workshop of O. N. Bulbenkova, St Petersburg,
late 19th-early 20th century
Silk, embroidery and artificial pearls: (length of bodice) 39
cm; (skirt) 103 cm; (train) 300 cm
Dress (bodice, skirt, train) of blue and white silk, artificial
pearls and cloth embroidery; lengthened bodice with a snip
with large oval *décolletage* and long folding sleeves, with a
partially opened armhole; skirt is flared, with pleats along the
back, with a train; a removable train on the belt with soft
pleats; embroidery with artificial pearls on bodice, on the
centre of skirt and along borderline of the train; dress is
decorated with fringe imitating fur
On the bodice is the name of the company in gold: 'Mrs
Olga Dresses S.-Petersburg Moyka № 8'
Origin: acquired in 1941 from the Museum of Ethnography of
the Peoples of the USSR; before that in the Winter Palace (in
the wardrobe of the Empress Alexandra Feodorovna)
State Hermitage Museum, inv. no. ERT-13146 a, b, c
 T.T.K.

E67

CEREMONIAL COURT COSTUME

St Petersburg, about 1900
Silk, satin, artificial pearls and embroidery:
(length of bodice) 33 cm; (skirt) 103 cm; (train) 228 cm
Costume is made of silk decorated with a pattern and
white satin; lengthened bodice with a snip has large oval
décolletage and long folding sleeves; flared skirt has soft
pleats on the back; a removable train on belt has pleats
along centre of the back; the costume is decorated with
chiffon and embroidery with artificial pearls
Origin: acquired in 1941 from the State Museum of
Ethnography of the Peoples of the USSR; before 1917 in
the Winter Palace
State Hermitage Museum, inv. no. ERT-13134 a, b, c

The style of female court costume was established in
1834 by a special decree which strictly regulated the
style and colour of fabric, as well as the kind of
decoration, depending on the court position of the
lady. The regulation about court dress was included in
the Collection of the Laws of the Russian Empire. *T.K.*

E68

COURT DRESS FOR A CHILD

Russian, early 1900s
Silk, silver wire and gauze, (length along back) 83 cm
Court *décolleté* dress for a child 'in Russian style' is made of
silk of silver colour with a woven silver 'Dandelion' pattern;
bordered with silver ribbon, it has metal buttons on the front
and lace on the back of the bodice; the silk-lined dress has
two flounces of Valenciennes lace along the hem
Origin: acquired in 1941 from the State Museum of
Ethnography of the Peoples of the USSR; before that in the
Alexander Palace at Tsarskoe Selo
State Hermitage Museum, inv. no. ERT-13600

The Grand Duchesses can be seen wearing similar
dresses in official photographs. According to the rules,
the dress had to be worn with a *kokoshnik* of glazed
brocade decorated with pearls and the Order of Saint
Catherine. *Y.P.*

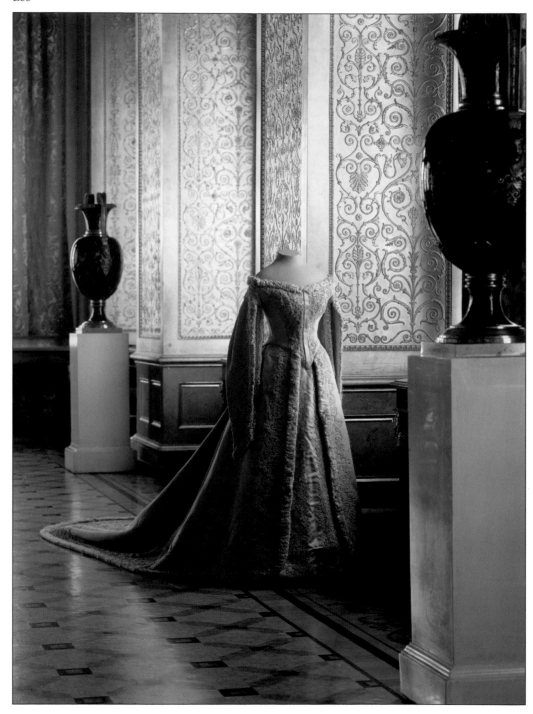

E69

CEREMONIAL COURT COSTUME OF THE GRAND DUCHESS OLGA NIKOLAEVNA

Workshop of O. N. Bulbenkova, St Petersburg, about 1913
Satin, tulle, imitation flowers, velvet and mother-of-pearl:
(length of bodice) 35 cm; (dress) 138 cm; (train) 262 cm
On the corset ribbon is the name of the company, printed in
gold: 'Mrs Olga. Court trains and dresses. Yekaterinski
Canal, block 68, apartment 4'
Origin: acquired in 1941 from the State Museum of
Ethnography of the Peoples of the USSR
State Hermitage Museum, inv. no. ERT-13142 a, b *T.T.K.*

E70

COURT BLACKAMOOR'S UNIFORM

St Petersburg, late 19th-early 20th century
Woollen cloth, silk and metallic threads, gold braid
and tassels, leather, metal, velvet, and other materials:
(outer jacket [bambette], length) 53 cm; (inner jacket
[bambette]) 54 cm; (camisole) 45.5 cm; (trousers) 117 cm;
(leggings) 49 x 44 cm; (shoes) 30 cm; (sash) 11 x 341 cm
Origin: acquired in 1941 from the State Museum of
Ethnography of the Peoples of the USSR
State Hermitage Museum, inv. nos. ERT-11901, 11899,
11946, 11904, 11962 a, b, 11970 a, b, 11952 *T.T.K., N.T.*

E71

UNIFORM OF A COURT FOOTMAN

St Petersburg, late 19th-early 20th century
Woollen cloth, silk and metallic threads, gold braid and cord,
leather, velvet and other materials: (caftan, length) 92 cm;
(epaulettes) 12 cm; (inner jacket) 71 cm; (trousers) 75 cm
Origin: acquired in 1941 from the State Museum of
Ethnography of the Peoples of the USSR
State Hermitage Museum, inv. nos. ERT-12095, 12096,
11820, 11817, 11813 *T.K., N.T*

E72

CEREMONIAL CHAMBERLAIN'S UNIFORM, WITH CHAMBERLAIN'S GILT BRONZE KEY ON RIBBON

St Petersburg, late 19th-early 20th century
Woollen cloth, silk and metallic threads, gold braid, leather,
metal, ostrich feathers, and other materials:
(jacket, length) 91 cm; (bicorn hat, height) 17 cm, (cross
section) 43 cm; (key) 15 cm
Origin: acquired in 1941 from the State Museum of
Ethnography of the Peoples of the USSR
State Hermitage Museum, inv. nos. ERT-10985, 11538,
3627 *T.T.K., N.T*

E73

THREE GOBLETS WITH THE MONOGRAM 'N II A' AND A DOUBLE-HEADED EAGLE

Workmaster Lavr Orlovsky, Imperial Glass Factory,
St Petersburg, late 19th century
Glass, with cut, engraved, painted and gilded decoration:
16.7 x 7.3 x 7.3 cm; 20 x 9.1 x 9.1 cm; 20 x 9.1 x 9.1 cm
Origin: acquired in 1948 from the State Museum of
Ethnography of the Peoples of the USSR
State Hermitage Museum, inv. nos. ERS-1131, 3029, 3030

These goblets were used on the most formal occasions.
T.M.

E74

PLATE FROM THE RAPHAEL SERVICE

Imperial Porcelain Factory, St Petersburg, 1884
Porcelain, with overglaze polychrome painting and gilding,
2.5 x 21 x 21 cm
Marks: underglaze green 'A III' beneath a crown, and a red
with gold hand-painted monogram 'A III' beneath a crown,
with handwritten date '1884' in gold
Origin: from the main collection of the State Hermitage
State Hermitage Museum, inv. no ERF-6978 *E.K.*

E75

PLATE FROM THE RAPHAEL SERVICE

Imperial Porcelain Factory, St Petersburg, 1885
Porcelain, with overglaze polychrome painting and gilding,
1.9 x 17.4 x 17.4 cm
Marks: underglaze green 'A III' beneath a crown, and a red
with gold hand-painted monogram 'A III' beneath a crown,
with handwritten date '1885' in gold
Origin: from the main collection of the State Hermitage
State Hermitage Museum, inv. no. ERF-8711

The Raphael service was designed under the super-
vision of the head of the painting workshops of the
Imperial Porcelain factory, L. L. Shaufelberger, and is
decorated with ornamental and allegorical composi-
tions based on Raphael's Loggia in Rome. It was begun
in 1883 and completed twenty years later. *E.K.*

E76

PLATE FROM THE ALEXANDRA TURQUOISE
SERVICE

Imperial Porcelain Factory, St Petersburg, 1900
Porcelain, with overglaze polychrome painting and gilding,
1.5 x 13.5 x 13.5 cm
Mark: underglaze green 'H II 1911' beneath a crown
Origin: acquired in 1941 from the State Museum of
Ethnography of the Peoples of the USSR
State Hermitage Museum, inv. no. ERR-6357 *T.V.K.*

E77

DESSERT BOWL FROM THE ALEXANDRA
TURQUOISE SERVICE

Imperial Porcelain Factory, St Petersburg, 1903
Porcelain, with overglaze polychrome painting and gilding,
4.5 x 21.5 x 21.5 cm
Mark: underglaze green ' N II 1911' beneath a crown
Origin: acquired in 1941 from the State Museum of
Ethnography of the Peoples of the USSR
State Hermitage Museum, inv. no. ERR-6359

The Alexandra Service was one of the last ceremonial
services to be commissioned for the Winter Palace and
was named after the Empress Alexandra Feodorovna,
who ordered it in 1899. *T.V.K.*

E78

PLATE FROM THE TSARSKOE SELO
PURPLE SERVICE

Imperial Porcelain Factory, St Petersburg, 1905
Porcelain, with overglaze monochrome painting and gilding,
2.7 x 24.8 x 24.8 cm
Mark: underglaze green 'N II 1905' beneath a crown
Origin: acquired in 1987 from the Expert-Purchasing
Commission of the State Hermitage
State Hermitage Museum, inv. no. ERF-8567

The Empress Alexandra approved the design of this
dinner service, by A. F. Maximov, for Tsarskoe Selo in
1902 and it was completed in 1908. *E.K.*

E79

RECORD OF THE IMPERIAL HUNT FOR 1908

Rudolf Feodorovich Frentz (1831-1918), dated 1908
Watercolours, pencil and ink on paper glued to card,
48.7 x 32 cm
Signed on the left: 'R. Frents'
Origin: acquired from the library of Nicholas II in the
Winter Palace
State Hermitage Museum, inv. no. ERR-8374

Tsar Nicholas frequently went hunting in the winter of
1907-8, usually in the area around St Petersburg. On 25
January 1908 he recorded in his diary: 'I bagged: 116
pheasants, 2 grey partridge and 1 white hare, total 119.'
 G.P.

E80

RECORD OF THE IMPERIAL HUNT FOR 1911

Rudolf Feodorovich Frentz (1831-1918), dated 1911
Watercolours, pencil and ink on paper glued to card,
52 x 33.4 cm
Signed on the left: 'R. Frents'
Origin: acquired from the library of Nicholas II in the
Winter Palace
State Hermitage Museum, inv. no. ERR-8377

Tsar Nicholas is depicted shooting pheasants, probably
around Gatchina, near St Petersburg. *G.P.*

E79

E80

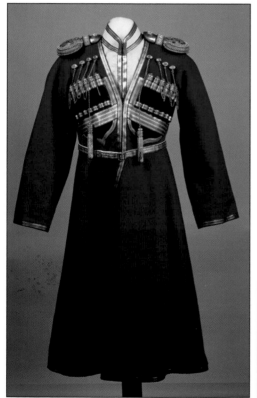

E81

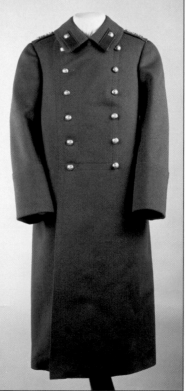

E82

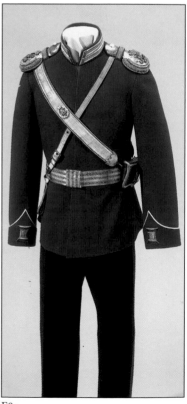

E83

E81

CHILD'S CEREMONIAL UNIFORM OF AN OFFICER OF HIS IMPERIAL MAJESTY'S OWN CONVOY, BELONGING TO THE TSAREVICH ALEXEI NIKOLAEVICH (CHERKESSKA WITH GAZYRS AND BESHMET)

Russian, 1910s
Woollen cloth, silver, velvet, silk, wood, leather, mother-of-pearl and other materials: (coat, length of back) 94 cm; (back of beshmet [caftan]) 75.5 cm
Origin: acquired in 1941 from the State Museum of Ethnography of the Peoples of the USSR; before that in the Alexander Palace at Tsarskoe Selo (in the wardrobe of the Tsarevich Alexei Nikolaevich)
State Hermitage Museum, inv. nos. ERT-13365/1-9; 13370 (beshmet) *S.L.*

E82

COAT AND JACKET OF THE UNIFORM OF THE LIFE-GUARDS CHASSEURS REGIMENT, BELONGING TO THE TSAREVICH ALEXEI NIKOLAEVICH

Russian, 1910s
Woollen cloth, silk, gold and other materials:
(jacket, back) 52 cm, (waist) 86 cm; (shoulder boards) 10.7 x 5 cm; (coat, back) 99 cm
Origin: acquired in 1941 from the State Museum of Ethnography of the Peoples of the USSR; before that in the Alexander Palace at Tsarskoe Selo
State Hermitage Museum, inv. nos. ERT-18202 a, b, c (jacket with cornet's shoulder boards); 12799 (coat) *S.L.*

E83

CHILD'S UNIFORM OF AN OFFICER OF THE 1ST URAL HUNDRED OF THE CONSOLIDATED COSSACK REGIMENT OF HIS IMPERIAL MAJESTY'S LIFE-GUARDS, BELONGING TO THE TSAREVICH ALEXEI NIKOLAEVICH

Russian, 1910s
Woollen cloth, silk, gold, silver, metal, card and other materials: (uniform, back) 55 cm, (waist) 78 cm; (epaulettes) 13 x 8.2 cm; (trousers, length) 88 cm; (cartridge pouch) 13 x 7.2 x 3 cm
Origin: acquired in 1941 from the State Museum of Ethnography of the Peoples of the USSR; before that in the Alexander Palace at Tsarskoe Selo (in the wardrobe of the Tsarevich Alexei Nikolaevich)
State Hermitage Museum, inv. nos. ERT-13372 (uniform); 13373 a, b (epaulettes); 13374 (trousers); 13375 a, b (cartridge pouch with sword belt); 13376 (shoulder belt); 13367 (sash) *S.L.*

E84

WORKING MODEL OF A PRINTING PRESS PRESENTED TO THE TSAREVICH ALEXEI NIKOLAEVICH BY THE PRISONERS OF THE FIRST PRISON, NIZHNY NOVGOROD, 1904-17

Steel, wood, lead, velvet and lacquer, 45 x 55.5 x 39 cm
Inscribed on the base: 'To His Imperial Highness the Heir to the Throne Tsarevich Alexei Nikolayevich'; on the top beam of the press frame: 'Made by the prisoners of the 1st prison of Nizhni-Novgorod'
State Hermitage Museum, inv. no. ONPTx-20 *G.BY.*

E85

MODELS OF A PLOUGH AND A HAY COLLECTOR PRESENTED TO THE TSAREVICH ALEXEI NIKOLAEVICH

Russian, 1915
Steel, copper and paint: 13.3 x 41 cm; 5 x 14.5 cm
Inscribed on the copper plate: 'TO TSESAREVICH ALEXEY NICKOLAYEVICH FROM THE METAL-WORK AND BLACK-SMITH CRAFT DEP. OF THE VOZNESENSKIY HIGHER PREPARATORY SCHOOL'
On the base: 'TEACHER – MASTER A. SOKOLOV. STUDENTS: SKRYABIN. A. PERETYAGIN. A. SHEMYAKIN. V. KHYDYNTSEV. I. 5 MAR.1915'
State Hermitage Museum, inv. no. ERTx-1782 *G.B.Y.*

E86

TOKEN OF THE INTERNATIONAL EXHIBITION OF THE NEWEST INVENTIONS UNDER THE AUSPICES OF THE TSAREVICH ALEXEI NIKOLAEVICH IN 1909, IN ITS ORIGINAL BOX

Silver, 7.3 x 2.6 cm (with chain)
Inscription on inside cover of box: Fabergé company's symbol denoting a supplier of the Imperial court, together with the double-headed eagle and inscription 'SAINT-PETERSBURG, MOSCOW, ODESSA'
Origin: from the personal collection of Nicholas II in the Winter Palace
State Hermitage Museum, inv. no. ONGE IO-3043 a, b
 L.D.

E87

THE CHILDHOOD, EDUCATION AND YOUTH OF THE RUSSIAN EMPERORS, PUBLISHED TO CELEBRATE THE TENTH BIRTHDAY OF HIS IMPERIAL HIGHNESS THE TSAREVICH ALEXEI NIKOLAEVICH

Compiled by I. N. Bozheryanov
A. Benke Press, St Petersburg, 1914
Leather binding with polychrome gilded design; with portrait of Alexei in the centre in a circle, paper and ink, 37 x 28 cm
State Hermitage Museum, inv. no. 365703 *G.V.Y.*

The Silver Age †

E88

PHOTOGRAPH FRAME IN THE SHAPE OF A LEAF

Fabergé, Moscow, early 1900s
Silver, gold, sapphire, glass and photograph, 6.2 x 6.5 cm
Marks: the Fabergé mark and Moscow assay mark for 1896-1903
Origin: acquired in 1941 from the State Museum of Ethnography of the Peoples of the USSR; before that in the Sheremetev's Fountain House
State Hermitage Museum, inv. no. ERO-6750

Count Boris Petrovich Sheremetev (born 1901) is portrayed in the photo. *L.Z., K.O.*

E89

DOUBLE-SIDED PHOTOGRAPH FRAME

Karl Gustav Hjalmar Armfeldt for Fabergé, St Petersburg, 1910s
Silver, enamel and gold, 10.6 x 7.5 cm
Marks: maker's mark 'ЯA', the Fabergé mark, and St Petersburg assay mark for 1908-17 with the silver standard '88'
Origin: acquired in 1929 from the State Museum Fund
State Hermitage Museum, inv. no. ERO-4915 *L.Z., K.O.*

E90

FOLDING LORGNETTE

Fabergé workshop, St Petersburg, made under the supervision of the workmaster Heinrik Emanuel Wigström, early 1900s
Gold, diamonds, sapphire, glass and enamel, 13 x 4 cm
Marks: maker's mark 'HW', and a St Petersburg assay mark for 1896-1907
Origin: acquired in 1984 through the Expert-Purchasing Commission of the State Hermitage
State Hermitage Museum, inv. no. ERO-9403 *L.Z., K.O.*

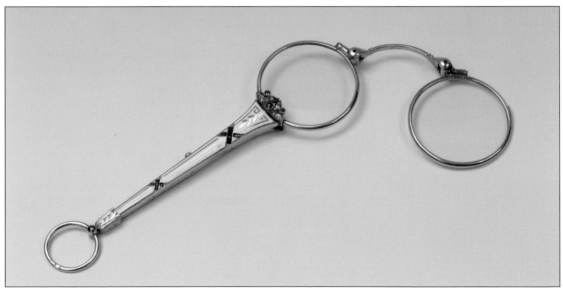

E91

SEAL WITH THE COAT-OF-ARMS
OF A GRANDSON OF AN EMPEROR

Yuli Alexandrovich Rappoport, St Petersburg
Silver, milk glass and almandine, 6.3 x 2.7 x 2.7 cm
Marks: maker's mark 'I.P.', St Petersburg mark with the initials
of the assay inspector 'Ya L' for Yakov Lyapunov (active
1899-1903), and the kokoshnik silver standard mark '88'
Origin: acquired in 1984 through the Expert-Purchasing
Commission of the State Hermitage
State Hermitage Museum, inv. no. ONGE IP-1364 *M.D.*

E92

BROOCH

August Wilhelm Holmström for Fabergé, St Petersburg,
1910s
Gold, diamonds and spinel, 2.5 x 2.5 cm
Marks: maker's mark 'AH', and St Petersburg assay mark for
1908-17 with the gold standard '56'
Origin: acquired in 1981 through the Expert-Purchasing
Commission of the State Hermitage
State Hermitage Museum, inv. no. ERO-9295

This brooch, decorated with the figure of a griffin, the
Romanov coat of arms, belonged to N. N. Veselago
(1870-1919). It was awarded for courage on the battle-
fields of the First World War. Veselago was a captain of
the first rank and a participant in two round-the-world
voyages on the ship *Vityaz*. After the October revolution
he was the Navy Inspector of the Soviet Republic.

L.Z., K.O.

E93

BROOCH IN THE SHAPE OF A HORSE-SHOE

Fabergé, St Petersburg, 1910s
Gold, diamonds and enamel, 2.8 x 2.2 cm
Marks: Fabergé maker's mark 'KF', gold standard mark '56',
and inventory number '26030'
Origin: acquired in 1995 through the Expert-Purchasing
Commission of the State Hermitage
State Hermitage Museum, inv. no. ERO-10037 *L.Z., K.O.*

E94

PENDANT IN THE FORM OF
TWO DIAMONDS ON A CHAIN

Fabergé, St Petersburg, 1910s
Gold, silver, platinum, diamonds, sapphire and enamel,
4 x 2.5 cm, (length of chain) 47.5 cm
Marks: Fabergé maker's mark 'KF', and gold standard
mark '56'
Origin: acquired in 1985 through the Expert-Purchasing
Commission of the State Hermitage
State Hermitage Museum, inv. no. ERO-9343 a, b
L.Z., K.O.

E95

PENDANT IN THE SHAPE OF AN EGG

Erik August Kollin for Fabergé, St Petersburg, early 1900s
Heliotrope, gold and enamel, 2.9 x 2.2 x 2.2 cm
Marks: maker's mark 'EK', and St Petersburg assay mark for
1896-1907 with the gold standard '56'
Inscribed on the belt of white enamel: 'GAGE DE MON
AMITIE' ['in sign of friendship']
Origin: acquired in 1941 from the State Museum of
Ethnography of the Peoples of the USSR
State Hermitage Museum, inv. no. ERO-6356 *L.Z., K.O.*

E96

FIGURE OF A LYING PIGLET,
IN AN ORIGINAL CASE

Fabergé, St Petersburg, 1910s
Beloretsk quartz and diamonds, 1.5 x 6.6 x 2 cm
Animal not marked, but case inscribed 'Fabergé. S.
Petersburg. Moscow. Odessa'
Origin: acquired in 1919 from the Kurakin's collection
State Hermitage Museum, inv. no. ERKm-487 *L.T.*

† PUBLISHER'S NOTE: Fabergé, one of the world's most famous
jewellery makers, was founded in St Petersburg by Gustav Fabergé
(1814-1893) in 1842. Karl Fabergé (1846-1920) expanded his father's
business considerably by combining with the finest jewellery makers
in St Petersburg: Erik Kollin, August Holmström, M. E. Perchin,
Heinrik Wigström and Yuli Rappoport.

Karl Fabergé was to become the Imperial family's favourite
jeweller and in 1885 was appointed Supplier to the Court of His
Imperial Highness. The company received commissions from the
family for diplomatic gifts, presents to mark the birth of their
children, and extravagant wedding presents.

Jewels by Fabergé were popular showpieces at national and
international exhibitions such as the Paris Exposition of 1900,
where Fabergé received a Grand-Prix and the Légion d'Honneur
for the miniature copy of the Imperial regalia (see this catalogue,
reference no. D14).

E96

E97

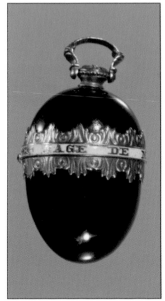

E95

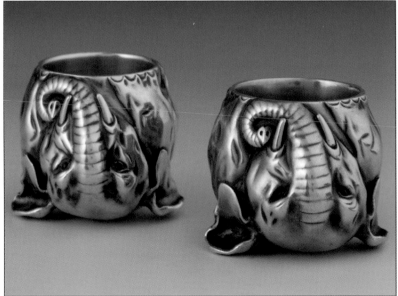

E103

E97
FIGURE OF A STANDING PIGLET,
IN ITS ORIGINAL CASE

Fabergé, St Petersburg, early 1900s
Beloretsk quartz and rock crystal, 2.8 x 4.8 x 3 cm
Animal not marked, but case inscribed 'Fabergé. S.
Petersburg. Moscow'
Origin: acquired in 1920 from the collection of A. Fabergé
State Hermitage Museum, inv. no. ERKм-486 a, b

The creation of realistic figures of animals brought
worldwide fame to the artists-lapidaries of the Fabergé
company. Using various kinds of semi-precious stones
they created remarkably lively and amusing miniature
sculptures, which revealed the character of each animal.

L.T.

E98
PERFUME BOTTLE

Fabergé workshop, St Petersburg, made under the super-
vision of the workmaster Heinrik Emanuel Wigström,
about 1900
Silver, gold, dentrite, diamonds and enamel, 2.5 x 3 x 1 cm
Marks: maker's mark 'HW' and St Petersburg town mark for
1896-1903 with the initials of the assay inspector Yakov
Lyapunov and the silver and gold standard marks '88'
and '56'
Origin: acquired in 1982 through the Expert-Purchasing
Commission of the State Hermitage
State Hermitage Museum, inv. no. ERO-9333 *L.Z., K.O.*

E99
PERFUME BOTTLE

Fabergé workshop, St Petersburg, made under the super-
vision of the workmaster M. E. Perchin, about 1900
Coloured gold, enamel and diamonds, 4.5 x 2 x 1 cm
Marks: Perchin's maker's mark 'MP', the Fabergé mark,
and St Petersburg townmark with the initials
of the assay inspector Yakov Lyapunov and the gold
standard '56'
Origin: acquired in 1982 through the Expert-Purchasing
Commission of the State Hermitage
State Hermitage Museum, inv. no. ERO-9328 *L.Z., K.O.*

E100
ASH-TRAY IN THE SHAPE OF A FISH

Fabergé, St Petersburg, 1890s
Silver and gold, 8.2 x 10.3 x 6.5 cm
Marks: the Fabergé mark and St Petersburg assay mark
with the silver standard '88'
Origin: acquired in 1957 through the Expert-Purchasing
Commission of the State Hermitage
State Hermitage Museum, inv. no. ERO-8857 *L.Z., K.O.*

E101
PEN CLEANER IN THE SHAPE OF A SNIPE

Yuli Alexandrovich Rappoport for Fabergé, St Petersburg,
early 1900s
Silver, 5.2 x 14 x 5 cm
Marks: maker's mark 'IR', the Fabergé mark, St Petersburg
assay mark for 1896-1907 with the silver standard '88',
and the inventory number '3374'
Origin: acquired in 1956 from the Central Depository of the
Leningrad Suburban Palaces; before that in Gatchina Palace,
and earlier in Strelna Palace
State Hermitage Museum, inv. no. ERO-8672 *L.Z., K.O.*

E102
FIGURE OF A FANTASTIC ANIMAL,
IN AN ORIGINAL CASE

Fabergé, St Petersburg, early 1900s
Bowenite, ruby, almandine and silver, 3.8 x 3.9 x 4.2 cm
Animal not marked, but case inscribed 'Fabergé. S.
Petersburg. Moscow'
Origin: acquired in 1982 through the Expert-Purchasing
Commission of the State Hermitage
State Hermitage Museum, inv. no. ERO-9329 *L.T.*

E103

TWO SMALL DRINKING VESSELS IN THE SHAPE OF ELEPHANTS

Fabergé workshop, St Petersburg, made under the super-
vision of M. E. Perchin and Heinrik Emanuel Wigström,
early 1900s
Silver, gold and garnets: 4.1 x 4.7 x 5.3 cm; 4.1 x 4.7
x 5.3 cm
Marks: maker's mark 'MP', the Fabergé mark, St Petersburg
assay mark for 1896-1903 with the silver standard '88'
Inscribed: '11.11.04 – Baby Helen'
Marks: maker's mark 'HW', the Fabergé mark, St Petersburg
assay mark for 1896-1903, with the silver standard '88',
and the inventory number '12437'
Inscribed: 'SEGE FROM GOLUBEEV 15.V.1913'
Origin: acquired in 1966 through the Expert-Purchasing
Commission of the State Hermitage
State Hermitage Museum, inv. nos. ERO-8964, 8965

L.Z., K.O.

E104

SET FOR PLAYING CARDS

Yuli Alexandrovich Rappoport for Fabergé, St Petersburg,
early 1900s
Silver and rhodonite: (brushes) 3.1 x 5.2 x 5.2 cm;
(chalk holders) 8.7 x 1.6 x 1.6 cm
Marks: maker's mark 'IR', and St Petersburg assay mark for
1896-1908 with the silver standard '84'
Origin: acquired in 1958 through the Expert-Purchasing
Commission of the State Hermitage
State Hermitage Museum, inv. nos. ERO-8864-8871

The set includes two chalk holders and two brushes.
Traditionally, cards were played at a table covered with
a green cloth on which players wrote down their gains,
losses and scores. *L.Z., K.O.*

E105

KORCHIK

Erik August Kollin for Fabergé, St Petersburg, early 1900s
Silver, enamel and almandine, 6.9 x 9.9 x 6.6 cm
Marks: maker's mark 'EK', and St Petersburg assay mark for
1896-1907 with the silver standard '88'
Origin: acquired in 1951 from the State Depository of
Treasures (Gokhran)
State Hermitage Museum, inv. no. ERO-7606

A silver rouble of the Empress Elizaveta Petrovna,
daughter of Peter the Great, is attached to the base.

L.Z., K.O.

E106

TANKARD

Anders Johan Nevalainen for Fabergé, St Petersburg, early
1900s
Silver, gold and enamel, 10.5 x 7 cm
Marks: maker's mark 'AN', the Fabergé mark, and St
Petersburg assay mark for 1896-1907 with the silver
standard '88'
Origin; acquired in 1951 from the State Depository of
Treasures (Gokhran)
State Hermitage Museum, inv. no. ERO-7698

The top and sides of the tankard are decorated with old
silver coins. A half-rouble of 1764 is attached to the lid
and ten-kopecks of 1744 and 1752 and a half-rouble of
1764 to the sides. *L.Z., K.O.*

E107

BEAKER FOR PENCILS

Yuli Alexandrovich Rappoport for Fabergé, St Petersburg,
1893
Nephrite and silver, 11 x 7.5 x 7.5 cm
Marks: maker's mark 'IR', the Fabergé mark, the St
Petersburg town mark 'AS/1893' of the assay master
A. T. Sevier, and the silver standard mark '88'
Origin: from the Diamond Room of the Winter Palace
State Hermitage Museum, inv. no. ERO-4911 *L.Z., K.O.*

E110

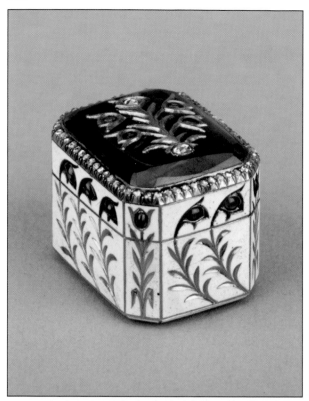

E111

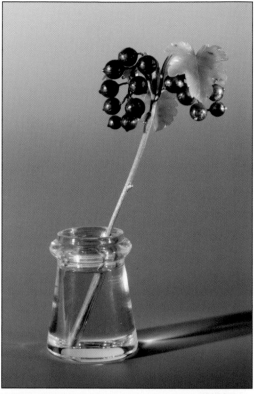

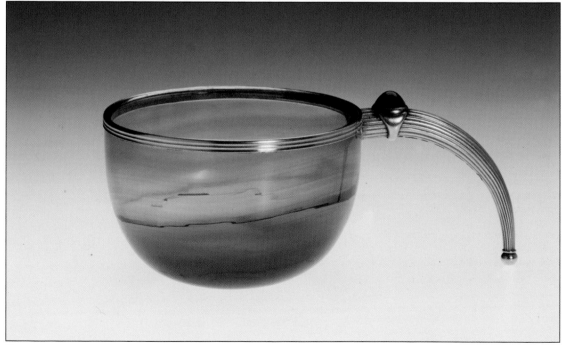

E113

E113 (*photography: National Museums of Scotland*)

E108
CIGAR CASE

Fabergé workshop, St Petersburg, made under the super-
vision of the workmaster M. E. Perchin, 1890s
Steel and gold, 9.8 x 5.8 cm
Marks: Perchin's maker's mark 'MP', the Fabergé mark,
and St Petersburg assay mark of the last quarter of the
19th century with the gold standard mark '56'
Origin: acquired in 1956 from the Central Depository of the
Leningrad Suburban Palaces; before that in Gatchina Palace
State Hermitage Museum, inv. no. ERO-8657

The cigar case, together with the matchbox holder and
cord for getting a light, belonged to the Emperor
Alexander III. *L.Z., K.O.*

E109
BOX, IN ITS ORIGINAL CASE

Fabergé, Moscow, early 1900s
Silver, sapphires, enamel and gold, 1.7 x 6.7 x 2 cm
Marks: the Fabergé mark, Moscow assay mark for 1896-
1903 with the silver standard '91', and the inventory number
'15946'
The case is inscribed: 'FABERGÉ. ST. PETERSBURG.
MOSCOW. LONDON'
On the base is the inscription: 'FROM SANDRO 1908'
Origin: from the collection of the Grand Duchess Xenia
Alexandrovna
State Hermitage Museum, inv. no. ERO-2581 a, b
 L.Z., K.O.

E110
GOLD BOX, DECORATED WITH ENAMEL
AND PRECIOUS STONES, INCLUDING A
LARGE CUT SAPPHIRE OF 43 CARATS

Fabergé workshop, St Petersburg, made under the super-
vision of the workmaster M. E. Perchin, 1890s
Gold, enamel, diamonds, rubies and sapphires,
2.8 x 2.3 x 2.2 cm
Marks: maker's mark 'MP', Fabergé mark, St Petersburg
assay mark with the gold standard '56', and inventory
number '47449'
Origin: acquired in 1908 from the collection of Grand Duke
Alexei Alexandrovich (1850-1908), fourth son of Alexander II
State Hermitage Museum, inv. no. E-307 *O.K.*

E111
BRANCH OF RED CURRANT IN A VASE

Fabergé workshop, St Petersburg, made under the super-
vision of the workmaster Heinrik Emanuel Wigström, 1910s
Gold, nephrite, enamel and rock crystal, 10 x 3.3 x 3.3 cm
Unmarked
State Hermitage Museum, inv. no. ERO-6157 a, b

Decorative desk accessories in the shape of flowers and
berries in rock crystal vases were popular from the
1880s. *L.Z., K.O.*

E112
ELECTRIC BELL

Johann Victor Aarne for Fabergé, St Petersburg, 1910s
Silver, sapphire, enamel and ebonite, 3.8 x 3.3 x 3.8 cm
Marks: the Fabergé mark, and St Petersburg assay mark
for 1908-17 with the silver standard '88'
Origin: acquired in 1941 from the State Museum of
Ethnography of the Peoples of the USSR
State Hermitage Museum, inv. no. ERO-4921 *L.Z., K.O.*

E113
VODKA CUP, IN ITS ORIGINAL CASE

Fabergé workshop, St Petersburg, made under the
supervision of M. E. Perchin, 1884-96
Agate, gold and sapphire; beech and other materials:
(cup) 3.7 x 8.5 x 5.1 cm; (box) 10 x 11 x 13 cm
Marks: maker's mark 'M.P.' and St Petersburg assay mark
with the gold standard '56'
National Museums of Scotland, inv. no. A.1969.582 & A
 G.E.

F. Change and Revolution

F01

MASQUERADE COSTUME OF THE EMPRESS
ALEXANDRA FEODOROVNA, AS A RUSSIAN
TSARINA OF THE 17TH CENTURY
(MARIA ILINICHNA, WIFE OF TSAR ALEXEI
MIKHAILOVICH)

St Petersburg, 1903
Silk, gold brocade, metallic thread, artificial pearls, sequins,
glass, and embroidery: (length along back) 158 cm; (crown)
17 x 57 cm; (length of shoes) 25.5 cm
Origin: acquired in 1941 from the State Museum of
Ethnography of the Peoples of the USSR; before that in the
Winter Palace
State Hermitage Museum, inv. nos. ERT-13435, 13440

E.M.

F02

MASQUERADE COSTUME OF PRINCE
F. F. YUSUPOV, AS A 17TH-CENTURY BOYAR

St Petersburg, late 19th-early 20th century
Brocade, velvet, plush, gold braid, cord, tassels and
embroidery: (caftan, length along back) 117 cm; (trousers)
112 cm
Origin: acquired in 1941 from the State Museum of
Ethnography of the Peoples of the USSR; before that in the
collection of the princes Yusupov
State Hermitage Museum, inv. no. ERT-13399 *E.M.*

F03

MASQUERADE COSTUME OF ADJUTANT-
GENERAL, PRINCE D. B. GOLTSYN, AS A
17TH-CENTURY LORD FALCONER

St Petersburg, 1903
Velvet, silk, satin, metallic thread, artificial pearls, and
embroidery: (caftan, length along back) 123 cm; (trousers)
120 cm; (hat) 26 x 58 cm
Origin: acquired in 1941 from the State Museum of
Ethnography of the Peoples of the USSR
State Hermitage Museum, inv. nos. ERT-13409, 13392,
13416. *E.M.*

F04

MASQUERADE COSTUME OF THE GRAND
DUCHESS MARIA GEORGIEVNA, AS A
17TH-CENTURY PEASANT WOMAN FROM
THE TOWN OF TORZHOK

Russian, 1903
Satin, velvet, brocade, crepe, gold braid, artificial pearls,
sequins, and embroidery using silver thread and silk:
(sarafan, length along the back) 126 cm; (shirt) 40 cm;
(sleeveless jacket) 54 cm
Origin: acquired in 1941 from the State Museum of
Ethnography of the Peoples of the USSR; before that in
Novo-Mikhaylovskiy Palace in St Petersburg
State Hermitage Museum, inv. nos. ERT-13429, 13436,
13437 *E.M.*

F05

MASQUERADE COSTUME OF PRINCESS E.V.
GOLTSYNA, AS A 17TH-CENTURY BOYAR

St Petersburg (?), 1903
Satin, brocade, braid, artificial pearls, spangles, metallic
thread and embroidery: (length along back) 147 cm; 146
cm; 26.5 x 9.5 cm; 14 x 16 cm
Origin: acquired in 1941 from the State Museum of
Ethnography of the Peoples of the USSR; before that in the
museum of everyday life of the Leningrad department of the
people's education (former palace of the princes Goltsyn)
State Hermitage Museum, inv. nos. ERT-13430, 13407,
13439 a, b, 13441 *E.M.*

F06

MASQUERADE COSTUME OF PRINCE
F. F. YUSUPOV, AS A 17TH-CENTURY BOYAR

Workshop of Laifert, St Petersburg, early 20th century
Velvet, taffeta, glazed brocade, artificial pearls, glass, copper,
and embroidery: (length) 126 cm
Origin: acquired from the State Museum of Ethnography of
the Peoples of the USSR; before that in the collection of the
princes Yusupov
State Hermitage Museum, inv. no. ERT-13400 *E.M.*

F07
A WOMAN'S FESTIVE FOLK COSTUME

Central Region of European Russia, first half 19th century
Silk cloth, brocade, cotton cloth, velvet, kersey, braid, glass,
metal thread, silver, and embroidery:
(sarafan, length) 126 cm; (shirt) 28 cm; (dushegreya) 25 cm;
(kokoshnik) 40 x 40 cm
Origin: acquired in 1941 from the State Museum of
Ethnography of the Peoples of the USSR; before that in the
collection of I. A. Galnbek
State Hermitage Museum, inv. nos. ERT-15065, 14682,
7190, 10136 *E.M.*

F08
ARMCHAIR

Russian, late 19th century
Wood, 85 x 68 x 67 cm
Origin: acquired in 1990 from shop-salon
'Gosizopropaganda'
State Hermitage Museum, inv. no. ERMb-1843

The armchair 'Arch, axe and gloves' was displayed for
the first time at the All-Russia Exhibition in 1870 by
the V. P. Shutov workshops. It was made, to modified
designs by different artists, over the next forty years. The
decoration is taken from the everyday life of peasants.
 N.G.

F09
TABLE

Russian, early 20th century
Wood, 75 x 54 x 54 cm
Origin: acquired in 1988 from shop-salon
'Gosizopropaganda'
State Hermitage Museum, inv. no. ERMb-1838

Similar 'Russian-style' tables were often used as serving
tables with samovars and trays. *N.G.*

F10
DECORATIVE LADLE WITH A HANDLE IN THE FORM OF A PAIR OF BIRDS

Abramtsevo, Moscow, second half 19th century
Wood, 39.8 x 60 x 27 cm
Origin: acquired in 2000 through the Expert-Purchasing
Commission of the State Hermitage
State Hermitage Museum, inv. no. ERD-3183

Such traditional utensils were used for ladling kvass
into drinking vessels. *I.U.*

F11
PAGES FROM THE 'ALBUM OF THE COSTUME BALL HELD IN THE WINTER PALACE IN FEBRUARY 1903'

Origin: acquired in 1941 from the State Museum of
Ethnography of the Peoples of the USSR
State Hermitage Museum, inv. no. 235619 (1-3/8-10)

a
EMPEROR NICHOLAS II IN THE COSTUME OF TSAR ALEXEI MIKHAILOVICH

Photo-engraving from the photograph by L. Levitsky,
48.5 x 34.5 cm
State Hermitage Museum, inv. no. 235619/1 *G.V.Y.*

b
EMPRESS ALEXANDRA FEODOROVNA IN THE COSTUME OF TSARINA MARIA ILINICHNA

Photo-engraving from the photograph by L. Levitsky,
48.5 x 34.5 cm
State Hermitage Museum, inv. no. 235619/2 *G.V.Y.*

c
GRAND DUCHESS ELIZAVETA FEODOROVNA IN THE COSTUME OF A PRINCESS OF THE 17TH CENTURY

Photo-engraving from the photograph by L. Levitsky,
48.5 x 34.5 cm
State Hermitage Museum, inv. no. 235619/3

The Grand Duchess Elizaveta Feodorovna (1864-1918)
was the elder sister of the Empress Alexandra and was
married to the Grand Duke Sergei Alexandrovich, the
uncle of Tsar Nicholas II. *G.V.Y.*

d

GRAND DUKE MIKHAIL ALEXANDROVICH IN THE 'FIELD COSTUME OF A TSAREVICH' OF THE 17TH CENTURY

Photo-engraving from the photograph by L. Levitsky,
48.5 x 34.5 cm
State Hermitage Museum, inv. no. 235619/8

The Grand Duke Mikhail Alexandrovich (1878-1918) was a brother of Nicholas II and the heir to the throne until the birth of his nephew, Alexei, in 1904. Tsar Nicholas abdicated in favour of Grand Duke Mikhail in 1917. *G.V.Y.*

e

GRAND DUKE SERGEI ALEXANDROVICH IN THE COSTUME OF A PRINCE OF THE 17TH CENTURY

Photo-engraving from the photograph by D. Asikritov,
48.5 x 34.5 cm
State Hermitage Museum, inv. no. 235619/9

The Grand Duke Sergei Alexandrovich (1857-1905) was a son of the Emperor Alexander II and was married to the elder sister of the Empress Alexandra. From 1891 he was Governor-General of Moscow and was blamed for the catastrophe at Khodynka Field after the coronation in 1896. In 1905 Grand Duke Sergei was killed in the Kremlin by the terrorist I. P. Kalyaev, who threw a bomb into his carriage. *G.V.Y.*

f

GRAND DUCHESS MARIA PAVLOVNA IN THE COSTUME OF A BOYAR'S WIFE OF THE END OF THE 17TH CENTURY

Photo-engraving from the photograph by L. Levitsky,
48.5 x 34.5 cm
State Hermitage Museum, inv. no. 235619/10

The Grand Duchess Maria Pavlovna (1854-1920) was the daughter of the Grand Duke of Mecklenburg-Shverein and the wife of the Grand Duke Vladimir Alexandrovich, third son of Alexander II and uncle of Nicholas II. She held her own court – a miniature copy of the Imperial court, according to the British ambassador, George Buchanan – in one of the biggest palaces in St Petersburg, where she tried to play the role of the 'first lady of the Empire'. *G.V.Y.*

G. 'We Seven'

G01

CORNER SOFA WITH A HIGH BACK

Factory of F. F. Melzer, St Petersburg, late 19th-early 20th century
Walnut, mirror and velvet, 175 x 141 x 43 cm
Origin: acquired in 1933 from the Lower Palace in Alexandria at Peterhof
State Hermitage Museum, inv. no. E-3572

The sofa was in the rooms of the Grand Duchess Olga Nikolaevna in the Lower Dacha at Peterhof. Photographs show Nicholas II, Alexandra Feodorovna and their daughters sitting on this sofa. *T.R.*

G02

WRITING DESK IN THE FORM OF A LECTERN

Factory of N. F. Svirsky, St Petersburg, 1894-96
Walnut and leather, 114 x 84 x 86 cm
Origin: from the Winter Palace
State Hermitage Museum, inv. no. ERMb-1321 *N.G.*

G03

ARMCHAIR

Factory of N. F. Svirsky, St Petersburg, 1894-96
Walnut, 85 x 80 x 50 cm
Origin: from the Winter Palace
State Hermitage Museum, inv. no. ERMb-1319

The writing desk and chair were made for Nicholas II's Neo-Gothic-style library in the Winter Palace. Along with other items in the library and elsewhere in the palace, they were designed by the architect N. V. Nabokov. The Svirsky company supplied the Imperial court with furniture and frequently participated in international exhibitions. *N.G.*

G04

MEDALLION WITH PORTRAIT OF NICHOLAS II

Charles Bertault, Paris, 1897
(Medallion) silver, (diam.) 8.8 cm; (frame) 14.5 x 16.5 cm
The Emperor is portrayed shoulder-length, turned right, in
military uniform with the cross of the Order of St Vladimir in
his buttonhole; below at the edge 'BERTAULT. CH. 1897';
the medallion is in a frame of gilt bronze, with green velvet,
decorated with the Imperial crown on the top
Origin: acquired in 1924 from the Winter Palace
State Hermitage Museum, inv. no. IM-4853 *E.S.*

G05

TSAR NICHOLAS II'S WALKING STICK WITH A SILVER HANDLE REPRESENTING A DRAGONFLY

René Jules Laliqué, Paris, early 1900s
Cane, silver, gold, steel and enamel, (length) 92 cm
Marks: signature of the artist and Paris assay marks for
1838-1919
Origin: acquired from the Central Storage of the Museum
Funds in Pushkin; before that it was stored in the Alexander
Palace, Swimming Room of Nicholas II
State Hermitage Museum, inv. no. E-17258

A drawing records that this stick was commissioned by
the Empress. *L.Y.*

G06

BOX WITH THE CROWNED MONOGRAM OF NICHOLAS II, CONTAINING FIFTEEN CROSSES AND ICONS

Russian, 1907
Wood, silver, velvet, satin, cloth and metal, 48 x 32.2 x 7 cm
Origin: acquired in 1958 from Pavlovsk Palace; before 1941
in the Alexander Palace at Tsarskoe Selo
State Hermitage Museum, inv. no. ERP-1287 (box)
Box contents: inv. nos. ERP-1288 (encolpion); 1289
(encolpion); 1290 (cross); 1291 (cross); 1292 (encolpion);
1293 (cross); 1294 (cross); 1295 (cross); 1296 (cross);
1297 (cross); 1298 (cross); 1299 (coin); 1300 (cross); 1301
(cross); 1302 (cross) *S.T.*

G07

ICON-CASE, CONTAINING NINE CROSSES AND ICONS

Russian, presented to Nicholas II on 25 December 1906
Oak, plywood, glass, copper, velvet, satin, silver and paper,
38.5 x 23.2 x 5.4 cm
A silver plate inside the case is inscribed: 'To His Imperial
Majesty … 25 December 1906'
Origin: acquired in 1958 from Pavlovsk Palace; before 1941
in the Alexander Palace at Tsarskoe Selo
State Hermitage Museum, inv. no. ERP-1277 (icon case)
Case contents: inv. nos. ERP-1278 (cross); 1279 (cross);
1280 (icon); 1281 (icon); 1282 (cross); 1283 (encolpion);
1284 (icon); 1285 (icon); 1286 (icon)

Both icon-cases (nos. G06-7) found their way into the
Alexander Palace during the hardest times for Nicholas
II's family (defeat in the Russian-Japanese war, the first
Russian revolution, Tsarevich Alexei's illness) and, like
other sacred objects from the Alexander Palace, they can
be considered memorials of the last crisis period of the
Russian monarchy. They illustrate the deep piousness
of the Imperial family and the interest of the court in
Russian antiquities. The givers intentionally chose to
present Tsar Nicholas with icons of Saint Nicholas the
Miracle Worker, the heavenly protector of the last
Emperor, and the most popular saint in Russia. *S.T.*

G08

PORTRAIT OF NICHOLAS II WITH A REMARQUE-PORTRAIT OF TSAREVICH ALEXEI NIKOLAEVICH

Mikhail Viktorovich Rundaltsov (1871-1935), dated 1913
After an original painting by V. A. Serov
Etching, with watercolours and ink, 28.2 x 21.5 cm
Signed bottom left: 'M. Rundaltsov, 1913'
Origin: from the original collection of the Hermitage
State Hermitage Museum, inv. no. ERG-28931

The portrait by V. A. Serov, which hung in the private
room of Empress Alexandra Feodorovna in the Winter
Palace, was considered by many contemporaries to be
the best portrait of Nicholas II. *G.M.*

G05

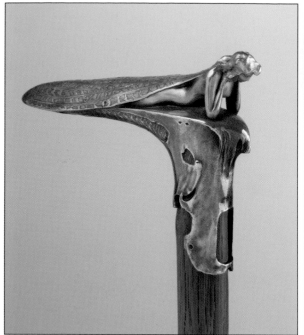

G06

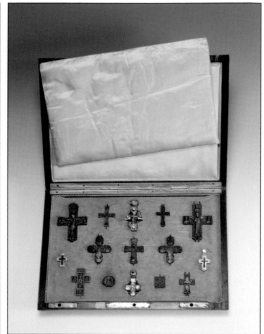

G07

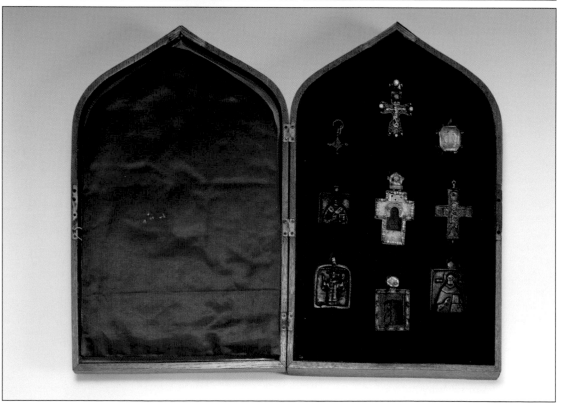

G09

HISTOIRE DE TURENNE, BY THEODORE CAHU

Firmin-Didot & Cie, Paris, 1898
Leather, paper, ink and gold, 26.5 x 35 cm
Reverse of outer fly-leaf inscribed: 'For darling Nicky fr. yr.
Alix. Xmas 1898'; with book-plate of the Emperor Nicholas II
Origin: acquired after 1917 from the library of Nicholas II
State Hermitage Museum, inv. no. 126734 *A.M.*

G10

JEANNE D'ARC, BY LOUIS MORIS BOUTET DE MONVEL (1851-1913)

E. Plon, Nourrit & Cie, Paris, 1896
Calico, paper and ink, 25 x 32.5 cm
The outer fly-leaf is inscribed: 'For my darling Nicky wishing
you a happy Xmas 1896. fr. yr. very loving Alix'; with book-
plate of the Emperor Nicholas II
Origin: acquired after 1917 from the library of Nicholas II
State Hermitage Museum, inv. no. 89945 *A.M.*

G11

VISITING DRESS

Workshop of Auguste Brisac, St Petersburg, beginning of the
20th century
Wool, silk, lace and embroidery: (length of bodice) 59 cm;
(skirt) 150 cm
The light lilac wool dress has a closed bodice with an inserted
dickey and band-collar made of chiffon in tone with the dress,
fitted at the waist, with a corset, lengthened; the dress has a
back with a seam at the waistline, with a basque, and long
sleeves with pleats along the armholes and puffs at the wrist,
with high lace wristbands; dress has flared skirt, pleats along
the back, wide flounce along the hem, and a train
Decoration: chiffon, lace, embroidery with satin stitch in tone
with dress fabric
On satin bodice ribbon is the name of the company printed
in gold: 'A. Brisac St. Petersbourg'
Origin: acquired in 1941 from the State Museum of
Ethnography of the Peoples of the USSR
State Hermitage Museum, inv. no. ERT-9481 a, b

The Brisac company was one of the most famous
fashion workshops in St Petersburg at the end of the
19th century, and beginning of the 20th. The Imperial
family and the aristocracy of St Petersburg placed
orders with the firm. According to contemporaries,
Brisac was the favourite dress designer of the Empress
Alexandra Feodorovna. This dress may have belonged
to the Empress, but further research needs to be carried
out to clarify its original ownership. *T.T.K.*

G12

EVENING DRESS OF THE EMPRESS ALEXANDRA FEODOROVNA

St Petersburg, early 20th century
Silk, satin, lace, sequins and steel beads:
(length of bodice) 30 cm; (skirt) 135 cm
Dress has open bodice with rounded *décolletage*, short
sleeves and flaring skirt with train; embroidered with black
sequins and steel beads; neckline, sleeves and skirt
decorated with flounces of black lace
Origin: acquired in 1941 from the State Museum of
Ethnography of the Peoples of the USSR; before 1917 in the
Winter Palace
State Hermitage Museum, inv. no. ERT-12890 a, b *T.T.K.*

G13

PHOTOGRAPH FRAME WITH PHOTOGRAPH

Fabergé workshop, St Petersburg, made under the super-
vision of the workmaster M. E. Perchin, 1890s
Silver, gold, enamel, ivory and photograph, 14.3 x 7 x 1 cm
Marks: Perchin's maker's mark 'MP', the Fabergé mark,
St Petersburg assay mark of the last quarter of the 19th
century with the silver standard '88', and the inventory
number '58606'
Inscribed on the back: 'From Nicki and Alex 25 May 1898'
Origin: acquired from the State Museum of Ethnography of
the Peoples of the USSR; before that in the palace of the
Grand Duchess Xenia Alexandrovna in St Petersburg
State Hermitage Museum, inv. no. ERO-6761

The photograph shows Tsarina Alexandra Feodorovna
and her daughter Tatiana. The frame and photograph
were presented to Nicholas II's sister, the Grand Duchess
Xenia Alexandrovna, by the royal couple. *L.Z., K.O.*

G14

VASE WITH TULIP MOTIF

Imperial Glass Factory, St Petersburg, 1898
Two-layered (colourless and turquoise-blue) glass with cut
decoration, 30 x 20 x 20 cm
Mark engraved on base: 'N II' beneath a crown and the date
'1898'
Origin: acquired in 1931; the Tulip vase was in the Silver
Drawing Room of the Empress Alexandra Feodorovna in the
Winter Palace
State Hermitage Museum, inv. no. ERS-2430 *T.M.*

G16 (MIDDLE); G17 (BELOW)

G15

VASE WITH IRIS MOTIF

Imperial Glass Factory, St Petersburg, 1900
(engraver A. Zotov)
Two-layered (matt lilac and purple-violet) glass with cut
decoration, 30.5 x 19.5 x 19.5 cm
Mark engraved on base: 'N II' beneath a crown and the
date '1900'
Origin: acquired in 1931; the Iris vase was in the Boudoir of
the Empress Alexandra Feodorovna in the Winter Palace
State Hermitage Museum, inv. no. ERS-2432 *T.M.*

G16

UMBRELLA WITH HANDLE IN THE SHAPE
OF A DUCK'S HEAD

Russian, early 1900s, C. Fabergé company (?)
(Umbrella) silk, wood, rock crystal, gold, silver, diamonds,
rubies and metal; (box) leather, silk and copper
(Umbrella, length) 93.1 cm; (box) 10 x 7 cm
Origin: acquired in 1941 from the State Museum of
Ethnography of the Peoples of the USSR
State Hermitage Museum, inv. no. ERT-13005 a, b *Y.P*

G17

UMBRELLA WITH HANDLE IN THE
SHAPE OF THE HEAD OF A GOOSE

Fabergé workshop, St Petersburg, made under the super-
vision of Heinrik Emanuel Wigström, 1910s
Silk, bamboo, rock crystal, sapphires, enamel and gold,
9 x 8.4 cm; (length of umbrella) 90 cm
Marks: maker's mark 'HW' and the gold standard mark '56'
Origin: acquired in 1941 from the State Museum of
Ethnography of the Peoples of the USSR
State Hermitage Museum, inv. no. ERO-6453 a, b
 L.Z., K.O.

G18

PORTRAIT OF THE TSAREVICH ALEXEI
NIKOLAEVICH WITH REMARQUE-PORTRAITS
OF HIS ELDER SISTERS, GRAND DUCHESSES
OLGA, TATIANA, MARIA AND ANASTASIA

Mikhail Viktorovich Rundaltsov (1871-1935), dated 1911
Drypoint, 46.5 x 33.8 cm
Signed bottom left: 'Mikh. Rundaltsov 1911'
Origin: from the original collection of the Hermitage
State Hermitage Museum, inv. no. ERG-28932

'Alexei Nikolaevich was at the heart of this close-knit
family – all their hopes and affections were invested in
him,' wrote his tutor Pierre Gilliard. 'The grand
duchesses were delightful – vigorous and healthy. It
would have been hard to find four sisters more
different in character and yet so close to each other.'
 G.M.

G19

FOUR CHAIRS AND A TABLE

Factory of F. F. Melzer, St Petersburg, early 1900s
Oak and other materials: (chairs) 89 x 44 x 47 cm;
(table) 89 x 69 x 69 cm
Origin: from the Alexander Palace at Tsarskoe Selo
State Hermitage Museum, inv. nos. ERMb-892-895, 903

Labels reveal that these five pieces were in the
'children's part' of 'the room of the small princesses'
in the Alexander Palace. *N.G.*

G20

DECORATED DISH

Fabergé, Moscow, early 1900s
Wood and silver, 44 x 44 cm
Marks: the Fabergé mark and Moscow assay mark for 1896-
1907 with the silver standard '84'
Origin: from the Diamond Room of the Winter Palace
State Hermitage Museum, inv. no. ERO-5427

The dish is decorated with an illustration of the
Russian folk story about the Hunchback Horse. At the
beginning of the 20th century, on the wave of general
interest in Russian folk art and folklore, craftsmen were
using stories of traditional beliefs, myths and tales to
decorate their items. *L.Z., K.O.*

G21

TOY BEAR

Early 1900s
Woollen plush, silk, glass, lint and chamois, 73 x 40 cm
Origin: acquired in 1941 from the State Museum of
Ethnography of the Peoples of the USSR; before that in the
Alexander Palace at Tsarskoe Selo
State Hermitage Museum, inv. no. ERT-14794 *Y.P.*

G22

TOY DOG

Early 1900s
Woollen plush, lint and glass, 33 x 47 cm
Origin: acquired in 1941 from the State Museum of
Ethnography of the Peoples of the USSR; before that in the
Alexander Palace at Tsarskoe Selo
State Hermitage Museum, inv. no. ERT-14795 *Y.P.*

G23

TOY CAT, WITH A RIBBON AND BELL AROUND ITS NECK

Early 1900s
Woollen plush, silk, glass, lint and chamois, 27 x 30.5 cm
Origin: acquired in 1941 from the State Museum of
Ethnography of the Peoples of the USSR; before that in the
Alexander Palace at Tsarskoe Selo
State Hermitage Museum, inv. no. ERT-14796 *Y.P.*

G24

TOY DOLL

Russian, late 19th century
Plush, fabrics and other materials, 35 x 27 cm
Origin: acquired from the Alexander Palace at Tsarskoe Selo
State Hermitage Museum, inv. no. ERTz-2707

All four toys (nos. G21-24) were used by Nicholas II's
children. *I.U.*

G25

TEN TOY SOLDIERS

Russian, early 20th century
Card, inks and wood, 11.5 x 16.5 cm
State Hermitage Museum, inv. nos. ONP-192-201

The soldiers are part of a game about the Napoleonic
Wars. The horse soldiers are a grenadier of the guards,
cuirassier and carabineer of the army of Napoleon I.
The foot soldiers are grenadiers of the guards of
Napoleon I, grenadiers of the Hungarian regiments of
the Austrian army and Hungarian musketeers of the
Austrian army. *S.N.*

G26

CHILD'S BOARD GAME 'WAR IN EUROPE'

Printers D. Kreines and Sh. Kovalsky, Vilna, early
20th century
Paper, cardboard, colour printing and metal: (box) 23 x 30.7
x 2.2 cm; (height of figures) 4.4-9.8 cm
Origin: acquired in 1941 from the Museum Fund; before that
in the Alexander Palace at Tsarskoe Selo
State Hermitage Museum, inv. no. ONP-70/1-128 *I.U.*

G27

INFANT DRESS OF TSAREVICH ALEXEI NIKOLAEVICH

Russian, 1904
Muslin, silk, lace, silk ribbons and mother-of-pearl,
(length along back) 109 cm
The long dress is made of veil lacework on a blue silk
covering; collar and sleeves and a tie of blue silk ribbons
are decorated with lacework flounces; bows of blue moiré
ribbons on the shoulders; bodice, skirt and hem are
decorated with lacework flounces; fastener with buttons
on the front
Origin: acquired in 1941 from the State Museum of
Ethnography of the Peoples of the USSR; before that in the
Alexander Palace at Tsarskoe Selo
State Hermitage Museum, inv. no. ERT-13589

Alexei can be seen wearing a similar dress in official
photographs. *Y.P*

G22

G23

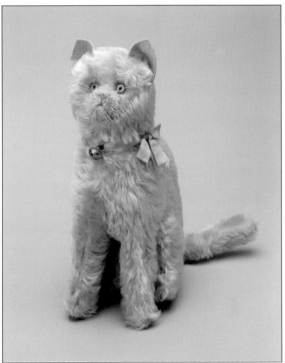

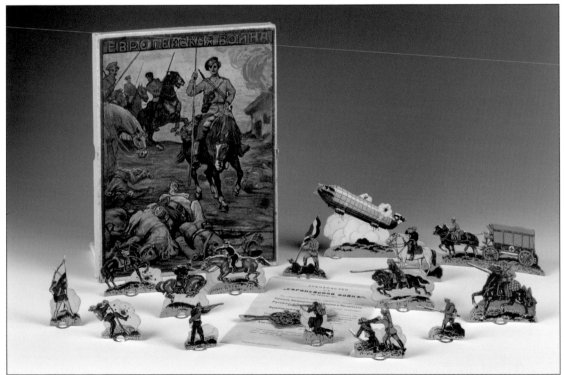

G26

G28

CAPE FOR AN INFANT

Russian, possibly made between 1895 and 1904
Satin, silk, guipure and satin ribbons, (length along back)
98 cm, (length double folded along hem) 92 cm
Cape of cream satin, quilted with cotton-wool and with a
turndown collar and a pelerine bordered with guipure, has
silk lining and a lace of wide satin ribbons
Origin: acquired in 1941 from the State Museum of
Ethnography of the Peoples of the USSR; before that in the
Winter Palace
State Hermitage Museum, inv. no. ERT-13634 *Y.P*

G29

BONNET FOR AN INFANT

Russian, possibly made between 1895 and 1904
Satin, lace, ribbon, and ostrich feathers, (height without
ribbons) 28 cm
Bonnet of plicate cream satin with the feathers of an ostrich
is bordered with gathered Valenciennes lacework and narrow
satin ribbons; the lace is made of cream satin ribbons
Origin: acquired in 1941 from the State Museum of the
Ethnography of the Peoples of the USSR; before that in the
Winter Palace
State Hermitage Museum, inv. no. ERT-6063 *Y.P*

G30

DRESS FOR AN INFANT

Moscow, possibly made between 1895 and 1904
Silk crepe, embroidery with gold, lace and moiré ribbons,
(length along back) 105 cm
Dress of cream silk crêpe decorated with gold embroidery,
with floral pattern along hem and on sleeves; shoulders
and waistline decorated with moiré ribbons; dress is on a
silk lining
Marked with the company name: 'Children's Clothes Shop,
Amsterdam, Moscow'
Origin: acquired in 1941 from the State Museum of
Ethnography of the Peoples of the USSR; before that in the
Alexander Palace at Tsarskoe Selo
State Hermitage Museum, inv. no. ERT-13594

Such dresses were considered ceremonial. They were
used when infants were shown to honoured
guests. *Y.P*

G31

CHILD'S NAPPY

Russian, possibly made between 1895 and 1904
Flannel, 111 x 50.5 cm
Origin: acquired in 1941 from the State Museum of
Ethnography of the Peoples of the USSR; before that in the
Winter Palace
State Hermitage Museum, inv. no. ERT-13486 *Y.P*

G32

BABY'S LOOSE JACKET OF GRAND DUCHESS
ANASTASIA NIKOLAEVNA

Russian, 1901
Cambric, lace and embroidery, 28 x 63 cm
Embroidered inscription: '24 1901' beneath Imperial crown
Origin: acquired in 1941 from the State Museum of
Ethnography of the Peoples of the USSR; before that in the
Winter Palace
State Hermitage Museum, inv. no. ERT-13469 *Y.P*

G33

UNDERSHIRT FOR A FEEDING CHILD

Russian, possibly made between 1895 and 1904
Woollen knitted fabric and lace, 31 x 28 cm
Origin: acquired in 1941 from the State Museum of
Ethnography of the Peoples of the USSR; before that in the
Winter Palace
State Hermitage Museum, inv. no. ERT-13504 *Y.P*

G34

CHILD'S SUMMER DRESS WITH
A SCARLET UNDER-DRESS

Russian, early 1900s
Cambric, satin, embroidered insertions and silk lace:
(dress, length along back) 96.9 cm; (under-dress, length
along back) 109 cm
Dress made of white cambric with satin stitch embroidery;
collar has tie and is decorated with lace; bodice and hem
decorated with insert lace embroidered with English satin
stitching; bodice, sleeves and hem have flounces decorated
with laced festoons; fastener has buttons; satin under-dress
has ties at waist and collar, and the collar, armholes and
flounces are decorated with lace; fastener is on the back
with buttons
Origin: acquired in 1941 from the State Museum of
Ethnography of the Peoples of the USSR; before that in the
Winter Palace
State Hermitage Museum, inv. nos. ERT-13540 (dress),
13587 (under-dress) *Y.P*

G30

G37

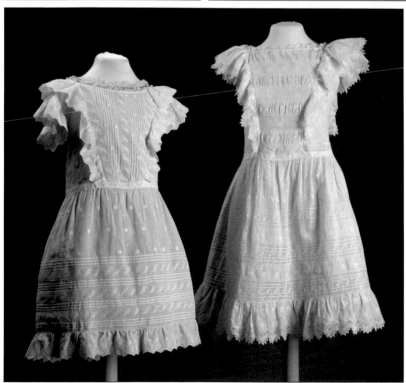

G34, G35

G35

CHILD'S SUMMER DRESS WITH
A BLUE UNDER-DRESS

Russian, early 1900s
Cambric, satin and lace: (dress, length along back) 97 cm;
(under-dress, length along back) 88 cm
Dress made of white cambric with satin stitch embroidery;
collar has a tie and is decorated with lace; bodice and hem
are decorated with insert lace embroidered with English satin
stitching; bodice, sleeves and hem have flounces decorated
with laced festoons; fastener has buttons; under-dress is
made of blue satin; waist and collar have ties, and collar,
armholes and flounces are decorated with lace; fastener is
on the back with buttons
Origin: acquired in 1941 from the State Museum of the
Ethnography of the Peoples of the USSR; before that in the
Winter Palace
State Hermitage Museum, inv. nos. ERT-13534 (dress),
13579 (under-dress) *Y.P.*

G36

DRESS FOR A CHILD 'IN RUSSIAN STYLE'

Russian, early 1900s
Cotton cloth, lace, mother-of-pearl and embroidery: (blouse)
47 x 124 cm; (skirt, height) 57 cm, (length folded along the
hem) 62 cm; (apron) 45 x 44, 144 cm
Blue cotton blouse decorated with cross-stitching, inserts
and edging of multicoloured lint lace, with internal sidelong
fastener of mother-of-pearl buttons; apron made of white
cotton, decorated with cross-stitching and multicoloured
lace; skirt made of blue cotton, bordered with red piping
and lace; a letter 'T' is cross-stitched on the skirt belt and
the apron, and a letter 'O' on the blouse
Origin: acquired in 1941 from the State Museum of
Ethnography of the Peoples of the USSR; before that in the
Alexander Palace at Tsarskoe Selo
State Hermitage Museum, inv. nos. ERT-7318 a (blouse),
7318 b, (skirt), 7315 b (apron)

These items belonged to the Grand Duchesses Olga
and Tatiana Nikolaevna. Costumes 'in Russian style',
made of cotton and lint and decorated with cross-
stitching and lacework, came into fashion among
young women as well as girls in the 1870s. They
were normally worn on summer promenades in the
countryside but never in town. *Y.P.*

G37

CEREMONIAL COSTUME OF TSAREVICH
ALEXEI NIKOLAEVICH

Russian, about 1905
Velvet, silk, gold, river pearls and metal: (jacket, length along
back) 35 cm; (trousers, length along side stitch) 47 cm
This ceremonial costume, consisting of a jacket and
trousers, has on its shoulder boards the monogram of
Nicholas II beneath a crown; with embroidered double-
headed eagle on corners of the collar; jacket, along its sides,
on the sleeves and pockets, and the trouser stripes, all
embroidered with gold
Origin: acquired in 1941 from the State Museum of
Ethnography of the Peoples of the USSR; before that in the
Alexander Palace at Tsarskoe Selo
State Hermitage Museum, inv. nos. ERT-12797 (jacket),
12798 (trousers) *Y.P*

G38

LE TRAGIQUE DESTIN DE NICOLAS II
ET DE SA FAMILLE, BY PIERRE GILLIARD

Payot & Cie, Paris, 1921
Card, linen, paper and ink, 23.2 x 15.3 x 3.8 cm
Lent by Dr and Mrs Duncan Poore, Invernessshire

The book contains notes, postcards and letters sent to
Miss Emily Loch by the Empress Alexandra and her
daughters from the late 1890s to 1915. All are written in
English and were sent as greetings for Christmas, the
New Year or Easter. Miss Loch lived at Cumberland
Lodge, Windsor, for at least part of this time. *G.E.*

G39

STANDARD COPY OF *QUEEN ALEXANDRA'S*
CHRISTMAS GIFT BOOK, PHOTOGRAPHS FROM
MY CAMERA

Card, paper, ink and photographs, 29 x 22.5 x 1.5 cm
National Museums of Scotland (Library 681.5) *G.E.*

G40

DE-LUXE COPY OF *QUEEN ALEXANDRA'S CHRISTMAS GIFT BOOK, PHOTOGRAPHS FROM MY CAMERA*, WITH SILVER MOUNTS

Leather, paper, ink, photographs, silver and gold,
29 x 22.5 x 2.8 cm
National Museums of Scotland (Library 681.55)

These books (nos. G39-40) contain photographs, taken by Queen Alexandra, of the British State Visit to Russia in 1908. They were published by *The Daily Telegraph*, for sale as Christmas presents, later the same year.

G.E.

G41

FOLDING KNIFE WITH SILVER HANDLE AND MANY TOOLS, OWNED BY ALEXANDER III AND NICHOLAS II

English, 1875-76
Steel and silver, 15.4 x 3.2 x 2.2 cm
Marks: maker's mark, London hallmarks for 1875-76, and the name of the retailer 'NICHOLLS & PLINCKE. S-t PETERSBURGH'
Engraved with the crowned monogram 'AA' of Alexander III
Origin: acquired in 1956 from the Central Storage of the Museum Funds in Pushkin; before that stored in the Alexander Palace at Tsarskoe Selo; the knife used to be in Nicholas II's study in the Alexander Palace
State Hermitage Museum, inv. no. E-17323 *L.Y.*

G42

PROPELLING PENCIL WITH WAX SEAL ENGRAVED WITH THE CROWNED MONOGRAM 'H II' OF NICHOLAS II

Russian(?), late 19th-early 20th century
Steel, silver, wood, diamond and turquoise, 5.1 x 1 x 1 cm
Origin: acquired in 1956 from the Central Storage of the Museum Funds in Pushkin; before that in the special funds of Pavlovsk Palace-Museum
State Hermitage Museum, inv. no. E-17315 *L.Y.*

G43

PENKNIFE IN THE FORM OF A FLAT FISH, WITH AN EXTENDABLE HOOK

S. Mordan & Co, London, 1882-83
Silver and steel, 10.5 x 2.8 x 0.7 cm
Marks: maker's mark, London hallmarks for 1882-83, and 'S. MORDAN & CO'
Origin: acquired in 1956 from the Central Storage of the Museum Funds in Pushkin; before that in Gatchina Palace-Museum; the knife was in Nicholas II's study in Gatchina Palace
State Hermitage Museum, inv. no. E-17316 *L.Y.*

G44

CIGAR-CUTTER

'J B', London, 1883-84
Silver and steel, 5.2 x 2.2 x 0.6 cm
Marks: maker's mark 'JB', London hallmarks for 1883-84, and the 'PT' struck on items imported through St Petersburg 1875-1900
Origin: acquired in 1956 from the Central Storage of the Museum Funds in Pushkin; before that in Gatchina Palace-Museum; the cutter was in Nicholas II's study in Gatchina Palace
State Hermitage Museum, inv. no. E-17317

Probably acquired by the Tsar during one of his visits to Britain. *L.Y.*

G45

MATCHBOX, DECORATED WITH THE RUSSIAN COAT OF ARMS

Albert Barker, London, 1887-88
Silver and enamel, 4.5 x 3.2 x 1 cm
On the reverse is a presentation inscription: 'Coessisce Sossisecier d' Alisce 1887'
Marks: maker's mark, London hallmarks for 1887-88, and 'ALBERT BARKER 5. NEW BOND ST. LONDON W'
Origin: acquired in 1956 from the Central Storage of the Museum Funds in Pushkin; before that in Pavlovsk Palace-Museum
State Hermitage Museum, inv. no. E-17335

Presumably a gift from Princess Alix to the Tsarevich Nikolai Alexandrovich. *L.Y.*

G55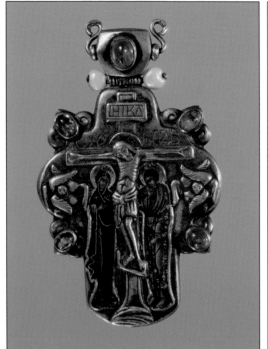

G57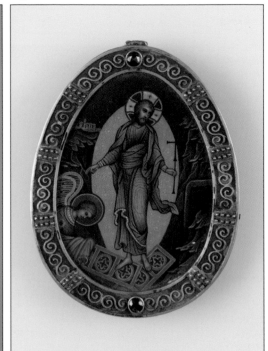

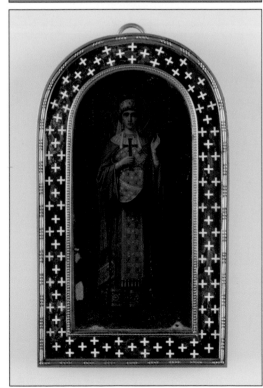
G58

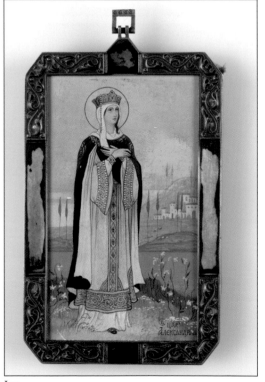
I07

G52
PENDANT IN THE FORM OF A HORSE'S HEAD

Russian(?), second half 19th century
Gold and smoky quartz, 2.5 x 2.1 cm
Origin: acquired in 1956 from the Central Storage of the
Museum Funds in Pushkin; before that in Pavlovsk Palace-
Museum
State Hermitage Museum, inv. no. E-17332 *L.Y.*

G53
DESK SEAL OF CITRINE

West European, second half 19th century
Gold, silver, citrine and porcelain: 7.3 x 2.7 x 2.2 cm;
(pedestal) 2.8 x 2.5 cm
The stone is engraved with the figure of a devil and the
inscription 'WHO THE [figure of devil] CAN THIS BE FROM'
Origin: acquired in 1956 from the Central Storage of the
Museum Funds in Pushkin; from the Lilac Study of the
Empress Alexandra Feodorovna in the Alexander Palace at
Tsarskoe Selo
State Hermitage Museum, inv. no. E-17328 *L.Y.*

G54
DOUBLE ICON OF SAINT BARBARA AND SAINT ARKADIY

Fabergé, St Petersburg, 1910s
Wood, tempera, silver, gold and almandine, 13 x 11.1 cm
Marks: Fabergé maker's mark 'KF', and St Petersburg assay
mark for 1908-17
Origin: from the Grand Duchess Xenia Alexandrovna
State Hermitage Museum, inv. no. ERO-6531 *L.Z., K.O.*

G55
ICON CROSS

Lyapanovsky workshops, Moscow, 1915
Silver, emeralds, tourmalines and mother-of-pearl,
8.5 x 5.5 cm
Marks: maker's mark and Moscow assay mark for 1908-17
with the silver standard '84'
On the reverse side is a scratched inscription: 'JESUS
RESURRECTED GOD BLESS YOU KSENYA 1915'
Origin: acquired in 1956 from the Central Depository of the
Leningrad Suburban Palaces; before that in the Alexander
Palace at Tsarskoe Selo
State Hermitage Museum, inv. no. ERO-8688

The cross was presented by the Grand Duchess Xenia
Alexandrovna to the Imperial family at Easter 1915.
 L.Z., K.O.

G56
ICON

Lyapanovsky workshops, Moscow, 1915
Silver, oil paint, emeralds, tourmalines and mother-of-pearl,
8.6 x 5.4 cm
Marks: maker's mark and Moscow assay mark for 1908-17
with the silver standard '84'
Inscribed on the back: 'BLESSING FROM MUM AND DAD
CHRISTMAS TREE 1915'
Origin: acquired in 1956 from the Central Depository of the
Leningrad Suburban Palaces; before that in the Alexander
Palace at Tsarskoe Selo
State Hermitage Museum, inv. no. ERO-8689

The icon was presented to the royal children at
Christmas in 1915. It shows the Mother of God, 'The
Saviour Not Made By Hands', Saint Nicholas of Myra,
and the Guardian Angel. *L.Z., K.O.*

G57
ICON OF THE 'RESURRECTION OF CHRIST'

Fabergé, Moscow, 1915
Wood, tempera, silver and sapphires, 8.4 x 6.2 cm
Marks: Fabergé mark and Moscow assay mark for 1908-17
with the silver standard '88'
Inscribed on the reverse: 'V. MOTHER DEAR EASTER 1915'
Origin: acquired in 1956 from the Central Depository of the
Leningrad Suburban Palaces; before that in the Alexander
Palace at Tsarskoe Selo
State Hermitage Museum, inv. no. ERO-8707

This egg-shaped icon was presented to the Empress
Alexandra Feodorovna by her children at Easter 1915.
 L.Z., K.O.

G58
ICON OF THE 'TSARINA ALEXANDRA'

Johann Victor Aarne for Fabergé, St Petersburg, early 1900s
Zinc, oil paint, silver, enamel, wood and glass, 12.6 x 7.3 cm
Marks: maker's mark 'VA', Fabergé mark, and St Petersburg
assay mark for 1896-1907 with the silver standard '84'
Inscribed in pencil on the reverse: 'GOD BLESS YOU'
Origin: acquired in 1956 from the Central Depository of the
Leningrad Suburban Palaces; before that in the Alexander
Palace at Tsarskoe Selo
State Hermitage Museum, inv. no. ERO-8705 *L.Z., K.O.*

H. 1613-1913:
The Romanov Tercentenary

H01

THE BALL IN THE ASSEMBLY HALL OF THE NOBILITY IN ST PETERSBURG ON 23 FEBRUARY 1913

Dmitry Nikolaevich Kardovsky (1866-1943), dated 1915
Watercolours and gouache on paper glued to canvas,
89 x 133 cm
Signed bottom right: 'D. Kardovskiy, 1915'
Origin: acquired in 1941 from the State Museum of
Ethnography of the Peoples of the USSR; originally in the
Winter Palace
State Hermitage Museum, inv. no. ERR-5990

The grand ball was held during the festivities celebrating the three hundredth anniversary of the House of Romanov. The Empress Alexandra is depicted sitting in the centre of the royal box, with Tsar Nicholas standing against the column to the right. The Dowager Empress Marie sits in front of the other column. Among the dancers in the centre foreground is the Tsar's eldest daughter, the Grand Duchess Olga. *G.P.*

H02

BADGE COMMEMORATING THE THREE HUNDREDTH ANNIVERSARY OF THE HOUSE OF ROMANOV IN 1913

Silver and gold, 5 x 4 cm
Marks: 'VD' (Vladimir Dinakov), 'Edward', and the
St Petersburg assay mark with the silver standard '84'
Origin: from the Gallery of Treasures of the Winter Palace
State Hermitage Museum, inv. no. ONGE IO-1338

This decoration was approved on 18 February 1913 and was intended for people who had personally congratulated Tsar Nicholas and his wife on the three hundredth anniversary of the Romanov dynasty between 21 and 24 February. *M.D.*

H03

PENDANT COMMEMORATING THE THREE HUNDREDTH ANNIVERSARY OF THE ROMANOV DYNASTY

Albert Holmström, St Petersburg, 1913
Gold, silver, diamonds and spinel, 6.2 x 3.7 cm
Marks: maker's mark 'AH' and the assay mark of
St Petersburg for 1908-17 with the gold standard '56'
Origin: acquired in 1985 through the Expert-Purchasing
Commission of the State Hermitage
State Hermitage Museum, inv. no. ONGE Vz-1439 *M.D.*

H04

BROOCH COMMEMORATING THE THREE HUNDREDTH ANNIVERSARY OF THE ROMANOV DYNASTY

Gold, silver, diamonds and glass, 2.2 x 2.2 cm
Origin: acquired in 1984 through the Expert-Purchasing
Commission of the State Hermitage
State Hermitage Museum, inv. no. ONGE Vz-1424 *M.D.*

H05

MENU OF THE DINNER IN MOSCOW ON 25 MAY 1913

S. Yaguzhinsky
Colour-printed paper, 44.5 x 15.8 cm
Origin: acquired in 1941 from the State Museum of
Ethnography of the Peoples of the USSR
State Hermitage Museum, inv. no. ERT-10629/68

This dinner was part of the celebrations of the three hundredth anniversary of the Romanov dynasty. At the top of the menu is an image of the first Romanov tsar, Mikhail Fyodorovich, sitting on the throne with the State Coat of Arms of Russia as a background. At the base of the throne are allegorical figures of a Russian boyar and a warrior with texts in their hands, which serve as slogans of their estates. Between them is an allegory of a young tsar from the future and a time of abundance. *G.M.*

H06

PRESENTATION DISH

Workshops of Nikolai Feodorovich Strulev, Moscow, 1913
Wood, silver, almandines, chrysolites and enamels,
52.5 x 53.5 x 5 cm
Marks: maker's mark 'NS' and Moscow assay mark for
1908-17 with the silver standard '84'
The dish is inscribed: 'To His Imperial Majesty the Emperor
Nikolai Alexandrovich from the ancient capital city of Vladimir,
16 May 1913'
Origin: acquired in 1956 from the Central Depository of the
Leningrad Suburban Palaces; before that in the Alexander
Palace at Tsarskoe Selo.
State Hermitage Museum, inv. no. ERO-8679

The celebration of the three hundredth anniversary
of the Romanov dynasty started triumphantly in St
Petersburg on 20-24 February 1913 and continued until
the end of May. On 15 May the Imperial family went
on a visit to the ancient towns associated with the
formation of the Russian state. This dish was presented
by the citizens of Vladimir on 16 May 1913. It is decor-
ated with painted enamel pictures of the ancient
Vladimir cathedrals of St Dimitry and the Uspensky
and also the building of the City Duma. In the centre
is the coat of arms of Vladimir. *L.Z., K.O.*

H07

PRESENTATION DISH

K. Konov for P. I. Olovianishnikov and Sons, Moscow, 1913
Wood, silver and enamel, 55 x 55 cm
Marks: maker's mark 'KK' and Moscow assay mark for
1908-17 with the silver standard '84'
Inscribed: 'TO HIS IMPERIAL MAJESTY THE EMPEROR
NICKOLAY ALEXANDROVICH FROM THE COMMONERS OF
YAROSLAVL 1613-1913'
Origin: acquired in 1956 from the Central Depository of the
Leningrad Suburban Palaces; before that in the Alexander
Palace at Tsarskoe Selo
State Hermitage Museum, inv. no. ERO-8677

This dish was presented to the Imperial family in
Yaroslavl on 21 May 1913, during the celebrations of the
three hundredth anniversary of the House of Romanov.
It is decorated with the coat of arms of Yaroslavl, a bear
standing on its hind legs. *L.Z., K.O.*

H08

PRESENTATION DISH

Fourth Moscow Jewellers Artel, Moscow, 1913
Wood, silver, jasper and chalcedony, 49.5 x 50 cm
Marks: maker's mark '4A' and Moscow assay mark for
1908-17 with the silver standard '84'
Inscribed: 'TO THE GREAT TSAR THE ORLOV NOBILITY
IS BOWING'
Origin: acquired in 1956 from the Central Depository of the
Leningrad Suburban Palaces; before that in the Alexander
Palace at Tsarskoe Selo
State Hermitage Museum, inv. no. ERO-8678

This dish was presented on 18 December 1913 when the
Imperial family visited Orel, on their return journey
from the Crimea. *L.Z., K.O.*

H09

ONE ROUBLE COIN ISSUED TO
COMMEMORATE THE TERCENTENARY OF
THE ROMANOV DYNASTY IN 1913

Silver, (diam.) 3.35 cm
National Museums of Scotland, inv. no. A.1928.170
Given by Mrs Hatcher, Edinburgh *G.E.*

I. Total War

101

GRAND DUKE NIKOLAI NIKOLAEVICH (1856-1944) ON HORSEBACK

Nikolai Semeonovich Samokish (1860-1944), after 1910
Oil on canvas, 67.5 x 55.5 cm
Signed bottom right: 'N. Samokish'
Origin: acquired in 1951 from the Artillery Museum in Leningrad
State Hermitage Museum, inv. no Ezn-pr 1036

The Grand Duke Nikolai Nikolaevich the Younger was a grandson of Emperor Nicholas I. He was Supreme Commander of the Russian Army during the first year of the First World War. In the portrait he is depicted in field uniform, wearing the insignia of the Order of St George and the French Military Medal. *S.P.*

102

HIS IMPERIAL HIGHNESS EMPEROR NICHOLAS II SERVING IN THE ARMY, SEPTEMBER-OCTOBER 1914

Compiled by Major-General Dmitry Nikolaevich Dubensky
R. Golike and A. Vilborg Press, Petrograd, 1915
Cardboard, paper and ink, 27 x 20 cm
Origin: acquired in 1941 from the State Museum of Ethnography of the Peoples of the USSR
State Hermitage Museum, inv. no. 365644

Under instructions from the palace, the Ministry of the Imperial Court issued a series of publications describing the travels of Nicholas II in the army and around Russia during the war of 1914. This volume was compiled by Major-General Dubensky (1858-1923), the editor of the journal *Chronicle of the 1914 War*, who accompanied the Emperor. Nicholas II wanted personally to see his forces and their commanders on the battlefield, to thank them and comfort those who had shed their blood defending Russia. The book contains numerous drawings, plans, and a map of Nicholas's travels, as well as a portrait of him in field uniform based on a work by Mikhail Rundaltsov. *G.V.Y.*

103

TSAREVICH ALEXEI NIKOLAEVICH

Mikhail Viktorovich Rundaltsov (1871-1935), dated 1917
Etching, with watercolours, 42.7 x 34 cm
Signed at the bottom: 'Mikh. Rundaltsov 1917'
Origin: acquired in 1951 from the Artillery Museum in Leningrad
State Hermitage Museum, inv. no. ERG-33987

Tsarevich Alexei was the patron of several army and guards regiments. During the First World War he accompanied Nicholas II on many of his journeys. He was awarded the Silver Medal of St George, Fourth Class, and received the rank of lance-corporal. *G.M.*

104

KEY-RING IN THE FORM OF AN EGG DECORATED WITH THE BADGE OF ST GEORGE

Fabergé, Russia, 1914-16
Brass and enamel, 2 x 1 cm
Origin: acquired in 1996 through the Expert-Purchasing Commission of the State Hermitage
State Hermitage Museum, inv. no. ERM-9549

During the First World War, many large Russian jewellery workshops and firms cut down their production. In 1915 the Fabergé Company received a military contract. The Moscow silver factory was re-equipped, and an additional workshop was opened in St Petersburg. The firm switched to producing hand grenades and shell-casings, but also made copper alloy tobacco-boxes, plates, cruet stands, mugs, key-rings, *etc*, which served as cheap gifts and souvenirs in these grim times. *M.K.*

105

TOBACCO BOX, DECORATED WITH A TWO-HEADED EAGLE IN A CIRCLE AND THE INSCRIPTION 'THE WAR OF 1914-1915'

Fabergé, Russia, 1915
Brass, 10 x 6.5 x 2 cm
Origin: acquired in 1951 from the State Museum of Ethnography of the Peoples of the USSR; before that in the collection of the Yusupov family
State Hermitage Museum, inv. no. ERM-944 *M.K.*

106

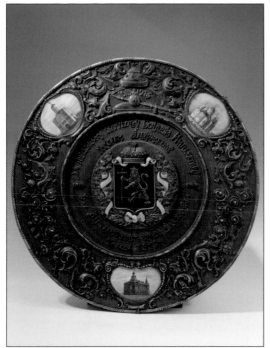

101

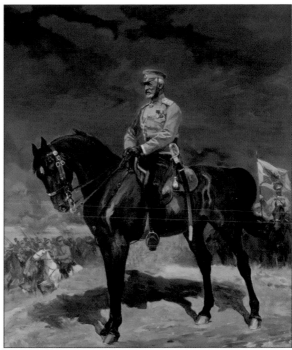

105

104

106

COMMEMORATIVE BOWL WITH THE RUSSIAN COAT OF ARMS

Fabergé
Brass, (diam.) 10.8 cm
Origin: acquired in 1989 through the Expert-Purchasing
Commission of the State Hermitage
State Hermitage Museum, inv. no. ONGE R-1592

From the beginning of the First World War, the
Fabergé company produced bowls, cigarette boxes and
other useful items decorated with a double-headed
eagle. They were generally marked on the base 'WAR'
and the year, and below the eagle 'C. FABERGÉ', and
were made of gold, silver or copper. *M.D.*

107

ICON OF THE 'TSARINA ALEXANDRA'

Fabergé, Moscow, 1916
Wood, oil paint, silver, enamel and cloth, 12.8 x 7.1 cm
Marks: Fabergé maker's mark, and Moscow assay mark
for 1907-17 with the silver standard '84'
Inscribed on reverse: 'TO HER IMPERIAL MAJESTY
EMPRESS ALEXANDRA FEADOROVNA FROM THE ODESSA
LADIES RED CROSS COMMITTEE IN MEMORY OF HER
VISIT TO HER IMPERIAL MAJESTY'S HOSPITAL ON THE
KHIDGINBECK ESTUARY ODESSA 10 MAY 1916'
Origin: acquired in 1956 from the Central Depository of the
Leningrad Suburban Palaces; before that in the Alexander
Palace at Tsarskoe Selo
State Hermitage Museum, inv. no. ERO-8693

This icon was presented to the Empress Alexandra
Feodorovna by the lady patronesses of the Odessa
hospital on 10 May 1916, during the royal family's trip
to the south regions of Russia. The trip was organised
with the purpose of collecting funds for the war loan.
 L.Z., K.O.

108

GRIGORY RASPUTIN (1869-1916)

Elena Nikandrovna Klokacheva (1871-after 1915),
dated 1914
Coloured pencil and pastel on grey card, 81.5 x 56 cm
Signed bottom right: 'E Klokacheva, June [1]914'
Origin: acquired in 1954 from the Museum of the Revolution
State Hermitage Museum, inv. no. ERR-5432

Grigory Efimovich Rasputin was a well-known *staretz*
(monk or spiritual advisor) and a popular figure at the
court of Nicholas II. He came from a prosperous peasant
family in the Tobolsk region and possessed the gift of
clairvoyance and hypnotic suggestion. In 1905 he came
to St Petersburg and through the rector of the St Peters-
burg Religious Academy was introduced to Grand Duke
Nikolai Nikolaevich the Younger. The Grand Duke's
wife introduced Rasputin to the Imperial family and he
began to visit Tsarskoe Selo. Rasputin had an extraor-
dinary influence over the Tsarina, her daughters and
even Tsar Nicholas himself, for the simple reason he
seemed able to relieve the suffering of the Tsarevich.

Rasputin's influence was especially strong during
the war years. From 1914-16 he was the Tsarina's only
advisor on matters of state government. Ministers were
appointed on his advice, which gave rise to protest from
all levels of society, including court circles and members
of the Romanov family. Rasputin was killed on the night
of 16/17 December 1916 at Yusupov's palace in St Peters-
burg. Among those who conspired to kill him were Prince
Yusupov, V. M. Purishkevich, a member of the State
Duma, and Grand Duke Dmitry Pavlovich. *G.P.*

109

COUNT F. F. SUMAROKOV-ELSTON (1887-1967)

R. de San-Gallo, early 1900s
Watercolour and gouache on bone, 9.4 x 7 cm (oval)
Signed on the left side of the oval: 'R. de San Gallo'
Origin: acquired in 1941 from the State Museum of
Ethnography of the Peoples of the USSR; originally in the
palace of the Yusupov family in St Petersburg
State Hermitage Museum, inv. no. ERR-61

Count Felix Felixsovich Sumarokov-Elston was the son
of Count F. F. Sumarokov-Elston (the elder) and Princess
Z. N. Yusupova. He became Prince Yusupov in 1908.
Yusupov married Irina Alexandrovna, niece of Nicholas
II, in 1914 and served in the Horse-Guards Regiment.
He was one of the organisers and participants in the
murder of Rasputin in 1916. *G.P.*

I10

CIGAR BOX

Karl Gustav Hjalmar Armfeldt for Fabergé, Petrograd, 1917
Birch, gold, silver and enamel, 7.2 x 25 x 13.5 cm
Marks: maker's mark ' A', the Fabergé mark, and Petrograd assay mark for 1908-17 with the silver standard '88'
Origin: acquired in 1941 from the department of the history of everyday life of the State Museum of Ethnography of the Peoples of the USSR; before 1926 in the museum of everyday life of the district department of the people's education (the museum was in the Fountain House of Count Sheremetev)
State Hermitage Museum, inv. no. ERO-6455

On the cover is the monogram 'GVR' of King George V of Britain (1865-1936), the date '17 January 1917 8 Febuary', and the monogram of his wife, Mary of Teck (1867-1953). The box was not presented because the 'r' was omitted from 'February'. *L.Z., K.O.*

I11

ILLUSTRATED JOURNAL BY DOROTHY SEYMOUR OF HER STAY IN ST PETERSBURG IN 1916-17

Card, paper, watercolours, inks and photographs, 32 x 26 cm
Lent from a private collection

Miss Seymour, the daughter of General Lord Seymour, went to Russia with the Voluntary Aid Detachments as a V.A.D. and saw the Tsarina and the outbreak of the first Russian revolution. *G.E.*

J. The End of a Dynasty

J01

ICON OF TSAR NICHOLAS II PRESENTED TO THE ROYAL SCOTS DRAGOON GUARDS BY THE CALEDONIAN SOCIETY OF MOSCOW IN 2001

Wood and paint, 34.4 x 26.5 x 1.8 cm
Lent by the Royal Scots Dragoon Guards (Carabiniers and Greys)

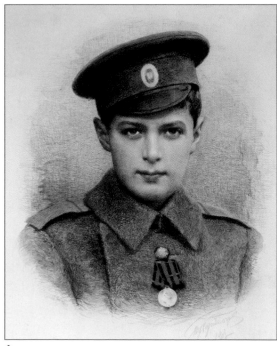

103

BIBLIOGRAPHY

Costume Ball in the Winter Palace
(2 volumes)
(Moscow: 2003)

Damskiy Mir (1908)

The Diaries of Tsar Nicholas II
(Moscow: 1991)

Count Aleksey Ignatiev:
Fifty Years in the Ranks: Memoirs
(Moscow: 2002)

Grand Duchess Olga Alexandrovna:
Memoirs
(Moscow: 2003)

Grand Duke Alexander
Mikhailovich:
Book of Memoirs
(Moscow: 1991)

Grand Duke Gavril
Konstantinovich:
*In the Marble Palace. Chronicles of
our family*
(St Petersburg: 1993)

*The holy coronation of Their Imperial
Highnesses and the ensuing festivities
in Moscow*
(St Petersburg: 1896)

V. Maslov:
Elizaveta Fedorovna. A Biography
(Moscow: 2004)

A. A. Mosolov:
In the Court of the Last Emperor
(St Petersburg: 1992)

Niva (no. 22) (1896)

S. S. Oldenburg:
The reign of Tsar Nicholas II
(St Petersburg: 1991)

Maurice Paléologue:
*Tsar's Russia on the Eve of the
Revolution* (Moscow: 1991)

Russian Historical State Archive
Stock 468, list 42

Y. Shelayev (*et. al.*):
Nicholas II. Pages from a life
(St Petersburg: 1998)

Prince Sergei Volkonsky:
My memoirs (part II)
(St Petersburg: 1992)

Sergei Y. Witte:
Reminiscences (vol. II)
(Moscow: 1994)